Sea
Change

Sea Change

An Atlas of Islands in a Rising Ocean

CHRISTINA GERHARDT

FOREWORDS
BILL McKIBBEN
HILDA HEINE
DESSIMA WILLIAMS

MAPS
MOLLY ROY
DESIGN
LIA TJANDRA

 UNIVERSITY OF CALIFORNIA PRESS

University of California Press
Oakland, California

© 2023 by Christina Gerhardt

Maps by Molly Roy
Illustrations by Zina Deretsky, www.levelfive.com

Permissions to reproduce material are located in credits at the back of this
book. Every effort was made to contact all rights holders. If you are a rights
holder and did not hear from the author or publisher, please contact us.

Cataloging-in-Publication Data is on file at the Library of Congress.

ISBN 978-0-520-30482-6 (cloth : alk. paper)
ISBN 978-0-520-97321-3 (ebook)

Composition: Lia Tjandra
Prepress: Embassy Graphics
Printer: Imago

Printed in Malaysia

32 31 30 29 28 27 26 25 24 23
10 9 8 7 6 5 4 3 2 1

Contents

Foreword

BILL McKIBBEN

Planet Earth is a big, sprawling place, except when it isn't. Some of the world's most remarkable cultures have risen on small islands, as this fine atlas makes clear; having had the pleasure of visiting many of these places, I can testify to the distinctive ways-of-being that come when people must learn to live with their neighbors because there is literally nowhere to go. The "island spirit" that outsiders often notice is a great gift to the rest of humanity.

And of course these places are now under the most severe threat, and through no fault of their own. To sit on an atoll, able to see the ocean on all sides, knowing that the highest place within reach is just a few meters above sea level—in the twenty-first century that's a truly vulnerable position.

The people of these islands are not giving up. "We are not drowning! We are fighting!" has become a rallying cry across the Pacific and Indian Oceans. This volume lets them speak, and reminds all of us precisely what is at stake. We should have this information close to head and heart: the geography, the history, the particular humanity of these places that in our carelessness we in the rich continents are on the edge of wrecking.

Author Christina Gerhardt and her many collaborators deserve our thanks. The worlds they describe are among the oldest, richest, and most dense with meaning that can be found here on our planet. We should know them, honor them, and let them live on far into the future.

Forewords

HILDA HEINE

Republic of the Marshall Islands

Ocean waters regularly flood over a temporary seawall shielding my property from the sea. If left unchecked, the ocean that has sustained us for so long will take my home. For many, the stakes are even higher. They say we will be underwater in the next twenty to fifty years. What of the survival of an entire culture? What of a home for my grandchildren? And while my island nation may be on the front lines, no country is immune.

The science tells us that climate change impacts will continue to worsen. At only 2 meters (6.56 feet) above sea level, the Republic of the Marshall Islands is at a severe risk. Current predictions run between 0.3 (1 foot) and 2.4 meters (8 feet) of sea level rise by 2100. The inundation of seawater gets into our wells and renders our water undrinkable. It gets into the soil and makes it a challenge to grow foods. The water floods into homes. Seawalls have

DESSIMA WILLIAMS

Grenada

Men, women, youth, and children from Small Island Developing States (SIDS) and low-lying countries face the imperative to present our own island realities and perspectives to the world. That is, to undertake the necessary movement of the needle on islands from where it was started centuries ago, mostly by early Europeans, who saw islands as *vacans terram,* empty of civilization but full of native cannibals and opportunities for the European (male) to carve out wealth. More recently, as islands settle into the psyche of the global public, they are seen as exotic or endangered, as sites for foreign investment or for a raft of illegal activities from human trafficking to drug smuggling and more. The universal agenda of human beings conducting the diversity of activities that constitutes human existence seems to escape common consciousnesses when it comes to islands.

been demolished. The inundation has washed away graves. Unlike continental land dwellers, we have no higher ground to run to.

Sea Change: An Atlas of Islands in a Rising Ocean presents islands globally that are at risk of sea level rise. Poems and texts of various genres foreground islanders' voices. In essays the book shares the islands' histories and stories. Maps show the impacts of sea level rise. This atlas shares not only the science related to climate change impacts and sea level rise but also the lived experience of islanders. Throughout the book the impact of colonialism and imperialism is a thread. Both the ongoing military occupation of islands and the tourism industry continue to challenge political and economic independence. These issues compound climate change effects.

As this atlas underscores, the view from the continent and from the islands differs starkly. While the islands may seem distant or remote to continental residents, as Christina Gerhardt writes, citing Epeli Hau'ofa, "islanders dispersed among an ocean . . . , reading it as the center, deem themselves to be connected." Epeli Hau'ofa has pointed out that "there is a gulf of difference between viewing the Pacific as 'islands in a far sea' and as a 'sea of islands.'" This atlas centers islands and tells the story about the connections among islanders.

Moreover, *Sea Change: An Atlas of Islands in a Rising Ocean* shares not only the histories and stories of islands and islanders but also the work being undertaken by islanders to address sea level rise. The Marshall Islands is currently

But the corpus of materials that helps to reverse or erase negatives on islands is indeed increasing, as positive voices on islands continue to spring to the fore worldwide. This is why *Sea Change: An Atlas of Islands in a Rising Ocean* is so welcome and critical. It presents an important shifting of the gaze toward truth-telling of islands. In poetry and prose, critical voices of and from around the world of islands give valuable messages and praises and issue calls. And sea level rise in and on islands requires more truth-telling. Indeed, in large measure, this book is about resetting the "narrative vantage point" in favor of a triple movement: celebrating islandness, confronting multiple and increasing vulnerabilities, and becoming reacquainted with a global community of island storytellers, including prize-winning intellectuals of various genres.

In his text *Globalised. Climatised. Stigmatised*, Camillo M. Gonsalves of Saint Vincent and the Grenadines in the eastern Caribbean writes of "small island exceptionalism . . . shaped by the practical realities of smallness, of islandness, and of the delicate dance of alternatively accommodating, resisting and adapting to tremendous exogenous pressures. Through this dance, small island states have forged a personality and development outlook without parallel in any other group of countries in the world" (12).

In this atlas, worldwide island exceptionalism jumps out at the reader, making the collection compelling as it combines

developing its National Adaptation Plan, a strategic plan that considers various responses to climate change, including the elevation of land, internal migration, or even the extreme option of building new islands. Islanders are actively working to bring awareness to and alleviate the impacts of climate change. The atlas highlights this work. Throughout the Pacific a battle cry can be heard: "We are not drowning! We are fighting!"

short essays and maps to focus on the impacts of sea level rise. Naturally then, the book provides insight into the painful nexus of the threats islands face and the resources they need to be themselves and, of course, to survive and thrive.

Author Christina Gerhardt reminds us that "Roman Pliny the Elder wrote of the Fortunate Islands in *Natural History* that they 'abound in fruit and birds of every kind.'" This atlas presents island words (fruits) of every kind from island writers (birds) of every kind; therein lies its appeal to all who value an island exceptionalism of author and of subject that is anchored in the responsibility of all to do everything they can to ensure that islands stay alive and thrive.

Introduction

> There is a gulf of difference between viewing . . . "islands
> in a far sea" and as a "sea of islands." EPELI HAU'OFA

ATLASES

Atlases are being redrawn as islands are disappearing. Yet many on continents are not even aware of where these islands are located, what their names are, or how climate change impacts them, despite the fact that continental land dwellers are often more responsible for producing carbon dioxide (CO_2) emissions and sea level rise. According to the Intergovernmental Panel on Climate Change (IPCC), Pacific Island nations are responsible for 0.03 percent of global emissions. Figures for islands in the Caribbean Sea are in a similar range. Island nations are among the nations that have contributed the least to CO_2 emissions and global warming; they are, however, suffering its impacts already, severely and disproportionately. Entire nations, their histories, cultures, and languages are at risk of being lost.

These low-lying islands are a harbinger of the future that awaits the residents of coastal cities and shorelines. Internationally, the cities projected to be most affected include but are not limited to Guangzhou and Shanghai, China; Hong Kong; Mumbai, India; Amsterdam, Netherlands; Lagos, Nigeria; Manila, Philippines; Dakar, Senegal; and Ho Chi Minh City, Vietnam.[1] Almost half of the US's population, about 40 percent, lives in coastal states and cities. In other words, or numbers, it is estimated about 13 million US residents would be affected, in particular, in order of impact, in the states of Florida, Louisiana, California, New York, and New Jersey. A study published in *Nature*

1. Jonathan Watts, "From Miami to Shanghai: Three Degrees of Warming Will Leave World Cities under Water," *The Guardian*, November 3, 2017; Josh Holder, Niko Kommenda, and Jonathan Watts, "The Three Degree World: Cities Drowned by Global Warming," *The Guardian*, November 3, 2017.

in 2016 estimated that by 2100 as many as 13 million US residents could be affected by sea level rise. So-called "hundred-year floods" will happen every year in New England and mid-Atlantic regions and every one to thirty years along the Southeast Atlantic and Gulf of Mexico.[2] All states along the Eastern Seaboard will be affected. The difference? Residents on continents can retreat inland. For many islands, sea level rise may spell the end of their nation's very existence.

How to make visible what might be geographically remote to some? How to render visible the climate science? How to encourage thinking with? How to encourage a thinking that is mindful of how we are all connected, as humans and with nonhumans? Spatially, actions in one place have an effect in another place. Temporally, actions in one era (the history of burning fossil fuels) have an effect in another era (the present). How to encourage a perspective that weaves together our past history and actions, including the legacy of colonialism, with a thinking about our present actions that works toward a livable future? How to activate a concept of living with? Is this about a world that structures its relations to land, people, animals, and ecosystems for profit and accumulation? Or is this about a way of living that is based on an acknowledgment of the interconnectedness of the ecosystems, of humans and nonhumans, and thinks those relations through to prioritize an equitable present and a livable future?

Atlases exist that map sea level rise impacts on cities in the US but no atlas exists that maps where the most impacted islands lie, that tells what the effects of sea level rise will be on these islands and that shares the islanders' strategies to address and resolve them. *Sea Change: An Atlas of Islands in a Rising Ocean*, through its texts and maps, allows us to understand the dramatic changes taking place and activates imaginings of possible futures.

ISLANDS—IN THE COLONIAL IMAGINATION

Every island has a story. There are, of course, many more stories than there are islands. Spanning the globe. Which is another way of saying: (Narrative) vantage point is everything.

Islands are deemed to be paradisiacal. The blue ocean. The beaches. Palm trees gently swaying in a balmy breeze. Soft white sand underfoot. The temperate clime. Do an internet search for "paradisiacal" and the first example of its use in a sentence features an island: "a paradisiacal island in the Bahamas." *Merriam-Webster*'s definition of "paradisiacal" features an island: "The 15-day, round-trip cruise, . . . includes visits to some of French Polynesia's most *paradisiacal* islands." Islands are paradisiacal. Paradise is an island.

2. Reza Marsooli, et al. "Climate Change Exacerbates Hurricane Flood Hazards along US Atlantic and Gulf Coasts in Spatially Varying Patterns," *Nature Communications* 10.1 (2019). DOI: 10.1038/s41467-019-11755-z.

The Western imagination often casts islands as utopias—or dystopias. Early on, in *Timaeus* and *Critias,* Plato wrote about the lost island of Atlantis that would threaten to conquer Ancient Greece.[3] Greece, the cradle of Western civilization, encompasses thousands of islands dispersed throughout the Aegean and Ionian seas. Of course, these islands are intimately tied to maps. In the sixteenth century, German-Flemish geographer Gerardus Mercator, who created the famous or perhaps infamous Mercator map, is credited with coining the term *atlas*, referring to a collection of maps in a book. Mercator named his *Atlas Sive Cosmographicae Meditationes de Frabica Mundi et Fabricati Figura* (Atlas or Cosmographical Meditations upon the Creation of the Universe and the Universe as Created) after the Greek god Atlas. The Atlantic Ocean, literally translated, is the sea of Atlas. Atlantis, translated from the Ancient Greek, means Atlas's island. Thomas More revisited the mythical place Atlantis in *Utopia* (1516) and Francis Bacon in *New Atlantis* (1627),[4] but More set his Atlantis in the Pacific between Sri Lanka and the Americas and Bacon locates it in the South Seas.[5]

For a long stretch, to Europeans, islands often rested in the fantastical realm of uncharted (to them) oceans accompanied by gods or sea monsters. In Ptolemy's *Geography*, which introduced latitude and longitude, the Fortunate Islands (or Isles of the Blessed) where the Greek gods lived was the westernmost land known at the time. Roman Pliny the Elder wrote of the Fortunate Islands in *Natural History* that they "abound in fruit and birds of every kind." Pliny the Elder put forward the notion that all land animals had an equivalent in the sea. If there were dogs and pigs, so the thinking went, there had to be sea dogs and sea pigs. Aside from these benevolent creatures, malevolent sea monsters were believed to lurk in the sea.

Monsters continued to adorn medieval *mappa mundi*.[6] Sea unicorns. Giant worms. Enormous lobsters. And, of course, those dangerous sirens, who since Odysseus's return have lured sailors to shipwreck with their beautiful voices. All of these fantastical creatures appeared on maps from the tenth to the sixteenth century. Then, as European navigators explored and charted the oceans, the sea monsters disappeared from their maps.

Narratives of disappeared islands—referred to as lost lands—took their place.[7] Lemuria might be the most famous example.[8] Also known as Kumari Kandam, this cradle of ancient Tamil

3. Plato, *Timaeus and Critias,* trans. Desmond Lee (Penguin, 2008).

4. Thomas More, *Utopia* (Penguin, 2012); Francis Bacon, *New Atlantis* (New Atlantis, 1952).

5. L. Sprague de Camp, *Lost Continents: Atlantis Theme in History, Science and Literature* (1954; Dover, 2012). Ignatius Donnelly, *Atlantis: The Antediluvian World* (Dover, 2011).

6. Chet Van Duzer, *Monsters on Medieval and Renaissance Maps* (British Library, 2014); Joseph Nigg, *Sea Monsters: A Voyage around the World's Most Beguiling Map* (University of Chicago Press, 2013); Ptolemy's *Geography,* 150; and Pliny the Elder, *Natural History,* 79.

7. Edward Brooke-Hitching, *The Phantom Atlas: The Greatest Myths, Lies and Blunders on Maps* (Chronicle Books, 2018).

8. Wishar S. Cerve, *Lemuria: The Lost Continent of the Pacific* (Rosicrucian Press, 1935); Sumathi Ramaswamy, *The Lost Land of Lemuria: Fabulous Geographies, Catastrophic Histories* (University of California Press, 2004).

civilization was believed to have rested in the Indian Ocean and to have bridged the African island of Madagascar to the west, India to the north, and Australia to the east in a theory proposed in 1864 by British zoologist and geographer Philip Sclater. Similarly, in the early twentieth century, the British engineer, inventor, and occult writer James Churchward argued that a lost continent of Mu once sat in the central Pacific Ocean, occupying a space that spanned from the Marianas (see Northern Mariana Islands (16) in this atlas) in the west to Rapa Nui (Easter Island) in the east, from Hawai'i in the north to the Kūki 'Āirani (see Cook Islands (31)) in the south.[9]

But the monsters lingered in the Western literary imagination. In Jules Verne's *Twenty Thousand Leagues under the Sea* (1870), Captain Nemo aims to find a mysterious sea monster that has sunk numerous ships.[10] In Daniel Defoe's *Robinson Crusoe* (1719), the eponymous protagonist is a castaway who spends twenty-eight years on an island near Trinidad.[11] He encounters cannibals and mutineers. So popular was the book that it launched a new genre about castaways marooned on islands: the Robinsonade.[12] Islands were framed as remote and thus dangerous. William Golding's *Lord of the Flies* (1954) tells of a group of British boys stranded on a desert island. Their attempt to survive does not end well.

In these tales the focus so often is on the explorers. Those who seek gold. Those who hunt whales. Those who mutinied. Those who are marooned. Those who die of thirst, of disease, on tropical islands. Those who freeze to death on Arctic islands. Those who look for the Northwest Passage and never return from the icy terrain. Most characters and protagonists in these tales are men. Few are women. Moreover, when islanders appear at all, they are cast from a colonizer's point of view. The islands are cast as remote. Desolate. Deserted. Too hot. Too cold. Islands empty due to volcanic eruptions. Islands empty because of nuclear testing. Islands that held prisoners. Islands whose creatures have been hunted to extinction.

But there is another vantage point, which follows after a brief excursus into the science.

THE SCIENCE

In 2009, I attended the Copenhagen climate conference, formally the fifteenth meeting of the Conference of the Parties (or COP 15) convened by the United Nations Framework Convention on Climate Change (UNFCCC). While some media coverage concentrated overly on the US-China

9. James Churchward, *The Lost Continent of Mu* (The Brotherhood of Life, 1987).

10. Jules Verne, *Twenty Thousand Leagues under the Sea* (Penguin, 2018).

11. Daniel Defoe, *Robinson Crusoe* (Penguin, 2014).

12. Rebecca Weaver-Hightower, *Empire Islands: Castaways, Cannibals and Fantasies of Conquest* (University of Minnesota Press, 2007).

relationship—that is, the question of whether either nation, as the largest emitters, would take the lead in emissions reductions—the stories shared inside the conference told another story. As nations stood up one by one, individually, and also as part of the UN cluster groups to which they belonged—in UN parlance, the Alliance of Small Island States (AOSIS), the Africa Group, the Least Developed Countries (LDCs), and the Small Island Developing States (SIDS)—they shared information about the ongoing situation in their home countries. Since the UNFCCC takes place annually toward the end of the year, many nations have just weathered the season when cyclones, hurricanes, or typhoons have been most active. After the annual UN climate negotiations, if one is listening to what is being presented by representatives of individual nations and UN cluster groups, one comes away with a visceral sense of climate change impacts worldwide. But one would never know about this larger context if one read the papers.

As to the US and China, many nations believe that the US, given its historical responsibility for producing CO_2 emissions and given its current per capita rates at more than twice China's amount (in 2021: US, 15.53 tons; China, 6.59 tons), should lead the way.[13] The US thinks China, which is currently the biggest producer of CO_2 emissions, should do so (in 2021: US, 5.00 billion tons; China, 9.04 billion tons).[14] China and other nations often counter that China's CO_2 emissions are high because of the products it produces and ships to the US (per capita rates). That debate continues.[15]

So, too, does the increase in CO_2 emissions and thus of global warming and therefore of sea level rise and, in turn, the impacts on low-lying island nations. Climate models take into account both air and water temperature, but much of the discourse on global warming tends to focus on air temperature and on keeping it from increasing more than 2.0°C (3.6°F). Yet Tony De Brum, the late former foreign minister for the Republic of the Marshall Islands, and other island nations advocate "1.5 to Stay Alive" or "1.5 to Thrive." For many Pacific Island nations—such as the Marshall Islands, which on average sit no more than 2 meters (6.56 feet) above sea level—a 2.0°C (3.6° F) increase would be what they refer to as a "death warrant," so they advocate a maximum increase of 1.5°C (2.7°F).

Sea levels rise mainly as a result of two factors, each created by global warming. First, increased ocean temperatures lead to thermal expansion: that is, when water heats up, it expands. Warmer

13. Kindest thanks to Lucia Green-Weiskel for helpful exchanges about the US and China with regard to the UN climate negotiations that help inform this paragraph.

14. "Emissions Database for Global Atmospheric Research," European Commission; "CO_2 Emissions from Fuel Combustion," IEA Atlas of Energy; "Statistical Review of World Energy 2021," BP; "Each Country's Share of CO_2 Emissions," Union of Concerned Scientists; and "Fossil CO_2 Emissions for All World Countries," European Commission Joint Research Centre, 2020.

15. See Tina Gerhardt and Lucia Green-Weiskel, "Obama Admin Takes Aim at China's Renewable Energy Subsidies," *Grist.org,* December 29, 2010; and Tina Gerhardt and Lucia Green-Weiskel, "Sputnik Moment: Historic Meetings between US and China May Spur a Clean Energy Race," *Grist.org,* January 17, 2011.

oceans take up more space. Second, melting land ice creates higher sea levels. Land ice includes ice sheets (or glaciers) and ice caps in Antarctica and Greenland. Melting in the cryosphere will add intensely to sea level rise. Greenland alone is estimated to contribute about 20 percent of sea level rise.

The most reliable scientific research to forecast climate change and related global effects, such as sea level rise, comes from the United Nations IPCC. Established in 1988 by the United Nations Environment Programme (UNEP) and the World Meteorological Organization (WMO), the IPCC gathers and reports the science related to climate change and its effects. This science is intended to provide a basis for what in UN speak are called mitigation and adaptation plans. In other words, how does a nation plan to mitigate? That is, to limit climate change impacts? Reduce CO_2 emissions? How does it plan to adapt, for example, to sea level rise? Managed retreat?

The current IPCC report is the Sixth Assessment Report (AR6) published in 2021.[16] The report puts together four different scenarios, ranging from a very low greenhouse gas (GHG) emissions scenario, to a low, to an intermediate, to a very high GHG emissions scenario. On a very high GHG emissions scenario, the IPCC predicts 0.63–1.01 meters (2.06–3.31 feet) of sea level rise by 2100. Under the most extreme emissions scenario, sea level rise could reach 2 meters (6.56 feet) by the century's end. The IPCC estimates are known to be quite conservative.

In February of 2018, the *Proceedings of the National Academy of Sciences* released a report stating that the melting in Greenland is accelerating and could lead to twice as much sea level rise as previously thought—that is, up from 1 meter (3 feet) by the century's end to over 2 meters (6.56 feet) by the century's end. In December 2018, a report published in *Nature* revealed that runoff from Greenland's ice sheets is about 50 percent higher than preindustrial levels. Also in 2018, a study published in *Nature Geoscience* found that ice sheets in Antarctica are melting away at their base, which had not been detected because it is below the sea surface, and could soon overtake Greenland to become the biggest source of sea level rise.[17] Research conducted by the Institute for Climate Impact Research and published in the *Proceedings of the National Academy of Sciences* in June 2019 stated: "We find that a global total SLR [sea level rise] exceeding 2 m by 2100 lies within the 90% uncertainty bounds for a high emission scenario. This is more than twice the upper value put forward by the Intergovernmental Panel on Climate Change in the Fifth Assessment Report."[18]

Moreover, sea level rise varies by location.[19] For example, according to the California Coastal Commission and its 2018 update *State of California Sea-Level Rise Guidance*, "California will be

16. Intergovernmental Panel on Climate Change, Sixth Assessment Report, August 7, 2021. www.ipcc.ch/report/ar6/wg1/downloads/report/IPCC_AR6_WGI_Full_Report.pdf. Information about the results of the high emissions scenario appears on page 29 of the report.

17. Hannes Konrad, et al., "Net Retreat of Antarctic Glacier Grounding Lines," *Nature Geoscience* (2018). DOI:10.1038/s41561-018-0082-z.

18. Jonathan L. Bamber, et al., "Contributions to Future Sea-Level Rise from Structured Expert Judgment," *Proceedings of the National Academy of Sciences* 116.23 (June 4, 2019): 11195–11200.

19. Rebecca Hersher, "Why Sea Level Rise Varies across the World," *All Things Considered*, NPR, August 20, 2019.

greatly impacted by sea level rise. San Francisco is projected to see a rise between 1.1 [0.33 meter] and 2.7 feet [0.85 meter] by 2050. By 2100, San Francisco could experience between 2.4 and 6.9 feet [0.073 and 2.1 meters] of sea level rise, depending on how strongly we curtail our use of fossil fuels, with a potential for more than 10 feet [3.04 meters] of rise if there is extreme melting of the West Antarctic ice sheet." As California Coastal Commissioner Donne Brownsey said in an interview, "We don't have as much time as we think." Sea level rise is "accelerating. Every year we find out our estimates were too conservative."[20]

Tools for checking predicted sea level rise for different locations are available online through Climate Central's Surging Seas site and the Sea Level Rise Viewer of the US's National Oceanic and Atmospheric Administration (NOAA). The latter only covers the US and its territories. For that reason, this book generalizes the IPCC data to say 1 foot (0.3 meter) by 2050 and 3 feet (0.91 meter) of sea level rise predicted by 2100. For a handful of islands (particularly those nearest the equator in the western Pacific Ocean), the numbers predicted in the IPCC report are slightly higher due to a combination of factors that will be discussed throughout the atlas. It is important to note that all of the numbers used in this book rest on the conservative end of possible predictions, so the reality of sea level rise could in fact be a lot more grave than what is shown on these maps (for more, see "Mapping Choices" in this introduction).

Climate change is, of course, not merely an issue. It is a framework that encompasses all else. It is the lens through which to see all else. That is, it is food (fish, produce). It is housing. It is health care. It is education. It is employment. It is transportation. Each one of these issues interfaces with global warming. Underpinning this atlas is a question: If climate change necessitates a radical retooling of our economies and infrastructures, why not do so in a way that deals not only with the climate threat but also with social justice, economic justice, and racial justice, in a way that ensures environmental justice. Opportunities to do so appear throughout the atlas.

ISLANDS—WHAT'S YOUR CENTER?

Narrative vantage point is everything. Vacation on an island and you will have one experience. Live on an island and you will have another experience. Being from and living on an island is yet an altogether different thing. And being from an island and being diasporic is yet another thing.

A vacation on the island will doubtless conjure up and confirm the images mentioned at the outset. These are images created and stoked by centuries of travel writing, films, and the tourism industry. "Oh my god! It must be *so* great to live there!" exclaim those who have never visited but have an image fully formed or quickly forming in their head.

20. Anne C. Mulkern, "Local and States Officials Clash on 'Managed Retreat,'" *E&E News*, July 15, 2019.

Live on an island and you will have another impression. The high cost of food. Why? Because most of it has to be shipped in. On some islands much of the land has been given over to the use of military bases or to tourism, often the two main industries or employers. One realizes the food insecurity when shipments only come in twice a week. Or the island might rely on subsistence agriculture and fishing. What happens to it when the land for the agriculture decreases? When sea surge salinizes the soil, challenging agriculture? When ocean temperatures rise and together with overfishing deplete fish stocks? What happens to food security when a hurricane, typhoon, or tropical storm passes through the ocean?

The high cost of housing. Why? Because housing often sits empty for seasonal tourists either as second homes or as timeshares. Because the occupying military on some islands, such as Hawaiʻi has run out of housing for its troops and now cuts into and competes on the local real estate market.[21] But the hourly wage of the locals cannot compete with the housing allowances members of the military receive. The higher cost also results from a limited amount of land on which housing can be built given an island space, compounded by land gobbled up by the aforementioned two industries: the military and tourism.

The high cost of energy bills. Why? Because often the energy source is oil. Even for electricity. Again, it is shipped in. Because the use of fossil fuels tethers an island more to an occupying force. Because many islands do not have the economic resources to transition to renewable energy. The challenge for a just energy transition is often not the technology but the capital. One realizes the energy insecurity.

Being from an island is yet another altogether different thing. It is the aforementioned and more. In terms of housing, in overpriced housing markets, such as Hawaiʻi, Native Hawaiians and Pacific Islanders constitute a disproportionate number of the homeless.[22] In terms of food, one realizes that the food that is shipped in is not as healthy as eating the local fish and produce one's grandparents once did, which would also reduce CO_2 emissions. Obesity rates run high for Pacific Islanders. According to the World Health Organization, of the top ten most obese countries or territories globally, nine are Pacific Islands.[23] Consequently, rates of diabetes are also high among Pacific Islanders.[24] One reason: instead of traditional diets of fresh fish, vegetables, and fruits, the diet now consists of canned foods, highly processed meat, and sugary soft drinks.[25]

21. Brenton Awa, "How the Military Impacts Rent Prices in Hawaiʻi," KITV, February 23, 2017.

22. Mahealani Richardson, "Count Shows Homelessness Down, but the Number of Unsheltered Homeless Swells," *Hawaii News Now,* May 25, 2019.

23. Meera Senthilingam, "How Paradise Became Fat," *CNN,* May 1, 2015.

24. See the article by Samoan poet Sia Figiel, "Diabetes Took My Teeth but Not My Life," *CNN,* February 21, 2014.

25. See Craig Santos Perez, "Spam's Carbon Footprint," *Prairie Schooner* 90.4 (Winter 2016): 12–16.

One has contributed the least to CO_2 emissions but is disproportionately experiencing its effects. The ten nations globally with the lowest CO_2 emissions are all island nations. An occupying colonial or imperial military power has often decimated the islands. France, the UK, and the US carried out nuclear testing over decades in the Pacific.[26] The US conducted a series of nuclear tests on Bikini Atoll in the Marshall Islands (20). The US military used the Hawaiian island of Kahoʻolawe and the Puerto Rican island of Vieques as bombing ranges and is currently considering setting one up on Tinian in the Northern Mariana Islands (16).

Islands function as key geopolitical sites for colonial and imperial powers. Currently, the US has more military bases and in more countries than any other nation. According to the Pentagon, the US has an estimated five thousand military bases, of which six hundred are overseas. Many of them are located on (colonized) islands (see the list in the following paragraph). For this reason, the US military has a disproportionate number of Pacific Islanders in it. A high percentage of foreign-born service members are from the Philippines and the Caribbean. Data artist, filmmaker, and app developer Josh Begley sought to map the global distribution of US military bases and to gather satellite imagery of them using Google and Bing Maps.[27] Begley's project was inspired by Trevor Paglen's *Blank Spots on the Map: The Dark Geography of the Pentagon's Secret World*, which maps the US government's black holes, secret military facilities, and prisons from Area 51 to Afghanistan, to render visible the previously invisible.[28] Begley mapped 650 bases and gathered satellite images for 644 of them.[29]

The US has at least fifty-two bases or installations on islands: Alaska Aleutian Islands (Eareckson Air Station); the Azores (Lajes Air Base); The Bahamas (Naval Undersea Warfare Center, Detachment AUTEC); Bahrain (Naval Support Activity Bahrain, Naval Regional Contracting Center Bahrain); Diego Garcia (Naval Support Facility Diego Garcia); Cuba (Guantanamo Bay Naval Base); Guåhan (Andersen Air Force Base, Andersen Base, Naval Base Guam); Greece (Naval Support Activity Souda Bay, Crete); Greenland (Thule Air Base); Hawaiʻi (Joint Base Pearl Harbor Hickam, Pacific Missile Range Facility Barking Sands, Fort DeRussy, Fort Shafter, Kunia Field Station, Pōhakuloa Training Area, Schofield Barracks, Tripler Army Medical Center, Wheeler Army Airfield, Marine Corps Base Hawaiʻi); Iceland (Naval Air Station Keflavík, NRTF Grindavik); Italy (NAS Sigonella, Sicily; NSA La Maddalena, Sardinia); Japan (Naval Air

26. See Japanese artist Isao Hashimoto's "A Time Lapse of Every Nuclear Explosion since 1945" (www.youtube.com/watch?v=LLCF7vPanrY), which maps 2053 nuclear explosions that have taken place between 1945 and 1998.

27. http://joshbegley.com/.

28. Trevor Paglen, *Blank Spots on the Map: The Dark Geography of the Pentagon's Secret World* (Dutton, 2010).

29. Josh Begley, "Mapping United States: How Do You Map a Military Footprint?," 2013. http://empire.is/.

Facility Agsugi, Naval Forces Japan, Okinawa; US Fleet Activities Yokosuka; US Fleet Activities Sasebo; Marine Corps Base Camp Smedley D. Butler, Okinawa and nine camps distributed throughout Okinawa; Marine Corps Air Station Futenma, Okinawa; Marine Corps Air Station Iwakuni, Yamaguchi Prefecture; Kadena Air Base, Okinawa Prefecture; Misawa Air Base; Yokota Air Base, Tokyo); the Marshall Islands (Bucholz Army Airfield, Kwajalein Island); Northern Mariana Islands (US Navy plans to build a live-fire range on Tinian); Philippines (Western Mindanao Command, Zamboanga); Puerto Rico (Fort Buchanan, Army National Guard Aviation Support Facility, Camp Santiago, Fort Allen, Roosevelt Roads Army Reserve Base); Seychelles (US Drone Base); Singapore (Logistics Group, Western Pacific); United Kingdom (RAF Alconbury; RAF Croughton, CIA communications hub; RAF Fairfond; RAF Lakenheath; RAF Menwith Hill; RAF Mildenhall); and Wake Island (Wake Island Airfield).

In sum, military bases on islands worldwide are pivotal to the US security interests. The US military is well aware of the impact of sea level rise on its navy bases, especially but not exclusively in the Pacific.[30] The US Department of Defense (DoD) commissioned a study published in *Science Advances* on April 25, 2018, which found that "more than a thousand low-lying islands risk becoming uninhabitable by the middle of the century—or possibly sooner—because of rising sea levels, upending the populations of some island nations . . . most atolls will be uninhabitable by the mid-21st century because of sea level rise."[31]

Soaring average air temperatures, rising sea levels, bleached coral reefs, and salinized drinking water will all make it increasingly difficult to conduct military exercises. The US DoD is very concerned about climate change. Since January 2017, twenty-one senior officials at the US DoD have publicly raised concerns about climate change. According to a 2019 brief from the Congressional Research Service, "The Department of Defense (DOD) manages more than 1,700 military installations in worldwide coastal areas that may be affected by sea-level rise."[32] In a nutshell, many islands are impacted not only by sea level rise but also by the legacy of colonialism and by contemporary competing geopolitical interests. This thread runs through *Sea Change: An Atlas of Islands in a Rising Ocean* and applies to most islands discussed.

30. Edward Hunt, "In the Pacific Islands, the Trump Administration Sees Empire, Ignores Climate Change," *The Progressive,* September 13, 2019.

31. Chris Mooney and Brady Dennis, "The Military Paid for a Study on Sea Level Rise. The Results Were Scary," *Washington Post,* April 25, 2018; C. D. Storlazzi, et al., "Most Atolls Will Be Uninhabitable by the Mid-21st Century Because of Sea Level Rise Exacerbating Wave Driven Flooding," *Science Advances* 4.4 (April 25, 2018).

32. See Congressional Research Service, "Military Installations and Sea-Level Rise," CRS In Focus, July 26, 2019.

The islands, from their vantage point, share very different stories. What follows aims to decenter colonial discourses, and how they structured notions of place, space, time, and relation, and to recenter islander conceptions of space, time, and relation, following what interdisciplinary scholar Vicente Diaz has called "Archipelagic Rethinking."[33]

Colonizers, whose centers of gravity were continental landmasses, read islands as remote. Islanders dispersed among an ocean or a sea, reading it as the center, deem themselves to be connected. As anthropologist Epeli Hau'ofa, who was born to Tongan parents in what was then the Territory of Papua and who taught in Fiji, has pointed out: "There is a gulf of difference between viewing the Pacific as 'islands in a far sea' and as a 'sea of islands.' The first emphasises dry surfaces in a vast ocean far from the centres of power. When you focus this way you stress the smallness and remoteness of islands. The second is a more holistic perspective in which things are seen in the totality of their relationships."[34] As historian Paul D'Arcy has argued, colonization—and its territorial carving up of the Pacific and replacement of existing structures with new institutions—often defined islands as isolated spaces.[35] Yet this reading erases from view, as Hau'ofa has pointed out, the relations *among* Pacific Islanders that inform both the real and the imaginary.[36] These relations are evidenced, as literary scholar Teresa Shewry has underscored, in "myths and legends," shared linguistic roots, and "material histories[,] such as exploration, migration, kinship and tracing."[37] "Theorists, such as Epeli Hau'ofa and Albert Wendt," Shewry writes, flip or undo "the European tendency to isolate the land from the sea, using the term *Oceania* to connect the sea, islands and all their life."[38]

Given colonialism's hegemony, in discourses that shaped historical, cultural, and geographic narratives, this framing of islands as remote and isolated versus connected across an ocean has had lasting impacts. So *Sea Change: An Atlas of Islands in a Rising Ocean* aims to make visible not only the impacts of sea level rise on islands but also the relations evidenced by material histories of ocean voyaging, shared histories, linguistic roots, myths and legends, stories and poems, thereby (re)connecting the sea, the islands and all their life, human and nonhuman.

33. Vicente Diaz, "Voyaging for Anti-colonial Recovery: Austronesian Seafaring, Archipelagic Rethinking and Remapping of Indigeneity," *Pacific Asia Inquiry* 2.1 (Fall 2011): 21–32.

34. Epeli Hau'ofa, "Our Sea of Islands," *We Are the Ocean: Selected Works* (University of Hawai'i Press, 2008), 27–40, 31.

35. Paul D'Arcy, *The People of the Sea: Environment, Identity, and History in Oceania* (University of Hawai'i Press, 2006), 168.

36. Hau'ofa, 31.

37. Teresa Shewry, "Hope in the Poetry of a Fractured Ocean," *Hope at Sea: Possible Ecologies in Oceanic Literature* (University of Minnesota Press, 2015), 84–113, 98.

38. Shewry, 203fn21. See also Albert Wendt, "Towards a New Oceania," *Writers in East-West Counter: New Cultural Bearings,* ed. Guy Amirthanayagam (Macmillan, 1982), 202–215.

Additionally, a low proportion of the world population lives in the vast region of the Pacific Ocean. As Henry Kissinger famously quipped about the forced relocation of residents of Bikini Atoll in the Republic of the Marshall Islands to make room for the US military's nuclear testing on their home island: "There are only 90,000 people out there? Who gives a damn?"[39] Charles de Gaulle had similarly once derided the size of the Antilles in the Caribbean Sea when viewed from a plane above as "dust-specks on the sea." Population density or size therefore becomes a way of creating hierarchies between regions, be they continents and islands, or, on continents, between urban and rural regions.

In American Studies, scholars have worked to undo what I call the "continental gaze." As scholars Brian Russell Roberts and Michelle Ann Stephens have pointed out in "Decontinentalizing the Study of American Culture," their introduction to *Archipelagic American Studies*, "every grade-schooler in the United States is taught to view President Thomas Jefferson's 1803 Louisiana Purchase as a landmark event in 'US history' one that, as the narrative goes, doubled the size of the United States." But this commonplace knowledge, they argue, pales in comparison to the "seldom discussed Cold War instigation of a US trusteeship in Micronesia, which more than doubled the size of the United States in terms of total land and water area, thereby constituting a massive geographical grounding for it [the US] as the dominant Pacific power."[40] Too often on the mainland, the US's borders are thought to end at the western edge of the continent, or, to take an ocean perspective, the eastern edge of the Pacific Ocean, which overlooks the territories that stand in different relationships to the US and that are located in the Pacific Ocean, such as Guåhan/Guam, the Northern Mariana Islands, Hawai'i, the Marshall Islands, and American Samoa. The cover of Daniel Immerwahr's *How to Hide an Empire: A History of the Greater United States* shows well how US territories—the islands and archipelagos that the US is currently occupying—are hidden from consciousness. (See the terms *territory* and *terripelago* in the glossary.)

In their introduction Roberts and Stephens also call into question the standard reading of both continents and oceans. Drawing on Martin W. Lewis and Kären E. Wigen's *The Myth of Continents: A Critique of Metageography*, they write:

> In this study, Lewis and Wigen unsettle readers' easy acceptance of "the standard seven-part continental scheme employed in the United States," convincingly arguing that "a sophisticated understanding of global geography [can] be reached" only after abandoning traditional geographical models and recognizing, at the most basic level, that "the division between Europe and Asia is entirely arbitrary," that in common parlance the area referred

39. W. J. Hickel, *Who Owns America?* (Prentice-Hall, 1971), 208.

40. Brian Russell Roberts and Michelle Anne Stephens, "Introduction: Archipelagic American Studies: Decontinentalizing the Study of American Culture," *Archipelagic American Studies* (Duke University Press, 2017), 1–56, 1.

to as "Africa begins south of the Sahara Desert," and that North and South America's separation has been only putative, with "little importance for either social history or the animal and plant kingdoms."[41]

Roberts and Stephens highlight not only that Lewis and Wigen unsettle the division of the globe into seven continents and the focus on them but also that Lewis "[i]n his essay 'Dividing the Ocean Sea,' further demonstrates that how we see the oceans—organized as discrete units into separate ocean basins in relation to their adjacent continents—is also culturally constructed and historically contingent."[42] The separation of the oceans and the focus on their relation to nearby continents are constructs, historically and culturally.

Shifting from the continents and the oceans to discuss islands, Roberts and Stephens argue that islands, too, are historically and culturally contingent. That is, they write, "what we are describing is a push and pull between *the metaphoric and the material,* in which the concept of the archipelago serves to mediate . . . humans' cultural relation to the solid and liquid materiality of geography." Parallel to the argument made by Roberts and Stephens that the archipelago exists somewhere in the push and the pull between the metaphoric and the material, Elizabeth DeLoughrey, among others, has argued that islands upend the artificial Western dichotomy between nature (material) and culture (metaphoric).[43] Indigenous worldviews undo this artificial division. For this reason, the texts that follow in this atlas weave together the material and the metaphoric.

The continental gaze not only blocks islands from view (think of the islands, such as Hawai'i, when it is included, seated at the side table of the US continental map) and thus impedes a more robust knowledge about islands but also about the push-pull between their repetition and differentiation. "Continentalism," as Roberts and Stephens put it, "has also stymied general acknowledgment of the Caribbean as an archipelago of jolting geopolitical diversity, with multiple political affiliations (in addition to independent nation-states, we see affiliations with the Netherlands, the United States, Britain, France, the European Union, etc.)" and "mediated," they add, by a range of governmental forms, including "territory, department, protectorate, municipality, commonwealth, and others."[44] Similarly, in the Pacific, affiliations, if you will, exist with France, New Zealand, and the United States. To undo the focus on the continent and to acknowledge *the relations among* while recognizing *the diversity between* seems to be the challenge.

41. Roberts and Stephens, 6. Martin W. Lewis and Kären E. Wigen, *The Myth of Continents: A Critique of Metageography* (University of California Press, 1997), 3.

42. Roberts and Stephens, 6–7 (emphasis added), citing Martin W. Lewis, "Dividing the Ocean Sea," *Geographical Review* 89.2 (1999): 188–214.

43. Elizabeth DeLoughrey, Renée K. Gosson, and George B. Handley, eds., *Caribbean Literature and the Environment: Between Nature and Culture* (University of Virginia Press, 2005).

44. Roberts and Stephens, 39.

In the Caribbean, Martinique poet, writer, and literary critic Édouard Glissant in an opening epithet to his volume *Poetics of Relation*, touches on this issue of the differences between but commonalities among islands, creating the term "unity-diversity" to describe it: "Evolving cultures infer Relation, the overstepping that grounds their unity-diversity." Importantly, Glissant put forward the concept of "relationality" or interdependence to think through the connected sense *among* islanders, while attendant to the differences. Furthermore, Glissant highlights three forms of relation, which he states are also forms of resistance, actively being engaged in Martinique: "relationship with the natural surroundings, the Caribbean; defense of people's language, Creole; protection of the land, by mobilizing everyone. Three modes of existence that challenge the establishment . . . , that do . . . link . . . to an ecological vision of Relation." Cuban novelist and literary critic Antonio Benítez-Rojo suggests a very different notion of this push-pull between shared affinities and differences among Caribbean islands when he proposes the term "repeating islands." He argues that while islands in the Caribbean have different colonial histories, ethnic groups, languages, cultures, and so on, out of this discontinuous range emerges "an island" that repeats itself: one marked by paradoxes.[45]

An island-focused perspective—that is, one centered on an island and radiating out from it—differs dramatically, historically, politically, culturally, linguistically, and environmentally. Oceanic voyagers navigated the great Pacific Ocean, the *moana nui,* without the use of magnetic compasses to determine direction; without the use of sextants to measure the distance between a celestial body and the horizon; and without longitude, which presupposes the Greenwich Meridian. Instead, they steered by the stars and kept course by reading the sun, the swells, and the shifts in the wind patterns.[46] The Marshallese created stick charts to map ocean swells. They used the presence of birds (such as terns and noddies, boobies and frigatebirds) and clouds (their color, brightness, and shape) to determine their proximity to archipelagos and islands.[47] They designed a sidereal compass to divide the horizon into points and map where the stars rise and set. So it is not only about decentering the "continental gaze" and recentering islands but also about decentering the human and recentering the relationships among the human, the nonhuman or more than human, the animals on land, in the sky, and in the waters, and the land, air, and waters themselves.

What I have missed most in atlases of islands are the voices of islanders. They share stories every day in a variety of media about their history and culture, and how it is imperiled by sea level

45. Édouard Glissant, *Poetics of Relation,* trans. Betsy Wing (University of Michigan Press, 1997), xxi, 145–146. Antonio Benítez-Rojo, *The Repeating Island: The Caribbean and the Postmodern Perspective* (Duke University Press, 1997).

46. David Lewis, *We, the Navigators: The Ancient Art of Landfinding in the Pacific* (University of Hawai'i Press, 1972), 82–136.

47. Lewis, 195–223.

rise. In Kathy Jetñil-Kijiner's poem "Tell Them" (at the end of this introduction), she speaks of a package she sends from the Marshall Islands to the US. The poem navigates, as Jetñil-Kijiner and diasporic islanders so often do, the distance, journey, and path from the islands to the continent and back. It also opens the eyes of continental land dwellers to the plight of the Marshall Islands.

MAPPING CHOICES

Sea level rise is not a line on a map. Neither the sea level nor the land is static. Moreover, it is better to think of the zone of their interface as one of inundation. That is, even what seems like a small amount of sea level rise and an island that does not show up as underwater on, say, the "Risk Zone Map" of Surging Seas or other online mapping sites might mean that an island has been rendered uninhabitable. When storm surges flood, they often salinize freshwater aquifer lenses. Many islands rely on rainwater and freshwater lenses for their drinking water. For example, Majuro, the main atoll of the Marshall Islands, relies on a freshwater lens for 60 percent of its freshwater. Storm surge impedes access to freshwater, rendering the water undrinkable and useless for crop irrigation.[48] Storm surges can also be life-threatening, and for this reason hurricane public advisory bulletins include not only hurricane warnings and watches and tropical storm warnings and watches but also storm surge warnings and watches.

If one envisions a simple line rising, one is using a bathtub model, which is a passive model.[49] This model overlooks active changes in ocean dynamics. For example, it does not take into account inland flooding (flooding because the mean level of the water table echoes that of sea level—e.g., at high tide or due to sea level rise), seasonal wave inundation (from swells, a series of long period waves that are generated from distant storms and that impact Hawaiian shores on a seasonal basis), coastal erosion, storm surge, and wind. Higher waves coupled with storms, king tides, or winds can reach further inland, which is called overwash. Wave overwash can inundate the freshwater supplies. In 2012 scientists explaining the model stated that "some islands will become uninhabitable long before they are submerged. Some islands will be destroyed up to 10 times faster than current models project."[50] The reason? The passive or bathtub model.

King tides are a good way to get a sense of possible future sea levels and their impacts. King tides take place during a full moon in the spring months and during a perigee when the moon is

48. This issue is also cropping up on the continental US: see Sarah Kaplan, "Saltwater Intrusion: Rising Seas Are Poisoning North Carolina's Farmland," *Washington Post*, March 1, 2019.

49. I thank Chip Fletcher, School of Ocean and Earth Science and Technology, University of Hawai'i at Mānoa, for exchanges about the bathtub model and its pitfalls.

50. Jessica Shugart, "New Model of Sea Level Rise Accounts for Splash in the Bath," AGU Blog, December 5, 2012.

closest to the earth, so that the tides are highest. During king tides we can get an idea of what a rise in sea level of a few inches to about one foot might look like in our communities. If this rise were coupled with a hurricane, tropical storm, or cycle, with floods or storms, the higher water level could inundate further than models predict. In 2010–2012, the California King Tides Project was launched through a partnership of federal and state agencies and nonprofit organizations. It encourages citizen science. That is, during king tides, people are encouraged to document the rising tide along the shoreline through photographs and upload them to a site that aggregates the information.[51] Now, a global network of king tides exists.

Not only is the water more dynamic, the islands are dynamic, too. There are vanishing islands, which appear at low tide and vanish at high tide. There are tidal islands, which are connected to the mainland by a natural or human-made causeway that is submerged at high tide. There are also ephemeral islands, which include floating objects, such as a "multi-species floating seaweed clump." The floating objects can range from small entities, such as plastic micro-litter, plant seeds, and volcanic pumice, to large items, such as whale carcasses and tree limbs and trunks.

Sea level rise is not only a story of oceans but also one of geology.[52] The geologic matter of the island is key. There are high, volcanic islands and low, coralline atolls. The coralline atolls and limestone islands, such as the Florida Keys, will be, by and large, much more impacted than volcanic islands. In the case of atolls, they are low-lying. In the case of limestone, it is porous. Nevertheless, volcanic or high islands will also be impacted. If, due to the mountains, there is a higher population density along the shoreline, it and infrastructure (such as power plants, water treatment facilities, roads and airports) will be affected. If the economy is highly reliant on tourism, and the beaches erode, it will be impacted.

Natural barriers, also referred to as soft engineering, to protect the shoreline exist. Oyster reefs, coral reefs, and mangroves provide protection against storm surge, but each one is affected by global warming. Coral reefs form a crucial barrier around islands against sea level rise: they break waves as they reach the island, thus reducing waves' impact. Additionally, they form a pivotal habitat for fish and other marine life. The ocean's absorption of CO_2 emissions and ocean temperature increase lead to the bleaching of coral reefs. While they can, if given the opportunity, recover, consistent and increasing CO_2 emissions lead the reefs to die off. Oyster reefs are to the temperate zone what coral reefs are to the tropical regions: they protect shorelines. Globally, 85 percent of oyster reefs have been lost. Mangroves grow in dense thickets along tidal estuaries, salt marshes, and on muddy coasts. They are extremely important to coastal ecosystems. Physically,

51. California King Tides Project, 2010–12. www.coastal.ca.gov/kingtides/.

52. Rosemary Gillespie and David A. Clague, *Encyclopedia of Islands* (University of California Press, 2009), 258–259. Thanks to Chip Fletcher for discussing geology with regard to sea level rise with me.

they serve as a buffer between the land and the ocean, protecting shorelines from damaging winds, waves, and floods and also reduce coastal erosion. An increase in coastal development, altered land use, and saltwater intrusion has led to a decline in global populations of mangroves. (See glossary.)

Artificial strategies, also referred to as hard engineering, for addressing sea level rise range from building seawalls or revetments to constructing artificial islands or floating cities.[53] Seawalls are a strategy for addressing sea level rise by building an armor to defend against the water's incursion. But seawalls cannot stem sea level rise, which can go over or around or, in the case of porous geologies, under. Furthermore, studies have shown that when the saltwater goes around the walls, it intensifies erosion. Revetments are walls built parallel to a shore to catch or break the impact of waves and protect the shoreline from erosion. Most recently, plans to build artificial islands that raise an island above predicted sea level rise have been put forward. They are under discussion in the Maldives (12), the Marshall Islands (20), and Kiribati (21).[54]

Managed retreat has been discussed as a strategy for addressing sea level rise by moving infrastructure and humans inland from areas threatened by or already experiencing inundation. "Managed retreat—the purposeful, coordinated movement of people and assets out of harm's way—is a controversial and often overlooked adaptation tool but also a potentially transformative one," writes climate change adaptation scholar AR Siders. "In the United States," Siders continues, "managed retreat has occurred primarily through federally funded property acquisition programs that are unlikely to be able to scale to meet the future demands of climate change."[55] US federal agencies include the Federal Emergency Management Agency (FEMA) as well as state and local government administered or funded programs.[56] At the state level this approach is being explored by, among other state programs, the California Coastal Commission, by the State of Hawai'i Office of Planning, and in New Jersey by the Blue Acres Buyout Program.[57] When "managed retreat" is suggested, it is often a contentious proposition and questions about it abound. Will private property be seized? Who has the decision-making power? Who will foot the bill? Will private property owners be bought out? By a federal agency? Or the state? Or cities? That is, by other taxpayers? Aside from the institutional, bureaucratic, financial, and practical concerns, what are the social and cultural impacts of managed retreat? In the US the residents of Sarichef Island (2) in Alaska have voted to relocate. The residents of Lennox Island (3) are making plans to move from

53. Wade Shepard, "Waterworld? Floating Cities Turn Hollywood Sci-Fi into Reality as Sea Levels Rise," *Forbes,* October 23, 2019.

54. Giff Johnson, "Marshall Islands President Says Atolls Must Raise Islands to Survive Sea Level Rise," *Marianas Variety,* February 25, 2019.

55. AR Siders, "Managed Retreat in the United States," *One Earth* 1.2 (October 25, 2019): 216–225.

56. Katharine J. Mach, Caroline M. Kraan, Miyuki Hino, AR Siders, Erica M. Johnston, and Christopher Field, "Managed Retreat through Voluntary Buyouts of Flood-Prone Properties," *Science Advances* 5.10 (October 2019).

57. Andrew S. Lewis, *The Drowning of Money: A Forgotten Community's Fight against the Rising Seas Forever Changing Coastal America* (Beacon Press, 2019).

the island. In the Pacific, residents of Lateu, a village in Vanuatu (23), were relocated. In Kiribati (21) the village of Tebunginako on Abaiang was abandoned and relocated. In 2012 when Anote Tong was president of Kiribati, he bought land on Vanua Levu, Fiji (26), in case his people need to migrate in the future, coining the phrase "migration with dignity." But this decision is fraught, as Fiji itself is relocating communities due to sea level rise.

In 2012, Ioane Teitiota, a Kiribati national, applied for asylum in New Zealand as a climate refugee, citing specifically sea level rise. His application was denied. He appealed the decision. The Supreme Court of New Zealand denied his appeal on the grounds that although climate change is impacting Kiribati, these changes did not qualify him for status as a refugee. Climate change conditions are not included in the 1951 United Nations Convention Relating to the Status of Refugees. Discussions are afoot, however, to have it included.

When it came to mapping sea level rise, cartographer Molly Roy and I considered a couple of approaches. Does one show the impact best by stacking on top of one another the layers of changing island outlines over time, differentiated by colors? Or does sea level rise show up more vividly by separating the coastline in the present, in 2050, and in 2100 into three distinct panels, revealing an island's shrinking size over time (see map, p. 19)? The answer depends on the nature of the island: its geography and topography, its geology, and its impacted infrastructure. A lower-lying island will be more fully inundated than a mountainous island, so the impact across the whole island can be seen visually when split out into separate panels. For mountainous islands, where less area will be inundated but coastal infrastructure will be heavily affected, we've stacked the separate layers on top of one another.

To find the most up-to-date data for all islands proved to be a challenge in many cases. LiDAR (3-D laser scanning) and drone technology are currently the most state-of-the-art ways to collect information to produce a digital elevation model (DEM), which is the basic model from which we derive sea level rise maps. These technologies have been implemented only more recently in the wealthier, data-rich nations (the United States and Canada being two examples), which, however, leaves smaller, poorer island nations in need of quality data. This information gap between the so-called first and third world nations, or the Global North and the Global South, pushed us to figure out how best to map sea level rise for this atlas. Where high-quality LiDAR and drone models were lacking, we turned to a combination of the most current close-up satellite imagery we could find, local island government reports, printed topographic maps, older satellite-based DEM data, and academic science articles on particular islands.[58]

58. Please note that the maps shown within this atlas are not intended to provide local regions and policy makers with the tailored information they need to understand and respond to the risks of sea level rise and coastal flooding. As is general best practice, local detail should be verified by consulting additional sources tailored to specific regions.

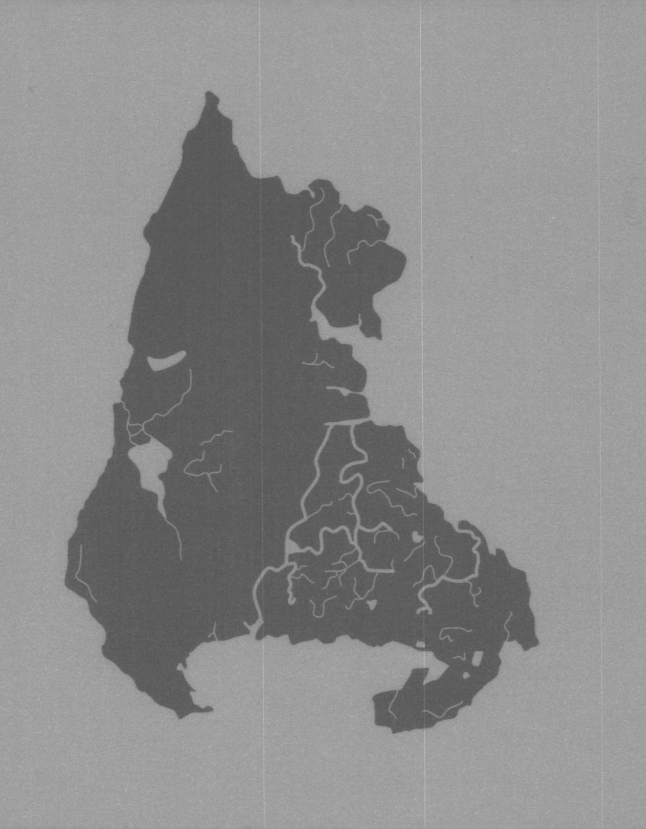

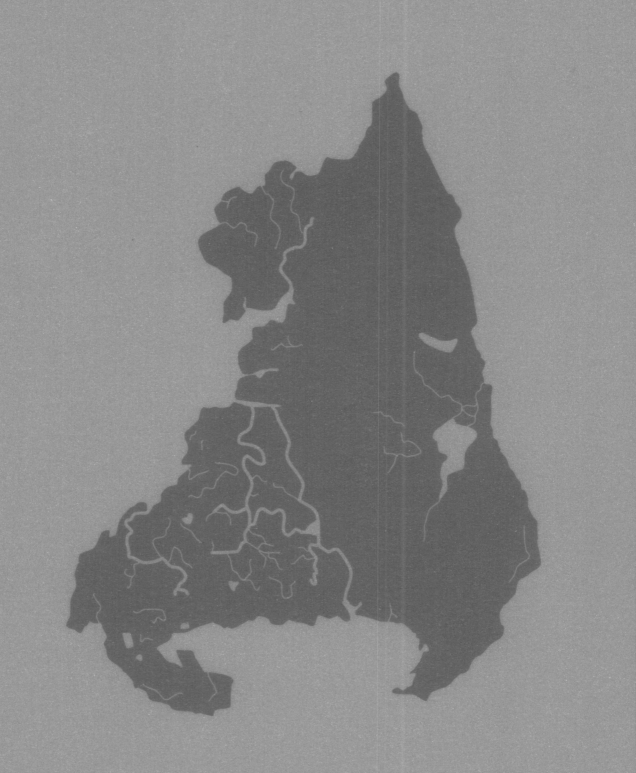

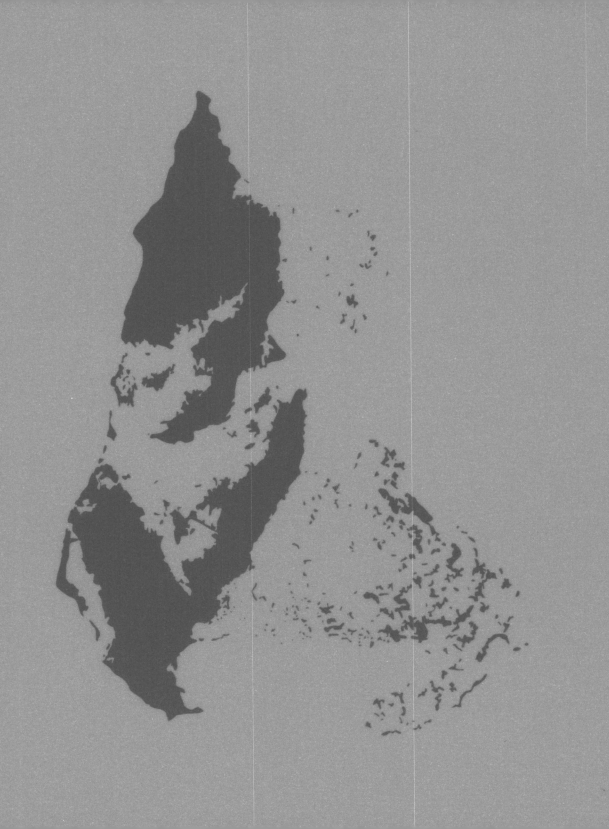

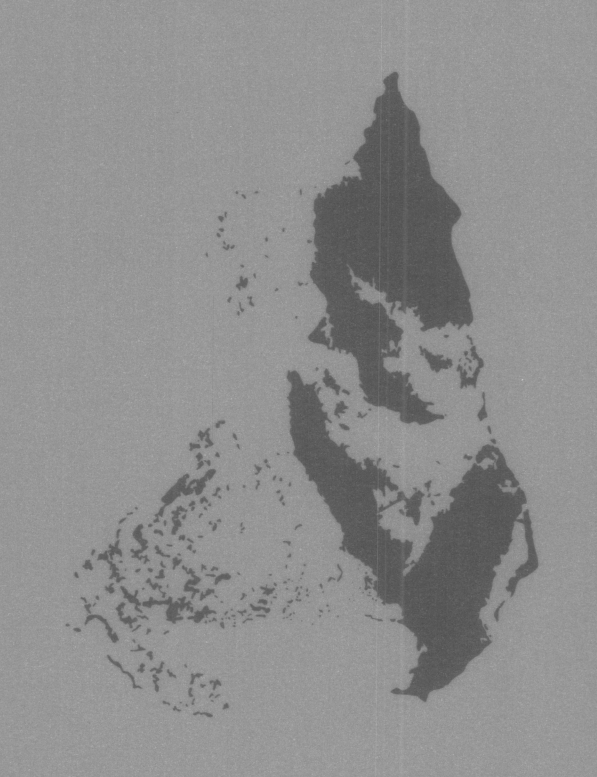

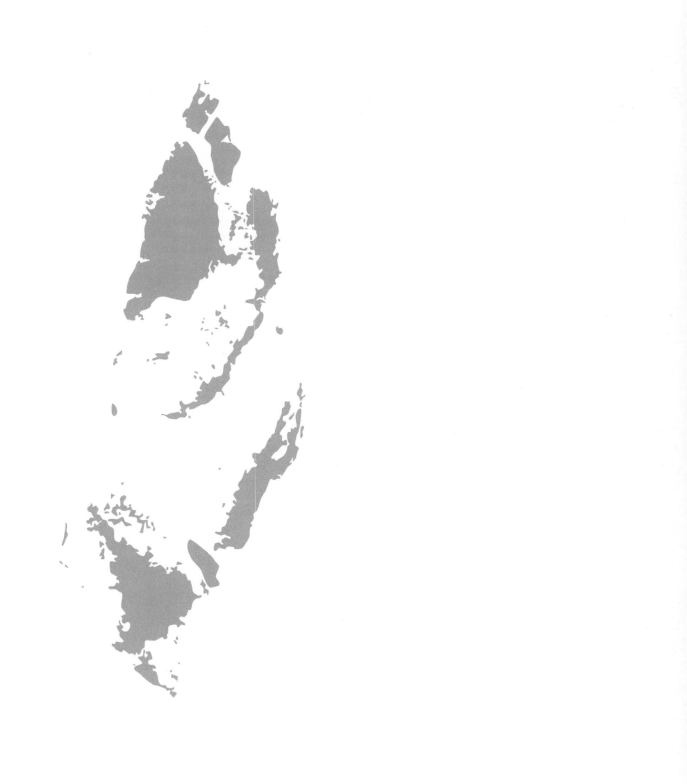

What follows in *Sea Change: An Atlas of Islands in a Rising Ocean* provides a glimpse of the islands and nations, whose histories, cultures, and languages, flora and fauna are at risk of being lost. I hope to spark interest in these islands. Again, for many islands sea level rise may spell the end of their nation's very existence. It is as much about pinpointing the challenges as it is about putting forward the solutions.

NOTES ON MAPS AND ON USING THIS BOOK

1. Not all islands that constitute an archipelagic nation are featured on the map page. Some archipelagic nations consist of thousands of islands. Showing all of a nation's islands is not compatible with maintaining a level of visible detail with regard to sea level rise and its impacts. For these reasons, not all islands that constitute an archipelago are shown on the maps.
2. Most but not all islands include maps.
3. Each island features underlined and italicized terms, such as *land ice* or *permafrost*. These are key terms related to climate change, sea level rise, or the islands. The terms appear in the glossary with a definition.
4. A number in parentheses after an island's name—for example, the Marshall Islands (20), refers to the chapter number of that island in the book.
5. The predictions made for future sea level rise are not specific. As will be discussed, sea level rise varies by location.

Kathy Jetñil-Kijiner

TELL THEM

I prepared the package
for my friends in the states
the dangling earrings woven
into half moons black pearls glinting
like an eye in a storm of tight spirals
the baskets
sturdy, also woven
brown cowry shells shiny
intricate mandalas
shaped by calloused fingers
Inside the basket
a message

Wear these earrings
to parties
to your classes and meetings

to the grocery store, the corner store
and while riding the bus
Store jewelry, incense, copper coins
and curling letters like this one
in this basket
and when others ask you
where you got this
you tell them

They're from the Marshall Islands

Show them where it is on a map
Tell them we are a proud people
toasted dark brown as the carved ribs
of a tree stump

Tell them we are descendants
of the finest navigators in the world
tell them our islands were dropped
from a basket
carried by a giant

Tell them we are the hollow hulls
of canoes as fast as the wind
slicing through the pacific sea
We are wood shavings
and drying pandanus leaves
and sticky bwiros at kemems

Tell them we are sweet harmonies
of grandmothers mothers aunties and sisters
songs late into night

Tell them we are whispered prayers
the breath of God
a crown of fuchsia flowers encircling
Aunty Mary's white sea foam hair

Tell them we are styrofoam cups of koolaid red
waiting patiently for the ilomij
tell them we are papaya golden sunsets bleeding
into a glittering open sea
We are skies uncluttered
majestic in their sweeping landscape
We are the ocean
terrifying and regal in its power

Tell them we are dusty rubber slippers
swiped
from concrete doorsteps
We are the ripped seams
and the broken door handles of taxis
We are sweaty hands shaking another sweaty hand in heat

Tell them
we are days
and nights hotter
than anything you can imagine

Tell them we are little girls with braids
cartwheeling beneath the rain
We are shards of broken beer bottles
burrowed beneath fine white sand
We are children flinging
like rubber bands
across a road clogged with chugging cars
tell them
we only have one road

And after all this
tell them about the water
how we have seen it rising
flooding across our cemeteries
gushing over the sea walls
and crashing against our homes
tell them what it's like
to see the entire ocean___level____with the land

Tell them
we are afraid

Tell them we don't know
of the politics
or the science
but tell them we see
what is in our own backyard

Tell them that some of us
are old fishermen who believe that God
made us a promise
Tell them some of us
are a bit more skeptical

But most importantly you tell them
that we don't want to leave
we've never wanted to leave
and that we

are nothing
without our islands.

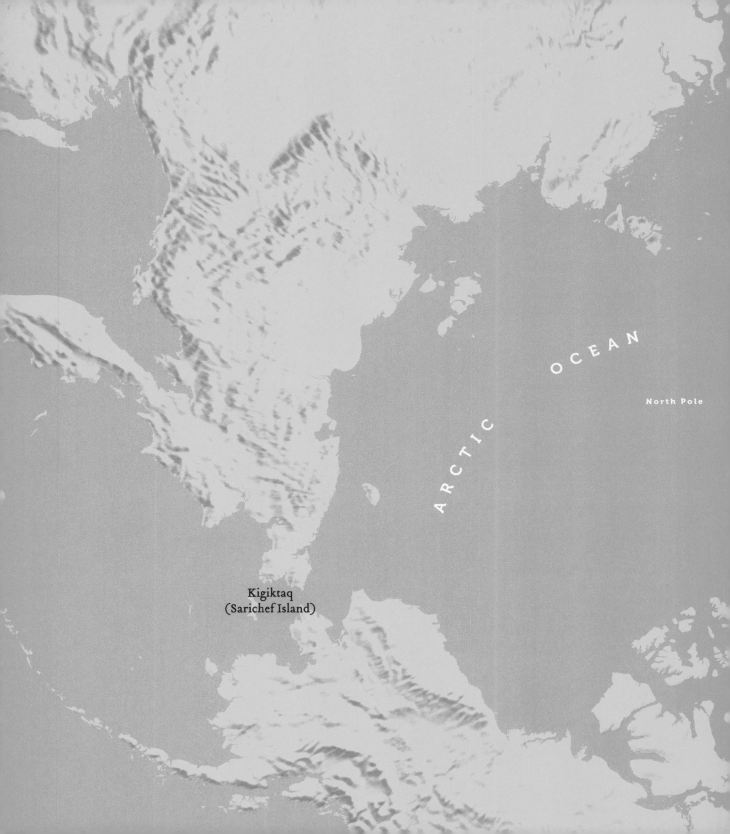

ARCTIC OCEAN

North Pole

Kigiktaq
(Sarichef Island)

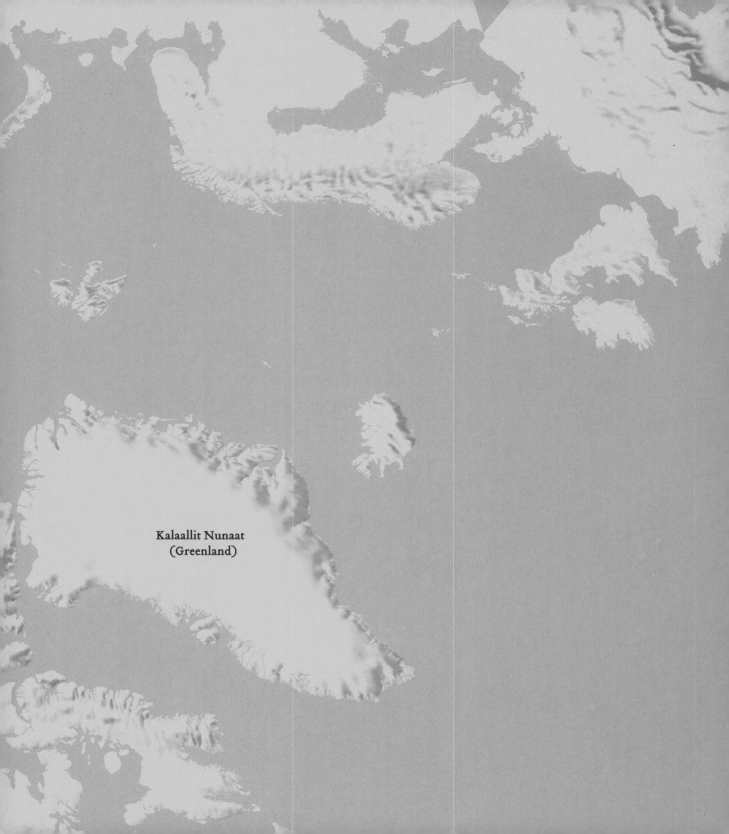

Kalaallit Nunaat
(Greenland)

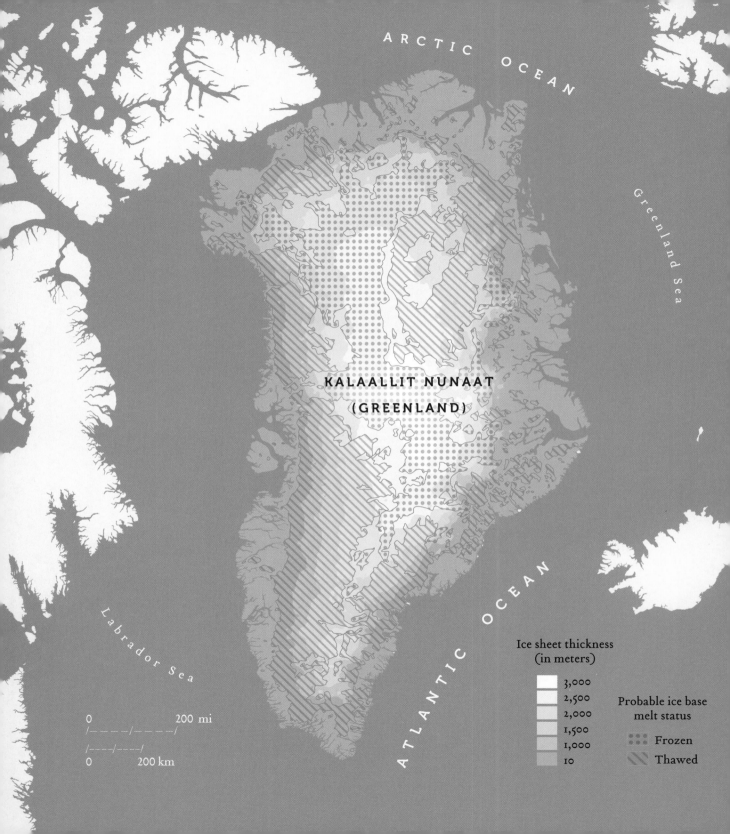

ARCTIC OCEAN

Greenland Sea

**KALAALLIT NUNAAT
(GREENLAND)**

Labrador Sea

ATLANTIC OCEAN

Ice sheet thickness
(in meters)

3,000
2,500
2,000
1,500
1,000
10

Probable ice base
melt status

Frozen

Thawed

0 200 mi
/----/----/
/----/----/
0 200 km

Kalaallit Nunaat (LAND OF THE KALAALLIT)

 Greenland

71.7069º N
42.6043º W

836,330 sq. mi. (2,166,086 km²)

Population: 57,792 (2022 est.)

88% Inuit (Indigenous Greenlandic, mostly Kalaallit), 12% Danes

Languages: Kalaallisut (or Greenlandic, related to Inuit), Danish

Mean Elevation: 5879 ft. (1792 m) | Highest Elevation: 12,119 ft. (3694 m)

2552 MI / 4107 KM
----/----/---> SARICHEF ISLAND (2)

6774 MI / 10,902 KM
----/----/----/----/----/----/---> MARSHALL ISLANDS (20)

10,426 MI / 16,779 KM
----/----/----/----/----/----/----/----/----/---> PINE ISLAND (49)

800 BCE–1500 CE	985 CE	1261	1397–1523	1979–2008
Indigenous Dorset inhabited western and eastern parts of the island	Norwegian explorer Eric Thorvaldsson renamed the island Greenland	Norway colonizes and rules Greenland	Part of Kalmar Union, under control of Norway	Home rule (between Danish rule and independence)

	986	1300–1850	1814–1979	2009
	Icelanders and Norwegians settled Greenland's West Coast	Indigenous Thule inhabited Greenland	Ruled by Denmark	Self-rule

We arrive via boat. Before we see it, we hear it. Initially, gentle popping sounds, as if of ice cubes dropped in a glass of warmer liquid, crackling as the air bubbles escape, melting. Then, the groaning, as if of a whale. Followed by the rumble and roar, clap and slap, of millions of tons of ice, of a *glacier* calving off and thunderously crashing into the sea. A floating *iceberg*.

The sound of a river, of water flowing, as the glacier melts and gushes into the sea: an *ice stream*. *Land ice*—that is, *glaciers*, *ice caps,* and *ice sheets*—constitutes Greenland, located between the Arctic Ocean to the north and the Atlantic Ocean to the south. In fact, the world's second largest ice sheet—after that of Antarctica—covers 79 percent of Greenland. It measures up to 2 miles (3.2 km) thick.

As a result of this vast ice coverage, Greenland with an estimated population of 57,792 is the world's most sparsely populated—with a population density of 0.0677 per square mile (0.0261 per km²).[1]

On the shore, the blinding white expanse of snow. Seemingly endless. Greenland is the world's largest island in the world's smallest ocean. Many mammals that live on Greenland blend into the frozen white landscape: polar bears, of course, but also arctic foxes and arctic hares, the Greenland wolf and the ermine.

The solitary but vocal and strong bowhead whales live in the Arctic waters year-round, as do bearded and hooded seals, even white whales. In late summer blue whales, humpback whales, and narwhals swim in the Arctic Ocean. Much of the Inuit's sustenance comes from caribou and seal meat as well as fish. To fish, the Inuit use *umiak*, a boat, like a kayak (from the Inuit *qajaq*) but larger, made of sealskin stretched over a whalebone frame.

But stand still for a while. And look. Differences and nuances start to become visible. Barren-ground caribou abound. The vegetation, as the caribou's full name suggests, is sparse and mostly low-lying. Shrubs dot the landscape with an occasional berry bush, vivid red alpine bearberry or cowberry, or the blue crowberry or juniper berry, breaking up the winnowed color palette. Wooly musk ox with long, curved white horns roam here, as they do in Alaska and in Canada. Hunting and fishing usually involve seasonal migrations over long distances.

The white landscape might look uniform to the untrained eye. But like the Tuareg, who read lines in the sand in the Sahara, the Inuit navigate the snowy terrain by reading the *sastrugi*, wave-like grooves, ridges, and furrows in snow. "Arctic snowdrifts hold clues about prevailing winds and thereby, cardinal directions" (Engelhard "Sky Above, Sea Below, Inuit Wayfinding"). The Inuit also read the *water sky*, which are the dark reflections of ice-free sea on the underbelly of clouds (Engelhard "Arctic Wayfinders"). They read them together with the constellations and the migration patterns of birds and whales, with the currents and the sounds of the surf on the shore, with the stories that had been told and retold about the landscape and with regular attentive movement through it (Engelhard "Arctic Wayfinders").

The Inuit carved wooden relief maps of the area where land and water meet. They have been the source of much confusion (Harmsen "Wooden Maps"). The Eastern Inuit or Tunumiit carved maps to accompany stories they shared with Danish explorer Gustav Holm about navigating the area's shoreline (see Figure 1, p. 27). He arrived in eastern Greenland, in the town of Ammassalik, now known as Tasillaq, in 1884 to map the coastline. To the Inuit, the process of making the map,

1. "Instead of simply identifying what was what, I had to go deeper," Alexis Pauline Gumbs writes in *Undrowned: Black Feminist Lessons from Marine Mammals.* "I took my cue from the many marine mammals who echolocate. I had to focus not on what I could see and discern, but instead on where I was in relation, how the sound bouncing off me in relationship to the structures and environments that surround me locates me in a constantly shifting relationship to you, whoever you are by now."

the story that was relayed, was often more important than the map itself. What was centered was the knowledge of the region, the recall and relaying of it. Working in Nunavut, Canada, geographer Robert A. Rundstrom writes: "One Inuk elder told me that he had drawn detailed maps of Hiquligjuaq [Yathkayed Lake] from memory, but he smiled and said that long ago he had thrown them away. It was the act of making them that was important, the recapitulation of environmental features, not the material objects themselves" (165). The focus was on the knowledge that went into mapping rather than on the map. This knowledge connected the lessons from the past to the present. And it was based on a deep knowledge of and connection to the space. Some argue that it is the difference between cartography and mapmaking. In Greenland the Eastern Inuit created three such wooden carvings, known today as the Ammassalik maps. Now Greenland's coastline is changing quickly and radically.

In the Arctic it's not the cold that's the problem; it's the heat. It is why Canadian Inuk activist Sheila Watt-Cloutier calls for *The Right to Be Cold*. On the first day of summer in 2020, the mercury hit 100°F (37.78°C) in Verkhoyansk, Siberia, a new record. It was broken on the first day of summer in 2021, when the mercury hit 118°F (47.8°C) in

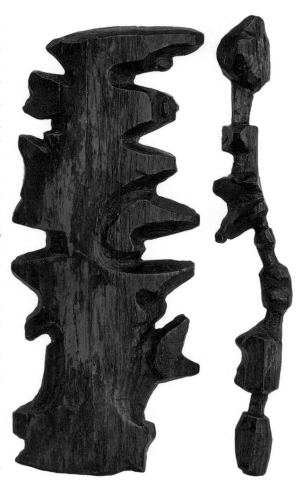

FIGURE 1. Wooden map, ca. 1885. Greenland National Museum and Archives.

Siberia. In 2017, 2019, 2020, and 2021, wildfires, once rare here, broke out. On August 11, 2021, for the first time in recorded history, smoke from wildfires reached the North Pole. The Arctic is warming twice as fast as the rest of the globe, a phenomenon referred to as the Arctic or polar amplification. The polar amplification results from a combination of factors. Among them is the region's decreasing *albedo*. Albedo refers to the ability of something to reflect back the sun's rays. Since ice is so reflective, it has a higher albedo and reflects back rather than absorbs the sun's energy. But due to global warming, the ice has been melting, creating a negative feedback loop:

more melting means less ice to reflect back, means more melting, means less ice and so on (see also Pine Island (49) in Antarctica).[2]

The land ice is thinning. According to Harold Wanless, a geologist at the University of Miami, "Greenland is currently calving chunks of ice so massive they produce earthquakes up to six and seven on the Richter scale" (Rush "Rising Seas"). It is worst along the shoreline. This melt of land ice is one of the two main reasons for *sea level rise*. The other is the increased temperature of oceans. When water heats up, it expands. So warmer oceans take up more space. Greenland's land ice melt accounts for approximately 25 percent of global sea level rise (Voosen). If all the ice sheets and glaciers on Greenland melted, it would raise sea levels by 24 feet (7.3 m).

On December 5, 2018, in a study published in *Nature,* scientists put forward a dramatic new hockey stick for Greenland ice melt, arguing that while melt began to pick up in the mid-1800s with industrialization, Greenland has been melting more in the past twenty years than at any other point in the past 350 years (Trusel). A month prior, on November 12, 2018, scientists published findings in *Nature Climate Change,* which argued that, like other elements of the climate system, both "the Greenland and Antarctic . . . ice sheets hav[e] tipping points at or slightly above the 1.5–2.0°C threshold; for Greenland, this may lead to irreversible mass loss" (Pattyn et al.).

In the summer of 2019, Greenland's ice melt spiked. And on August 13, 2020, a study found that Greenland's ice sheet has melted to the point of no return (King et al.).

In the summer of 2021, it rained in Greenland. No one knows how much because it has never rained before in Greenland and so there are no rain gauges on Greenland.

Halfway around the globe, in the middle of the Pacific, rests another island nation, the Republic of the Marshall Islands (20), with a population of 79,906, relatively close to that of Greenland. But their sizes contrast sharply: the Marshall Islands measures only 70 square miles (181 km²) of land to Greenland's 836,330 square miles (2,166,086 km²). And the Marshall Islands' mean elevation is 6.56 feet (2 m) above sea level to Greenland's 5879 feet (1792 m). When the glaciers melt in Greenland, they flood low-lying islands in the Pacific on the other side of the planet (see Marshall Islands (20) and Kathy Jetñil-Kijiner's poem "Dear Matafele Peinam"). We are all connected.

But if Greenland and the Marshall Islands are disproportionately experiencing the dangers associated with climate change and sea level rise, they might also suggest the solutions. It is not only about what might be lost but also about what can be saved and how.[3]

2. "This guide to undrowning listens to marine mammals," Gumbs writes, "specifically as a form of life that has much to teach us about the vulnerability, collaboration and adaptation we need in order to be with change at this time, especially since one of the major changes we are living through, causing, and shaping in this climate crisis is this rising of the ocean."

3. "Listening is not only about the normative ability to hear," Gumbs writes, "it is a transformative and revolutionary resource that requires quieting down and tuning in."

Like in the Marshall Islands, where 92 percent of the population is Indigenous, the majority of Greenland's population or 88 percent is Indigenous, Greenlandic Inuit. The Inuit span Greenland, Siberia, northern Canada, and Alaska (see Sarichef Island (2)). In Greenland the Inuit include the Kalaallit in the west, the Tunumiit in the east, and the Inughuit in the north. The remaining 12 percent of Greenland's population is of European, mostly Danish, heritage. The official language is Greenlandic, an Indigenous Eskimo-Aleut language closely related to the Inuit languages of Canada.

In 2018, Greenlandic poet Aka Niviâna and Marshallese poet Kathy Jetñil-Kijiner shared how their islands are interrelated in their poem "Rise" (following).

"Sister of ocean and sand," Niviâna says, addressing Jetñil-Kijiner, "Can you see our glaciers groaning / with the weight of the world's heat? / I wait for you, here, / on the land of my ancestors heart heavy with a thirst / for solutions / as I watch this land / change / while the World remains silent."

"Rise" highlights that the climate change effects manifesting in either location result mostly from CO_2 emissions produced in other regions, which, too, will now "try to breathe underwater." "These issues," the poem continues, "affect each and every one of us / None of us is immune."

Kathy Jetñil-Kijiner and Aka Niviâna

RISE

Sister of ice and snow
I'm coming to you
from the land of my ancestors,
from atolls, sunken volcanoes—undersea descent
of sleeping giants

Sister of ocean and sand,
I welcome you
to the land of my ancestors
—to the land where they sacrificed their lives
to make mine possible
—to the land
of survivors.

I'm coming to you
from the land my ancestors chose.
Aelon Kein Ad,
Marshall Islands,
a country more sea than land.
I welcome you to Kalaallit Nunaat,
Greenland,
the biggest island on earth.

Sister of ice and snow,
I bring with me these shells
that I picked from the shores
of Bikini Atoll and Runit Dome

Sister of ocean and sand,
I hold these stones picked from the shores of Nuuk,
the foundation of the land I call my home.

With these shells I bring a story of long ago
two sisters frozen in time on the island of Ujae,
one magically turned into stone
the other who chose that life
to be rooted by her sister's side.
To this day, the two sisters
can be seen by the edge of the reef,
a lesson in permanence.

With these rocks I bring
a story told countless times
a story about Sassuma Arnaa, Mother of the Sea,
who lives in a cave at the bottom of the ocean.

This is a story about
the guardian of the Sea.
She sees the greed in our hearts,
the disrespect in our eyes.
Every whale, every stream,
every iceberg
are her children.

When we disrespect them
she gives us what we deserve,
a lesson in respect.

Do we deserve the melting ice?
the hungry polar bears coming to our islands
or the colossal icebergs hitting these waters with rage
Do we deserve
their mother,
coming for our homes
 for our lives?

From one island to another
I ask for solutions.
From one island to another
I ask for your problems

Let me show you the tide
that comes for us faster
than we'd like to admit.
Let me show you
airports underwater
bulldozed reefs, blasted sands
and plans to build new atolls
forcing land
from an ancient, rising sea,
forcing us to imagine
turning ourselves to stone.

Sister of ocean and sand,
Can you see our glaciers groaning
with the weight of the world's heat?
I wait for you, here,
on the land of my ancestors' heart heavy with a thirst
for solutions
as I watch this land
change
while the World remains silent.

Sister of ice and snow,
I come to you now in grief
mourning landscapes
that are always forced to change

first through wars inflicted on us
then through nuclear waste
dumped
in our waters
on our ice
and now this.

Sister of ocean and sand,
I offer you these rocks, the foundation of my home.
On our journey
may the same unshakable foundation
connect us,
make us stronger,
than the colonizing monsters
that to this day devour our lives
for their pleasure.
The very same beasts
that now decide,
who should live
who should die.

Sister of ice and snow,
I offer you this shell
and the story of the two sisters
as testament
as declaration
that despite everything
we will not leave.
Instead
we will choose stone.
We will choose
to be rooted in this reef
forever.

From these islands
we ask for solutions.
From these islands

we ask
we demand that the world see beyond
SUV's, AC's, their pre-packaged convenience
their oil-slicked dreams, beyond the belief
that tomorrow will never happen, that this
is merely an inconvenient truth.
Let me bring my home to yours.
Let's watch as Miami, New York,
Shanghai, Amsterdam, London,
Rio de Janeiro, and Osaka
try to breathe underwater.
You think you have decades
before your homes fall beneath tides?
We have years.
We have months
before you sacrifice us again
before you watch from your tv and computer screens waiting
to see if we will still be breathing
while you do nothing.

My sister,
From one island to another
I give to you these rocks
as a reminder
that our lives matter more than their power
that life in all forms demands
the same respect we all give to money
that these issues affect each and every one of us
None of us is immune
And that each and every one of us has to decide
if we
will
rise

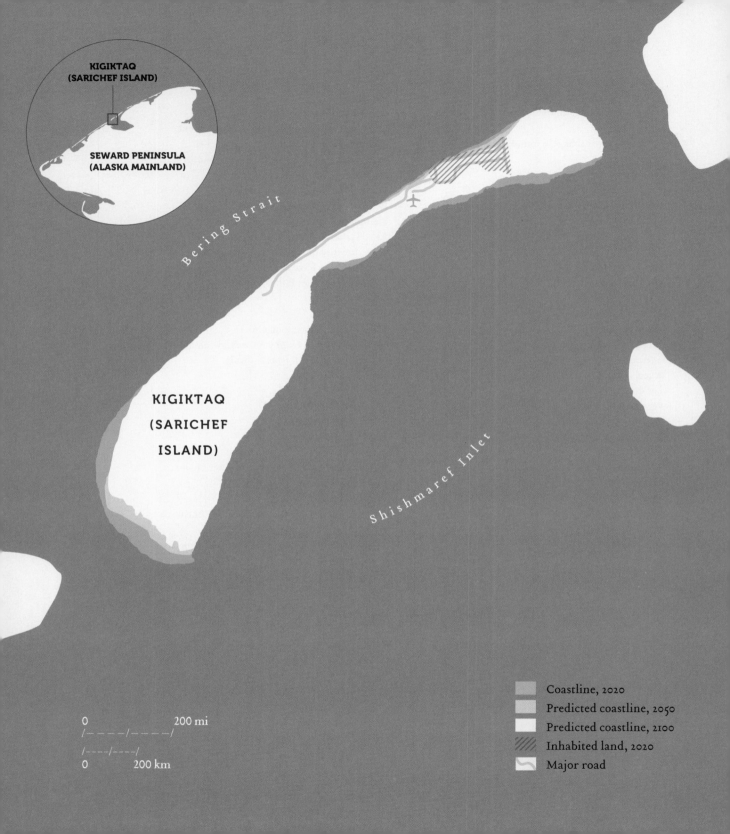

KIGIKTAQ
(SARICHEF ISLAND)

KIGIKTAQ
(SARICHEF ISLAND)

SEWARD PENINSULA
(ALASKA MAINLAND)

Bering Strait

Shishmaref Inlet

0 200 mi

0 200 km

Coastline, 2020
Predicted coastline, 2050
Predicted coastline, 2100
Inhabited land, 2020
Major road

Kigiktaq
Sarichef Island

66.2464° N
166.1023° W

2.22 sq. mi. (5.75 km²)

Population: 563 (2010 census)

93.24% Iñupiat, 5.34% white, 1.42% from more than one race

Languages: Iñupiaq (a dialect of Inuit), English

Highest Elevation: 19.69 ft. (6 m)

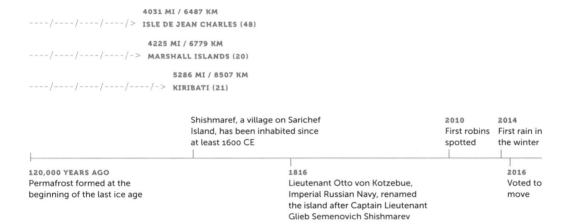

4031 MI / 6487 KM
----/----/----/----/> ISLE DE JEAN CHARLES (48)

4225 MI / 6779 KM
----/----/----/----/-> MARSHALL ISLANDS (20)

5286 MI / 8507 KM
----/----/----/----/----/-> KIRIBATI (21)

Shishmaref, a village on Sarichef Island, has been inhabited since at least 1600 CE	**2010** First robins spotted	**2014** First rain in the winter

| **120,000 YEARS AGO** Permafrost formed at the beginning of the last ice age | **1816** Lieutenant Otto von Kotzebue, Imperial Russian Navy, renamed the island after Captain Lieutenant Glieb Semenovich Shishmarev | **2016** Voted to move |

Turn the globe and view it from atop, looking at the Arctic Ocean. Gathered in the Arctic are Inuit, who—despite regional variations—share geographies, histories, cultures, and languages that transcend the lines on the map brought on by colonization. The relations among here—but also in the Pacific and the Caribbean—reconfigure. Centering the top (or bottom) of the globe is a choice in mapping. So, too, is the north-up versus the south-up or east-facing. Maps from the classical Greco-Roman eras (Castagnoli) and early Arab and Egyptian maps were south-up, such as the map by Arab geographer Muhammad al-Adrisi, the *Nuzhat al-mushtaq fi'khtiraq al-afaq* (literally "the book of pleasant journeys into faraway lands," but referred to by some as the *Tabula Rogeriana,* the map of Roger, as it was made for King Roger II of Sicily). Maps have previously also faced east, the source of the word *orient*-ation. The north-up orientation became a default when the magnetic field in the north was discovered in the twelfth century. (The magnetic north is

famously not the true north. Moreover, to underscore that nothing is fixed, the North Pole moves in tandem with Earth's axial tilt, tectonic activity, and other factors.) Magnetic compasses were invented by the Chinese and used soon thereafter in Europe. Eurocentric Europe liked to place itself at the top of the map. *Mafalda*, the Argentinian comic strip, once inverted South and North America in a political gesture. Which direction to face? What to center?

Sarichef Island, Alaska, is located only 20 miles (32 km) south of the Arctic Circle and less than 150 miles (241 km) east of Siberia. The Iñupiat who inhabit the island are Inuit.

For millennia the Indigenous Iñupiat on Sarichef Island have led a *subsistence* fishing and hunting lifestyle, meaning they survive mostly off of what they hunt and fish. A hole is cut into the ice to fish the salmon, whitefish, herring, and smelt. And the Iñupiat hunt caribou and moose, seals and walrus, migrating waterfowl and ptarmigan.

At Sarichef Island's northern end lies Shishmaref, a small village, home to 563 inhabitants (2010 census). Overall, the island has about 151 houses, a health clinic, a post office, a city hall, a church, and a school. Katherine Kokeok (Iñupiaq), who teaches at the school, describes the subsistence fishing and hunting lifestyle as follows: "The ugruk (bearded seal) is the main subsistence food source in Shishmaref. For me, the ugruk season is one of the busiest times of the year. The men and women go out hunting and bring the ugruk back for preparation. When the family decides that they have enough ugruk to last them the winter, the hunters no longer go out hunting. . . . About 20 years ago, the men hunted ugruks at the end of May, well into June/July. Now, they hunt as early as mid-May, and the ice is usually rotten or gone by the beginning of June or mid-June. . . . The families want to teach the children young so that they can continue to practice the subsistence lifestyle. If they are not taught, they might not know what kind of ice is good and when to go out. If you go out in a certain kind of wind, the ice can block you in, and you can be out there for days. So, they pay attention to the weather" (Adams and Decker).

Iñupiaq and Arctic Youth Ambassador Esau Sinnok, in testimony to the US House Natural Resources Committee, describes the subsistence relations as follows: "My family and people of Shishmaref have been living our traditional Inupiaq lifestyle for the past 4,000 years. . . . For thousands of years, we depended on the land and sea for surviving. In my culture, I was told that the animals give their lives for us so that we can eat and so our families can live. My grandparents and elders of the communities told me that our ancestors used to speak with the animals, that we can communicate with the animals at one time. We are very respectful to them and we still follow traditions that respect our animals that we catch."

This relationship is what Potawatomi plant ecologist and botanist Robin Wall Kimmerer refers to as "a web of reciprocity, of giving and taking. . . . Through unity, survival. All flourishing is mutual" (20). This gesture informs the welcome and the shells and stones and stories shared in

the poem "Rise." But it not only manifests between humans. "Soil, fungus, tree, squirrel, boy," in Kimmerer's example, "all are the beneficiaries of reciprocity" (20). Now, climate change is unsettling these relationships.

As environmental journalist Elizabeth Kolbert writes in *Field Notes from a Catastrophe,* 120,000 years ago, at the beginning of the last ice age, permafrost formed at Sarichef. Geology defines *permafrost* as ground frozen for two or more years. As a result of climate change, the permafrost is melting. The ice that had once provided a buffer against waves is gone. The shorelines are eroding. The ice forms later and later in the year and remains frozen for shorter periods of time, making traditional fishing and hunting and the subsistence lifestyle difficult. In June 2019, scientists established that permafrost in the Canadian Arctic has thawed seventy years earlier than predicted.

On August 16, 2016, the residents of Sarichef Island, Alaska, voted to move to the mainland located a mere 5 miles (8 km) away. (They are one of a number of tribes on Turtle Island relocating due to sea level rise: see also Isle de Jean Charles (48).) By the US Army Corps of Engineers estimates, the relocation will cost approximately $180 million.

Sarichef Island measures a mere 4 miles (6.4 km) long by 0.25 miles (0.4 km) wide. It is a *barrier island*, which are typically elongated and separate from and parallel to the shore (see map). Sarichef, like most barrier islands, consists mostly of sand. Barrier islands break the incoming waves and are thus very prone to *erosion*. According to Sinnok's testimony, "over the past 35 years, we've lost 2,500 to 3,000 feet [762 to 914 m] of land to coastal erosion." Buildings are starting to topple on the eroding shorelines. Sinnok writes that they have had to move thirteen houses, including that of his grandmother. While efforts to stabilize the shoreline have been undertaken, such as installing *seawalls*, they are costly and do not address the underlying issue of permafrost melt (Cooper and Pilkey).

"Slow violence" is what Rob Nixon, professor of English, terms this type of violence. "By slow violence," he writes, "I mean a violence of delayed destruction that is dispersed across time and space, an attritional violence that is typically not viewed as violence at all. Violence is customarily conceived as an event or action that is immediate in time, explosive and spectacular in space" (2). This nonevent-based notion of slow violence is a pivotal concept for the impacts of climate change and of sea level rise. As Nixon argues, "We need, I believe, to engage a different kind of violence, a violence that is . . . incremental and accretive, its calamitous repercussions playing out across a range of temporal scales" (2).

It is what Sinnok speaks of when he says that Shishmaref has been losing land "since the 1950s, way before climate change was recognized." Slow violence. The impacts that accrue slowly. Their accumulated effects manifest here and now. "In the year 2014," Sinnok states, "we saw a

very strange occurrence happened in the winter that we have never seen before in oral history; there was rain in that winter." In past decades residents spotted robins for the first time. As Kolbert writes, no word for *robin* exists in the Iñupiaq language.

Esau Sinnok

TESTIMONY

Quyanna. Thank You.

Uvlaallutaq. Avunga Atiga Esau Sinnok. Kiqigtamui. Good Morning/Good Afternoon. My name is Esau Sinnok and I am 18 years old. I am from an island called Shishmaref, Alaska. I am Inupiaq Eskimo. I am currently going to school at the University of Alaska Fairbanks studying Tribal Management, in hopes of becoming mayor of Shishmaref after I graduate from college, and I am strongly considering as running for Governor of Alaska in the year 2030 or 2034. I am here on behalf of my people of Shishmaref, the animals that cannot speak for themselves, and on behalf of the indigenous people of Alaska.

Shishmaref, Alaska is currently losing 3 to 4 meters of land each year from storm surges, rising sea level, and flooding caused by climate change. With this current trend of climate change, we can see Shishmaref gone within the next 25 to 30 years. Shishmaref, ever since the 1950s, way before climate change was widely recognized, has lost 2,500 to 3,000 feet of land. My grandfather told me that the ice that surrounded Shishmaref used to freeze around late September, or middle of October, and in recent years, we saw the ice freeze enough to safely cross on in late November, early December, which means we had to wait later in the winter to catch our winter food and fish; we had to buy more food and supplies from the local store in the winter in recent years to eat, which I am not fond of, because all that food is processed and man made. In the year 2014, we saw a very strange occurrence happened in the winter that we have never seen before in oral history; there was rain in that winter. That is very strange, as we did not know how to respond to that. My family and people of Shishmaref have been living our traditional Inupiaq lifestyle for the past 4,000 years. We do not want to see any types of new offshore or even onshore drilling in my state of Alaska. Mother Nature is tired of us taking oil from the ground. We saw that a few days ago with Shell Oil spill, with 90,000 gallons of oil that spilled in the Gulf of Mexico. They do not get the problem. IT IS RIGHT IN FRONT OF THEM. In front of their own eyes. They cannot see what is happening. Oil will always spill in the Gulf no matter where or how much research they do. It will

always happen. And with more leases in the Gulf to be sold, that means more oil spills, and that means more wildlife being killed and I don't want that to happen in Alaska. What if there is an oil spill in our Arctic waters? We have been living off the land and sea for thousands of years. The land and sea is what our [*sic*] majority of our diet is based off of. For thousands of years, we depended on the land and sea for surviving. In my culture, I was told that the animals give their lives for us so that we can eat and so our families can live. My grandparents and elders of the communities told me that our ancestors used to speak with the animals, that we can communicate with the animals at one time. We are very respectful to them and we still follow traditions that respect our animals that we catch.

The Walrus, Ugruq or Bearded Seal, Spotted Seals, Beluga, Whales, and Fish have been living there and migrating from there for thousands of years also, and with the development of offshore drilling in the Arctic, that will interrupt their migration path and we might not be able to hunt for them where we usually get them if their migratory path is changed due to the oil rigs. We are one with nature. We do not fight against it: If that is not bad enough, 223 other communities in Alaska are seeing the effects of climate change. With all these communities affected by climate change, I, as a young Inupiaq man, feel very upset that Obama and his administration is going with this 5 year plan, because no matter where oil companies drill oil, it affects the Arctic and the world. If the Arctic is not taken off this 5 year plan, and there is a spill in the Artic, our animals will die. And we will see a very sad seasonal year or even years, of our supply of food that comes from the sea, that we might even be able to eat our traditional sea animals until the spill is cleaned up and who knows how long that will be. Our culture, our way of life we have been living for thousands of years will be greatly affected if an oil spill occurred, and many families in the Artic and Shishmaref will starve, since a majority of us rely on our traditional foods instead of man made food sold at the store. I hope that the Arctic will be taken off of the 5 year plan, as climate change is not only a political issue to me, it is my future.

Thank you.

Note: This testimony was delivered at the forum on climate refugees, titled "Confronting a Rising Tide: The Climate Refugee Crisis" and convened on May 16, 2016, by US House Natural Resources Committee Ranking Member Raúl M. Grijalva (D-Ariz.).

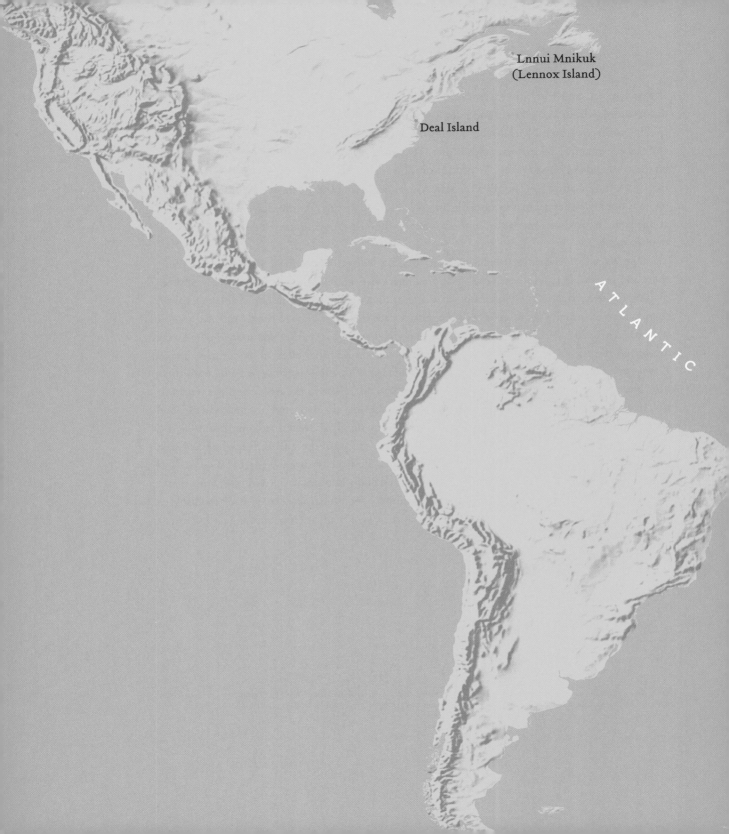

Lnnui Mnikuk
(Lennox Island)

Deal Island

ATLANTIC

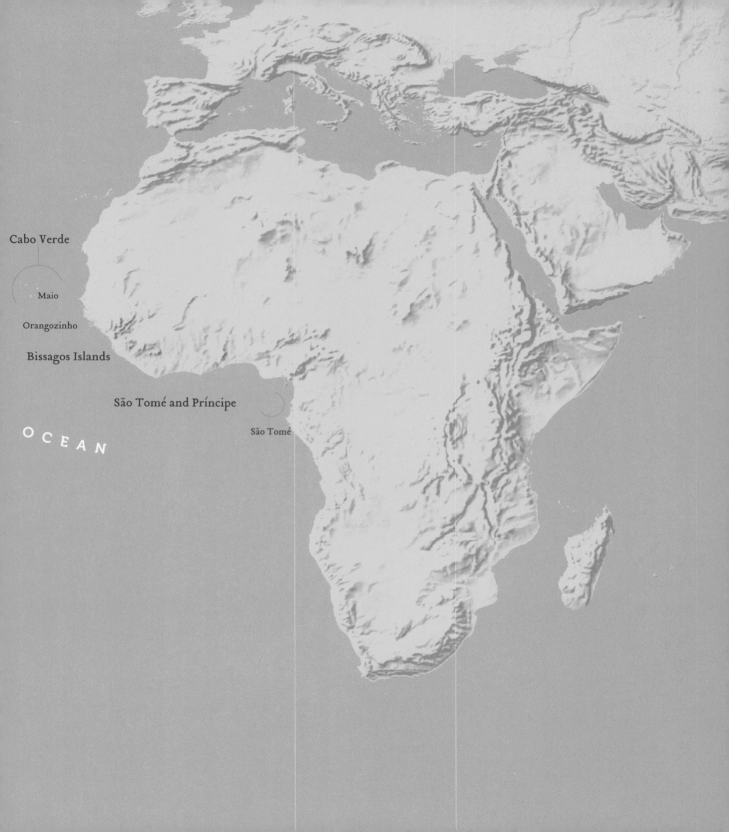

Cabo Verde

Maio

Orangozinho

Bissagos Islands

São Tomé and Príncipe

OCEAN

São Tomé

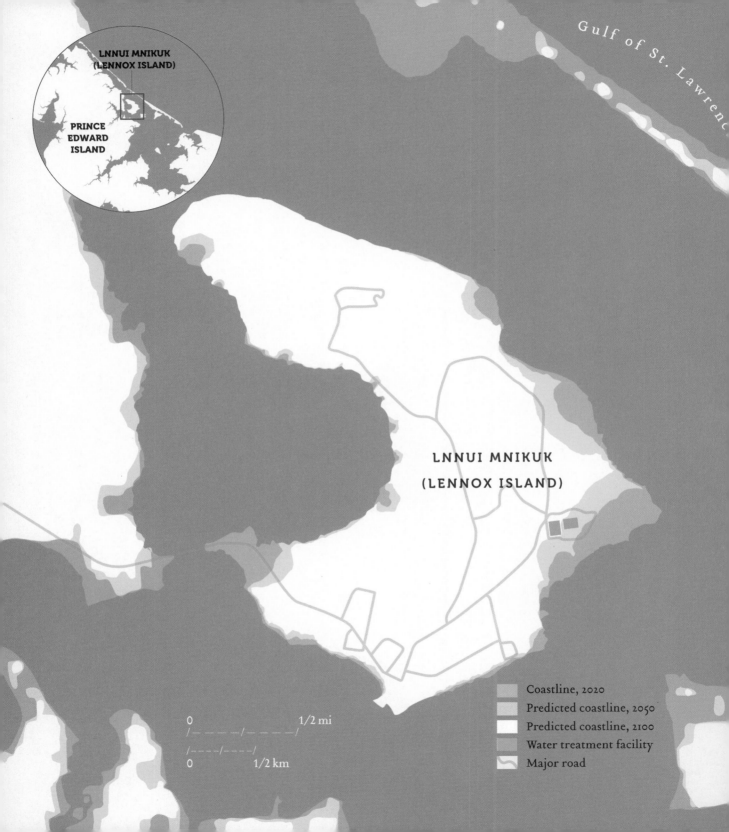

Gulf of St. Lawrence

LNNUI MNIKUK
(LENNOX ISLAND)

PRINCE
EDWARD
ISLAND

LNNUI MNIKUK

(LENNOX ISLAND)

0 1/2 mi

0 1/2 km

Coastline, 2020
Predicted coastline, 2050
Predicted coastline, 2100
Water treatment facility
Major road

Lnnui Mnikuk
Lennox Island

1.718 sq. mi. (4.449 km²)
Population: 450 (2020)
Mi'kmaq
Languages: Mi'kmaq, English
Elevation: 13.12 ft. (4 m)

849 MI / 1366 KM
---> DEAL ISLAND (4)

3123 MI / 5026 KM
----/----/----/> CABO VERDE (5)

5293 MI / 8519 KM
----/----/----/----/----/-> SÃO TOMÉ AND PRÍNCIPE (7)

| Mi'kmaq presence on Lnnui Mnikuk dates back over 10,000 years | 1880 Island measured 1520 acres | 2015 Island shrunk to 1100 acres |

1497 CE
First contact in the area with Venetian explorer Giovanni Caboto

Lnnui Mnikuk (Lennox Island) is shrinking. Located off the northwest coast of Abegweit (or Epekwitk, meaning "at rest in the sea" or "cradled in the arms of the encircling shore," also referred to as Prince Edward Island), Lnnui Mnikuk rests, on average, a mere 13 feet (4 m) above sea level.

The island is part of the homeland of the Mi'kmaq First Nation. Mi'kmaq refer to their Indigenous territory (which exceeds Lnnui Mnikuk) as Mi'ma'ki (also known as Canada's maritime provinces and northern Maine).

Abegweit First Nation Chief Junior Gould says "'Netukulimk'—taking what you need and leaving the rest for the next generations" guides Mi'kmaq. For example, Abegweit Mi'kmaq pick blueberries and cranberries on neighboring Pituamkek (Hog Island Sandhills), a chain of barrier islands along the Atlantic to the east. Many other berries grow in the area: among them blackberries, elderberries, gooseberries, huckleberries, raspberries, and strawberries.

The waters, especially those of Malpeque Bay, have long sustained the Mi'kmaq. The word *Malpeque* is derived from the Mi'kmaq magpeg (or makpāāk) meaning "large bay." Mi'kmaq poet Rita Joe writes about her reverence for the element in her poem "Waters" (see poem following).

Historically, the Mi'kmaq traveled eastward by *dory* (flat-bottomed boats) to harvest lobster and snow crabs and to fish the Atlantic cod, herring, and mackerel. They still fish these waters. Recently, they have also founded an oyster seed facility, the Bideford Shellfish Hatchery.

Across Malpeque Bay, Abegweit, to the south, used to be densely forested with beech, black ash, red oak, sugar maple, and white pine. Black bear and marten inhabited the forests. Over the past two hundred years, the forest has been mostly cleared. But black ash are being replanted. And speckled alder and yellow birch grow. Teaberry shrubs brighten up the landscape with their red berries. Mi'kmaq weave the wood and bark of black ash and maple wood as well as rush and sweetgrass into baskets. They are also known for their quillwork—that is, the work with porcupine quills, creating mosaics woven into leather moccasins or birchbark boxes.

In September 2020, the Sipekne'katik First Nation launched a fishery in Saulnierville, Nova Scotia, to the south. Plans are afoot to implement a moderate livelihood fishery in Abegweit.

Indigenous fishing rights grant the right to fish for a "moderate livelihood." They were confirmed in the September 1999 Supreme Court of Canada decision in the Donald Marshall case, which holds that the treaties signed in 1760–1761 by the Mi'kmaq and the British Crown are valid. They confirm the Mi'kmaq right to "sell, trade or barter items that are hunted, fished or gathered to generate a 'moderate livelihood'" (Gould). But one could discuss who has the right to determine fishing rights on colonized land.

As Abegweit First Nation Chief Junior Gould and Lennox Island First Nation Chief Darlene Bernard point out: "Our people have lived here for 12,000 years and our priority for the resources has always been and always will be inherently based on conservation. . . . For centuries we have existed in accordance with the principle of 'Netukulimk'" (Gould). The Mi'kmaq on Lennox Island plan to launch a fishery in 2021.

The fish, lobsters, and oysters, like other flora and fauna in the region are a gift. As Potawatomi plant ecologist and botanist Robin Wall Kimmerer writes: "For the greater part of human history, and in places in the world today, common resources were the rule. But some invented a different story, a social construct in which everything is a commodity to be bought and sold. The market economy story has spread like wildfire, with uneven results for human well-being and devastation for the natural world. But it is just a story we have told ourselves and we are free to tell another, to reclaim the old one" (31).

"One of these stories sustains the living systems on which we depend," Kimmerer continues, writing, "One of these stories opens the way to living in gratitude and amazement at the richness and generosity of the world. One of these stories asks us to bestow our own gifts in kind, to celebrate our kinship with the world. We can choose. If all the world is a commodity, how poor we grow. When all the world is a gift in motion, how wealthy we become" (31).

Not only has traditional fishing been preserved and strengthened, language revitalization has taken place as well. Rita Joe writes in the poem "I Lost My Talk" (see poem following) about how _settler colonialism_ took away her language at Shubenacadie school. The Shubenacadie Indian Residential School was built on Nova Scotia and in operation from 1930 to 1967. Nora Bernard attended the school from 1945 to 1950 and later organized the largest class action lawsuit, representing seventy-nine thousand to eighty-three thousand residential school survivors, charging the Canadian government with "sexual and physical abuse, . . . the withholding of . . . food, clothing and . . . education; [and] for the loss of language and culture; and no proper medical attention" (Clark "Residential School Survivors"). In May 2020, new road signs in Mi'kmaq were posted on neighboring Abegweit.

In the distance, Pituamkek, a sliver of red sand, protects Lnnui Mnikuk somewhat from the powerful waters of the Gulf of Saint Lawrence. It is a _barrier island_. Barrier islands offer some protections to the islands and shoreline behind them by breaking the incoming waves. Yet barrier islands tend to move, either landward or seaward. Thus, their protection is fickle. The ocean occasionally already breaches Pituamkek, allowing the waters to reach Lnnui Mnikuk.

Lnnui Mnikuk's seventy-nine homes, nestled on its highest and southernmost point, were once out of reach of the ocean. Now sea level rise or storm surge threatens to wash ten of the homes away.

Here, like on Sarichef Island (2), the season of ice has shortened: the ice hardens later in winter and melts sooner in spring. With this shorter season the shoreline is less protected against the seas. Add to it the sea level rise and it means the high tides now reach further, to places _storm surge_ previously only occasionally touched.

When the waters hit Lnnui Mnikuk, they threaten crucial _infrastructure_. The island has only one bridge, which connects it to Abegweit. In 2010, storm surge cut the island off from Abegweit and the nearby mainland. Additionally, a sewage treatment facility on Lnnui Mnikuk close to the shoreline lies only 3 feet above sea level. A storm could flood it and lead wastewater to breach, contaminating area waters.

It will be difficult for Lnnui Mnikuk to protect its shorelines against _erosion_. Geologically, the island lacks hard stone and consists mostly of sand and sandstone.

In 1880, the island measured 1520 acres (615 hectares) but shrunk to 1100 acres (445 hectares) by 2015. It is projected to decrease a further 50 percent in the next fifty years. Its residents point to boats now docked where they once played baseball on a field.

The Mi'kmaq are using computer data visualization to project future shorelines. They are also scouting places to which they could relocate—for example, on Abegweit.

Rita Joe

WATERS

They have been here since the morning of time
These waters which make three-quarters of earth.

Whitewashed stones of grime
The food no end
And admired across the realm.

But fear and suspicion when they toss
The serenity felt when calm
Awareness when cold, inspiring valour.

There is no other element as cruel
Nor kinder to survive man's abuse.

Comfort to body when bathers cool
Pay honour to these waters
Their supremacy rule

Rita Joe

I LOST MY TALK

I lost my talk
The talk you took away.
When I was a little girl
At Shubenacadie school.

You snatched it away:
I speak like you
I think like you
I create like you
The scrambled ballad, about my word.

Two ways I talk
Both ways I say,
Your way is more powerful.

So gently I offer my hand and ask,
Let me find my talk
So I can teach you about me.

Rita Joe

THE LANGUAGE THE EMPIRE OF MY NATION

I have such inque language, Se'sus for instance
Jesus in yours.
Wa'so'q
The heaven where you make it.
Wastew
Snow so beautiful as it falls in flakes.
Tupkwan
Mud or soil grows living things.
Stoqn
The balsam tree, its aroma no match.
Kmu'j
Wood we value more than its worth.
Kmu'ji'japi'
The Maple tree, the emblem of Canada.
Alukji'j
The small cloud in the sky.
Musikisk
The blue sky.
Kloqoej
The star at night
Ni'n
Me, I am a poet.
Ankita'si
I think what is right.
To teach you about my empire.
I have it all in my head.
Listen, the royalty may surprise you.

Coastline, 2020

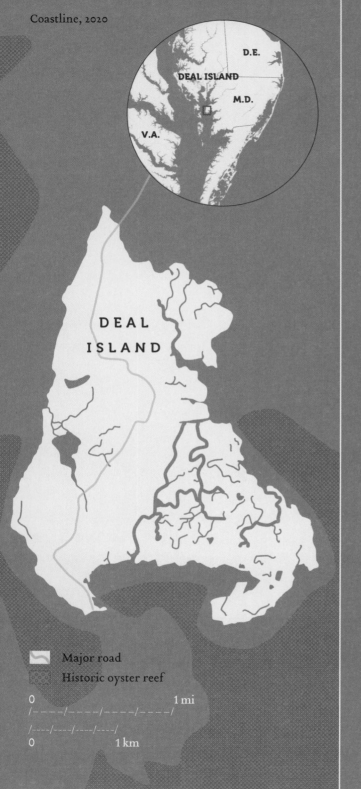

Coastline, 2050

DEAL ISLAND

D.E.

DEAL ISLAND

M.D.

V.A.

DEAL
ISLAND

Major road

Historic oyster reef

0 1 mi

0 1 km

Deal Island

38.1590° N
75.9480° W

5.4 sq. mi. (14 km²)

Population: 371 (2018 census)

Originally: Nantiquak (Nanticoke) People

90.31% white, 7.96% African American, 0.87% Native American

Language: English

Elevation: 2.953 ft. (0.9 m)

1106 MI / 1779 KM
----/--> LENNOX ISLAND (3)

3516 MI / 5658 KM
----/----/----/--> CABO VERDE (5)

5803 MI / 9339 KM
----/----/----/----/----/---> SÃO TOMÉ AND PRÍNCIPE (7)

Nanticoke inhabited the region

1608–1609 CE
First contact in the area with British explorer Captain John Smith

1933
Chesapeake-Potomac Hurricane category 4 destroys the sole bridge to the mainland

"Oyster," as Maryland environmental journalist Tom Horton put it, "appears to be the least glamorous of Chesapeake seafood, no match for the blue crab's colors, the sportiness of striped bass or the eel's epic migration from Bay streams to Sargasso Sea."

Glamorous or not, oysters are vital. *Oyster reefs* are to the temperate zone what coral reefs are to the tropical regions: they protect shorelines by buffering waves and promoting sedimentation (see illustration, p. 51). This dual action allows sea grass and coastal marshes to grow, preventing erosion. Oysters

also filter water. Oyster larvae develop a foot or ped, to crawl over and explore a surface before settling. Once they find a suitable surface, they secrete an adhesive, like mussels and barnacles, which affixes the oyster. They can settle on any hard surface such as rocks, piers, and submerged wrecks, and on top of other oysters, making a dense reef. Oyster reefs provide a habitat for marine life. In Chesapeake Bay the yellow boring sponge and ghost anemones grow on the oyster reefs. Other species nearby include Chesapeake blue crab and fish, such as the striped bass, rockfish, and the lookdown. Today, oyster reefs in Chesapeake Bay are in decline due to a variety of factors, including overharvesting, dredging, pollution, poor water quality, and disease. Globally, 85 percent of oyster reefs have been lost.

In Chesapeake Bay the oyster stock has been decimated. It was overfished in the nineteenth and early twentieth centuries. Then, in the twentieth century, two pathogens showed up: Dermo and MSX. Dermo was first "found in Chesapeake Bay in 1949 and has consistently been present. . . . since that time" (Virginia Institute of Marine Science or VIMS). MSX was first found in the lower Chesapeake Bay in 1959 (VIMS). Oyster reef restoration has been taking place especially in the upper bay, near the Patapsco River, and in the southern bay, at the mouth of the James River. Dredging is now only allowed every two to three years and is monitored vigilantly by the Maryland Natural Resources Commission and the Virginia Marine Resources Commission.

The loss of protective oyster reefs that prevent erosion are not the only source of concern: Deal Island, located in Chesapeake Bay, is sinking and sea levels are rising. The island measures 6 miles (9.656 km) in length by 3 miles (4.828 km) in width, totaling 5.4 square miles (14 km²). More than half of that area is wetland.

Over the past century, sea levels have risen on Deal Island by 1 foot (0.3 m). Currently, the island rests less than 2.9 feet (1 m) above sea level, and according to the *Intergovernmental Panel on Climate Change*, sea level rise could reach this level by 2100 in a very high emissions scenario, so Deal Island could be submerged by the century's end.

Additionally, as a result of geologic shifts, there is *subsidence* or a sinking of the earth's surface in the region. Deal Island, like most islands in Chesapeake Bay, consists predominantly of clay, sand, and silt, meaning it has little geologically to anchor it. The amount of subsidence is tiny, an estimated inch every sixteen years (Swift *Chesapeake Requiem* 65). But even such a negligible amount means that the tides' impacts are greater in terms of *erosion* and the waves' effects are greater in that they reach further inland. Moreover, erosion and sea level rise are related: as sea levels rise, erosive power grows. Subsidence intensifies both and thus their impacts.

Already, the rising seas, which flood the island during *king tides*, have turned the island amphibious. The *salinization* of soil has led massive numbers of the native pine trees to die off. Locals call them *ghost forests*.

Indigenous Nanticoke live in the Nanticoke River watershed region, Chesapeake Bay and Delaware. Their name, from Nantaquak, means "the tidewater people." The Nanticoke watershed region flanks the Nanticoke River, a tidal river once surrounded by *wetlands* that feeds into Tangier Sound and Chesapeake Bay in Maryland. The Nanticoke fished and clammed in the tidal waters. Clams, crabs, eels, fish, mussels, and oysters were abundant. Ducks, geese, and waterfowl were hunted. On land, they grew beans, corn, pumpkins, and squash.

The Nanticoke, specifically the Manokin, originally inhabited Deal Island. Due to *settler colonialism*, many Nanticoke moved beginning in 1742, according to the Nanticoke Museum, accepting "an offer of the Six Nations of the Iroquois in the New York, Pennsylvania and Canadian areas . . . [of] both land and protection." Later, many but not all Nanticoke moved to Oklahoma Territories: many remain in the eastern shores of Delaware and Maryland. In 1921, the Nanticoke established the Nanticoke Indian Association and later the Nanticoke Indian Museum, both located in Millsboro, Delaware.

By the nineteenth and twentieth centuries the island's residents were mostly settlers. On an 1840 map published by the National Oceanic and Atmospheric Administration, the island is named Devil's Island. According to the Maryland Historical Trust, after settlers colonized the area, it was "known as Devil's Island, later named Deil's Island or Deal's Island," and finally Deal Island.

Most residents live along Deal Island Road; it follows the high ground that runs down the island's center. There are two towns on the island: Deal on the northern end and Wenona on the southern end. The population hovers around 370 residents.

Residents crab in the summers and dredge for oysters in the winters in the brackish Chesapeake Bay waters. They designed a unique sailboat, the *skipjack*, just for the purpose of oyster dredging. The skipjack, the state vessel of Maryland, is an elegant boat: it has an extremely long boom and a sloop, and the jib is mounted on a bowsprit. The wooden hull is V-shaped and has a hard chine and a square stern. The centerboard is retractable, allowing it to glide over shallow waters. Combined, these features allow the crew to focus on fishing rather than on boat navigating. The boat is honored with an annual Skipjack Race and Festival that takes place over Labor Day weekend.

Now, islands are disappearing across Chesapeake Bay. In October 2019, the Chesapeake Bay Foundation closed its long-standing Education Program on Fox Island as a combination of sea level rise and erosion has taken away 70 percent of the island. Watts Island, a thin strip about 1 mile long that rests between Tangier Island and Virginia's Eastern Shore, once housed a lighthouse, built in 1833 and destroyed by a storm in 1944. The island is now a *shoal*[1]. Poplar Island in the northern

1. In *The Black Shoals*, Tiffany Lethabo King defines shoals geologically, geographically, and theoretically as "liminal, indeterminate and hard

part of Chesapeake Bay once measured 1100 acres that stretched in a 4-mile-long arc. In the 1800s a hundred settlers inhabited it but abandoned it in 1920 due to erosion. By 1990, Poplar Island had dwindled to a mere 5 acres. Some islands are uninhabited by humans, such as Bloodsworth Island, which lies northwest of Deal Island. Bloodsworth Island is off-limits to civilians because the US Navy used it as a bombing range between 1942 and 1995, so it is loaded with ordnance. Along with the nearby Blackwater National Wildlife Refuge, Bloodsworth Island is an important stop on the Atlantic flyway. Its best-known visitor is the American bald eagle.

Twelve thousand years ago, when the glaciers melted and flooded into the streambed of the ancient Susquehanna—from the Lenape meaning "oyster river"—sea levels rose. The islands were formed in Chesapeake Bay, from the Algonquian *chesepiooc* meaning at "a big river."

As the peninsula flooded, it morphed into islands. Historical maps show the ghostly outline and shadow of the peninsula behind the islands (Swift *Chesapeake Requiem* 112). For example, an 1850 US Coast Survey map shows Holland Islands in the shadow of the former peninsula. In 1850, it was Holland Islands—plural. Now, only one of its islands remains. What was a peninsula became islands as sea levels rose. What were plentiful islands became less numerous as sea levels rose even more.

Moreover, Holland Island, which neighbors Deal Island, is only visible during low tide and home to birds. During high tides, it is submerged. "Under the surface are the remains of an entire community—homes, schools, churches, shops and a post office," writes science communicator Caitlyn Johnstone. "In 1910, Holland Island was the most populated island in Chesapeake. . . . By 1922, Holland Island was abandoned. With no bedrock to hold it in place, erosion quickly took back the island to the Bay" ("Portrait of an Island Part I"). It was home to flocks of songbirds, blue herons, and seagulls. Its last house, captured in a photograph from October 2009 that circulated widely on social media, fell into the bay in 2010.

Deal Island is being lost in whispers rather than as dramatically as Tangier Island and Smith Island. According to oceanographer William Cronin's book *The Disappearing Islands of the Chesapeake*, "Deal Island's acreage dropped from 2280 in 1948 to 1950 [acres] in 1998" (107). Yet even if Deal Island's shrink is less dramatic than that of neighboring islands, it is still stark.

to map" (3). "Its unpredictability exceeds full knowability/mappability and in some senses is what Sylvia Wynter and Katherine McKittrick would call a 'demonic' space" (3). As such, "The Black Shoals," King writes, "will interrupt and slow the momentum of long-standing and contemporary modes and itineraries for theorizing New World violence, social relations, Indigeneity, and Blackness in the Western Hemisphere" (2).

OYSTER REEF

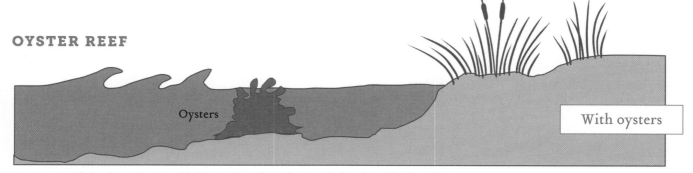

With oysters

Oyster reefs absorb wave impact and build coastal marshes and sea grass beds, reducing flooding and preventing erosion. They also provide a marine habitat.

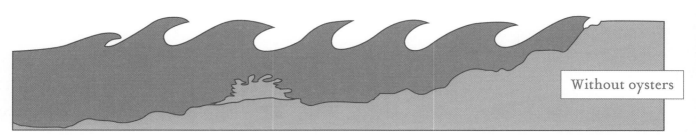

Without oysters

Absent oyster reefs, the shoreline is subject to more flooding and erosion.

OYSTER COMMUNITY

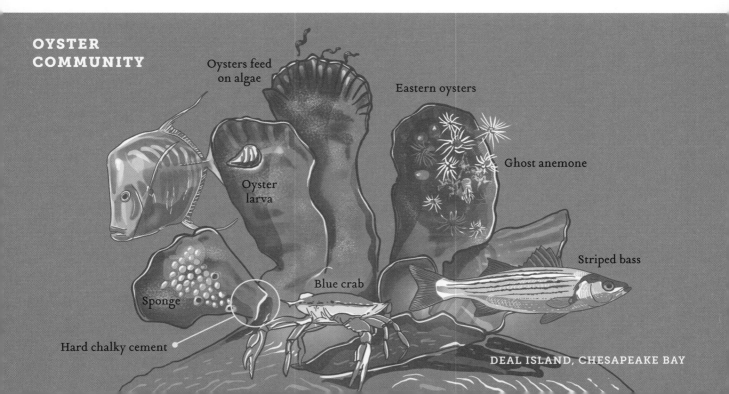

Oysters feed on algae

Eastern oysters

Oyster larva

Ghost anemone

Striped bass

Blue crab

Sponge

Hard chalky cement

DEAL ISLAND, CHESAPEAKE BAY

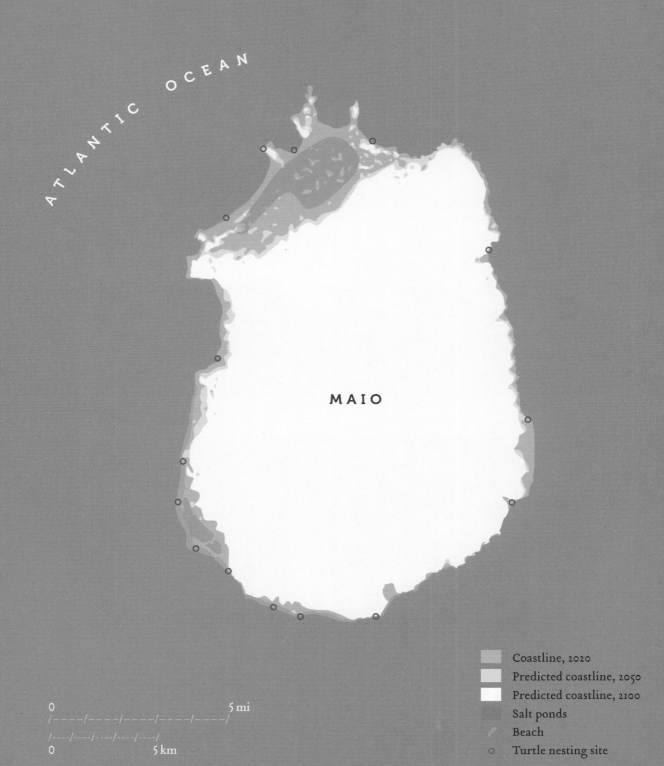

ATLANTIC OCEAN

MAIO

Coastline, 2020
Predicted coastline, 2050
Predicted coastline, 2100
Salt ponds
Beach
Turtle nesting site

0 ————————— 5 mi

0 ————————— 5 km

República de Cabo Verde
Republic of Cabo Verde

Archipelagic nation of 10 islands and 8 islets

1557 sq. mi. (4033 km²) | Maio: 106 sq. mi. (275 km²)

Population: 596,707 (2022 est.) | Maio: 6980 (2015)

Mestiço or Crioulo, of African and European heritage

Languages: Portuguese, Cabo Verdean Crioulo

Highest Elevation: 9282 ft. (2829 m) | Maio: 49 ft. (15 m)

549 MI / 884 KM
--> BIJAGÓS (6)

2306 MI / 3711 KM
----/----/--> SÃO TOMÉ AND PRÍNCIPE (7)

4939 MI / 7948 KM
----/----/----/----/----/> COMOROS (9)

1460 CE
Uninhabited when Genoese navigator António de Noli reported the islands sailing for the Portuguese Crown

1869
Slavery abolished in Portuguese colonies

1975
Independence

16TH–19TH CENTURY
Islands served as key site for the Atlantic slave trade

2015
Hurricane Fred struck, estimated $2.5 million in damages

That islands so blessed could also be so cursed. Starts with the *morna*. Presumed to mean a song of mourning, thus read as dolorous, like the *fado* in Portugal, it could also derive from the Portuguese word *morna,* meaning balmy and warm.

Blessed. The Republic of Cabo Verde together with the Azores, Madeira, the Selvagens or Savage Islands, and the Canary Islands forms the southern tip of the Macaronesian region, a unique biogeographic realm. Each archipelago within it is of volcanic origin and features a rich biodiversity.

An arrow-shaped archipelago, Cabo Verde points at Senegal, 280–385 miles (450–620 km) to the east. Its ten islands (nine of which are inhabited) and eight islets are spread out over 22,394 square miles (58,000 km²) of ocean.

Typically, the islands are divided into the windward islands in the north and the leeward islands in the south. But they could also be divided into the *volcanic islands* of the west and the flat islands in the east. The volcanic or high islands are sinewy. Muscular ridges lead up to the volcanic peaks. Ranging in height from 1270 to 9282 feet (387–2829 m), they peak at the still active volcano on Fogo. The islands' variation bespeaks their formation, a topic of geologic controversy, and their ages range from 26 million years to 100,000 years.

Blessed. Cabo Verde is also known for its role in decolonization and independence movements. Amílcar Cabral, born in Guinea to Cabo Verdean parents, was one of the most important anticolonial leaders. In 1956, he established the African Party for the Independence of Guinea and Cabo Verde (PAIGC), which fought for independence from Portugal. Cabral was assassinated in 1973. After decades of struggle, Cabo Verde established independence in 1975. In 1980, the two countries split.

Present-day Cabo Verde has a high standard of living relative to other western African nations, measured by the gross domestic product and per capita income, both of which have been increasing, and unemployment and poverty, both of which have been decreasing.

Cabo Verde's location combined with the area's ocean and wind currents create favorable conditions for ocean crossings, key to both the slave trade and hurricanes. Dolorous.

Cursed. Slavery began in the Macaronesian region. Cabo Verde islands were uninhabited until a Genoese navigator, sailing for the Portuguese Crown, alighted upon them in 1460. They then became a key node of the triangular transatlantic slave trade among Europe, Africa, and the Americas, after the Portuguese settled the islands in the fifteenth century.

In *A Billion Black Anthropocenes or None,* Kathryn Yusoff discusses the dating of the Anthropocene's beginning, asking does one date it to the "1800s industrialization; [or] 1950s Great Acceleration" (19)? Yusoff cites Sylvia Wynter, who "suggests that we should in fact consider 1452 as the beginning of the New World, as African slaves are put to work on the first plantations on the Portuguese island of Madeira, initiating the 'sugar-slave' complex" (33). (In "1492: A New World View," Wynter suggests an even earlier date of 1441, when "the Portuguese finally rounded the cape [Bojador] . . . , landing on the shores and in the lush green territory of Senegal.") This focus on 1452 returns to "murderous origins," which narratives of 1492 avoid to be "exclusionary at the point of origin, and precisely because of the history of those murderous origins" (Yusoff 34). So rather than starting with the steam engine, Wynter expands ranges and shifts from machines to the Black bodies, which provided the labor, which generated the sugar, which fueled Europe, which fueled the coal mining that fueled the steam engines. "Coal was the inhuman corollary of those dehumanized black bodies," Yusoff writes. "Coal black. Yet, histories of the Anthropocene

ubiquitously begin with meditations on the great white man of industry and innovation to reinforce imperial genealogies" (15). Starting earlier than 1492, Yusoff argues, undoes the valorization of some notions of man and of land that void other subjects and their relations to earth.

A closer look at what happened on Madeira, at the northern end of the Macaronesian region of which Cabo Verde forms a part, illustrates Yusoff's point. The name Ilha da Madeira translates into "the island of wood"; it was specifically laurel. In 1455, as Venetian traveler Alvise da Ca'da Mosto (Cadamosto) wrote: "[T]here was not a foot of ground that was not entirely covered with great trees" (cited by Patel and Moore 16). "By the 1530s," as Raj Patel and Jason Moore write, "it was hard to find any wood on the island at all. There were two phases in the clear-cutting of Madeira. Initially trees had been profitable as lumber for shipbuilding and construction. . . . The second, more dramatic deforestation was driven by the use of wood as fuel in sugar production" (14–15). *Roça,* the Portuguese word for "plantation," also means "clearing."

Then came the need for labor. "In Madeira," Patel and Moore write, "they were Indigenous People from the Canary Islands [Guanche], North African slaves, and—in some cases—paid plantation laborers from mainland Europe" (16). Sugar production reconfigured relations, between humans and between humans and nature, to economic ends. "Centuries before Adam Smith could marvel at the division of labor across a supply chain that made a pin," Patel and Moore write, "the relationship between humans, plants and capital had forged the core ideas of modern manufacturing—in cane fields. The plantation was the original factory" (16). First implemented on Madeira, the *plantation* model was then transported to other Atlantic African islands, such as São Tomé and Príncipe (7), before it was brought to islands in the Caribbean and the Pacific. This reconfiguration has had a range of lasting impacts on islands: cultural, economic, environmental, and more.

Cursed also because so-called Cape Verde hurricanes originate in the region. Often reaching the Caribbean Sea and the Gulf of Mexico, these hurricanes are frequently the season's most powerful, since they have warm water and the entire expanse of the Atlantic to build momentum. Recent Cape Verde hurricanes include Ivan (2004), Irma (2017), Laura (2020), and Dorian (2019), the strongest storm on record in the Atlantic.

Sea level rise will impact Cabo Verde. The easternmost islands—Boa Vista, Maio, and Sal—are older and low-lying. They will therefore be most affected by sea level rise. Maio is mostly flat with a desertlike interior. Its dunes are occasionally interrupted by acacia trees, which can survive on little rainfall. It measures 106 square miles (275 km²) and has a peak height of 49 feet (15 m). Sea level rise will impact Maio's coastline, its northern tip and western edge, where large *salt ponds*

exist. (They also exist in the southwest.) Starting in the sixteenth century, when the British colonized the island, salt was gathered here and shipped to Britain. They say that's why its largest city, Vila do Maio, was renamed Cidade de Porto Inglês. Now, a women's cooperative works the salt ponds, providing economic opportunities that promote social equity. The wetlands are an important breeding and feeding habitat for a range of birds. These salt ponds are at risk of inundation.

Rising sea levels will also affect sea turtles, which nest and lay their eggs on Maio's coastline in the summer. Cabo Verde has one of the world's largest loggerhead turtle nesting populations. Additionally, hawksbill and leatherback inhabit the Cabo Verde waters, as do beaked whales and spotted and long-beaked common dolphins. Blue whales and humpback whales migrate through with their newborn calves in the winter and spring.

Lastly, drought and chronic water shortages pose grave concerns for Cabo Verde. The archipelago is a marine extension of the Sahara. Rainfall levels are low. Northeast trade winds blow in dry air. The annual Harmattan winds between November and March desiccate the air and soil with humidity levels often falling below 20 percent. They cause erosion. The flatter eastern islands are drier than the western ones. Rainfall typically arrives in brief torrential downpours during the rainy season, which lasts from July to October. They continue the soil's erosion and cause flooding. Rainfall is a key source of *freshwater* and gathered through *rainwater harvesting*, wells, or cisterns. Rainfall does not, however, always suffice for human, animal, or plant life. *Desalination plants* supplement the rainwater, but they are energy intensive and electricity is expensive. Because rainfall is so important, it is celebrated. As Cabral puts it in his poem "Return": "the whole island / within days becomes a garden."

Amílcar Cabral

RETURN

Old mama, come and let's listen
To the beat of the rain against the door
It is the beating of a friend
that vibrates in my heart

The rain friend, old mama, the rain
that hasn't been falling this way
In a long time I heard that Cidade Velha
—the whole island—
within days becomes a garden

I heard that the country is covered in green
The most beautiful color, the color of hope
That now, the soil really looks like Cape Verde
And the storm turned calm

Come with me, old mama, come
Regain your strengths and come to the door
The rain friend sends its salvation
And beats inside my heart

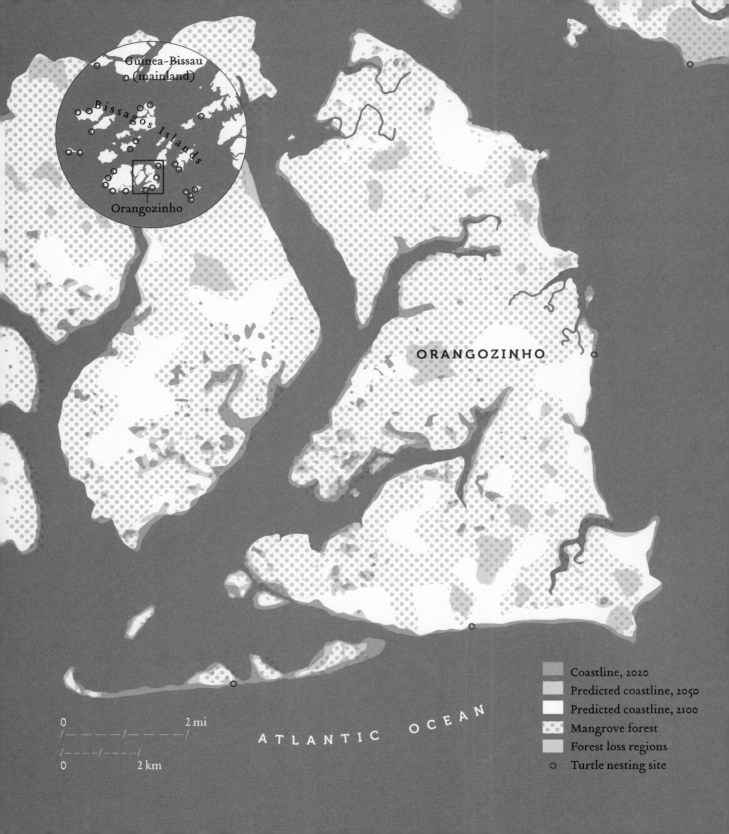

Guinea-Bissau
(mainland)

Bissagos Islands

Orangozinho

ORANGOZINHO

ATLANTIC OCEAN

	Coastline, 2020
	Predicted coastline, 2050
	Predicted coastline, 2100
	Mangrove forest
	Forest loss regions
○	Turtle nesting site

0 2 mi

0 2 km

Arquipélago dos Bijagós
Bissagos Islands

11.2905° N
15.9708° W

Archipelago of 88 islands and islets, 23 of which are inhabited

1013 sq. mi. (2624 km²) | Ilha de Orangozinho (Little Orango): 41 sq. mi. (106 km²)

Population: 33,385 (2012 census) | Ilha de Orangozinho: 706

Languages: Bidyogo, Portuguese, Crioulo

Mean Elevation: 230 ft. (70 m) | 20 ft. (6 m)

597 MI / 961 KM
--> CABO VERDE (5)

1731 MI / 2786 KM
----/---> SÃO TOMÉ AND PRÍNCIPE (7)

4372 MI / 7036 KM
----/----/----/----/-> COMOROS (9)

9000 BCE	1446–1535 CE	1869		1936	
First settled	Portugal colonized Guinea-Bissau	Slavery abolished in Portuguese colonies		Islands annexed by Portugal	
	1500s				1974
	Slave trade begins in Guinea				Independence

This tree walks. On stilts, no less. _Mangroves_ are tropical trees. They grow in thickets along tidal estuaries, in salt marshes, and on muddy coasts. Mangroves are the only trees that can tolerate so much saltwater. Their tangle of roots is submerged in the brackish water at high tide and visible at low tides (see illustration, p. 61). Parts of the roots are above the saline water, to take in oxygen. Either the trees grow vertically or the trunk arches horizontally and prop roots appear so it does not fall over. As the tree grows, more prop roots develop and it looks like the tree is walking.

Mangroves densely forest the island's coastline. They are extremely important to shoreline ecosystems. Ecologically, the trees provide a habitat for an array of fish and mollusk, which call the dense web of roots home. The roots protect young fish, which grow nestled among the roots. About one-third of all young fish are sheltered in mangrove forests, before heading into the open ocean. Shellfish rely on the root web as their breeding, spawning, and hatching grounds.

Physically, mangroves work against *erosion* in two directions. They buffer shorelines from waves, damaging winds, and storm surge arriving from the ocean. They also trap sediments flowing down from rivers into the ocean. And they improve water quality by filtering pollutants from land sediments. Globally, mangroves are at risk due to *deforestation* for logging or construction along shorelines, especially of infrastructure for tourism.

Mangroves line Ilha de Orangozinho (Little Orango). It forms part of the Arquipélago dos Bijagós (Bissagos Islands). Although the islands sit about 30 miles (48 km) west off the coast of Guinea-Bissau, a three- to four-hour ferry ride away, they remain fairly separate and protected.

Formed in an ancient delta at the confluence of the Rio Geba and the Rio Grande, the archipelago boasts a considerable diversity of fauna. Crocodiles, dolphins, manatees, turtles, and pygmy hippopotamus live in the tidal waters. The estuary's *mudflats* provide lush habitats for the many migrant birds passing through, including flamingos and pelicans.

The archipelago's population is estimated to be 33,385. A high percentage of its inhabitants are Indigenous Bidyogo, who are matriarchal and matrilineal. The island residents are mostly subsistence farmers and fishers. They use *pirogue* to navigate the shallow, sandbar-filled waterways between the islands and to fish. The region's waters are among the most fertile fishing regions in West Africa. Atlantic cod, barracuda, pink dorade, Senegal jack, and red snapper swim here. Harvests from rice patties supplement the fish.

Little Orango, like other Bijagós islands, is a lively habitat for wildlife. Neighboring Orango is the largest Bijagós island and home to saltwater hippos. Five of the world's eight sea turtle species inhabit the waters around Bijagós: green sea, hawksbill, leatherback, loggerhead, and olive ridley sea turtles. Little Orango is a key green sea turtle nesting site. Between June and December tens of thousands of sea turtles come to the shores to lay eggs. The survival rate is low: an estimated twelve of a thousand hatchlings survive. Sea level rise further threatens sea turtle nesting sites globally and here. Little Orango is low-lying with an elevation of 20 feet (6 m) and thus particularly at risk of sea level rise.

Maybe the tree on stilts provides an architectural model? Stilt houses have been built inland in Guinea and Mali to house grain. Unique to African islands, and similar to architecture in Borneo, stilt houses over land exist on Madagascar. Stilt houses over water have long been a hallmark of coastal Austronesian architecture. That said, while stilt houses might save humans, neither the pivotal habitat the stilt trees (the mangroves) provide nor their work to reduce CO_2 emissions (to protect shorelines and to buffer waves) can be replicated. Luckily, they grow quickly and movements to replant them are afoot.

MANGROVE FOREST

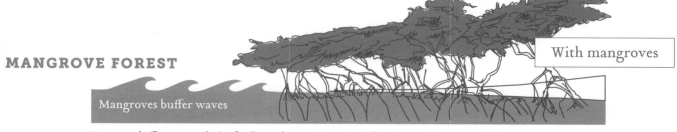

With mangroves

Mangroves buffer waves

Mangroves buffer waves, reducing flooding and preventing erosion. They also provide a marine habitat.

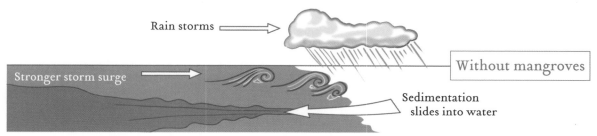

Rain storms

Without mangroves

Stronger storm surge

Sedimentation slides into water

Absent mangrove forests, the shoreline is subject to more flooding and erosion and lacks a marine habitat.

MANGROVE COMMUNITY

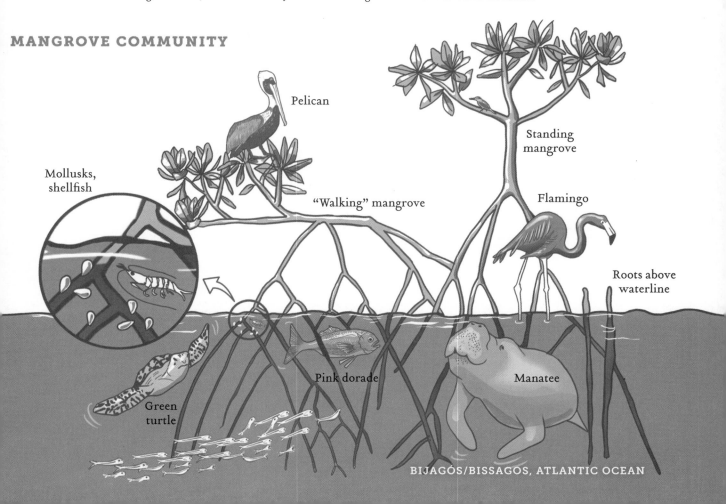

Pelican

Standing mangrove

Flamingo

Mollusks, shellfish

"Walking" mangrove

Roots above waterline

Green turtle

Pink dorade

Manatee

BIJAGÓS/BISSAGOS, ATLANTIC OCEAN

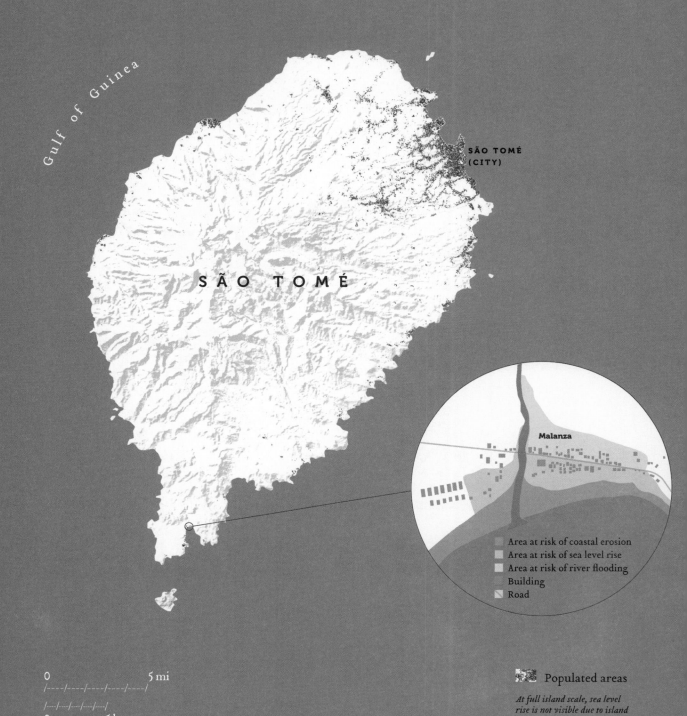

Gulf of Guinea

SÃO TOMÉ
(CITY)

SÃO TOMÉ

Malanza

Area at risk of coastal erosion
Area at risk of sea level rise
Area at risk of river flooding
Building
Road

0 5 mi
/----/----/----/----/----/

/----/----/----/----/
0 5 km

Populated areas

*At full island scale, sea level
rise is not visible due to island
size and mountainous terrain*

República Democrática de São Tomé e Príncipe

Democratic Republic of São Tomé and Príncipe

0.3302° N
6.7330° E

332 sq. mi. (859 km²) and 55 sq. mi. (142 km²)

Population: 217,164,948 (2022 est.)

Languages: Forro Creole or Sãotomense, Angolar, Principense, Portuguese

Elevation: 144–449 ft. (44–137 m) | Highest Elevation: 6640 ft. (2024 m)

```
          2315 MI / 3725 KM
----/----/-> CABO VERDE (5)

          2649 MI / 4263 KM
----/----/--> COMOROS (9)

               5804 MI / 9340 KM
----/----/----/----/----/---> DEAL ISLAND (4)
```

1470 CE		1553		1869	
Uninhabited until Portuguese arrived		Yon Gato, blind planter, leads a revolt among the enslaved colonies		Slavery abolished in Portuguese colonies	

1485	1500s	1575			1975
Portuguese colony founded	Portuguese colonizers used enslaved Africans to labor on sugar plantations	Rebellion of enslaved Africans			Independence

The food of the gods, cacao, grows in furrowed elongated pods, ranging in hues from green to yellow to deep red. The trees typically range from 6 to 12 feet in height. Large leathery leaves shade the pendulous pods. A family of larger trees, such as banana or palm trees, protect the smaller sibling cacao trees from the sun and wind. Cacao accounts for about 95 percent of all exports of the Democratic Republic of São Tomé and Príncipe, the first African nation where it was introduced. That said, the cacao industry has declined from previous decades. Other export crops include coffee and copra, the kernel or dried meat of the coconut from which coconut oil is extracted.

Santomean poet Alda do Espírito Santo in her poem "The Same Side of the Canoe" writes: "my brother contracted to the coffee plantation / . . . brothers, in the harvest of cacao" (following).

São Tomé measures 30 miles (50 km) by 20 miles (30 km), and Príncipe measures 20 miles (30 km) by 4 miles (6 km). Both are volcanic islands, also known as *high islands*, because they are mountainous. São Tomé's peak towers at 6640 feet (2024 m) and Príncipe's at 3110 feet (948 m). Lush green rainforest covers three-quarters of the island, and rivers crisscross the islands. The islands boast the highest density of endemic birds and some, such as the elusive São Tomé fiscal and the São Tomé grosbeak, can be found in the southwest river area.

The volcanic soils are fertile. Historically, there has been no shortage of water. Ideal growing conditions. Agriculture accounts for roughly 70 percent of the population's income. Aside from cocoa, which is the main crop, avocado, bananas, breadfruit, coconut, jackfruit, mango, papaya, pineapple, and taro are grown on the islands. Approximately 20 percent of the population works in the fishing industry.

The center of the globe. Just north of the equator. Just east of the Prime Meridian. Here rest São Tomé and Príncipe in the Gulf of Guinea, just off the western coast of central Africa. They were uninhabited until the Portuguese arrived in 1470. Soon thereafter, settlements were founded and sugar was planted. The tropical location close to the equator and the volcanic soil made the islands ideally suited for cane cultivation.

The center of the slave trade. Since the islands sit just 224 miles (360 km) west of Gabon, they were close to one of the main harbors for the slave trade: Libreville, Gabon's capital on the coast of central Africa. It is estimated that the majority (39.4 percent) of enslaved Africans brought across the Atlantic traveled through central Africa. In the sixteenth century the island's Portuguese settlers started to use the labor of enslaved Africans on their sugar *plantations*. The enslaved Africans were mainly from Benin, Gabon, the Democratic Republic of the Congo, and the Republic of the Congo.

Raw material—both the natural resources and the labor—is central to plantations. Neither is sustained but rather viewed as expendable. The plantation system, as Patel and Moore write, "robs life from the worker just as it exhausts the soil of the capitalist farmer" (27). After being developed on the island of Madeira, north of Cabo Verde (5), the plantation system was exported to São Tomé and then across the Atlantic. Due in part to the plantation system, islands, even ones with ideal growing conditions, are now often not self-sufficient and need to import food. "Europe's wealthy ate the sugar, and the sugar ate the island" (Patel and Moore 17).

"Madeira crashed in the 1520s and was overtaken by São Tomé in the 1550s," Patel and Moore write, "which crashed and was overtaken by Pernambuco in the 1590s, which crashed and was

overtaken by Bahia in the 1630s, which crashed and was overtaken by Barbados in the 1680s, which crashed and was overtaken by Jamaica and Haiti in the 1720–1750s" (215n56).

In 1875, slavery was formally abolished on São Tomé and Príncipe. Subsequently, contract laborers from Angola, Cabo Verde, and Mozambique worked the plantations, which had transitioned to cocoa and coffee in the nineteenth century. Cabo Verdeans form the largest *diasporic* population group in São Tomé and Príncipe, followed by Angolans and Mozambicans. They share a Luso-African heritage and have cultural connections. Old Cabo Verdean songs tell about working on São Tomé.

The population consists mostly of *mestiços*, mixed-race descendants of Portuguese colonizers and Forros (from the Portuguese *Alforrio,* meaning "freedom"), freed enslaved Africans. It also includes Angolares, descendants of enslaved Angolans who shipwrecked off the southern coast of São Tomé around 1540.

After the Seychelles (11), São Tomé and Príncipe is the least populous African nation. But that does not preclude *population density* from being an issue. Like on other volcanic islands, such as the Seychelles and Fiji (26), most of the population is clustered along the flatter perimeter of coastline due to the steep inland terrain. According to the United Nations Economic Commission for Africa, "96% of the population of São Tomé and Príncipe live within 10 km [6.21 miles] of the coastline," which makes it particularly vulnerable to sea level rise. One-third of the population lives in São Tomé, the capital city with an estimated population density of eleven thousand inhabitants per square mile (4200 per km²). On Príncipe most of the population lives in Santo Antonio. These cities lie in the north of their respective islands and have the highest population density. On São Tomé sea level rise will impact the coastline most intensely in this densely populated northeast region and in the south near Malanza. In Malanza, *infrastructure* such as roads and buildings are at high risk of inundation due to a combination of river flooding, coastal erosion, and sea level rise.

São Tomé and Príncipe are among the ten nations globally that have produced the least amount of *CO2 emissions*. All ten of these nations are islands.

Alda do Espírito Santo

THE SAME SIDE OF THE CANOE

The words of our day
are simple words
clear as brook waters
spurting from rust-red slopes
in the clear morning of each day.

So it is I speak to you,
my brother contracted to the coffee plantation
my brother leaving your blood on the bridge
or sailing the sea, a part of yourself lost
 battling the shark
My sister, laundering, laundering
for bread to feed your sons,
my sister selling pits of fruit
to the nearest shop
for the mourning of your dead,
my adjusted sister
selling yourself for a life of greater ease,
in the end only suffering more . . .

It is for you, my brothers companions of the road
my cry of hope
with you I feel I am dancing
on idle nights
on some plantation where people gather

together, brothers, in the harvest of cacao
together again on market day
where roasted breadfruit and chicken will bring money.
Together, impelling the canoe along the shore,
joining myself with you,
around the brimming bowl,
joining in the feast
flying through
the ten toasts.

It is suddenly dark.
There on the far side of the beach
on the Point of São Marcal
there are lights, many lights
in the dark pal-thatched sheds . . .
the sweet whistle thrills—
strange beckonings—
invitation to this ritual night . . .

Note: Translated by Kathleen Weaver.

Here, only the initiated
in the frenetic rhythm of the dance of propitiation
here, the brothers of the *Santu*
madly wrenching their hips
releasing wild cries,
words, gestures
in the madness of the age-old rite.
In this side of the canoe I also am, my brother,
in your agonizing voice uttering prayers, oaths and maledictions.
Yes, I am here, my brother,
in the needless wakes for the dead
where the people play
with the life of their sons,
I am here, yes, my brother,
in the same side of the canoe.

But we want something still more beautiful.
We want to join our millenary hands,
hands of the cranes on the docks,
hands of the plantations and beaches,
in a great league encompassing
the earth from pole to pole
for our children's dreams
so we may be all of us on the same side of the canoe.

Afternoon descends . . .
The canoe slips away, serene,
on course to the marvelous beach
where our arms join
and we sit side by side
together in the canoe of our beaches.

Bahrain

Maldives Malé

Chagos

Dieg
Garci

Qamar
(Comoros)

Mahé

Seychelles

Agaléga

Gran Comoro

Mauritius

I N D I A N

Sandwip

Singapore

OCEAN

Al-Bahrayn
Kingdom of Bahrain

26.0667° N
40.5577° E

Archipelagic nation consisting of Bahrain Island and ~30 smaller islands

293 sq. mi. (760 km²)

Population: 1,540,558 (2022 est.)

46% Bahraini Arab, 45.5% Asian

Languages: Arabic, English, Farsi, Urdu

Highest Elevation: 440 ft. (134 m)

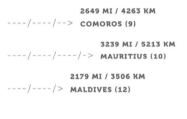

2649 MI / 4263 KM
----/----/--> COMOROS (9)

3239 MI / 5213 KM
----/----/----/-> MAURITIUS (10)

2179 MI / 3506 KM
----/----/-> MALDIVES (12)

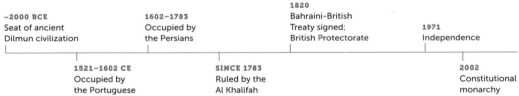

~2000 BCE
Seat of ancient
Dilmun civilization

1602–1783
Occupied by
the Persians

1820
Bahraini-British
Treaty signed;
British Protectorate

1971
Independence

1521–1602 CE
Occupied by
the Portuguese

SINCE 1783
Ruled by the
Al Khalifah

2002
Constitutional
monarchy

Navigational treatises in verse. Why not? Verse was key to oral literature in Arabic, African, Greek and Oceanic traditions. Ahmad ibn Majid Al-Najdi, one of the best-known Arab navigators, often wrote his navigational treatises in verse. His *Hāwiyat al-ikhtisār fī usūl ʿilm al-bihār* (the gathering of the first principles of the knowledge of the sea) consists of 1082 verses in the Classical Arabic rajaz meter and details how to determine distances, latitude, lunar mansions, rhumbs (a navigational path with constant bearing—that is, crossing all meridians of longitude at the same angle), and routes. Navigating out of sight of land took into account differences in winds (especially the trade winds), tides, and swells. Closer to land, landmarks were key to orientation. Majid presented many landmarks on coastlines that were unfamiliar to navigators.

Majid is best known as the author of *Kitāb al-Fawā'id fī usūl al-bahr wa'l-qawā'id* (On the origins and the power of the sea) (see excerpt following). In it he discusses what he deems to be the twelve key principles of navigation. They include the lunar mansions and compass rhumbs. Signs at sea, such as birds, were key for determining proximity to land. In the *Fawā'id,* as interesting for historians and geographers as it is for navigators, Majid also describes his travels past Indonesia to the Bay of Bengal (13) and along the coast of Myanmar.

One chapter focuses on islands, including the Kingdom of Bahrain, which lies just to the east of Saudi Arabia and northwest of peninsular Qatar in the Persian Gulf. The island's name, from the Arabic *al-bahrayn,* means "two seas"—a reference, it is believed, to the saltwater of the Persian Gulf and the sweet water of Bahrain's springs. The kingdom consists of the main Bahrain Island, about thirty smaller natural islands, and dozens of artificial islands. The kingdom's area, 293 square miles (760 km²), is just slightly larger than Singapore (14).

In his chapter on Bahrain, Majid describes the sweet water springs, including one underwater, and the pearl fisheries. Oysters create pearls when grit enters the shell. The pearls from Bahrain were particularly valuable and thus a key industry. While oyster pearls form in salty seawater, they have a unique color due to the underwater freshwater springs that flow past. The industry waned in the 1930s after Japanese developed cultured pearls and after the discovery in 1932 of oil in Bahrain.

Traditionally, Bahrainis built *dhows* (large sailboats) to voyage, fish, and pearl. According to Dionisius A. Agius, professor of Islamic Material Culture and Maritime Studies, the dhow was key to prosperity in the Gulf region prior to the discovery of oil (*In the Wake of the Dhow*).

Bahrainis also used *kamal* to navigate. Developed by Arab navigators in the tenth century, kamals are celestial navigation devices that determine latitude by the elevation of the Pole Star and thus permitted latitude sailing (McGrail *Boats of the World*). Arab navigators and cartographers used the kamal to voyage the Indian Ocean and beyond. In *On the Origins and the Power of the Sea*, Majid describes its use (190).

Now, Bahrain's boats are mostly fueled by petroleum, which is also its main import from Saudi Arabia. Bahrain's main exports are petroleum, which it both processes and refines, and aluminum, which it smelts. An Oil Museum sits at the point where oil was first discovered in Bahrain. The country derives 100 percent of its electricity from fossil fuels and as a result consistently ranks among the highest CO_2 emitters globally when measured per capita. Its banking and financial sector is fast-growing and among the world's largest, particularly for Islamic banking.

Bahrain's strategic location, both in proximity to petroleum sources and in the Persian Gulf, through which oil tankers must travel to reach the open Indian Ocean, is a key asset. Bahrain trades mainly with Saudi Arabia, the US, the United Arab Emirates, Oman, China, and Qatar. It

is home to the US Navy's Fifth Fleet. The base was established during World War II for actions in the Central Pacific. It was inactive from 1947 until 1995, when it was reactivated following the 1990–1991 Gulf War.

Bahrain's climate is generally arid, although the summers are humid. The kingdom's smaller islands are low-lying. Geologically, the main island consists of limestone and sandstone. Low desert plains dominate, especially in the south and west. The interior of the island is barren with a low running down the middle and two peaks. A mere 2 percent of the land is arable. Animals include the desert fox, desert hare, gazelles, and jerboa. To the north, almond, date, fig, pomegranate, orange, and lime trees grow. Springs exist in this region. _Desalination plants_ supplement the limited _freshwater_, providing about 90 percent of it. The capital, Manama, is located here. About 90 percent of Bahrain's population is urban, with one-third living in the main cities: Manama and Muharraq.

Drought, dust storms, desertification, and heat are key environmental issues. Additionally, the coastlines, coral reefs, and sea life have been degraded by oil refineries, spills, and tankers. Nonetheless, after Australia, the waters around Bahrain boast the second-largest population worldwide of dugong, a marine mammal related to manatees.

The biggest environmental concern presently is sea level rise. Like nearby Dubai with its famous artificial Palm Islands, Abu Dhabi, and Singapore (14) in Southeast Asia, Bahrain has been expanding via _land reclamation_ or infill. For example, it has built an _artificial island_ named Reef Island north of downtown Manama. Throughout the Gulf states, reclaimed land now constitutes the coastline of many of Peninsula countries.

But land reclamation aside, due to sea level rise, Bahrain is now forecast to contract in size. By 2050 an estimated 11 percent to 22 percent of Bahrain's total land area will be lost to sea level rise. By 2100, according to Bahrain's Second National Communication to the United Nations Framework Convention on Climate Change, 27 percent of Bahrain could be underwater with a rise of 4.9 feet (1.5 m) of sea level, and up to 56 percent could be submerged with a rise of 16.4 feet (5 m).

Sea level rise will have numerous impacts. It will further degrade coastal fisheries. It will erode shorelines and lead to a loss of coastal and urban habitats. Bahrain ranks fourth globally for _population density_, with an estimated 5593 inhabitants per square mile (2159 per km²). Most of the population lives in coastal regions, in particular in the capital. These areas barely measure more than 16.4 feet (5 m) in height. Additionally, sea level rise will further contaminate Bahrain's already limited and salinized freshwater supply. To address these predicted impacts, Bahrain is restoring coastal mangrove forests and working to protect coral reefs.

Ahmad ibn Majid Al-Najdi

FROM **ON THE ORIGINS AND THE POWER OF THE SEA**

Know oh reader, that sailing the sea has many principles. Understand them: the first is the knowledge of lunar mansions and rhumbs and routes, distances, *bashiyat* [latitudes], latitude measuring, signs (of land), the courses of the sun and moon, the winds and their reasons, and the seasons of the sea, the instruments of the ship. . . . It is desirable that you should know about risings and "southings" and the methods of taking latitude measurements and their variations and graduations, the risings and settings of the stars, their latitudes, longitudes and distances and their passing the meridian. . . . It is also desirable that you should know all the coasts and their landfalls and their various guides such as mud, or grass, animals or fish, sea-snakes and winds. You should consider the tides, and the sea currents and the islands on every route.

Union of the Comoros

Archipelagic nation centered on 4 main islands and many smaller islets

785 sq. mi. (2034 km²)

Population: 876,437 (2022 est.)

Languages: Shikomoro (Bantu language related to Swahili, 96.9%), Arabic, French

Highest Elevation: 7743 ft. (2360 m)

```
                    2306 MI / 3711 KM
----/----/->  SÃO TOMÉ AND PRÍNCIPE (7)

              1118 MI / 1799 KM
----/>  MAURITIUS (10)

                    2294 MI / 3692 KM
----/----/->  MALDIVES (12)
```

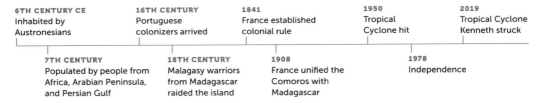

6TH CENTURY CE	16TH CENTURY	1841	1950	2019
Inhabited by Austronesians	Portuguese colonizers arrived	France established colonial rule	Tropical Cyclone hit	Tropical Cyclone Kenneth struck

7TH CENTURY	18TH CENTURY	1908	1978
Populated by people from Africa, Arabian Peninsula, and Persian Gulf	Malagasy warriors from Madagascar raided the island	France unified the Comoros with Madagascar	Independence

Living fossils. Dying fossil fuels. Coelacanths are considered to be a living fossil. Thought to have been extinct sixty-five million years ago, they were rediscovered off the Union of the Comoros in 1938. Were they hard to track because they were hiding? At least, from a human vantage point. Coelacanths prefer the *benthic zone*. Meaning "deep of the sea," the benthic zone is the lowest oceanic region, the ocean floor. Two species of coelacanths exist: one here and one off the coast of Indonesia. Coelacanths mark a transition from fish to *tetrapods*—that is, four-legged amphibians and reptiles. A sign? Their front and back lobed fins move in an alternating pattern (like those of a trotting horse), like a big alligator climbing ashore. Eadweard Muybridge's "The Horse in Motion" photographs come to mind. A trotting fish. Coelacanths grow to be about 6 feet long, can weigh up to 200 pounds, and live to be sixty years old. Most endemic species in the Comoros, which also include chameleons, geckos, skinks, and lemurs, have close relatives in nearby Madagascar.

Located between Mozambique on the eastern coast of the African continent and Madagascar in the Indian Ocean, the Comoros is an archipelagic nation centered on four main islands and many smaller islets.

The islands show a combination of African, Arab, Austronesian, French, and Malagasy influences in their languages, religions, culture, and cuisine. The cuisine, for example, features root-based stews common in East Africa as well as rice-based curry dishes common in Southeast Asia.

In the sixth century CE, Austronesians arrived by boat. Subsequently, African, Arab, and Persian traders inhabited the Comoros. The African traders brought the Bantu language and laid the foundation for Swahili culture. Starting roughly in the tenth century, Arab traders brought the Arabic language as well as Sunni Islam from the Arabian Peninsula and the Persian Gulf, which has flourished since. Currently, an estimated 98 percent of the population is Sunni Muslim.

Centuries after these hybrid Afro-Islamic societies were established, Europeans arrived. First, in the sixteenth century, Portuguese colonizers arrived. Then, in 1841, France colonized the islands, unifying them with Madagascar in 1908. When Madagascar regained independence in 1960, the Comoros remained under French rule. The Comoros achieved independence in 1978 but have experienced decades of political turbulence. Mahore (Mayotte), one of the four main islands, is—unlike the others and by its own vote—a French-administered region.

The scents. Of the rose-like plumeria, of the floral but slightly musky jasmine, of the sweet fruity floral ylang-ylang. The Union of the Comoros have been called the "perfume islands" for their abundance in fragrant plants. The ylang-ylang essence, used in perfumes worldwide, is a lead export as are cloves. And after neighboring Madagascar, the Comoros are the world's second largest producer of vanilla.

The majority of Comorans rely on subsistence agriculture, mainly bananas, cassava, and sweet potatoes. Although 84 percent of the island is given over to agriculture, like São Tomé and Príncipe (7) and Tuvalu (27) at 80 percent, a high percentage of food on the Comoros (70 percent) is imported.

The Comoros are among the poorest and smallest economies globally measured in terms of both per capita income and *gross domestic product* (GDP). An estimated 175,000 Comorans live in the diaspora, mostly in France, to pursue educational and employment opportunities. Remittances constitute about 25 percent of the annual GDP of the Comoros.

The economic situation is compounded by environmental factors. They include limited access to freshwater, climate change–induced drought, subsidence, sea level rise facing off with population density along the shoreline, and a high risk of cyclones striking. *Threat multipliers*, whereby

the climate change–induced factors exacerbate and compound already existing inequities and the challenges they produce.

Access to freshwater on the islands is limited. Currently, about 80 percent of the Comoros relies on rainfed agriculture. Rainwater is harvested in reservoirs. The island's volcanic provenance means drilling wells is difficult. Due to sea level rise, the wells are salinized. According to Henry Rene Diouf, regional technical advisor on the Comoros to the United Nations Development Programme (UNDP), "On the Grande Comore [the main island], groundwater is the main water source for 30% of the population, primarily in the coastal towns and villages. All boreholes are close to the coast and many exhibit elevated salinity year-round."

As a result of climate change, drought is also a real concern. The UNDP predicts that rainfall may decrease by almost 50 percent by 2090 during the dry season (May–October) with an uptick in rains during the wet season (November–April). The National Action Programme of Adaptation (NAPA), a UN agency that helps countries adapt to climate change, stated in a 2006 report that in the Comoros "over the past ten years, drought has become a quasi-permanent phenomenon and cannot therefore be considered as an exceptional event."

Furthermore, according to the NAPA report, the islands are subsiding or sinking. Here, like on Deal Island (4), Vanuatu (23), and the Solomon Islands (24), *subsidence*, or island sink, combined with sea level rise intensifies the amount of saltwater inundation.

Additionally, although the population of the Comoros overall is among the lowest in the world, the islands are densely populated, like São Tomé and Príncipe (7), Bahrain (8), and the Seychelles (11), with an average of 710 inhabitants per square mile (275 per km²). Two-thirds of the population is urban, living mostly on N'gazidja (Grande Comoro), clustered around the coastal capital, Moroni, and on Nzwani (Anjouan). Islands with *population density* along the shoreline will be particularly impacted by sea lea level rise.

Lastly, the Comoros are also particularly vulnerable to tropical *cyclones*. According to NAPA, "between 1911 and 1961, the archipelago experienced 23 cyclones, an average of one cyclone every two years." In March 2019, Tropical Cyclone Idai was one of the worst to hit Africa, damaging Mozambique, Zimbabwe, and Malawi and killing more than one thousand people. In April 2019, Tropical Cyclone Kenneth slammed the Comoros and then continued on to Mozambique, which was still reeling from Idai. It was the tenth tropical cyclone in the region in 2019, breaking records. Taken together, dwindling freshwater supplies, drought, tropical cyclones, and sea level rise threaten to make some parts of the Comoros uninhabitable.

INDIAN OCEAN

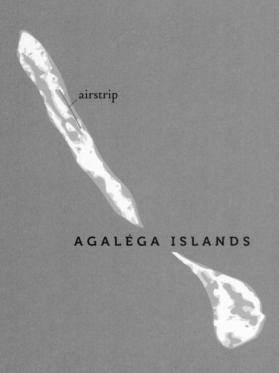

airstrip

AGALÉGA ISLANDS

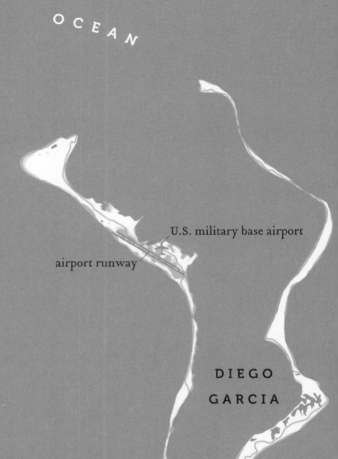

U.S. military base airport

airport runway

DIEGO GARCIA

0 1 mi
/----/

/----/
0 1 km

Coastline, 2020
Predicted coastline, 2050
Predicted coastline, 2100
Major road

Republic of Mauritius

20.3484° S
57.5522° E

Archipelagic nation of 4 main islands

Mauritius: 790 sq. mi. (2040 km²) | Population: 1,308,222 (2022 est.)

Agaléga: 9.2 sq. mi. (24 km²) | Population: 289 (2011 census)

Diego Garcia: 17 sq. mi. (44 km²) | Population: 4239 (2012)

Indo-Pakistani-Mauritian (66%), Creole, Sino-Mauritian, Franco-Mauritian

Languages: Creole, Bhojpuri, French, English, Hindi, Mandarin, Marathi, Tamil, Telugu

Mean Elevation: 984–1312 ft. (300–400 m) | Diego Garcia: 4 ft. (1.21 m)

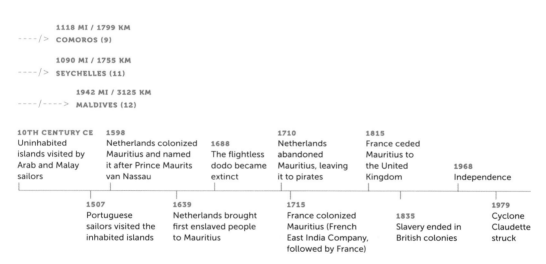

1118 MI / 1799 KM
----/> COMOROS (9)

1090 MI / 1755 KM
----/> SEYCHELLES (11)

1942 MI / 3125 KM
----/----> MALDIVES (12)

10TH CENTURY CE Uninhabited islands visited by Arab and Malay sailors

1507 Portuguese sailors visited the inhabited islands

1598 Netherlands colonized Mauritius and named it after Prince Maurits van Nassau

1639 Netherlands brought first enslaved people to Mauritius

1688 The flightless dodo became extinct

1710 Netherlands abandoned Mauritius, leaving it to pirates

1715 France colonized Mauritius (French East India Company, followed by France)

1815 France ceded Mauritius to the United Kingdom

1835 Slavery ended in British colonies

1968 Independence

1979 Cyclone Claudette struck

The flightless dodo, related to pigeons and doves but much larger and with much smaller wings, was endemic to the Republic of Mauritius and remains a national symbol. The story typically goes that within one hundred years of the 1598 Dutch colonization of Mauritius, the dodo, a squat bird short in stature and intelligence, was extinct. Yet the bird was neither as diminutive nor as dim-witted as legend has it. Moreover, the reasons for its extinction are complex. They include the creatures the colonizers brought—such as deer, goats, pigs, and rats—and the environmental havoc they wreaked. There's a lesson here about the fragility of ecosystems, especially on islands.

Currently, we are in what scientists have called the "sixth extinction" (Kolbert *Sixth Extinction*). Not only a scientific phenomenon, extinction is also influenced by and in turn impacts "histories, cultures and values" (Heise). And extinction cannot be understood outside of the current economic system (Dawson).

79

Environmental journalist Elizabeth Kolbert writes about how land-bridge islands—ones located close to a shore—and volcanic islands, both of which Mauritius is, feature less species diversity than the continents of which they once formed a part. "They keep on bleeding species—a process that's known by the surprisingly sunny term 'relaxation,'" Kolbert writes (*Sixth Extinction* 180). On a continent, after the members of a species have been wiped out in an area, other members of a species might wander in and repopulate. On an island that is less likely. "What distinguished islands," Kolbert continues, "is that recolonization is so difficult, in many cases, effectively impossible" (*Sixth Extinction* 181). Introducing species such as cats, dogs, pigs, and rats to islands can put endemic species at risk.

Mauritius is located about 1200 miles (2000 km) off the east coast of the African continent. Geologically, Mauritius forms part of the Mascarene Islands, which also includes Rodrigues and Réunion, a French territory. All three islands are volcanic.

To the northeast lie the Outer Islands of Mauritius, Agaléga and the Cargados Carajos Shoals, and two contested territories, Tromelin Island and the Chagos Archipelago.

Agaléga are two islands about 620 miles (1000 km) northeast of Mauritius in the Indian Ocean. Agaléga measures 9.2 square miles (24 km²) and its population is 289. It is low-lying, coral, and particularly vulnerable to sea level rise. A coral reef encircles the islands.

The Cargados Carajos Shoals rest 293 miles (472 km) to the northeast of Mauritius. *Shoals* are offshore geologic formations, ridges or banks, that are partly submerged and partly exposed, partly sea and partly sand, consisting of sand and other natural material. The number of islands and islets here varies depending on storms and sand movements. Twenty-two islands and shoals are named, but the actual number ranges from twenty-eight to forty.

Tromelin lies to the northwest of Mauritius, equidistant between it and Madagascar. It is uninhabited by humans but populated by sea turtles and birds. It houses a meteorological monitoring station used to forecast weather and monitor cyclones. France administers Tromelin, but Mauritius claims the island as part of its territories.

According to the *Human Development Index*, Mauritius ranks second highest after the Seychelles (11) of any African nation. Although the island is not wealthy, it boasts one of the highest standards of living globally. It provides free health care, education, and transportation. It spends 0.18 percent of its GDP on the military (2017), which ranks third lowest globally. (Only Iceland and Somalia spend less on their militaries.)

Yet external military pressures—signs of colonialism's legacy and of present-day imperialism—continue to inform territorial disputes. In 1598, the Netherlands colonized Mauritius, first

bringing enslaved people to the island in 1639 to work on the tobacco and sugarcane plantations. In 1710, the Netherlands left Mauritius.

In 1715, France colonized Mauritius, bringing in more enslaved people from Madagascar and from France's colonies on the African continent. By the end of the eighteenth century, enslaved people accounted for about 80 percent of the island's population.

In 1815, France surrendered Mauritius to the United Kingdom after the Napoleonic Wars. Mauritius was the last British colony to abolish slavery, in 1835. Subsequently, people were brought in as indentured servants from India and Pakistan in what was then the British Indian Empire. Mauritius was under British rule until independence in 1968.

As with other islands in the region, such as the Maldives (12), geopolitical interests play an important role. In 2015, India's prime minister Rajendra Modri signed a Memorandum of Understanding with Mauritius to upgrade infrastructure on Agaléga, permitting better air connectivity. It was viewed as bolstering both Mauritius's and India's regional interests. The countries have historical ties, and an estimated 66 percent of Mauritians are of Indo-Pakistani heritage.

Currently, Mauritius has two territorial disputes: with France over Tromelin Island and with Britain over the Chagos Archipelago. Three years before Mauritius gained independence, Britain split off the Chagos Archipelago, forcing Chagossians to evacuate and sending them to live on Mauritius and on the Seychelles (11). Britain placed the archipelago under the jurisdiction of the British Indian Ocean Territory.

Then the UK allowed the US to build a naval base on Diego Garcia, the largest island, used in the US wars against Afghanistan and Iraq. The US named it "Camp Justice." Alongside Guåhan (17), Diego Garcia is a key naval base for long-range bombing.

On February 26, 2019, the International Court of Justice (ICJ) advised that Britain must return the Chagos Archipelago to Mauritius "as soon as possible." On May 22, 2019, the United Nations General Assembly voted in favor of the ICJ decision and demanded the British withdraw from the islands, return them to Mauritius, and allow Chagossians to resettle. The US responded that the UK and the US will continue to use the joint base until 2036. In 2020, the Chagossians filed for compensation via the US Foreign Claims Act, which awards compensation for injury, death, or property damage caused by US military personnel overseas. In 2021, the US State Department wrote that "the United States unequivocally supports UK sovereignty" over the islands (DeYoung).

Diego Garcia, however, is itself under pressure. Diego Garcia is an *atoll*, a low-lying coral island. Diego Garcia, like most atolls, is small, measuring 15 miles (24 km) in length and at most 7 miles (11 km) in width. Most atolls rest mere feet above sea level. Diego Garcia is no exception, sitting a scant 4 feet (1.21 m) above sea level and thus at severe risk of being submerged by rising sea levels.

Edouard J. Maunick

FROM **LES MANÈGES DE LA MER (TAMING THE SEA)**

0.

The earth is old from this history of the sea
The words the portraits always witness the same fate

but the poets have their apocrypha
books prohibited on fiery mornings
arsonists of the sea
they never consumed the memory
only at the beaches the resonances

Khal Torabully

LIKE SPUME, EACH BODY

Like spume, each body
wakes up on a wave.
One straw, two straws
four score sepoys
and for entrails
a coulis of blue men
paw through
stone-clotted field.
We are molasses, we are bagasse
my African brother descended from slaves
our skin is the trace
like yours, of the same dark race.
One straw, two straws
fourscore sepoys
for full-face deduction
devalued by French tarot
man tied to the tides
by the spar made of coconut wood
a flaw falters
a seedless man
destitute die-rolling race
hanged from pandanus trees,
in the name of a stunning sea,
in the name of the stunning sea

Note: Translated by Nancy Naomi Carlson. Translator's note: "Sepoy" is an Indian soldier who served under colonial rule.

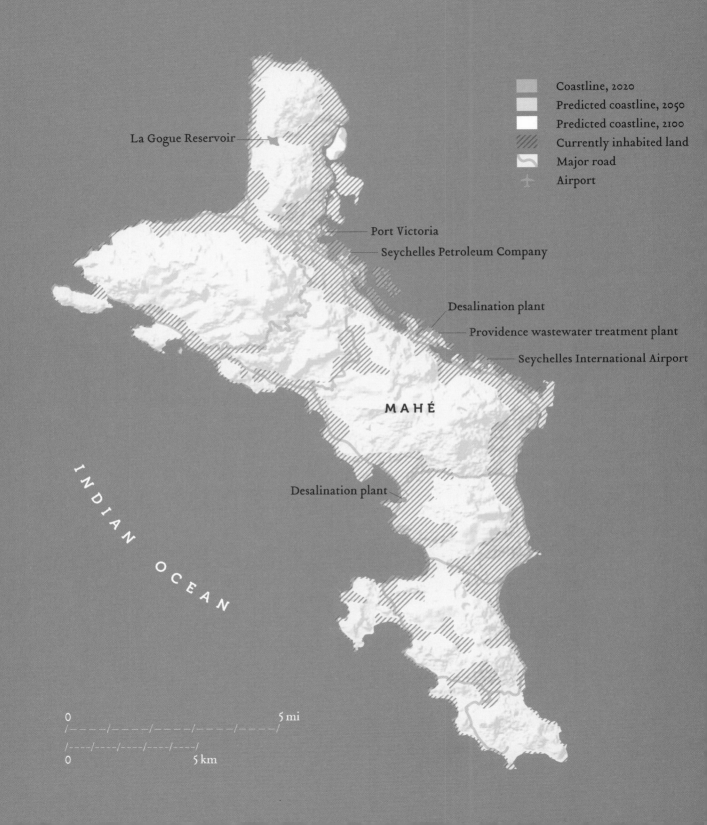

La Gogue Reservoir

Port Victoria

Seychelles Petroleum Company

Desalination plant

Providence wastewater treatment plant

Seychelles International Airport

MAHÉ

Desalination plant

INDIAN OCEAN

Coastline, 2020
Predicted coastline, 2050
Predicted coastline, 2100
Currently inhabited land
Major road
Airport

0 5 mi

0 5 km

La Repiblik Sesel
Republic of Seychelles

4.6796º S
55.4920º E

Archipelagic nation of 115 islands

176 sq. mi. (455 km²) | Mahé: 61 sq. mi. (157 km²)

Population: 97,017 (2022 est.) | Mahé: 72,762 (2022 est.)

93.2% Creole; Arab, French, Indian, Chinese

Languages: Creole, English, French

Mean Elevation: 13.1234 ft. (4 m)

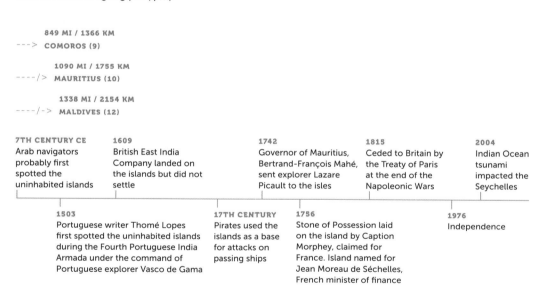

849 MI / 1366 KM
---> COMOROS (9)

1090 MI / 1755 KM
----/> MAURITIUS (10)

1338 MI / 2154 KM
----/-> MALDIVES (12)

7TH CENTURY CE
Arab navigators probably first spotted the uninhabited islands

1609
British East India Company landed on the islands but did not settle

1742
Governor of Mauritius, Bertrand-François Mahé, sent explorer Lazare Picault to the isles

1815
Ceded to Britain by the Treaty of Paris at the end of the Napoleonic Wars

2004
Indian Ocean tsunami impacted the Seychelles

1503
Portuguese writer Thomé Lopes first spotted the uninhabited islands during the Fourth Portuguese India Armada under the command of Portuguese explorer Vasco de Gama

17TH CENTURY
Pirates used the islands as a base for attacks on passing ships

1756
Stone of Possession laid on the island by Caption Morphey, claimed for France. Island named for Jean Moreau de Séchelles, French minister of finance

1976
Independence

Each one large and slow, the Aldabra giant tortoises and *coco de mer* can be found only in the Republic of Seychelles. The Aldabra giant tortoises are among the world's largest. They live in the Seychelles, on Aldabra Atoll. Mostly herbivores, they feed on grasses and leaves. They live to be two hundred years of age and can weigh up to 770 pounds. Once on the brink of extinction, an estimated one hundred thousand tortoises, most of the world's tortoises, now live on Aldabra. Aldabra is a natural preserve; almost half of the Seychelles have been set aside as natural preserves. Two related species live on other Seychelles islands. Aldabra is a *coralline island*, most of which, such as Aldabra, do not have freshwater supplies and are uninhabited.

Coco de mer are the Seychelles' national symbol. Double coconuts, two-lobed and grown together, they can weigh up to 50 pounds (23 kg). They grow on large, slow-growing trees. The nuts, too, are slow-growing, taking about ten years to ripen.

The islands are home to hundreds of plant species, eighty of which are unique to the Seychelles, as well as hundreds of species of mammals and birds and over nine hundred species of fish.

The Republic of Seychelles rests about 1000 miles (1600 km) to the east of the African continent and 700 miles (1100 km) to the northeast of Madagascar. It is Africa's smallest nation. Contrasts mark the islands: eighty-three are coralline and thirty-two are granitic. While the coralline islands will be intensely impacted due to their low height, the granitic islands, too, will be affected.

The main island, Mahé, is granitic and about 90 percent of the population lives here. *Granitic islands* are extensions or fragments of continents, thus also named *continental islands*. Typically closer to continents, they rest above sea level and rarely show signs of subsidence. (They contrast with *oceanic islands*, which rise from the ocean floor through volcanic action.) The granitic islands here are generally taller. The highest peak, on Mahé, towers at 2969 feet (905 m).

On Mahé most residents crowd around the flatter but narrow coastal perimeter. With a population around 94,000, the Seychelles is by far the least populated African nation. Despite the low population, the *population density* along the shoreline is high, with an estimated 1270 inhabitants per square mile (490 per km²).

Additionally, about 80 percent of the Seychelles' economic development centers on the coastal areas. The 1–3 feet (0.28–1.02 m) of sea level forecast by the century's end by the IPCC's Sixth Assessment Report of the UN would submerge 70 percent of the Seychelles. Much of Mahé's *infra-structure* is located along the coastline, including a desalination plant and a wastewater treatment plant, the island's roads and airport, and the Seychelles Petroleum Company's plant. Sea level rise will impact both the population and the infrastructure along the coastline.

The Seychelles lie outside the cyclone belt in the Indian Ocean, so severe storms here are rare. That said, high waves from the 2004 Indian Ocean tsunami waves hit the Seychelles. According to scientists, "damage to coastal infrastructure was most severe where coasts had been modified. Most damage was experienced at hotels and restaurants. . . . Dock structures were damaged in Port Victoria . . . and causeway bridges failed between Victoria and the airport" (Shaw et al.) The coauthored report states that there were "two deaths in the entire Seychelles Archipelago. Seychelles was spared a higher death toll because the first and largest tsunami waves occurred at low tide at a weekend, when the docks were inactive and schools were closed" (Shaw et al.).

Like with Mauritius (10), *geopolitical interests* compound the climate change impacts. During World War II, the Seychelles, like Mauritius and the Comoros (9), were used as military bases, to refuel airplanes and ships and to gather intelligence and conduct surveillance. Islands are also key nodes for underwater cables for communication (see Figure 2, p. 89).

These undersea cables come ashore on coastlines usually near cities. While the undersea cables are designed to be water resistant, the fiber optics near the shoreline are not. Sea level rise will inundate these hubs, affecting not only the coastline location but also the global communications network.

More recently, in 2018, in a sign of shifting geopolitical players, the Seychelles signed an agreement with India, allowing it to build an airport and naval base on Assumption Island, a small island in the Seychelles Outer Islands that lies to the north of Madagascar. India, China, and the US, among others, have competing interests in the region. In the 1960s, the US proposed building a base on Assumption Island just south of Aldabra and the UK considered building a base on Aldabra. The plans were rejected. Subsequently, the US built the base on Diego Garcia (see Mauritius (10)).

Assumption Island is a *coralline island*, measuring a mere 4.5 square miles (11.6 km²). It lacks freshwater, which drought will exacerbate. Additionally, Assumption Island is low-lying, which means sea level rise will impact it intensely. In these ways, while geopolitical interests affect the islands, they will be compounded by climate change.

Antoine Abel

YOUR COUNTRY

Your country
Is studded with mountains,
Seychelles lad.

With tough granite
With crude gravel
And with coral, your country.

Your country
Wears a belt
Of white beaches loosening in the tides.

FIGURE 2. Trevor Paglen, "NSA-Tapped Fiber Optic Cable Landing Site, New York City, New York, United States," 2015. C-print, mixed media on navigational chart.

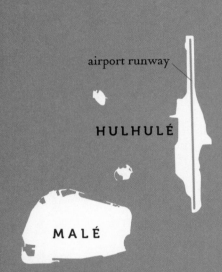

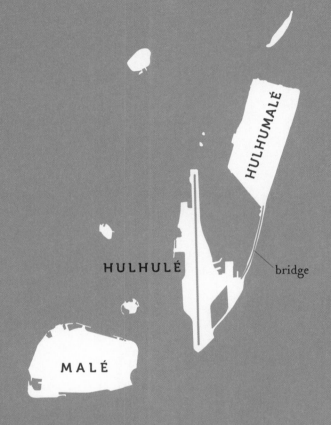

airport runway

HULHULÉ

MALÉ

0 1 mi
/— — — —/— — — —/
/----/----/
0 1 km

HULHUMALÉ

HULHULÉ

bridge

MALÉ

Laccadive Sea

M

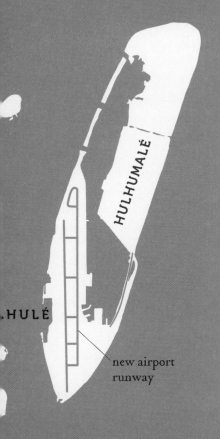

HULHUMALÉ

...HULÉ

new airport runway

Predicted sea level rise data does not yet exist for recently reclaimed artificial islands

Republic of Maldives

3.2028° N
73.2207° E

Archipelago of 1192 islands (200 inhabited) and 26 atolls
115 sq. mi. (298 km²) | Malé (city): 4 sq. mi. (9 km²)
Population: 390,164 (2022 est.) | Malé: 133,412 (2014 census)
Languages: Maldivian (Dhivehi), Arabic, Hindi, English
Mean Elevation : 4 ft. 9 in. (1.5 m)
Highest Elevation: 7 ft. 10 in. (2.4 m)

2294 MI / 3692 KM
----/----/-> **COMOROS (9)**

1879 MI / 3024 KM
----/---> **MAURITIUS (10)**

1328 MI / 2128 KM
----/-> **SEYCHELLES (11)**

500 BCE
Inhabited by Buddhists mostly from India and Sri Lanka

1153
Islam adopted

1558
Portuguese occupied Maldives

17TH CENTURY
Under the protection of the Dutch, which ruled Ceylon (Sri Lanka)

1887
Maldives became a British Protectorate

1968
New republic established

300 CE
Beginning the 2nd century CE, Arab navigators stopped through on voyages

1573
Portuguese expelled

1796
British drove out the Dutch and took possession of Ceylon (Sri Lanka) and the Maldives

1965
Independence from the UK

The City of Hope. If you were the world's lowest lying island and thus at high risk of sea level rise, taking action would be vital. The Republic of Maldives has responded by building an artificial island named "City of Hope" on Hulhumalé, a flat reef.

In the run-up to the 2009 United Nations climate change talks in Copenhagen, President Mohamed Nasheed (2008–2012) pulled a highly visual stunt to illustrate viscerally the forecast impact of sea level rise: he convened a televised cabinet meeting *underwater,* committing to cut greenhouse gas emissions and demanding other nations to do the same.

On average the Maldives rests a mere 4 feet (1.5 m) above sea level. Its highest natural point is only 7 feet 10 inches (2.4 m)—the lowest for any country. The nation's name means garland or necklace of islands and is believed to be derived either from Sanskrit or Sinhala. The atolls cluster mainly in two necklaces, one northern, one southern. Envision two necklaces, one above the other.

The archipelago's thousands of islands are coral *atolls*, created by volcanoes that have since eroded. The Maldives rest atop an underwater plateau, the Chagos-Laccadive Ridge, that stretches from the Chagos Islands (see Mauritius (10)) in the south to the Lakshadweep Islands in the north. The atolls encircle a lagoon; and reefs encircle the atolls and on them reef fish abound. Further out, sea turtles and pelagic fish are common as are many types of shark.

Spotted whale sharks with quarter-sized white spots on a dark grey background can be seen in the clear and temperate waters offshore between August and October. Sometimes referred to as gentle giants, they are the largest nonmammalian fish. The females grow to be 50 to 60 feet long; the males 20 to 30 feet long. Their heads are flat and wide with eyes at each side. Their mouths are at the front of their heads (unlike other sharks, which are at the bottom), which helps them to filter feed. Spotted whale sharks are deemed to be gentle because the risk of attack from them is low: they feed mainly on plankton.

Maldivians are of Arab, Indian, Indonesian, Malagasy, and Sri Lankan heritage. Islam is the official and majority religion. More than half the population is rural, living in villages spread out across thousands of atolls. Only twenty or so islands have a population over one thousand. Most practice subsistence fishing, not limited to but most abundant in tuna, and subsistence farming. Coconuts are gathered to make coir, a fiber derived from coconut husks, and used to make brushes, doormats, and floor mats as well as mattresses. The Maldives' territory is 99 percent water: it measures 34,749 sq. mi. (90,000 km²) of which only 115 sq. mi. (298 km²) is land. So boats are the main method of traveling between the islands and boatbuilding and repair are important industries.

Over 80 percent of its land area sits less than 3.2 feet (1 m) above sea level. As a result, the islands are very susceptible to sea level rise. In 1992 at the first UN climate summit also known as the Rio Earth Summit, President Maumoon Abdul Gayoom (1978–2008) called attention to the

risks when he said: "I stand before you as a representative of an endangered people. We are told that as a result of global warming and sea-level rise, my country, the Maldives, may sometime during the next century, disappear from the face of the Earth" (Hamilton). The statement stunned many, since it was well before most people had heard of climate change.

Gayoom sought to address sea level rise by building a multimillion-dollar seawall of *tetrapods* around the capital city and island Malé. Some take issue with building *seawalls*, viewing them as a stopgap measure, since sea levels will continue to rise. Seawalls are also very expensive.

The Maldives, alongside the Marshall Islands (20), Kiribati (21), and Tuvalu (27), is most at risk of being underwater by the century's end. Some even forecast the Maldives might be underwater by midcentury. Aware of the predictions, Nasheed stated that he would use funds from the country's tourism industry, which generates about 33 percent of the Maldives' GDP, to look into buying new land for *resettlement* of some of the population. Possible locations included Sri Lanka and India due to proximity and similarities in climate, culture, and cuisine. Australia was also considered. This proposal was shelved when the new administration came into office.

Instead, the Maldives turned to geoengineering, building Hulhumalé. It rests about 5 miles (8 km) northeast of Malé. Malé houses about a third of the nation's residents and is one of the world's most densely populated islands. To address both sea level rise and population density, the Maldives, like Bahrain (8) and Singapore (14), has been engaging in *land reclamation* or infill. Dredging sand and layering it, Hulhumalé now sits 6.5 feet (2 m) above sea level. Construction of this *artificial island* began in 2004. According to a 2018 article in *Nature Climate Change*, "island construction is, for densely populated atoll nations, a relatively low-cost option because the reef-flats that need to be filled with sand are shallow (1–2 m in the case of Hulhumalé), which minimizes sand requirements. The costs of reclaiming Hulhumalé were about US$30 per m²" (Hinkel). By 2019 an estimated 50,000 people had moved to the new island. The goal is to move 240,000 people to Hulhumalé by the mid-2020s.

THE FORMATION OF
BHASAN CHAR

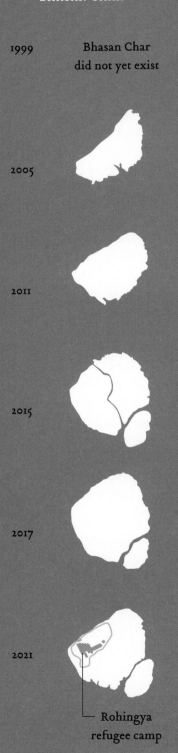

1999 — Bhasan Char did not yet exist

2005

2011

2015

2017

2021

└─ Rohingya refugee camp

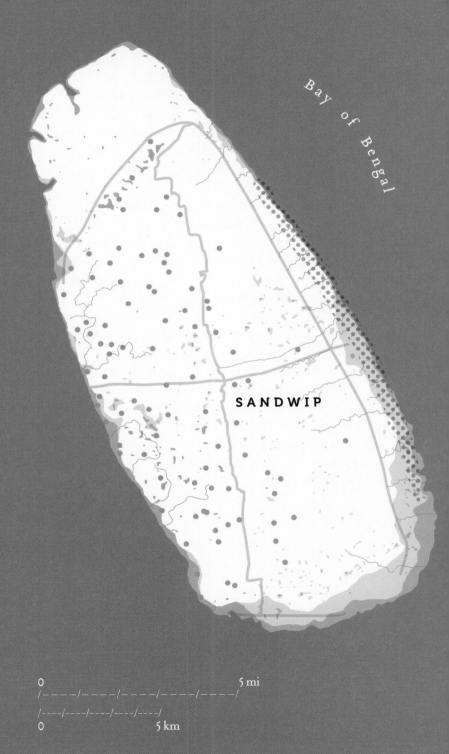

Bay of Bengal

SANDWIP

0 — 5 mi

0 — 5 km

INDIA

BANGLADESH

BHASAN CHAR
SANDWIP

Bhasan Char and Sandwip

22.4937º N
91.5015º E

294.4 sq. mi. (762.492 km²)

Population: 350,000 (2011 census)

98% Bengali

Language: Bengali

Mean Elevation: 6.56 ft. (2 m)

1808 MI / 2911 KM
----/---> MALDIVES (12)

5370 MI / 8643 KM
----/----/----/----/----/-> MARSHALL ISLANDS (20)

6926 MI / 11,147 KM
----/----/----/----/----/----/---> KIRIBATI (21)

9TH CENTURY BCE Mentioned in the Hindu epic Mahabharata	**1202– 1707 CE** Ruled by Muslims: 1576–1707, part of the Mughal Empire	**1858–1947** Part of Indian Empire under British rule	**1947–1955** Part of East Bengal		**1991** Cyclone struck, killing 140,000	**2016** Three cyclones hit the Bay of Bengal
332–304 Reign of Buddhist emperor Ashoka; Buddhism thrived in the region until the 12th century, when Hindu armies came to rule	**1757–1858** Part of British East India Company	**1905–1911** Part of Eastern Bengal and Assam, regions of the Indian Empire	**1955– 1971** Part of East Pakistan	**1970** Cyclone Bhola hit, killing 300,000– 500,000 **1971** War of Liberation; Bangladesh established	**2019** Cyclone Fani struck, killing 89 **2020** Cyclone Amphan hit the Bay of Bengal, causing an estimated $130 million in damage, killing 29 in Bangladesh and 1 on Sandwip	

Coastline, 2020

Predicted coastline, 2050

Predicted coastline, 2100

Mangrove forest

Primary school

Major road

Current river

Located only 18.6 miles (30 km) from the mainland of Bangladesh, the island of Bhasan Char has been selected to house up to one hundred thousand Rohingya refugees. The move poses serious concerns, both with regard to the environment and human rights.

Bhasan Char rests at the confluence of three large rivers—the Brahmaputra, the Ganges, and the Meghna Rivers. Together they form the Ganges Delta, the largest delta in the world. Collectively they bring rich deposits of silt to the bay. The island formed over the past twenty years as a result of silt buildup. It is low-lying, prone to flooding, and thus has been uninhabited.

Sitting in the Bay of Bengal, Bhasan Char is also subject to frequent *cyclones*, which are at risk of intensifying as they circle in the Bay's funnel shape. On average, three to four storms form in the basin, and Bhasan Char lies in the historical path of cyclones. In 2020, Cyclone Amphan, a Category 5 storm and one of the strongest on record, formed in the Bay of Bengal. It caused $130 million in damage. Such super cyclones are more likely in the future.

In 2020, Bangladesh began relocating Rohingya refugees from a camp in the coastal city Cox's Bazaar to Bhasan Char. The UN has expressed concerns about whether the refugees are moving voluntarily and whether they have access to services, such as "education, healthcare and livelihood opportunities" (UN Human Rights, Office of the High Commissioner). (For refugee internment on islands, see also Nauru (22).)

The nearby island of Sandwip, located about 6 miles (10 km) northeast of Bhasan Char, sits in the northern Bay of Bengal in the Meghna River estuary. Silt deposits flow down the river making the estuary very fertile. The island's residents are day laborers, fishers, and subsistence farmers. The farmers cultivate rice in marshes and grow brinjal (eggplant), carrots, cauliflower, sweet potatoes, and betel leaf and nut. The fruit grown includes bananas, dates, guavas, jackfruits, jujubes, mangos, papayas, and watermelon. Jute is also cultivated. It is a coarse fiber that can be spun into strong threads to use as twine or to make fabrics such as burlap to create sacks.

Sandwip is a shapeshifter, shrinking due to *erosion* or gaining soil through sedimentation. At the time of writing, it measures a mere 25–31 miles (40–50 km) in length and 3–9 miles (5–15 km) in width.

Sandwip's mean elevation of 6.56 feet (2 m) and location in the Bay of Bengal means it is particularly exposed to cyclones during the region's storm season. "Over the last 100 years, 508 cyclones of varying intensity have originated in the Bay of Bengal," Sanjay Chaturvedi and Vijay Sakhuja write, continuing: "Nearly 17 per cent [*sic*] of these hit Bangladesh, averaging a severe cyclone almost one every three years."

The most severe cyclones struck the Bay in 1970 and 1991. In 1970, Cyclone Bhola killed 300,000 to 500,000 people in Pakistan and Bangladesh, making it the deadliest cyclone on record. In 1991, a

cyclone hit Bangladesh killing an estimated 140,000. Due in part to early warning systems, evacuations, and shelters implemented in response to the 1991 cyclone, the death toll of Cyclone Amphan was much lower at 128.

Cyclones have not only become more intense but also more frequent. Since 2006, the Bay of Bengal has experienced severe to very severe cyclonic storms or cyclones every single year. In 2016, three cyclones struck the region. In 2019, Cyclones Bulbul and Fani hit the Bay of Bengal.

Storm surge is often the most deadly part of a tropical cyclone. It can measure up to 20 feet (6 m) in height and push water onto the shore at this height. An already elevated base water level, for example, due to sea level rise, means that storm surge reaches further inland. Chaturvedi and Sakhuja write that "the cyclones can reach as far as 200 kilometres [124 miles] inland." The single death on Sandwip during Cyclone Amphan was due to storm surge.

STORM SURGE

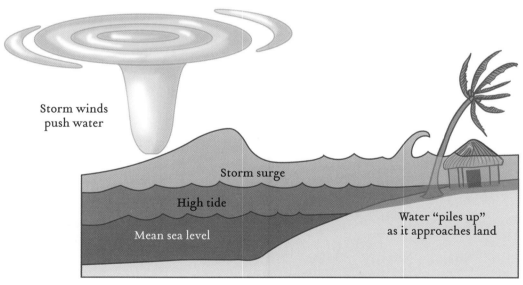

Storm winds push water

Storm surge

High tide

Mean sea level

Water "piles up" as it approaches land

Storm surge can measure up to 20 feet (6 m) in height and push water onto the shore at this height. An already elevated water base, due to sea level rise, means that storm surge will reach further inland and reach higher elevations.

SANDWIP, INDIAN OCEAN

Mangrove forests flank the eastern edge, protecting the shoreline from sea level rise. Primary schools exist across the island but are more densely distributed on the island's western half. Schools along the coastline may be impacted by sea level rise.

Bangladesh is known as being home to the Sundarbans, the world's largest mangrove forest. It stretches to reach about 50 miles (80 km) inland. Twenty-six of fifty-four species of mangrove worldwide exist here. Royal Bengal tigers live among the mangroves. Even inland, Bangladesh is watery. It features seven hundred rivers and about 500 miles (800 km) of navigable waterways, more than any other country. Nouka, wooden boats, are used to navigate the rivers.

The Bay of Bengal features not only natural islands, such as Sandwip, but also *polders*, artificial islands "reclaimed" from the Bay. The word is borrowed from the Dutch and means "boggy or marshy soil." The Netherlands, which, as the name suggests, has a very low-lying geography, resting at best just feet or meters above sea level, pioneered the technique. Since the 1960s, about 140 polders have been built in Bangladesh. Their structures vary. Typically, dikes or higher mounds along the outer edges protect the polders. Together with mangroves that have been planted along the shoreline, the polders create both more living space and, like *barrier islands*, buffer the land behind them.

But the sea level rise and increased cyclones means that the polders that were once a buffer are now also suffering impacts. As *Science Magazine* reported, "episodes of extremely high water driven by storms and tides, which today occur once a decade, will probably happen three to 15 times every year at the end of the century" (Cornwall). While the walls that line the polders' perimeter attempt to provide protection, they are highly at risk of flooding.

Republic of Singapore

1 main island and 60 islets

279 sq. mi. (723 km²) | Pulau Ujong (Singapore Island): 261 sq. mi. (697 km²)

Population: 5,921,231 (2022 est.)

74.3% Chinese, 13.4% Malay (includes Indonesians), 9% Indian (includes Pakistani, Bangladeshi, Sri Lankan), 3.2% others

Languages: English, Mandarin Chinese, Malay, Tamil

Mean Elevation: 49 ft. (15 m) | Highest Elevation: 531 ft. (162 m)

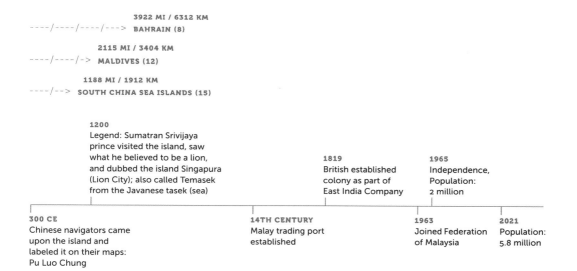

3922 MI / 6312 KM
----/----/----/---> **BAHRAIN (8)**

2115 MI / 3404 KM
----/----/-> **MALDIVES (12)**

1188 MI / 1912 KM
----/--> **SOUTH CHINA SEA ISLANDS (15)**

1200
Legend: Sumatran Srivijaya prince visited the island, saw what he believed to be a lion, and dubbed the island Singapura (Lion City); also called Temasek from the Javanese tasek (sea)

1819
British established colony as part of East India Company

1965
Independence, Population: 2 million

300 CE
Chinese navigators came upon the island and labeled it on their maps: Pu Luo Chung

14TH CENTURY
Malay trading port established

1963
Joined Federation of Malaysia

2021
Population: 5.8 million

Along the northwest coast of the Lion City, Singapura, the Republic of Singapore, some mangrove forests remain, lining estuaries. Native animals, such as the long-tailed macaque, the scaly anteater, and the slow loris (a nocturnal lemur), inhabit these trees. The slow loris—with its perked-up ears and large round eyes, curious stare, and coloration patterns of a triangle above the eyes to suggest raised eyebrows—looks constantly surprised, caught in the act, or fearful. It is a distant relative of the lemurs of Madagascar. As their name suggests, they move slowly through vegetation and usually at night. Their eyes have a reflective layer allowing them to see better in the dark, when they forage for fruit, gums, and insects. In neighboring Indonesia, they are called malu malu, the shy one, because, when spotted, they stop and cover their face with their front paws.

Mangrove forests and endemic wildlife might not be the first thing that comes to mind when one thinks of Singapore, which typically conjures up modern architecture and skyscrapers. Singapore sits just south of Malaysia and north of the Singapore Strait, which connects the Indian Ocean and the South China Sea. The republic consists of the main island, Pulau Ujong (Singapore Island), and sixty islets. Pulau Ujong constitutes 261 square miles (697 km²) of the republic's 279 square miles (723 km²). It is connected to Malaysia on the continent by bridges.

Singapore's population is of diverse heritages, mostly Chinese, Indian, Malay, or a combination, and Singapore recognizes four official languages: English, Tamil, Mandarin Chinese, and Malay. During Singapore's administration as part of the British East India Company, Sir Stamford Raffles drew up a plan in 1822 for the city, dividing its population along ethnic, linguistic, and religious lines.

Measured by both GDP per capita and the Human Development Index, Singapore is one of the world's most prosperous countries, ranking in the top ten for each one. Unemployment is low. Singapore is a key financial, technology, and transportation hub in the region. And export, transportation, business, and financial services form key motors of the economy.

Singapore's location is important: it sits at the southern tip of the Malay Peninsula, right at the entranceway of the narrow Strait of Malacca. The strait is named after the Malacca Sultanate (1400–1511) that once straddled both sides of the strait, including modern-day Indonesia, Malaysia, and Singapore, then called Temasek from the Javanese *tasek,* meaning "sea." The Strait of Malacca connects the Bay of Bengal (13) with the South China Sea (15), or, zooming out, the Indian Ocean with the Pacific Ocean. By some estimates it is the world's busiest strait. Zooming out further, it connects the Persian Gulf with China. An estimated twelve million barrels of oil pass through the Strait of Malacca every day en route to China.

The island's geology and geography varies widely. The central region is hilly with craggy granite rocks. Here, the island's highest point, Bukit Timah Hill, peaks at 531 feet (162 m). The Bukit Timah Hill and Central Catchment Reserve are located near the geographic center of Singapore.

In the 1970s, the international airport was moved from a more central location to the lower eastern part of the island. It consists of sand and gravel, forming a low plateau prone to *erosion*. Land was reclaimed and new runways were built. Planes now land on what was once water.

The island's south and west consist of sedimentary rocks that form lower scarps. Traditionally, Malay kampong (village) houses were built on the island. These wood houses rested on stilts. The approach to them was often from the water and via boat. Beginning in the 1970s, these houses were razed to make way for the skyscrapers that dominate Singapore today.

The island is generally low-lying, resting less than 50 feet (15 m) above sea level. More than 30 percent of the island lies less than 16.4 feet (5 m) above sea level. If high tide and storm surge occur at the same time, sea levels could rise over 13 feet (4 m) and inundate the island's low-lying regions.

Singapore ranks second globally for *population density*. In 2018, there were 20,113 people per square mile (7774 per km²). One hundred percent of its population is urban. The population is most dense along the southern shore, where the city of Singapore is located, and in the central region.

Currently, Singapore is considering both hard engineering, such as reclaiming land off the east coast to address population density, as well as soft engineering, such as restoring coastal *mangroves* and *wetlands* to create a buffer against sea level rise.

Land reclamation has removed original islets and created new *artificial islands*.

Singapore artist and former Olympic sailor Charles Lim puts the term "reclamation" into question, stating that "terra-forming" might be more appropriate, since the land is not being reclaimed. Instead, he argues, it is a sea state: the area where land is being created consists of water. His nine-part video installation *SEA STATE* (2005–2015), which represented Singapore at the 56th Venice Biennale in 2015, tracks how sand is imported to create the land.

Between the 1960s and 2018, Singapore grew about 23 percent as a result of land reclamation. By 2030, it is projected to grow to 300 square miles (766 km²).

Less than 5 percent of Singapore's original forests remain. They lie in the central Timah Nature Reserve and in the Sungei Buloh Wetland Reserve in the northwest of Singapore. Parts of Timah Nature Reserve's tropical rainforest predate British colonization in 1819.

Pulau Tekong, which lies northeast of the main island, is home to the one of the largest remaining mangrove forests in the islands. Pulau Tekong is used by Singapore's military and thus off-limits to visitors. That did not prevent three Indian elephants from swimming across the Straits of Johor in 1990 for a visit. They were eventually captured with the assistance of two trained elephants and returned across the strait to Johor at the southern tip of Malaysia. Pulau Tekong is also where the slow loris resides.

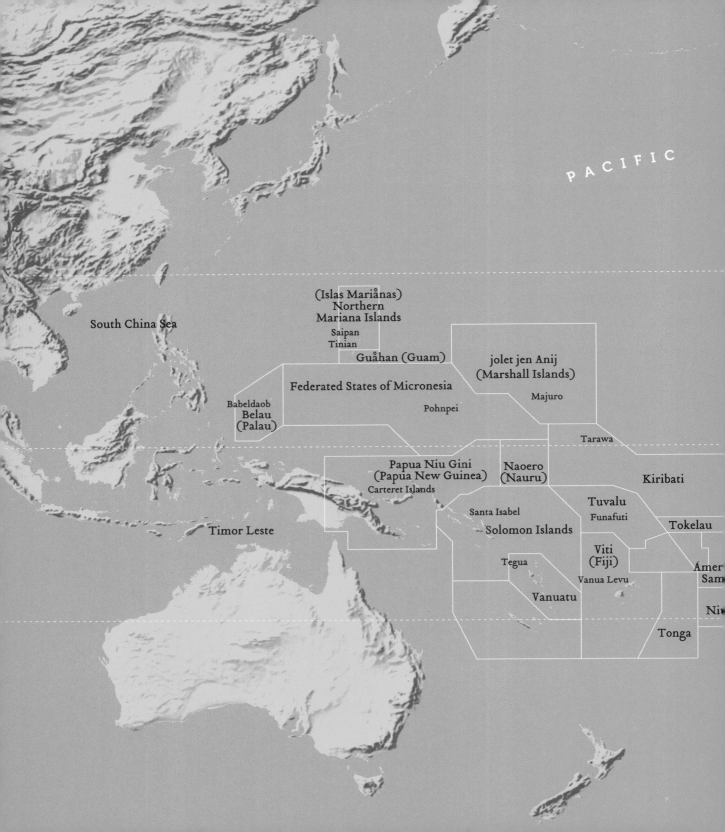

PACIFIC

South China Sea

(Islas Mariånas)
Northern
Mariana Islands
Saipan
Tinian
Guåhan (Guam)

jolet jen Anij
(Marshall Islands)

Federated States of Micronesia
Majuro

Babeldaob
Belau
(Palau)

Pohnpei

Tarawa

Papua Niu Gini
(Papua New Guinea)
Carteret Islands

Naoero
(Nauru)

Kiribati

Tuvalu
Funafuti

Santa Isabel

Tokelau

Solomon Islands

Timor Leste

Viti
(Fiji)

Tegua

Vanua Levu

Amer
Sam

Vanuatu

Tonga

Niu

O C E A N

Tropic of Cancer

Equator

Tropic of Capricorn

ook
nds

South China Sea Islands

15.4881° N
114.4048° E

1,423,000 sq. mi. (3,685,000 km²)
Uninhabited

4148 MI / 6676 KM
----/----/----/----/> BAHRAIN (8)

2768 MI / 4455 KM
----/----/---> MALDIVES (12)

1214 MI / 1953 KM
----/--/--> SINGAPORE (14)

15TH CENTURY CE
China explored and
mapped the region

1939–1945
Japan occupied
during World War II

19TH CENTURY
France occupied the region
as part of Indo-China

1949
China claimed
the islands

The Mischief Islands are among many islands in the South China Sea; their name bespeaks the vexed territorial claims on the region. The Mischief Islands, reefs in the Spratly Islands, are claimed by both the Philippines and China.

The South China Sea rests between the Indian and Pacific Oceans and spans 1,423,000 square miles (3,685,000 km²). Vietnam lies to the west and the Philippines to the east, China to the north and Borneo to the south. The seafloor beneath the South China Sea is believed to contain minerals, natural gas, and oil deposits. Due to the sea's location, islands in it play a key role in the region's geopolitical interests and due to these resources are hotly contested.

The United Nations Convention on the Law of the Sea, signed in 1982 and in effect since 1994, states that an *Exclusive Economic Zone* (EEZ) can be established extending 200 nautical miles (370 km) from a country's coastline. According to the Law of the Sea, countries can fish, extract resources from the seabed, and construct artificial islands in the EEZ. Hence the land disputes. China has constructed seven *artificial islands* in the South China Seas.

Over 250 islands, _atolls_, _coral reefs_, _shoals_, and sandbars are located here. The region's islands are coral and low-lying and uninhabited by humans. Undisputed islands rest off the eastern coast of Vietnam, on the southern coast of China, in the Taiwan Strait off the western coast of the Philippines, and in the waters near Borneo and Indonesia.

Disputed are the Paracel Islands, the Spratly Islands, and Pratas Island. The Paracel Islands lie in the north. They consist of about 130 small coral islands and reefs just 250 miles (400 km) east of Vietnam and 220 miles (350 km) southeast of China. The islands total 3 square miles (7.75 km²); none measures larger than 1 square mile (2.5 km²). They all lack freshwater.

The Spratly Islands consist of more than one hundred islets and reefs spread out over 158,000 square miles (409,000 km²). There are twelve main islands, but collectively they total less than 1.93 square miles (5 km²). Many are submerged. No humans inhabit them. Sea turtles and seabirds do.

The Paracel and the Spratly Islands are among the world's ten smallest islands and disputed among China, Taiwan, and Vietnam. Malaysia and the Philippines also claim portions. Pratas Island is occupied by China.

Additionally, Macclesfield Bank and Scarborough Shoal lie in the region, both disputed among China, Taiwan, and the Philippines. Both are sandbanks. Macclesfield Bank has no land above sea level. Scarborough Shoal has only rocks above sea level.

Islands in the region are simultaneously disappearing, due to their shapeshifting consistency, and appearing, as they are being built through _land reclamation_.

The legendary explorer, admiral, and eunuch Zheng He passed through the South China Sea and the Straits of Malacca (14) on his expeditions en route to Southeast Asia, India, the Arabian Peninsula, and East Africa. Born into a Muslim family, Zheng led seven voyages between 1405 and 1433 during the early Ming dynasty. The first voyage consisted of sixty _baoshan_ (treasure ships), which were about 540 feet (164 m) long. It makes them the era's biggest wooden ships built: double the size of European-produced ships and five times the length of Columbus's _Santa Maria_. Not only was the size of Zheng's fleet novel, the routes he used were previously unknown. He used a magnetic compass, which had been invented by the Chinese.

Zheng's expeditions also contributed to Chinese cartography. Zheng's Navigation Map, also referred to as the Mao Kun map, was a set of navigation charts published in 1628 based on documents from his expeditions. The charts show coastlines and islands between China's east coast and Africa's west coast, including Singapore (14), the Bay of Bengal (13), and the Maldives (12). Zheng's Navigation Map also includes the Paracel Islands, Macclesfield Bank, or Spratly Islands.

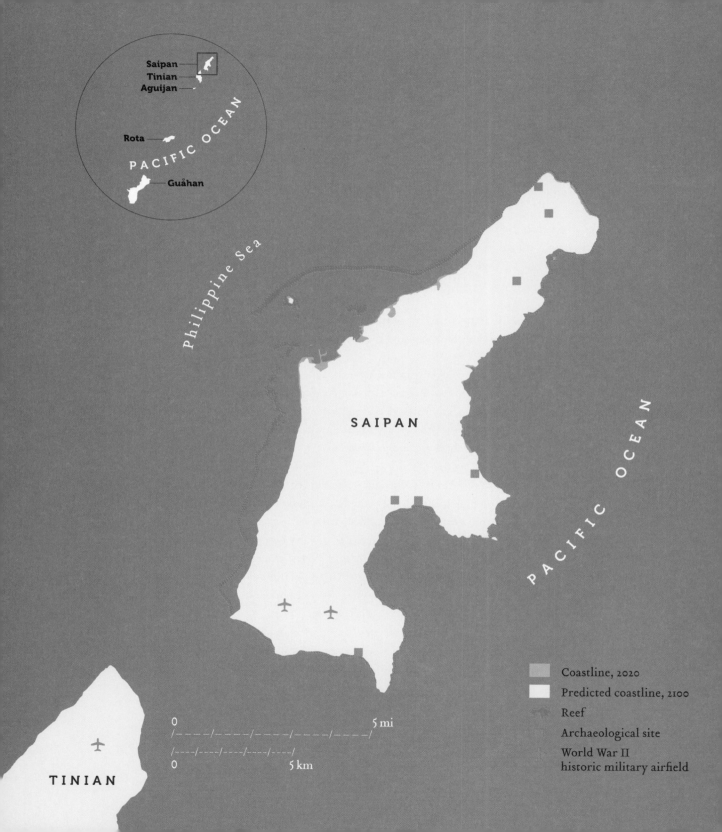

Saipan
Tinian
Aguijan

Rota

PACIFIC OCEAN

Guåhan

Philippine Sea

SAIPAN

PACIFIC OCEAN

TINIAN

	Coastline, 2020
	Predicted coastline, 2100
	Reef
	Archaeological site
	World War II historic military airfield

0 5 mi

0 5 km

Sankattan Siha Na Islas Mariånas

Commonwealth of Northern Mariana Islands

15.0979° N
145.6739° E

Archipelagic nation of 14 islands

179 sq. mi. (464 km²) | Saipan: 45 sq. mi. (115 km²)

Population: 51,475 (2022 est.) | Saipan: 1028 (2010 census)

35% Filipino, 24% CHamoru, 13% multiracial

Languages: CHamoru, Carolinian, English, Filipino, Chinese

Highest Elevation: 3166 ft. (965 m)

149 MI / 219 KM
-> GUÁHAN (17)

1809 MI / 2911 KM
----/---> MARSHALL ISLANDS (20)

915 MI / 1472 KM
----> BELAU (18)

2000 BCE	800 CE	1667	1672–1698	1899	1919–1947	1978
Austronesians arrived on the islands	Latte stones dating back to this era have been found on Saipan, Tinian, Aguijan, and Rota	Spain established colony named Las Marianas	Spanish-Chamorro Wars	Spain sold the islands to Germany	Controlled by Japan	Commonwealth of the US

1668–1500 BCE	1521	1668–1898	1898	1919	1947–1978
Precolonial Chamorro era	Ferdinand Magellan landed on the islands, leading a Spanish expedition	Spanish colonial rule	Spanish-American War	Germany lost the islands, Versailles Treaty	US controlled as part of the Trust Territory of Pacific Islands

The history of navigation begins in the Pacific. Austronesians navigated long distances over open waters without compasses or sextants, arriving on the Marianas up to four thousand years ago. It makes the archipelago home to one of the Pacific's oldest civilizations. Prehistoric red-slipped pottery dating back to 1500–1400 BCE has been found on the islands as have latte stones dating back to 800 CE. The legacy of voyaging continued as Indigenous Chamorros (descended from the Austronesians) designed the *sakman*, single outrigger boats, that flew across the open waters.

Stretching like a crescent across a 466-mile (750 km) span north of the equator in the western Pacific Ocean, the Mariana Archipelago sits amid the Philippines to the west, Japan to the north, the Federated States of Micronesia to the south, and the wide open Pacific to the east.

Geologically, the Northern Mariana Islands and Guåhan to the south constitute the Mariana Archipelago. The Commonwealth of Northern Mariana Islands consists of fourteen islands. The ten northern islands are volcanic and uninhabited. The four southern islands—Saipan, Tinian, Aguijan, and Rota—consist of limestone.

The Mariana Trench—the tallest mountain range submerged in the Pacific Ocean, towering up to 2700 feet (820 m) in height but deep underwater—spoons the eastern edge of the Northern Mariana Islands. At the trench's southern point rests the Pacific's deepest point, the Challenger Deep in the Federated States of Micronesia (19).

Politically, due to colonization, the islands in the Mariana Archipelago are separate entities with differing statuses. Present-day Northern Mariana Islands are a *commonwealth* and Guåhan is an unincorporated *territory* of the US. They were initially rent asunder in 1898 when, at the end of the Spanish-American War, Spain sold the Northern Mariana Islands to Germany and ceded Guåhan—along with Puerto Rico (42), Cuba (46), and the Philippines—to the US.

After the Spanish colonized, they forcibly moved many Chamorros to Rota and Guåhan. Interisland navigation via *sakman* was prohibited. And in schools the Spanish colonizers set up, the Chamorro language was not taught; Spanish was. Later, during the Japanese occupation of World War II, Japanese was taught. Since World War II, English has been taught.

Tinian, in the south and measuring just 39 square miles (101 km²), was used as a military base during World War II, first by the Japanese and then the US, when the *Enola Gay* and *Bockscar* departed from the island to drop nuclear bombs on Hiroshima and Nagasaki. Given the Northern Marianas' location, they are key to *geopolitical interests*.

In the summer of 2019 protests erupted on Tinian against the US Navy's implementation of bombing ranges and its effects on the landscape, on reefs, on fishing, and on historical sites. Northern Mariana also questioned the very presence of the US military on the islands. One protestor stated, "this isn't your island."

As Chris Gelardi and Sophia Perez write: "The military has tried to downplay the destructive aspects of its plan. . . . But residents aren't having it. Even though they're a small, low-income community facing down the world's largest military; even though their only elected representative has no voting rights in the House of Representatives; even though most mainland Americans don't know their islands exist, much less that they're part of the United States—they're holding their own in the fight to protect their home."

The military is not the only concern: the Northern Mariana Islands are extremely exposed to *typhoons*. They rest in the Typhoon Alley, the most active storm region in the western Pacific. According to the IPCC's Fifth Assessment Report (2014), the Northern Mariana Islands lost 59.4 percent of its GDP due to storms between 1998 and 2009, and 58.2 percent of the Northern Mariana Island's population is exposed to storms, ranking the island first for the Asia Pacific region for both categories.

Saipan, 5 miles (9.3 km) northeast of Tinian, is the Northern Marianas' largest island. It measures 45 square miles (115 km²) and is home to 90 percent of the Northern Marianas' population. *Coral reefs* run alongside the coasts. On the west coast the Lighthouse Reef Trochus Reserve, the Mañagaha Marine Conservation Area, the Puetton Tanapag (Tanapag Harbor), and the Saipan Lagoon lie between the barrier reef and the coastline.

Located in this lagoon rests Mañagaha, a sand island surrounded by coral reef. Mañagaha is the burial site of Carolinian Chief Aghurubw, who resettled in Saipan with his people after his home island of Satawal, now part of the Federated States of Micronesia (19), was destroyed by a typhoon in 1815.

The reefs on the west coast have long protected the shoreline and Garapan, the largest village on the islands. Despite the protective reef, Saipan's western coast will be most impacted by sea level rise, especially near Garapan.

Stronger storms are forecast for the region. In 2018, Typhoon Yutu, a Category 5 typhoon, hit Saipan and Tinian. It is the most powerful typhoon to hit the Northern Mariana Islands, the most powerful typhoon to hit the US territories, and the most powerful typhoon of 2018. It destroyed the airport on Saipan, electric and communications infrastructure, and three thousand homes. Just a month earlier, Typhoon Mangkhut had struck Guåhan. The year 2018 was one of the most active storm seasons in the Pacific and in the Atlantic, which is an anomaly: usually the storm season is active in one location or the other.

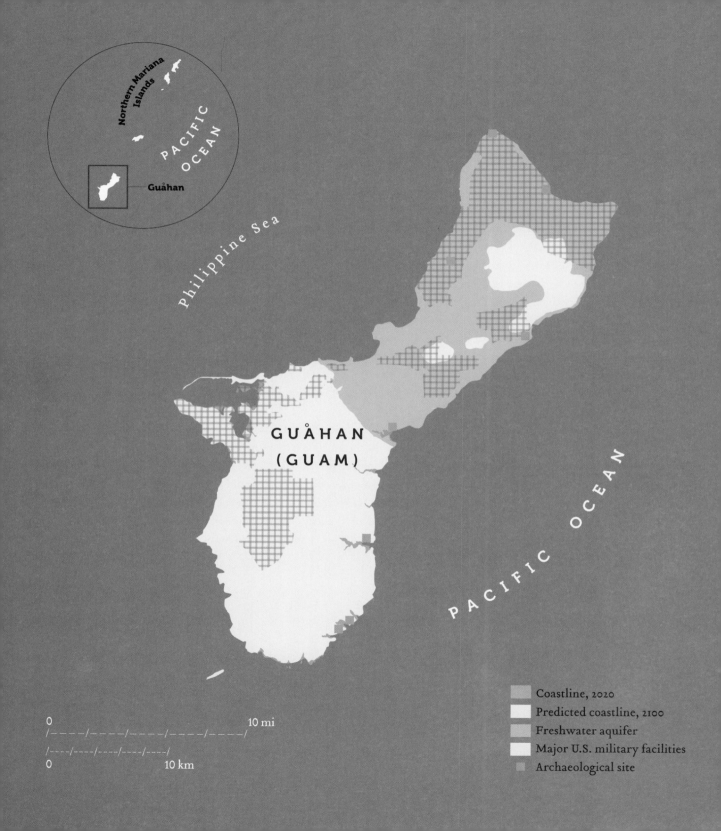

Northern Mariana
Islands

PACIFIC
OCEAN

Guåhan

Philippine Sea

GUÅHAN
(GUAM)

PACIFIC OCEAN

0 10 mi

0 10 km

Coastline, 2020
Predicted coastline, 2100
Freshwater aquifer
Major U.S. military facilities
Archaeological site

Guåhan

Guam

13.4443° N
144.7937° E

210 sq. mi. (540 km²)

Population: 169,086 (2022 est.)

37% CHamoru, 26% Filipino, 9% multiracial

Languages: CHamoru, English

Highest Elevation: 1334 ft. (407 m)

149 MI / 219 KM
-> **NORTHERN MARIANA ISLANDS (16)**

570 MI / 918 KM
----> **FEDERATED STATES OF MICRONESIA (19)**

3389 MI / 5454 KM
----/----/----/-> **KIRIBATI (21)**

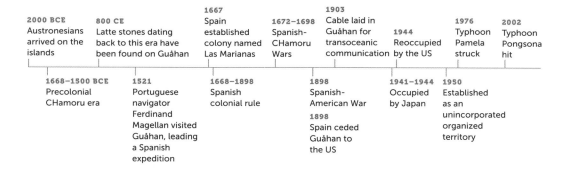

2000 BCE	800 CE	1667	1672–1698	1903	1944	1976	2002
Austronesians arrived on the islands	Latte stones dating back to this era have been found on Guåhan	Spain established colony named Las Marianas	Spanish-CHamoru Wars	Cable laid in Guåhan for transoceanic communication	Reoccupied by the US	Typhoon Pamela struck	Typhoon Pongsona hit

1668–1500 BCE	1521	1668–1898	1898	1941–1944	1950
Precolonial CHamoru era	Portuguese navigator Ferdinand Magellan visited Guåhan, leading a Spanish expedition	Spanish colonial rule	Spanish-American War / 1898 Spain ceded Guåhan to the US	Occupied by Japan	Established as an unincorporated organized territory

Guåhan (Guam), along with the Northern Mariana Islands (16), is home to one of the oldest civilizations in the Pacific: Austronesian voyagers from insular Southeast Asia settled the islands up to four thousand years ago. Guåhan's Indigenous CHamoru navigated the great Pacific Ocean in boats known as flying *proa*. "Flying" because of their remarkable speed attributable to three innovations. First, proas typically have two hulls of differing lengths: the waka or main hull is curved and kept windward (upwind or the direction from which the wind is blowing); the other hull is straight and kept leeward (downwind). This asymmetrical shape allows proas to counter the drag

111

of the outrigger that runs alongside the boat. Second, to make up for the fact that one side of the boat always has to be windward, the boat shunts to tack, a process also used by druas in Fiji (26). Third, proas have crab-claw sails, triangular sails with the narrowest point at the bottom and widening upward, where they can catch stronger winds. When shunting, crab-claw sails can be moved from one end of the boat to the other.

Guåhan is the southernmost island of the Mariana Archipelago, which rests in the western Pacific Ocean, north of the equator. It shares a geology, history, and culture with the Northern Mariana Islands (16). At 210 square miles, Guåhan is the largest island in the region.

CHamoru society was matrilineal, as were those of other Micronesian islands. CHamorus built latte houses—one-story houses that rested atop latte stones. Latte houses are among the island's important archaeological sites.

Along the northwestern coast of Guåhan is an area known as Ritidian (Litekyan in CHamoru). According to Dominica Tolentino, it means "'a stirring place,' presumably because of the rough ocean current there" (*Guampedia*). "Ancient fishing camps, dating over 3000 years ago have been uncovered in recent archaeological investigations. Along the edge of the steep limestone cliffs between twenty-five and fifty feet high," Tolentino continues, "are . . . caves that contain ancient CHamoru cave drawings . . . painted in limestone, charcoal and red clay." The drawings depict an ancient star calendar and constellations, including Orion, Cassiopeia, and the Southern Cross. "Although it is not known how the ancient Chamoru would have developed their knowledge of astronomy, an extensive knowledge of stars was essential for seafaring and navigation over long ocean voyages."

Then, Guåhan was occupied successively by Spain, Japan, and the US.

In a speech CHamoru Chief Hurao stated: "The Spaniards would have done better to remain in their own country. We have no need of their help to live happily. Satisfied with what our islands furnish us, we desire nothing." He was shot in the back in 1672 at a meeting to negotiate peace. Instead of peace, in 1672 the Spanish-CHamoru War started and lasted until 1684, with some uprisings taking place in 1695 and flare-ups continuing until 1698.

In *From Unincorporated Territory [hacha],* CHamoru poet and literary scholar Craig Santos Perez cites Robert F. Rogers, who writes in *Destiny's Landfall: A History of Guam*: "When the Spaniards were subjugating the Marianas, they compelled all Chamorros to live on Guam and Rota. Interisland trips, or even sailing beyond the reef, were prohibited without permission of Spanish authorities. As a consequence the original Chamorro flying proa disappeared by the 1780s. . . . The Chamorros

themselves were by then no longer a people of the open sea, only beach-bound throwers of *talaya* cast nets to catch tiny reef fish or leisurely gatherers of nonpelagic fish with various seine nets."

Each occupying force taught its language, leaving the Indigenous CHamoru language to appear as what Perez refers to as "the contours of a drowned / language." Glimmers of it haunt and reappear throughout his poetry, naming the land, the sea, roots, plants, and more.

"'Redúccion,'" Perez writes, "is the term the Spanish used to name their efforts of subduing, converting and gathering natives through the establishment of missions and the stationing of soldiers to protect these missions" (10-11). He offers his poems as "a strategic position for 'Guam' to emerge from imperial 'redúccion(s)' into further uprisings of meaning" (11).

To push back against reduction and all the forms in which it manifested and manifests. In his essay "For Opacity," Martinican poet and literary scholar Édouard Glissant writes about "the right to opacity," stating: "The theory of difference is invaluable. It has allowed us to struggle against the *reductive* thought produced . . . for example, by the presumption of racial excellence or superiority" (189), continuing: "The opaque is that which cannot be *reduced*" (191, emphasis added). This is not only a refusal of reduction but also an unmaking and a remaking.

Guåhan is of keen geopolitical interest, specifically a key strategic military defense site, given its location in the northwest Pacific. Beginning in 1667, Spain occupied the archipelago calling the islands Las Marianas. The Marianas were administered as one territory together with the Philippines and the Caroline Islands, which then consisted of Belau (18) and the Federated States of Micronesia (19). In 1898, as a result of the Spanish-American War, Guåhan, Puerto Rico (42), and the Philippines were ceded to the US; the Northern Mariana Islands (16) along with the Caroline Islands were sold to Germany. Due to this colonial history, despite the shared geology, history, and culture, Guåhan has been split politically from the rest of the Mariana islands since 1898.

As of 1950, Guåhan has been an unincorporated organized territory of the US. As Perez writes: "'unincorporated' because it is an area under U.S. jurisdiction in which only certain 'natural' protections of the U.S. constitution apply; 'organized' because the 1950 Guam Organic Act conferred US citizenship and organized local government" (*[hacha]*). Guamanians can participate in the caucus during the US presidential primary season, but they cannot vote in US elections. Like the US Virgin Islands, Guåhan elects a delegate to Congress who can participate in debates but cannot vote.

Perez has proposed the term "*terripelago* (which combines *territorium* and *pélago,* signifying sea), to foreground territoriality as it conjoins land and sea, islands and continents." "Indeed, mapping the American imperial terripelago," he writes, "draws our attention to the shifting histories

of territorial regimes, including incorporated territories (states), unincorporated territories, trust territories, commonwealth territories, freely associated states, tribal territories, and federal territories" ("Transterritorial Currents").

The US military has seven bases on Guåhan, which take up 29 percent of the island's land (like on other occupied islands, such as Hawai'i, where it uses an estimated 25 percent of the land). As the map shows, historical and cultural CHamoru sites are on US military facilities. For example, the US military had made Ritidian (Litekyan in CHamoru) inaccessible to CHamorus. It is now part of the Guam National Wildlife Refuge. Along with the US Virgin Islands, Guåhan is one of three regions occupied by the US on the United Nations General Assembly's list of seventeen non-governing territories that have yet to be decolonized.

Guåhan rests in the Typhoon Alley, a region in the western Pacific that experiences an average of thirty-one tropical storms per year. According to research of the University of Hawai'i at Mānoa's School of Ocean and Earth Science Technology, on average three tropical storms and one *typhoon* pass within 180 miles of Guåhan each year. And according the National Oceanic and Atmospheric Administration, "Guam has been impacted by 16 typhoons since 1970 and devastated by four since 1960." In 2002, Typhoon Pongsona struck Guåhan, leading to $700 million in damages, destroying thirteen hundred homes, and leaving the island without power ("What Climate Change Means for Guam"). In 2018, Typhoon Mangkhut hit Guåhan.

Due to global warming, the temperatures of both air and water have increased on and around Guåhan. Excessive heat is related to numerous health conditions. Increased air temperatures also lead to drought. According to the Water and Environmental Research Institute of the Western Pacific, "Guam suffers negative effects of drought almost every year." "Every three or four years," its report states, "the drought is especially severe," particularly "in the year during or following an El Niño." Increased temperatures not only mean drought but also that water evaporates.

Warmer waters lead to increased *surface sea temperatures*, which fuel more intense tropical storms. Warmer waters also take up more space, leading to sea level rise. Sea level rise has started to salinize the Northern Guam *freshwater aquifer*, which provides 80 percent of Guåhan's drinking water.

The combination of drought and water salinization decreases potable freshwater for humans, animals, and plants. A 2019 US Geological Survey–funded study found that Guåhan's water resources will have diminished by 2080 due to higher temperatures and lower rainfall (Gingerich et al.). Added to this, the US military manages its own water sources and does not reveal where or at what depth they draw water. The continued military presence stretches Guåhan's water

and land resources. Due to the occupation of land, most food is imported or shipped in, making it more expensive and often more unhealthy than fresh produce.

An anticipated incursion of migrants will further impact these limited resources. As an organized unincorporated US territory, Guåhan counts as a territory to which members of the Compact of Free Association (COFA) can migrate. COFA members comprise the three island nations of Belau (18), the Federated States of Micronesia (19), and the Marshall Islands (20). Since these three island nations are low-lying and much closer to Guåhan in geography, history, culture, and environment than the continental US, some have been migrating to Guåhan from them. Guåhan's natural resources are thus stretched thin between the demands put on them by the still occupying military and the newly arriving migrants seeking to retreat from sea level rise.

Craig Santos Perez

INTERWOVEN

1.
I come from an island
and you come from a continent,
yet we are both made of stories
that teach us to remember
our origins and genealogies,
to care for the land and waters,
and to respect the interconnected
sacredness of all things.

2.
I come from an island
and you come from a continent,
yet we both know invasion.
Magellan breached our reef thirty years
 after Columbus raided
your shore. We were baptized
in disease, violence, and genocide.
We both carry the deep grief
of survival.

3.
I come from an island
and you come from a continent,
yet we both know the walls
of boarding schools. We were punished
for breathing our customs and
speaking our language. We learned
the Western curriculum
of fear and silence.

4.
I come from an island
and you come from a continent,
yet we both know desecration.
We witnessed minerals, trees, wildlife,
and food crops extracted for profit.
We mourn lands stolen and re-named,
waters diverted and dammed.
We inherit the intergenerational
loss of removal.

5.
I come from an island
and migrated to your continent.
Hundreds of thousands of us
have settled in your territories
for military service, education,
health care, and jobs.
We were so busy searching
for better lives, we didn't ask
your permission. We didn't even
recognize how our American dream
was your American nightmare.

6.
Native American cousins, I see you now
across this vast, scarred continent,
reviving your languages and cultures,
restoring native schools and tribal governments,
planting heritage seeds and decolonizing your diets,
blockading pipelines and protesting mining,
fighting for renewable energy
and a sustainable future.

Native cousins, I see you now
dancing, chanting, drumming,
rapping, writing, researching,
publishing, digitizing, animating,
filming, video gaming, and
revitalizing your ancestral stories.
I hear and honor your voices.

7.
I come from an island
and you come from a continent,
yet let us gather, today, and
share our stories of hurt,
our stories of healing.
I hope, seven generations from now,
our descendants will continue
interweaving our struggles.
I hope the stories we share today
and in the future will carry us
towards sovereign horizons.

Philippine Sea

PACIFIC OCEAN

BABELDAOB

KB Bridge

KOROR

0 ⊢—/——/——/——/——/——/——/—⊣ 5 mi

0 ⊢—/——/——/——/—⊣ 5 km

Coastline, 2020
Predicted coastline, 2100
Mangrove forest
Reef
Bridge

Beluu er a Belau
Republic of Palau

7.5150° N
134.5825° E

Archipelagic nation of 8 main islands and 300 to 340 smaller islets

177 sq. mi. (459 km²) | Babeldaob: 128 sq. mi. (331 km²)

Population: 21,695 (2022 est.) | Babeldaob: 6000 (est.)

72.5% Palauan, 16.3% Filipino

Languages: Palauan, English, Sonsorolese, Tobian

Mean Elevation: 3.281 ft. (1 m)

```
          805 MI / 1295 KM
---->  GUÅHAN (17)

           1093 MI / 1759 KM
----/>  FEDERATED STATES OF MICRONESIA (19)

               3977 MI / 6400 KM
----/----/----/---->  KIRIBATI (21)
```

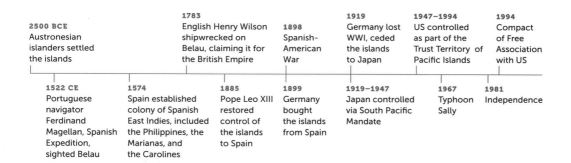

2500 BCE Austronesian islanders settled the islands	1783 English Henry Wilson shipwrecked on Belau, claiming it for the British Empire	1898 Spanish-American War	1919 Germany lost WWI, ceded the islands to Japan	1947–1994 US controlled as part of the Trust Territory of Pacific Islands	1994 Compact of Free Association with US	
1522 CE Portuguese navigator Ferdinand Magellan, Spanish Expedition, sighted Belau	1574 Spain established colony of Spanish East Indies, included the Philippines, the Marianas, and the Carolines	1885 Pope Leo XIII restored control of the islands to Spain	1899 Germany bought the islands from Spain	1919–1947 Japan controlled via South Pacific Mandate	1967 Typhoon Sally	1981 Independence

The lungs of the ocean. It is what *coral reefs* are called. They are to the oceans what rainforests are to the land: a pivotal carbon sink and a habitat for rich ecosystems (see illustration, p. 123). And although they only take up an estimated 0.1 percent of the ocean, they are home to one-quarter of its species. In the waters surrounding the Republic of Palau live more than 1450 species of fish as well as crocodiles and dugong. Green and hawksbill turtles breed here.

Corals are marine invertebrates and vary greatly by species and type. Hard corals build reefs; soft coral, such as sea fans and sea whips, do not. Sea fans and sea whips wave around like the

inflatable air dancers at auto dealerships. The greatest number of coral species are found in the western Pacific Ocean, between Indonesia, New Guinea, and the Philippines, also referred to as the coral triangle. Belau has over four hundred species of coral; neighboring Guåhan (17) has about three hundred.

The reefs consist of individual polyps, related to sea anemones, jellyfish, and Portuguese man o'war. Soft and tubelike, the polyps have an opening at the top ringed by stinging, waving tentacles called nematocysts. The tentacles can grab food, such as small fish or zooplankton. They also gather food through algae called zooxanthellae with which the coral live in a symbiotic relationship. The polyps offer the algae shelter and the algae photosynthesize, producing food for the polyps. Polyps secrete a calcium carbonate skeleton, which forms a hard skeleton base. As a new coral grows on the old dead one, it forms a colony and these, building up slowly but steadily, eventually form coral reefs. Established reefs are estimated to be between five thousand and ten thousand years old.

A nearly continuous *barrier reef* encircles Babeldaob and several other islands in Belau. Barrier reefs typically run roughly parallel to a landmass and a few miles or kilometers away from it. By buffering waves, barrier reefs protect low-lying atolls.

Yet they are at risk due to climate change. Each year, the oceans absorb an estimated quarter of global CO_2 emissions. It makes the ocean more acidic, which in turn bleaches or kills the coral. Increased ocean temperatures have the same effect. The coral expels the algae and turn white. *Ciguatera* is a toxin found in the expelled microalgae. It can travel up the food chain, to reef fish and then humans. Ciguatera can lead to fevers, diarrhea, and vomiting.

In addition to the barrier reef, *mangroves* along the shore protect it. Unlike many islands mangrove forests are intact along most of Babeldaob's coastline.

Due to climate change, much talk is afoot about the notions of time. Deep time—first coined by John McPhee in his book *Basin and Range* (1981), the first volume of what became the *Annals of the Former World* (1998)—refers to how geology measures time. In the era of the climate crisis, discussions abound about a measure of the Anthropocene in the geologic record and about when the Anthropocene started and what to name it (see Haraway; Lewis and Maslin; Moore; Yusoff; Davis and Todd). It has also unleashed discussions about the varying natures of time. Deep time. Geologic time. Much longer in time span than human time. Tree time. Tree rings. Whale time.

Time before colonialism and after, as Canisius Filbert discusses in their poem following: "Long ago my / Ancestors knew time / They counted moons / They watched sunrises / . . . Then a new dawn came / With the shipwreck / Of a ship from the east . . . Life changed and time / Time

was theirs to control." Undoing that time, as Sylvia Wynter writes in *Black Metamorphosis*: "the subversive quality of black popular music has been primarily its assault on this [colonial] sense of time, its freeing of time from a market process, its insistence on time as a *life* process" (cited in McKittrick *Dear Science,* 162, emphasis added).

Belau. Time. Belau—like the Northern Mariana Islands (16) and Guåhan—was among the earliest Pacific islands Austronesians settled. Belau. Space. The archipelago rests in the western Pacific Ocean just north of the equator and of West Papua and to the east of the Philippines. The winds blow west to east for part of the year and then east to west, facilitating travel back and forth between the islands.

Geologically, Belau and the Federated States of Micronesia (19) form one archipelago, which stretches 1800 miles from west to east. Named the Caroline Islands by the Spanish colonizers after King Charles II, the archipelago is split between the two nations: Belau to the west and the Federated States of Micronesia to the east. In 1978, Belau opted for independence, splitting off from the Federated States of Micronesia.

Due to Belau's geologic range, the islands have dramatically differing heights from mountainous volcanic islands to low-lying atolls. The *volcanic islands*, such as Babeldaob, Koror, and Ngerekebesang, typically feature steep slopes with the islanders living around the coastline. To the northeast lie *atolls*, which, by contrast, are low-lying. The hundreds of central and southern islands are formed of coralline limestone.

While the low-lying atolls will be impacted by sea level rise, the volcanic islands will be affected, too. Belau's volcanic islands are more populous, and an estimated 81 percent of the population is urban. Most of the population, like on the Seychelles (11), lives along the coastline.

Almost 70 percent of Belau's population lives on Koror, where the capital was previously located. A bridge connects Koror to neighboring Babeldaob, the largest island in Belau, the second largest Micronesian island, after Guåhan and the capital's current site. Babeldaob is home to about 30 percent of Belau's population, most of which lives at the southern end.

In the western Pacific Ocean, where Belau is located, sea levels have risen at a rate that is three times the global mean since the 1990s. A study by Pacific Climate Change Science found evidence of this disproportionate rise in Belau. Under a high emissions scenario, the Intergovernmental Panel on Climate Change's Sixth Assessment Report predicts sea level will continue to rise by 1.64 feet (0.5 m) by 2100, if temperatures increase 2°C, and up to 2.3 feet (0.7 m) if temperatures increase 3–4°C. Some estimates are even higher and project a sea level rise of up to 9.8 feet (3 m) by 2070.

Canisius Filibert

TIME

Long ago my
Ancestors knew time
They counted moons
They watched sunrises
No one needed hours
Nor tiny little seconds
Days were enough
Shadows told time
Time was on our side
We were simple but
We were free brown
People of the blue sea
Simple lives uncomplicated
Then a new dawn came
With the shipwreck
Of a ship from the east
Days of the pale race
My fathers and mothers
And their and theirs and theirs
Life changed and time
Time was theirs to control
Now life revolves around
A face with endless
circling hands and ticks
Tocks became rules
Now moons go unnoticed
Sunrises sunsets unlearned
Hearts beat to a new
Time as was known to
My people of brown
Now unsung and
Never untied

CORAL REEF

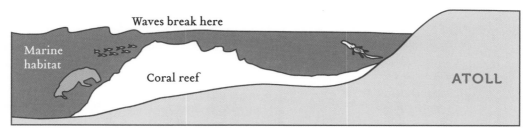

Waves break here

Marine habitat

Coral reef

ATOLL

Coral reefs break waves, reducing flooding and preventing erosion. They also provide a marine habitat.

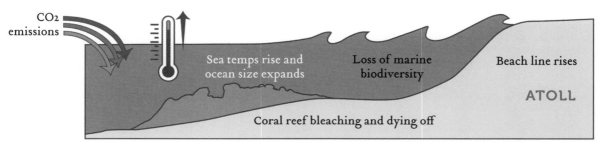

CO₂ emissions

Sea temps rise and ocean size expands

Loss of marine biodiversity

Beach line rises

ATOLL

Coral reef bleaching and dying off

Absent coral reefs, the shoreline is subject to more flooding and erosion and lacks a marine habitat.

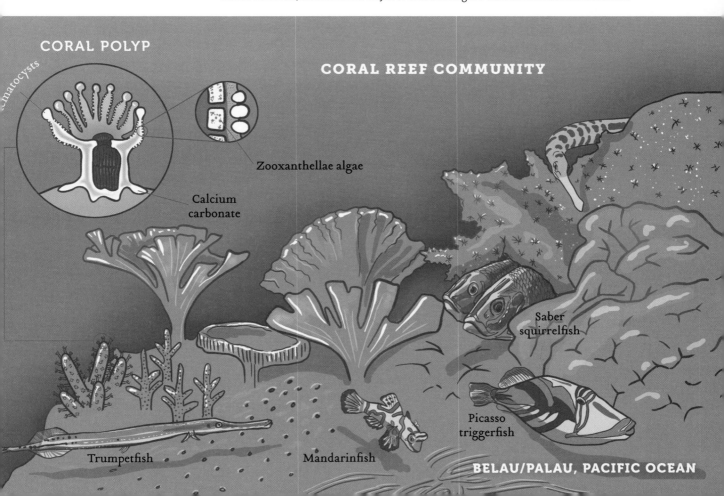

CORAL POLYP

Nematocysts

Zooxanthellae algae

Calcium carbonate

CORAL REEF COMMUNITY

Saber squirrelfish

Picasso triggerfish

Trumpetfish

Mandarinfish

BELAU/PALAU, PACIFIC OCEAN

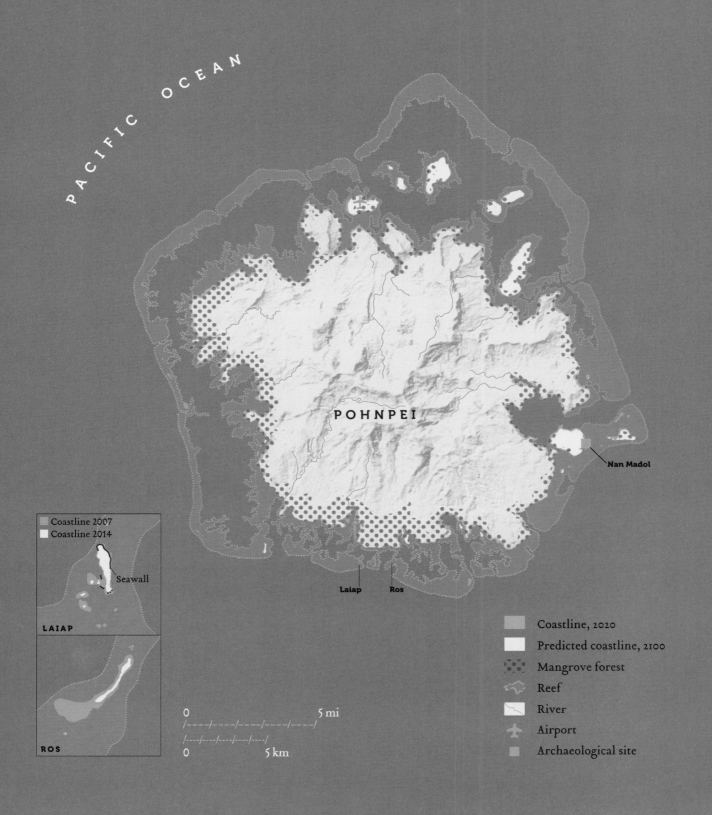

PACIFIC OCEAN

POHNPEI

Nan Madol

Laiap Ros

Coastline 2007
Coastline 2014

Seawall

LAIAP

ROS

0 5 mi
/----/----/----/----/----/

/----/----/----/----/
0 5 km

Coastline, 2020
Predicted coastline, 2100
Mangrove forest
Reef
River
Airport
Archaeological site

Federated States of Micronesia

7.4256° N
150.5508° E

Archipelagic nation of 4 main islands and 607 other islands
271 sq. mi. (702 km²) | Pohnpei: 144 sq. mi. (372 km²)
Population: 101,009 (2022 est.) | Pohnpei: 36,196 (2010)
48.8% Chuukese, 24.2% Pohnpeian, 6.2% Kosraean, 5.2% Yapese
Languages: Chuukese, English, Kosraean, Pohnpeian, Yapese, Ulithian, Woleaian, Nukuoro, Kapingamarangi
Mean Elevation: 7 ft. (2.1 m) | Laiap and Ros: 3.93 ft. (1.2 m)

```
      281 MI / 452 KM
->  BELAU (18)

      524 MI / 843 KM
-->  GUÁHAN (17)

              3977 MI / 6400 KM
----/----/----/----> KIRIBATI (21)
```

2500 BCE	1574							
Austronesian islanders settled the islands	Spain established colony of Spanish East Indies, included the Philippines, the Marianas, and the Carolines	1898 Spanish-American War	1914–1919 Japan occupied during WWI	1944–1945 US occupied	1975 New constitution drafted	1994 Compact of Free Association with US		

500–1628 CE	1628	1899	1919–1944	1947–1979	1986
Pohnpei united under the Saudeleur dynasty	Isokelekel overthrew the Saudeleur dynasty	Germany bought the islands from Spain	Japan controlled via South Pacific Mandate	US controlled as part of the Trust Territory of Pacific Islands	Independence

Pitch black, the deepest known point in the sea is the Challenger Deep, measured to be 35,839 feet (10,924 m)—almost 7 miles—in depth by benthic landers. Sunlight only hits to about 1000 feet. In the first 650 feet, the *epipelagic zone*, marine plants such as kelp, plankton, and reefs reside. So, too, do the creatures that feed on them, fish and marine mammals.

Few creatures live at the *hadal zone*, the deepest region of the ocean, named after Hades, the underworld in Greek mythology. Not only is it dark, the pressure is immense, an estimated 15,000 pounds per square inch. Over one thousand times the pressure at sea level. It is also cold.

In 1960, nine years before the first humans landed on the moon, two men dove to the Challenger Deep in a *bathyscaphe*. It took an estimated four hours and forty-seven minutes. The Challenger Deep plunges more in depth than Mount Everest towers in height at 29,032 feet (8,849 m).

The benthos that lives at this depth include creatures such as amphipods. These shrimplike creatures can measure up to 12 inches (30 cm) in this region. They are the knights in shining armor of these depths: to survive the pressure, the amphipods' digestive system produces aluminum hydroxide gel that creates aluminum suits of armor.

Also in the hadal zone are cusk eel, actually a fish—in fact the deepest dwelling fish. Its eyes are nonfunctional, for who needs eyes in such darkness? Like the snailfish, which can also be found in this nether region, the cusk eel has a gelatinous layer under the skin that creates buoyancy, aides with locomotion, and also protects against the pressure. The snailfish has a skeleton that consists of cartilage rather than bone, in order to handle the pressure. These two creatures are the ocean's deepest vertebrates. Heading up a bit further, one finds the translucent ctenophores, from the Greek for "comb-bearers." They are also known as comb jelly fish, although they are not really jellyfish (just as the cusk eel are not really eel). The ctenophores are the disco queens of the deep sea, sporting a row of brightly colored bands or combs that consist of glowing and glittering cilia.

Each ocean has a deep point but due to the challenges of exploring and mapping them, their precise locations are not yet agreed upon. That said, the five deepest points might be the Molloy Hole in the Arctic Ocean (18,599 ft. / 5669 m); the Puerto Rico Trench in the Atlantic Ocean (27,858 ft. / 8408 m); the Java Trench in the Indian Ocean (23,917 ft. / 7290 m); the Challenger Deep in the Mariana Trench (35,839 ft. / 10,924 m) and the South Sandwich Trench in the Southern or Antarctic Ocean (24,229 ft. / 7385 m). The Challenger Deep lies in the territory of the Federated States of Micronesia.

The Federated States of Micronesia forms the eastern part of the Caroline Islands; Belau (18) forms the western half. Approximately 607 islands constitute the Federated States of Micronesia. While the land totals only 271 square miles (702 km²), the islands span 1,000,000 square miles (2,600,00 km²) of ocean. The country is sometimes simply referred to as Micronesia. But that could also refer to the Pacific region in which it is located. In 1832, French navigator Jules Dumont D'Urville coined the terms Micronesia, Melanesia, and Polynesia for what he deemed to be the region's main three geographic and ethnic groups: Micronesia named the island size and Melanesia as a racial categorization. Given the terms' colonial genesis and meanings, they are viewed critically. Most prefer the term Oceania, which captures the relations among the great ocean's islands and islanders—historical, cultural, and geographic ties forged by navigation.

Micronesian navigators are among the Pacific's best known. Using a combination of star compasses, swell orientation, and dead reckoning, they navigated the great ocean. Micronesia is home to Weriyeng or Warieng, a school that trains in traditional navigational skills on *wa*, the single outrigger. It is located on the atoll Pulap in the Chuuk State. Pius "Mau" (meaning "strong")

Piailug (1932–2010), one of the most famous Oceanic navigators, first learned and later taught at the school. Piailug grew up on Satawal Island, which lies to the south of the Marianas. He trained Hawaiian navigator Nainoa Thompson (b. 1953), who has worked actively to revive traditional Polynesian navigating through the Polynesian Voyaging Society and long distance voyages on the *Hōkūle'a* and *Hikianalia*. In 1976, Piailug navigated the *Hōkūle'a* on its first trip from Hawai'i to Tahiti and back, a distance of 4800 miles (7725 km). Navigator David Lewis writes that "current Carolinian usage may be studied directly, because techniques are still being practiced and concepts are still being applied at sea" (200). Of the techniques Lewis writes about, the sidereal compass and spotting homing birds are key.

Micronesian voyagers developed the *sidereal compass*. It divided the horizon's circle into thirty-two points. Navigators then marked so-called compass stars and noted when they rose and set, thus constituting the points distributed irregularly around the horizon and the compass (see illustration, p. 129). Even if not all stars were visible, enough could be tracked around the rim to determine location. The navigator would then superimpose the islands and their locations onto this compass. While rectangular or circular versions of the compasses exist, they were more for training. Navigators would typically internalize the compass. While the *kamal* was in use by Arab navigators (see Bahrain (8)) by the ninth century, the sidereal compass was in use in the western Pacific by the tenth century, after the invention of the magnetic compass in China in the third century BCE but well in advance of its use in Europe in the twelfth century.

Important, too, was the sighting of *homing birds*. Lewis writes: "In the Gilberts archipelago (now Kiribati), Teeta and Abera told me, cloud signs are the preferred method of locating islands, just as in the Carolines observation of homing birds is the technique of choice, and in the Marshalls the pattern of swells" (216). Lewis details the birds that can be found within proximity to an island: "within 30 to 50 miles of shore, boobies in threes and fours, often accompanied by a predatory frigatebird or two, are extremely common. Closer in still, when the nearest atoll is 20 to 25 miles off, mixed flocks of white terns and noddies will be encountered busily searching for fish" (205).

Four states constitute the nation: Yap, Chuuk, Pohnpei, and Kosrae. They are *volcanic islands*. Pohnpei's mountainous terrain includes lush rainforests. Its highest peak measures 2595 feet (791 m). *Mangroves* line the perimeter of Pohnpei. *Barrier reefs* encircle the island. They run alongside the shore but further out. Some are also *fringing reefs*, which, by contrast, grow directly from the shore. Both are separated from the shoreline by waters; for fringe reefs, a lagoon. Together, the concentric circles of mangroves and reefs form a buffer zone around the island. They illustrate how functioning natural layers help protect islands against waves and floods and sea level rise. On many islands these natural layers have been destroyed by development on the shoreline.

About half the nation's population lives in Chuuk, and about one-third lives on Pohnpei, mostly along the coastline. They survive on subsistence farming and fishing. Bananas, breadfruit, cassava, coconuts, sweet potatoes, and taro are grown. Pigs and poultry are also raised.

The island's revenue is supplemented by US aid through the Compact of Free Association (COFA). Residents of nations that are part of COFA have the right to federal services, such as health care, and the right to live, study, and work in the US. COFA includes Belau (18), the Federated States of Micronesia, and the Marshall Islands (20). The US, under COFA, has the right to station its military on these island nations.

Artificial islands lie just off the coast of Pohnpei. Although artificial islands are typically associated with _land reclamation_ in the modern era, such as in Bahrain (8), the Palm Island in Dubai, the Maldives (12), Singapore (14), or the South China Sea (15), artificial islands have a long history stretching back millennia. Tenochtitlan, the capital of the Aztec empire, rested on an island, surrounded by _chinamitl_ or _chinampa_, artificial islands created for agricultural use. In Micronesia, Nan Madol was constructed off the eastern edge of Pohnpei under the Saudeleur dynasty beginning in the eighth or ninth century CE. Nan Madol consists of ninety-two artificial islands, built of stone with a network of canals weaving through. Some speculate that Nan Madol might be the lost mythical continent of Lemuria or Mu.

Numerous _reef islands_ surround Pohnpei, too. Reef islands consist of sand and gravel. They are low-lying and particularly vulnerable to erosion by higher waves. Sea level rise poses another threat to reef islands. According to research by Patrick Nunn, a lead author of the Intergovernmental Panel on Climate Change (IPCC)'s Sixth Assessment Report, many other islands in the area have shrunk over the past decade. "Islands such as Laiap and Ros, which have lost two-thirds of their land area over this time, are likely to disappear completely within the coming decade" ("Sea Level Rise Is Washing Away"). Laiap and Ros rise less than 3.93 feet (1.2 m) above sea level (Nunn personal correspondence). "Why are islands in the western Pacific becoming the earliest casualties of sea level rise? Partly because sea levels in this region have risen at two to three times the global average over the past few decades," Nunn writes ("Sea Level Rise Is Washing Away"). In the western Pacific just north of the equator, he continues: "Sea level rise has risen by 10 to 12 mm (0.39 to 0.47 of an inch) each year between 1993 and 2012, far outpacing the global average of 3.1 mm per year [0.12 inch]." While Nunn believes "this rate is unlikely to be sustained indefinitely, the current trend would raise sea levels by a further 30 to 40 cm (11.8 to 15.7 inches) by mid-century if it were to continue." Efforts to protect Laiap with _seawalls_ have been undertaken but have not been successful. In fact, one island, Nahlapenhlohd, has completely disappeared.

Micronesia produces the least _carbon dioxide (CO_2)_ emissions _in the world_ from consumption

of energy, only a mere 105 tons. In 2019, China, which ranked first, produced 10,060,000,000 tons (Friedlingstein et al. "Global Carbon Budget 2019"). The US, which ranked second, produced 5,410,000,000 tons.

SIDEREAL COMPASS

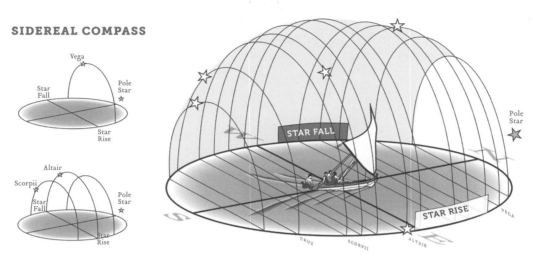

FEDERATED STATES OF MICRONESIA

FROM **THE CONSTITUTION OF THE FEDERATED STATES OF MICRONESIA (1975)**

WE, THE PEOPLE OF MICRONESIA, exercising our inherent sovereignty, do hereby establish this Constitution of the Federated States of Micronesia.

With this Constitution, we affirm our common wish to live together in peace and harmony, to preserve the heritage of the past, and to protect the promise of the future.

To make one nation of many islands, we respect the diversity of our cultures. Our differences enrich us. The seas bring us together, they do not separate us. Our islands sustain us, our land nation enlarges us and makes us stronger.

Our ancestors, who made their homes on these islands, displaced no other people. We, who remain, wish no other home than this. Having known war, we hope for peace. Having been divided, we wish unity. Having been ruled, we seek freedom.

Micronesia began in the days when man explored seas in rafts and canoes. The Micronesian nation is born in an age when men voyage among stars: our world itself is an island. We extend to all nations what we seek from each: peace, friendship, cooperation, and love in our common humanity. With this Constitution, we, who have been the wards of other nations, become the proud guardian of our own islands, now and forever.

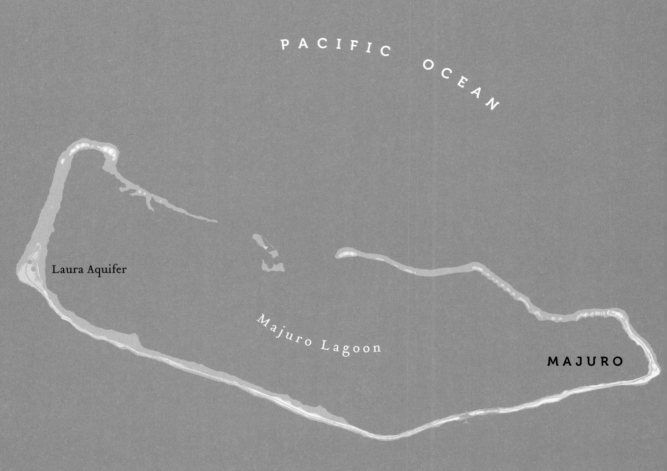

PACIFIC OCEAN

Laura Aquifer

Majuro Lagoon

MAJURO

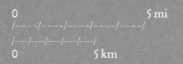

0 5 mi

0 5 km

Submerged coastline, 2020
Current coastline, 2020
Predicted coastline, 2100
Freshwater aquifer
Major road
Airport

Aolepān Aorōkin Ṃajeḷ
Republic of Marshall Islands

7.1315° N
171.1845° E

Archipelagic nation of 2 island chains of 29 atolls, 1100 islets, and 5 islands

70.05 sq. mi. (181.43 km²) | Majuro: 3.7 sq. mi. (9.7 km²)

Population: 79,906 (2022 est.) | Majuro: 31,000 (2018)

Languages: Kajin Majōl (Marshallese), English

Mean Elevation: 6.56 ft. (2 m) | Majuro, Highest Elevation: 10 ft. (3 m)

908 MI / 1461 KM
---> **FEDERATED STATES OF MICRONESIA (19)**

2186 MI / 3518 KM
----/----/> **KIRIBATI (21)**

608 MI / 979 KM
--> **NAURU (22)**

3000 BCE Austronesians settled the Marshall Islands	**1788** British Captain John Charles Marshall visited the islands	**1914–1945** Japan colonized the islands	**1948–1958** US detonates forty-three nuclear bombs on Enewetak	**1986** Compact of Free Association with US	**2013** State of emergency, drought	**2019** National climate crisis declared
1526 CE Spanish navigator Alonso de Salazar saw the islands	**1885–1914** Germany colonized the islands	**1947–1979** US controlled as part of the Trust Territory of Pacific Islands	**1979** Independence	**2008** State of emergency, Majuro flooded	**2014** State of emergency, flooding	

Imagine living on an island that measures a mere few dozen yards (30–40 m) wide by 1 mile (1.6 km) long amid the vast Pacific Ocean. Then, imagine that small island resting less than 6.5 feet (2 m) above sea level, as the waters begin to rise, first during the full moon's king tides or storm surges and then more consistently as the island's coastline erodes. No space inland or uphill to which you can retreat. This situation is the present-day reality of the Republic of the Marshall Islands.

The Republic of the Marshall Islands consists of two island chains of twenty-nine atolls—many small islets, about eleven hundred in all, constituting each chain—and five single islands. The nation's population is almost eighty thousand, with about half the islanders living on Majuro,

the capital. Although the Marshall Islands land area is only 70 square miles (181 km²), its *Exclusive Economic Zone* (EEZ) measures over 1 million square miles (2.5 million km²) of ocean.

This wide oceanic expanse led the Marshallese to become among Oceania's best navigators. Marshallese constructed stick charts to navigate the Pacific Ocean (see Figure 3, p. 137). Made of palm ribs and sticks bound by sennit or coconut fiber, the stick charts document ocean *swells*. Swells are generated by strong winds but travel beyond the wind systems that create them and remain after the wind has died away. Swells from distant origins tend to have a longer and slower undulation than swells and wind waves from nearby sources, which are shorter and steeper (Lewis 126). Importantly, when swells reach islands, they bounce back in counterswells, which radiate back to an approaching boat and are perceptible.

On stick charts the straight sticks represent regular currents and waves, seashells represent islands and atolls, and the curved sticks represent ocean swells. They document understandings of swells and how islands bend them. This detail helps to navigate the open oceans. Even if an island is not visible on the horizon, its distant effects can be felt in the water. While neighboring islands, such as Kiribati (21) and the Solomon Islands (24), as well as more distant Tonga (32), all had knowledge of swells, stick charts are unique to the Marshall Islands, where the study of swells is the most developed.

Stick charts do not represent exact distances between islands, nor are they consulted during the journey, unlike maps in Western navigation. They are mnemonic devices to help remember the information they contain. It is shared orally by the maker's explanation and paired with the experiential. In these ways stick charts are interwoven with an oral tradition handed down and with embodied knowledge, learned by being in and on the water.

The knowledge is mapped onto a felt knowledge of the swells, experienced by being in the water. As Marshallese Raymond de Brum, speaking to David Lewis about the training of navigators, put it: "These elder skippers, first of all would take the younger man out to the ocean . . . they would lay the young man in the water, on his back, and tell him to float and relax so that he would get to know the feel of the waves as they came along" (244). Lewis writes that reading the swells to navigate the ocean was akin to reading ridges in the snow—that is, sastrugi, a method used by the Chukchi in Russia for finding their way across the tundra, or akin to reading sand ridges in the desert, each produced by winds (384fn9).

Enewetak Atoll in the northwest of the Marshall Islands was home to master builders of *walap*, outrigger canoes, and some of the best Marshallese navigators. Then, starting in 1914 at the outset of World War I, Japan occupied the islands. In February of 1944, at the end of World War II, the

US captured and occupied the islands. They forced the islanders to relocate and destroyed both their boats and the boating culture. Then, the US military detonated forty-three nuclear bombs on Enewetak. Subsequently, from 1977 to 1980, the US military built the Runit Dome on Runit Island, one of forty islands that make up Enewetak Atoll. Under the dome in a crater created by a detonated bomb, the US military placed contaminated soil mixed with concrete from Enewetak Atoll. Enewetak residents were encouraged to return home. In 2013, a study conducted by the US Department of Energy found cracks in the dome. In 2019, an investigation by the *Los Angeles Times* confirmed the cracking and found that 130 tons of soil from the Nevada Test Site had been dumped in the Marshall Islands and that US government scientists had also sprayed an "incapacitating bacterial agent" on the islands. Now, as sea levels rise, concerns abound about how it could lead nuclear radiation to leak out from the dome.

Between 1946 and 1958, the US military detonated sixty-seven nuclear bombs on the Marshall Islands. Cumulatively, they are equivalent to over seven thousand Hiroshima bombs. Twenty-three of the bombs were detonated on Pikinni (Bikini) Atoll to the east of Enewetak Atoll. Bikinians were resettled to Rongerik, where they lived from 1946 to 1948 before being relocated first to Kwajalein Atoll and then to Kili Island. Rongelap Atoll was exposed to the fallout. The Rongelapese were evacuated three days after the nuclear explosion and returned three years later, given assurances by the US that it was safe to do so. As a result of these nuclear detonations, the cancer rates—lung, throat, and thyroid as well as leukemia and lymphoma—in the Marshall Islands are high.

Climate change poses new threats to the islanders' homeland. The two main climate threats to the Marshall Islands are a lack of potable *freshwater* and sea level rise. On the map, to the west in the yellow area lies Laura, the freshwater aquifer that provides 60 percent of Majuro's freshwater via two freshwater drinking supply wells. In a freshwater *lens* (see illustration, p. 135), rainwater forms a layer over saltwater, which is denser and thus hangs a bit lower.

Drought further impacts the already limited freshwater supply. The Marshall Islands rely on rainfall for 90 percent of their freshwater needs. In 2013 the drought was so severe that then President Hilda Heine declared a state of emergency.

Sea level rise both impacts the freshwater supply and creates other threats. During flooding, *saltwater* inundates and thus salinizes the water, making it undrinkable. The Marshall Islands' freshwater could no longer be drinkable by 2030. Rising sea levels also flood agricultural lands and upset the balance of soil salinity or salt content in soil. *Salinization* or increased salt content in the soil is a concern because excess salt hinders crops' ability to take up water. The *saltwater intrusion* into aquifers and agricultural soils makes Majuro increasingly uninhabitable.

Rising sea levels threaten the Marshall Islands, given the atolls' low height with a mean elevation of 6.5 feet (2 m) and peak at 10 feet (3 m). Sea level rise predictions do not translate neatly into a static wave height. Factors such as waves or winds can increase the forecast water heights. Parts of Majuro are often uninhabitable due to wave-driven *overwash*, which floods homes. When sea level rise combines with wave-driven overwash, waves are higher and seawater washes over the atolls. Rising sea levels challenge not only human but also animal habitats, creating a loss for birds as well as plants. Many parts of Majuro are already submerged. The Marshall Islands thus paradoxically suffer from a combination of not enough freshwater and too much saltwater.

While much of the discourse on global warming has sought to keep the temperature from increasing no more than 3.6°F (2.0°C), the late Tony De Brum, who served as the foreign minister for the Republic of the Marshall Islands, advocated for "1.5 to Stay Alive" or even "1.5 to Thrive." It is the mantra of many island nations. For low-lying island nations, such as the Marshall Islands, a 2°C increase would be what they have called a death sentence, so they advocate a maximum increase of 2.7°F (1.5°C).

Marshallese poet Kathy Jetñil-Kijiner writes in her poem "Tell Them": "Tell them what it's like / to see the entire ocean__level __with the land / Tell them / we are afraid . . . But most importantly you tell them / that we don't want to leave / we've never wanted to leave / and that we / are nothing / without our islands."

The Marshall Islands convened a climate change conference in July 2018 and discussed raising the islands to withstand sea level rise and to maintain a footprint as a nation. For legal reasons, a nation must maintain a physical footprint. A passport must have land to go with it. Similar plans are being discussed in the Maldives and in Kiribati. *Artificial islands* are thus being built not only to secure geopolitical interests—for example, in the South China Sea (15)—but also to ensure some island nations' very survival.

Subsequently, on September 26, 2019, the country's Nitijela (parliament) passed a resolution that declared a "National Climate Crisis as the Low-Lying Coral Atoll Nation." Resolution 83 laid responsibility for creating the crisis at the feet of the international community and states that fighting climate change is now the Marshall Island's top priority.

In October 2019, then President Hilda Heine declared a National Climate Crisis, stating: "As one of only four low-lying coral atoll nations in the world, the failure of the international community to adequately respond to the global climate crisis of its own making holds particularly grave consequences." The four atoll nations most at risk globally are the Marshall Islands, the Maldives (12), Kiribati (21), and Tuvalu (27).

Kathy Jetñil-Kijiner brought global attention to the situation of the Marshall Islands and of low-lying island nations in her poem "Dear Matafele Peinam," delivered at the opening ceremony of the 2014 United Nations Climate Summit in New York City. The poem was addressed to her then newborn daughter. The Marshall Islands, like Belau (18), the Federated States of Micronesia (19), and Nauru (22), is a matrilineal society. Jetñil-Kijiner also coestablished Jo-Jikum, a nonprofit dedicated to empowering Marshallese youth to work for solutions to environmental issues on their islands. She is climate envoy for the Marshall Islands. And she works as part of the Pacific Climate Warriors. Their motto and message: "We are not drowning! We are fighting!"

FRESHWATER LENS

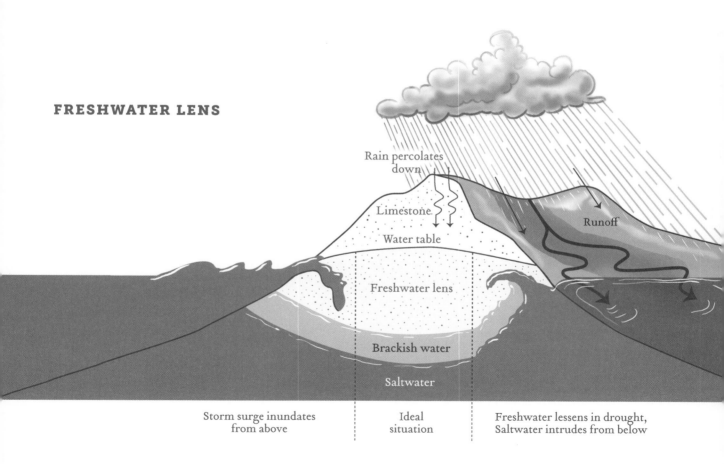

Rain percolates down

Limestone

Water table

Runoff

Freshwater lens

Brackish water

Saltwater

Storm surge inundates from above

Ideal situation

Freshwater lessens in drought, Saltwater intrudes from below

COOK ISLANDS, PACIFIC OCEAN

Kathy Jetñil-Kijiner

DEAR MATAFELE PEINAM

Dear Matafele Peinam,

You are a seven month old sunrise of gummy smiles
You are bald as an egg and bald as the Buddha
You are thighs that are thunder and shrieks that are
 lightning
so excited for bananas, hugs and
our morning walks past the lagoon

Dear Matafele Peinam,

I want to tell you about that lagoon
that lucid, sleepy lagoon
lounging against the sunrise

Men say that one day
that lagoon will devour you

They say it will gnaw at the shoreline
chew at the roots of your breadfruit trees
gulp down rows of your seawalls
and crunch your island's shattered bones

They say you, your daughter
and your granddaughter, too
will wander
rootless
with only
a passport
to call home

Dear Matafele Peinam,

Don't cry
Mommy promises you

No one
will come and devour you

No greedy whale of a company sharking
 through political seas
no backwater bullying of businesses with
 broken morals
no blindfolded bureaucracies gonna push
this mother ocean over
the edge

No one's drowning, baby

No one's moving
No one's losing
their homeland
No one's gonna become
a climate change refugee

Or should I say
no one else

To the Carteret Islanders of Papua New
 Guinea
and to the Taro Islanders of the Solomon
 Islands
I take this moment
to apologize to you
We are drawing the line here

Because baby we are going to fight
your mommy daddy
bubu jimma your country and president
 too
we will all fight

and even though there are those
hidden behind platinum titles
who like to pretend
that we don't exist
that the Marshall Islands
Tuvalu
Kiribati

Maldives
and Typhoon Haiyan in the Philippines
and floods of Pakistan, Algeria, Colombia
and all the hurricanes, earthquakes, and tidalwaves
didn't exist

Still
there are those
who see us

hands reaching out
fists raising up
banners unfurling
megaphones booming
and we are

canoes blocking coal ships

the radiance of solar villages

the rich clean soil of the farmer's past

petitions blooming from teenage fingertips

families biking, recycling, reusing,
engineers dreaming, designing, building,
artists painting, dancing, writing
and we are spreading the word

and there are thousands
out on the street
marching with signs
hand in hand
chanting for change NOW

and they're marching for you, baby
they're marching for us

because we deserve
to do more
than just
survive
we deserve
to thrive

Dear Matafele Peinam,

you are eyes heavy
with drowsy weight
so just close those eyes, baby
and sleep in peace

because we won't let you down

you'll see

FIGURE 3. Stick Chart, Republic of the Marshall Islands.
Collection of the Denver Museum of Nature and Science.

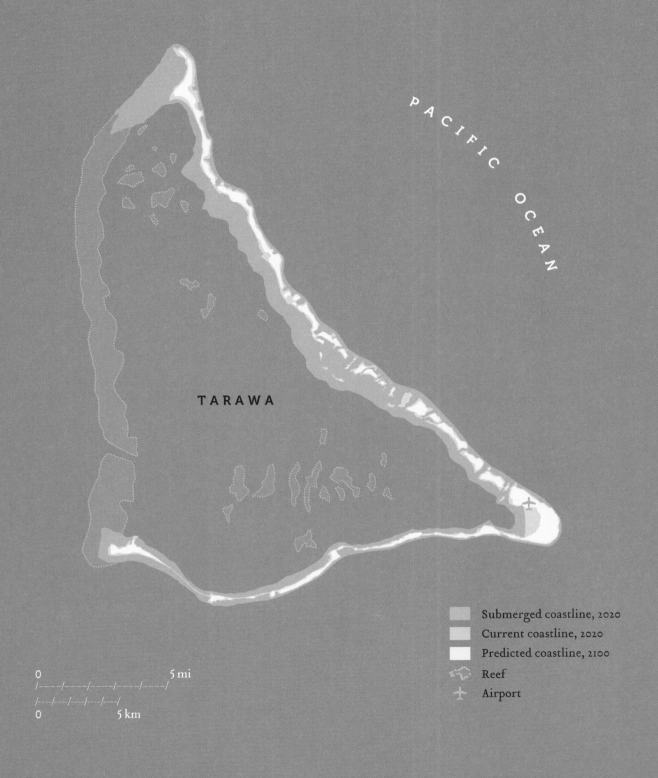

P A C I F I C O C E A N

TARAWA

Submerged coastline, 2020
Current coastline, 2020
Predicted coastline, 2100
Reef
Airport

0 5 mi

0 5 km

Ribaberiki Kiribati
Republic of Kiribati Islands

3.3704° S
168.7340° W

Archipelagic nation of 32 atolls and 1 island

313 sq. mi. (811 km²) | Tarawa: 193 sq. mi. (500 km²)

Population: 114,189 (2022 est.) | Tarawa: 56,284 (2010 census)

98% I-Kiribati, 0.2% Tuvaluan

Languages: I-Kiribati, English

Mean Elevation: 6.56 ft. (2 m) | Highest Elevation: 14.7 ft. (4.5 m)

```
             1691 MI / 2721 KM
----/-->  NAURU (22)

             1334 MI / 2147 KM
----/->  FIJI (26)

         971 MI / 1563 KM
--->  TUVALU (27)
```

3000–2000 BCE
Austronesians settled Kiribati

1886
Britain and Germany signed two agreements about territories in the western Pacific

1916–1974
Colony of Gilbert and Ellice Islands

2015
Cyclone Pam struck

1788 CE
British explorer Thomas Gilbert saw the islands

1892–1916
British Protectorate named the Gilbert Islands and administered together with Tuvalu (then named Ellice Islands)

1941–1943
Japan occupied some Gilbert Islands

1979
Independence as Republic of Kiribati Islands

The Republic of Kiribati Islands is the only country in the world to span all four hemispheres. The nation straddles the international date line and the equator. The reach of Kiribati's thirty-two coral atolls and one raised coral island is extensive: they are spread out over 1.3 million square miles (3.5 million km²) of ocean.

Like neighboring nations, I-Kiribati are expert navigators, developing, in particular, the art of reading cloud signs to locate islands. "'As you approach land from a distance,'" I-Kiribati

navigator Abera Beniata of the atoll Nikunau said, "the '*land cloud* at first lies on the horizon like other clouds, but as the hours go by, you notice that it stays in the same place . . . ' This process . . . brings out the importance of prolonged observation" (Lewis 217). "Abera mentioned two special signs," navigator David Lewis continues. "The one occurs when it is calm and there are no other clouds. If you look carefully, he told me, you may see a pair of clouds low on the horizon of the type called *te nangkoto,* which are like a pair of eyebrows" (217). Upon approach, the color and even more so the brightness of clouds indicate proximity to land.

Now, sea level rise threatens these low-lying atolls. On average, the islands sit a mere 6.56 feet (2 m) above sea level. Additionally, the atolls' average width is 1410–1476 feet (430–450 m) and often much narrower. Given the slim sliver, people typically live in close proximity to the shoreline. Often only enough room exists for one road. Homes, hospitals, and schools are located close to the waterfront. The atolls have already been struggling against rising seas, frequently experiencing inundation during *king tides*, also referred to as the perigean tides, the high tides that arrive when the moon is new or full and closest to the earth. As a result, homes are frequently flooded.

The western Kiribati Islands are also some of the most densely populated places globally, with most residents living on Tarawa Atoll. The eastern part of Tarawa is called North Tarawa and the southern part is called South Tarawa. In 1999 two islands—Tebua Tarawa and Abanuea—once part of North Tarawa disappeared underwater. Both were uninhabited. According to the World Bank, 18–80 percent of North Tarawa could be underwater by 2050.

While the population density on the islands is 647 per square mile (250 per km²), in South Tarawa it is 4663 per square mile (1800 per km²), comparable to the population density of Hong Kong or Tokyo. On this overcrowded atoll infrastructure, providing access to potable water and sanitation of wastewater, is sorely lacking. Most drinking water comes from rainwater *catchment*. (See Teresia Teaiwa's poem "I Will Drink the Rain (for Toma)" following.) A drought could quickly exhaust these reserves. In urban settings only 51 percent have access to sanitation facilities; in rural environments only 31 percent do.

Anote Tong, president from 2003 to 2016, made climate change and sea level rise key pillars of his political platform. In June of 2008, he made global headlines when he asked both Australia and New Zealand to accept citizens of Kiribati for permanent *resettlement* as *climate refugees*.

This resettlement would not be the nation's first. Like islanders in neighboring countries, such as the Northern Mariana Islands (16), Guåhan (17), and the Marshall Islands (20), I-Kiribati were forcibly resettled by colonizers. In 1900, the British annexed the island of Banaba and discovered *phosphate*, also located on Nauru (22), 185 miles to the west. The British began to mine the phosphate to use it as fertilizer. In 1945, the British forced Banaba's population to relocate to Rabi Island, Fiji

(26). (Banaba is administered by Rabi Island, Fiji, and the Banabans have both Kiribati and Fijian citizenship.) The mining profits went to the British, so the Banabans sued in 1970 to receive a higher percentage of revenues. Although Britain agreed to give Banabans half the revenues in 1973, by that point the remaining phosphate was minimal.

Kiribati has already lost territory to saltwater inundation. For example, the atoll of Abaiang has lost 262 feet (80 m) since 1964. As a result, the atoll's once thriving village Tebunginako was abandoned in 1994 and its residents relocated 164 feet (50 m) inland. What remains of the original location now rests about 98 feet (30 m) offshore. Most visible is a church.

Ghost forests of coconut trees due to saltwater intrusion are abundant here. On Abaiang, when the coconuts do grow, their size and shape is diminished due to drought and wave overwash. Coconut and copra, its meat, are key crops. Breadfruit trees suffer a similar fate.

In 2012, Ioane Teitiota, a Kiribati national, applied for asylum in New Zealand as a climate refugee, stating that sea level rise makes it impossible for him to have potable water and to grow food. His application was denied. He appealed the decision. The Supreme Court of New Zealand denied the appeal, arguing that although climate change is impacting Kiribati, climate change conditions are not included in the 1951 United Nations Convention Relating to the Status of Refugees. New Zealand has, however, created an annual lottery, the Pacific Access Ballot. Annually, approximately 75 I-Kiribati, 250 Fijians, 75 Tuvaluans, and 250 Tongans are allowed to emigrate through this program.

According to a UN report, climate change contributes considerably to moves in Kiribati, accounting for one in seven moves, whether interisland or international or both. The report also found that half of Kiribati households are already impacted by sea level rise. As journalist Laura Walters wrote with regard to displacement: "Papua New Guinea and Bougainville, Fiji and the Solomon Islands are already struggling to manage internal climate-related displacement, and a country with limited stable and productive land like Kiribati doesn't have the same options when it comes to migration within its own borders."

In 2012, then President Tong purchased 6000 acres of land on Vanua Levu, Fiji's second largest and very mountainous island, 1000 miles away, in case his people need a place to migrate to in the future. But this decision is fraught, as Fiji itself is relocating communities due to sea level rise. Coining the phrase "migration with dignity," Tong sought to provide secure housing for his country's people well before the Kiribati islands become uninhabitable.

Alongside three other atoll island nations, the Maldives (12), the Marshall Islands (20), and Tuvalu (27), Kiribati is now exploring raising part of its islands—in particular, the capital atoll Tarawa.

Teresia Teaiwa

I WILL DRINK THE RAIN (FOR TOMA)

Ko na moi? I ask.

 Moi n te ra? He asks.

Te ranibue? Te maitoro? I offer a choice.

 His face is blank. He appears unimpressed.

Coke? I suggest, with bated breath.

 He shakes his head. And slowly says, N ma moi te karau.

So I get him a glass. For the rain.

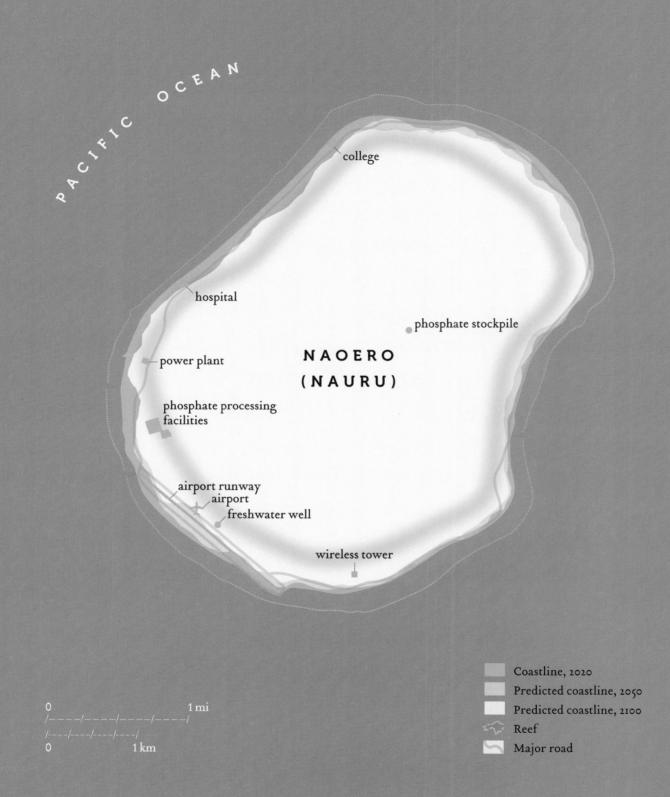

PACIFIC OCEAN

college

hospital

phosphate stockpile

power plant

NAOERO
(NAURU)

phosphate processing
facilities

airport runway
airport
freshwater well

wireless tower

0 1 mi
/----/----/----/----/----/
/----/----/----/----/
0 1 km

Coastline, 2020
Predicted coastline, 2050
Predicted coastline, 2100
Reef
Major road

Repubrikin Naoero
Republic of Nauru

0.5228° S
166.5500° E

8.1 sq. mi. (21 km²)

Population: 9811 (2022 est.)

88.9% Nauruan, 6.6% part-Nauruan, 2% I-Kiribati

Languages: Nauruan, English

Mean Elevation (along coast): 9.8 ft. (3 m) | Highest Elevation: 213 ft. (65 m)

186 MI / 300 KM
-> KIRIBATI (21)

841 MI / 1353 KM
---> MARSHALL ISLANDS (20)

941 MI / 1514 KM
----> TUVALU (27)

1ST MILLENNIUM BCE
Austronesians settled
Nauru

1888–1918
Germany colonized Nauru,
calling it Nawodo or Onawero

1968
Independence

1798 CE
British captain John Fearn visited
Nauru on a whaling expedition
and called it Pleasant Island

1900
Phosphate
discovered

1919–1923
Ceded to and administered
by Australia, New Zealand,
and the UK

The Republic of Nauru is the world's smallest independent island nation and once boasted the world's highest GDP. In 1900 *phosphate*, a valuable natural resource derived from bird droppings or guano, was discovered on the island. Nauru is one of three rock islands worldwide with considerable phosphate; the other two are Banaba Island in Kiribati (21) and Makatea in French Polynesia.

After Nauru gained independence in 1968, phosphate became its main export and Australia its main destination. By the 1980s, phosphate exports allowed Nauru to boast the highest per capita income globally.

Phosphate is a valued fertilizer. In 1856 the US passed the Guano Islands Act by dint of which the US took possession of hundreds of islands with guano deposits.

Phosphate mining was carried out under a series of colonial rulers: Germany, Japan, Britain, Australia, and New Zealand. By 1990, the phosphate reserves were depleted. The environmental degradation unleashed by strip mining is extensive. Now, 90 percent of the island is a wasteland, its air and water polluted and useless for agriculture.

As Naomi Klein writes: "Colonial rulers . . . had a simple plan for Nauru once all the phosphate had been extracted—simply ship the islanders to another island. In other words, Nauru was developed in order to disappear—an acceptable (and largely invisible) sacrifice to make for the advancement of industrial agriculture" (*This Changes Everything*).

In 1962, Australia's prime minister, Robert Menzies, stated that Australia, Britain, and New Zealand had a "clear obligation . . . to provide a future for the Nauruans," given how they had benefited from the phosphate mining but devastated the island (McAdam). Proposals were floated to move the entire population either to one of the three aforementioned nations or to the Solomon Islands (24), Papua New Guinea (25), and Fiji (26) (McAdam). Ultimately the plan was dropped. The Nauruans did not want to go. Lawyer Jane McAdam, in her article on Australia's proposal, mentions the intergenerational trauma that results from forced relocations, such as the forced relocation of Banabans in 1945 from Kiribati to Fiji.

With the phosphate mining shut down, unemployment increased. It currently stands at 90 percent. In order to address it, Nauru houses an offshore detention center for Australia (2001–2007 and 2012–present). The detention center employs about 10 percent of the island's population. It houses migrants, including asylum seekers and refugees, intercepted on boats by Australian navy ships. They are mostly from Afghanistan, Iran, Iraq, Pakistan, and Sri Lanka. Agencies such as Amnesty International have decried the center as inhumane, since the detainees languish there often for years, leading many to attempt suicide.

Like other low-lying islands, Nauru also faces both rising sea levels and *saltwater* inundation and not enough potable *freshwater*. The island's central plateau is higher and constitutes about 80 percent of the island. The island's remaining coastal land, where most people live and the infrastructure is located, has a mean elevation of 9.8 feet (3 m) above sea level. The *infrastructure*— including the road that encircles the island, the lone airport and its sole runway, the freshwater well, hospital, college, power plant, and wireless tower—are all at risk of inundation.

Klein writes that mining has hollowed out the island: "By the 1990s it was a hollow shell with a small strip around the edge where people lived" (*This Changes Everything*). As sea levels rise, they eat away at the edges, which are the last place to live on the eviscerated island.

Former president Marcus Stephen writes that a lush tropical rainforest once covered the island's interior (following).

Marcus Stephen, President (2007–2011), Republic of Nauru

ON NAURU, A SINKING FEELING

You've probably never heard of my country, and for that, I forgive you.

At just 8 square miles—about a third of the size of Manhattan—and located in the southern Pacific Ocean, Nauru (na-OO-roo) appears as merely a pinpoint on most maps—if it is not missing entirely in a vast expanse of blue.

But make no mistake: We are a sovereign nation, with our own language, customs, and a 3,000-year history. Nauru is worth a quick Internet search, I assure you. Not only will you discover a fascinating country that is often overlooked, you will find a cautionary tale about life in a place with hard ecological limits.

Phosphate mining—first by European companies in the early 1900s and later our own—cleared the lush tropical rainforest that once covered our island's interior, scarring the land and leaving only a thin strip of coastline for the island's 10,000 people to live on. The legacy of exploitation left us with few economic alternatives and one of the highest unemployment rates in the world, nearly 90 percent.

I am not looking for sympathy, but rather warning you what can happen when a country runs out of options. The world is headed down a similar path with the relentless burning of coal and oil, which is altering the planet's climate, melting ice caps, making oceans more acidic, and edging us ever closer to a day when no one will be able to take clean water, fertile soil, or abundant food for granted.

VANISHING NATIONS

With sea levels expected to rise three feet or more by the end of the century, climate change threatens the very existence of many countries in the Pacific. Already, Nauru's coast, the only habitable area, is steadily eroding. . . . The low-lying nations of Tuvalu, Kiribati, and the Marshall Islands may vanish entirely within our grandchildren's lifetimes.

Similar climate stories are playing out on nearly every continent, where a steady onslaught of droughts, floods, and heat waves—which some scientists expect will become even more frequent and intense with climate change—have displaced millions of people and led to widespread food shortages.

The changes have already heightened competition over scarce resources and could foreshadow a world in which conflicts are increasingly driven by environmental catastrophes.

GLOBAL WAKE-UP CALL

Yet the international community has not begun to prepare for the political instability that could result around the world.

I believe it's crucial for the international community to recognize climate change as a threat to international peace and security. It is a danger as great as nuclear proliferation or global terrorism, and the stakes are too high to ignore until after a disaster is upon us. . . .

I forgive you if you have never heard of Nauru—but you will not forgive yourselves if you ignore our story.

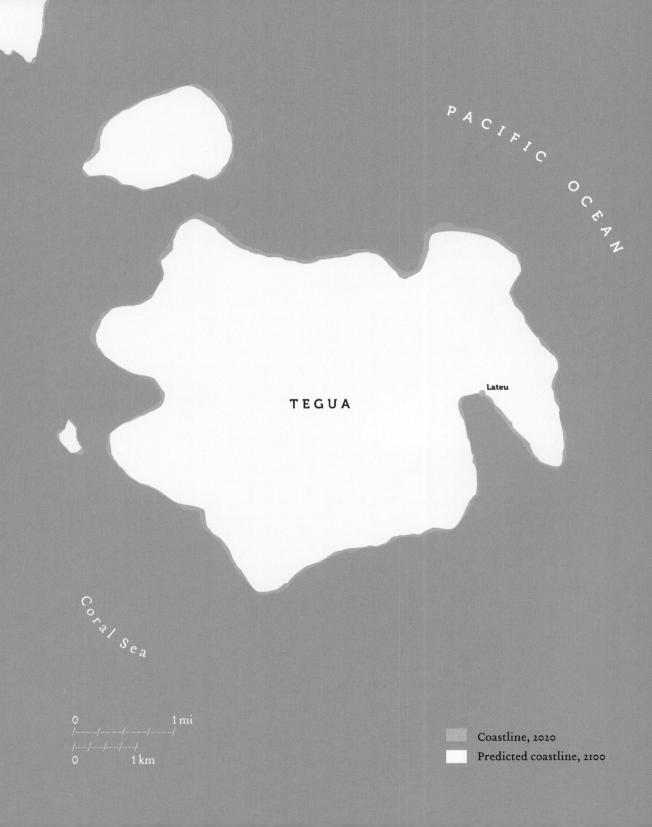

PACIFIC OCEAN

TEGUA

Lateu

Coral Sea

0 1 mi
/----/----/----/----/
/----/----/----/
0 1 km

Coastline, 2020
Predicted coastline, 2100

Ripablik blong Vanuatu
Republic of Vanuatu

15.3767° S
166.9592° E

Archipelagic nation of 82 small, volcanic islands

4706 sq. mi. (12,189 km²) | Tegua: 12 sq. mi. (31 km²)

Population: 304,043 (2022 est.) | Tegua: 58

98.5% Ni-Vanuatu

Languages: Bislama, English, French, over 100 Indigenous languages

Mean Elevation (along coast): 16.4 ft. (5 m) | Highest Elevation: 6158 ft. (1877 m)

476 MI / 975 KM
-> SOLOMON ISLANDS (24)

752 MI / 1211 KM
---> FIJI (26)

1235 MI / 1988 KM
----/-> TONGA (32)

1200 BCE
Lapita people settled the islands; archaeological finds of Lapita pottery date back to this era

1606 CE
Portuguese explorer Pedro Fernandes de Queirós on a Spanish expedition arrived on the largest island, which he named Terra Australis del Espiritu Santo (The Southern Land of the Holy Spirit). Espiritu Santo remains the largest island's name

1768
French explorer Bougainville alighted on the islands and named them the Great Cyclades

1774
Captain Cook voyaged through and mapped the islands, naming them the New Hebrides

1906
France and Britain took control through the Joint Condominium

1980
Independence

2020
Cyclone Pam struck

On Vanuatu, which has nine active volcanoes (seven on land and two underwater), even the birds have adapted to them. Vanuatu megapodes, also called incubator birds or mound-builders, lay their eggs in the hot volcanic soils to incubate them. Medium-bodied like turkeys with a small head, megapodes have large feet and strong claws with which to dig and build mounds. The mounds can take eleven months to build and reach 3 feet (0.9 m) in height and 10 feet (3 m) in width. They consist of decomposing vegetal matter: twigs, leaves, and the like. Sometimes the megapodes use sun-heated sand to incubate. On Vanuatu they also use warm volcanic soil. The heat generated by the mounds, rather than the bird's body heat and roosting, incubates the eggs. The female lays an

egg every few days for thirty days, then walks away, leaving the mound to incubate and the male to maintain its ideal incubation temperature. Is this where the expression "free as a bird" came from? The eggs hatch on their own and neither parent tends to feeding—common for reptiles, such as crocodiles, lizards, snakes, and turtles, but rare among birds.

The Republic of Vanuatu consists of eighty-two *volcanic islands* in the South Pacific Ocean. About sixty-five are inhabited. The archipelago spans 810 miles (1300 km) in a Y-shape, also on the national flag. Vanuatu rests to the east of Australia and the west of Fiji, to the south of the Solomon Islands and to the north of New Zealand.

The terrain is fairly steep, mostly mountain summits and ridges jutting up from the ocean floor. *Vanua* (meaning "black stone" or "home") constitutes the islands. At least 35 percent of the country measures above 984 feet (300 m). The hilly regions are mostly forested, including with rainforests. Due to its steep terrain, only 9 to 15 percent of the land is used for agriculture.

Vanuatu rests in a region exposed to *cyclones*. In 2020 Cyclone Pam struck the islands and wreaked havoc, damaging much of the *infrastructure*, causing power outages, bringing down communication lines, destroying homes, and killing over a dozen people. Cyclone Pam and Cyclone Yasa were tied as 2020's second most intense tropical storms.

The nation also lies on top of the Pacific Ocean's *Ring of Fire*. Thus volcanic activity and earthquakes are common. They can lead to *tsunamis* and to subsidence.

Subsidence is the sinking of the earth's surface due to natural or human causes. Natural causes include tectonic shifts and earthquakes. Neighboring Solomon Islands (24) and Samoa (29) to the east are also experiencing subsidence. Human causes include the extraction of fluids, such as water or petroleum, which are issues on Isle de Jean Charles (48).

In northern Vanuatu rests the island of Tegua. Tegua is subsiding due to tectonic shifts that are pulling the island underwater. The island measures a mere 4 miles (6.48 km) in length by 10 miles (16 km) in width. In 2004, residents of the village Lateu relocated to higher ground about 984–1968 feet (300–600 m) inland. An elder said the village first flooded in the 1980s. Lateu was a low-lying settlement only 16 feet (5 m) above sea level.

Subsidence combined with sea level rise intensifies the inundation. According to a 2011 report published in the *Proceedings of the National Academy of Sciences*, between 1997 and 2009 the island subsided by 5 inches (12 cm) and the waters rose by 6 inches (15 cm) for a combined inundation of 11 inches (27 cm) (Ballu et al.). Although the aforementioned relocation to ground 49 feet (15 m) higher succeeded, the island's small size limits further retreats as a long-term solution. In 2005 the United Nations called the residents of Lateu the world's first *climate refugees*.

Grace Mera Colisa

INTEGRATION OF WOMEN

We talk
as if Women
are new-comers
to the planet,
as if Women
are new-arrivals
hanging in the wings.

Women
are mothers
of humanity.
Women are teachers of Society.
As such,
Women
cannot lay blame
on anyone
for their nonentity
because
Women
are party to
the maintenance
of an oppressive
macho status quo.

What needs
to occur
in the mind
consciousness
understanding
and practice
of men and women
alike
are these prerequisities:

To accept
women
as fellow humans
in the human society.

To accept and recognise
the existence
of women
in the Human
Community
and Society.

To accept
recognise
and respect
the Labour
as a valuable
Contribution
to the Life
Growth
Development
Progress
Prosperity
Perpetuity
Posterity
of Man
the Human
Community

Human Society
and Humankind
by
accepting
adopting
accounting or
quantifying
enumerating
remunerating
the product
of the Labour
of Women
as a valuable
essential
and Integral
Input by Women
into Nation Building
National Development
National Life.

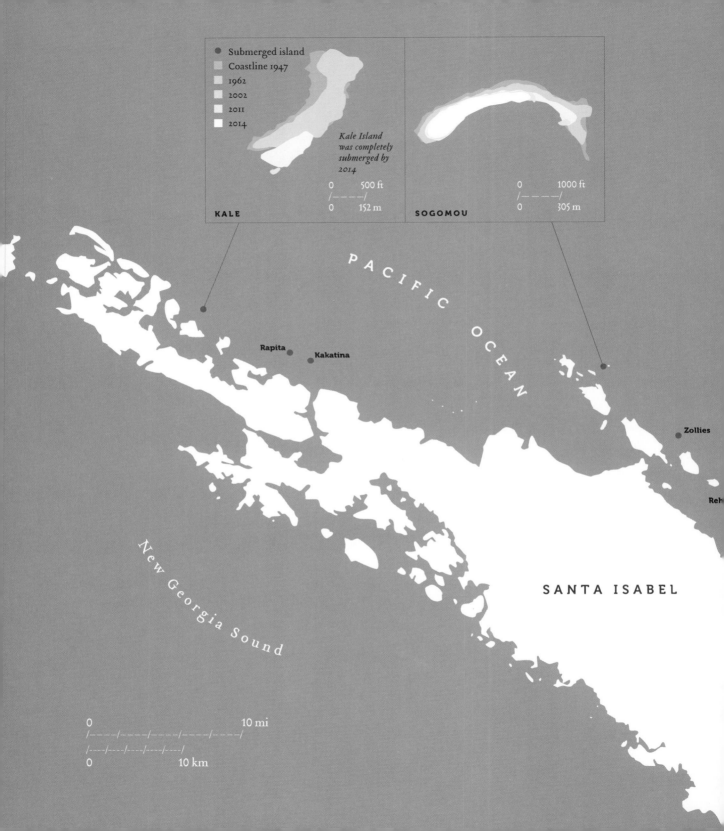

Submerged island
Coastline 1947
1962
2002
2011
2014

Kale Island was completely submerged by 2014

0 500 ft
/----/
0 152 m

KALE

0 1000 ft
/----/
0 305 m

SOGOMOU

PACIFIC OCEAN

Rapita
Kakatina

Zollies

Reh

SANTA ISABEL

New Georgia Sound

0 10 mi
/---/---/---/---/---/
/---/---/---/---/
0 10 km

Solomon Islands

9.6457º S
160.1562º E

Archipelagic nation of 2 island chains, 1000 volcanic islands and coral atolls

11,000 sq. mi. (28,400 km²) | Santa Isabel: 1158 sq. mi. (2999 km²)

Population: 702,694 (2022 est.) | Santa Isabel: 26,158 (2009 census)

94.5% Melanesian, 3% Polynesian, 1.2% Micronesian

Language: English

476 MI / 975 KM
-> VANUATU (23)

1132 MI / 1821 KM
----/> PAPUA NEW GUINEA (25)

1207 MI / 1943 KM
----/-> TUVALU (27)

30,000 BCE Papuans from New Guinea settled the Solomon Islands	2000–1200 Lapita people settled the islands	1768 French navigator Louis-Antoine de Bougainville traveled through and named Choiseul after a French diplomat	1886 Germany and Britain divided the Solomon Islands among themselves: Choiseul, Santa Isabel, the Shortlands, and Ontong Java Atoll became part of the German Solomon Islands Protectorate	1899 Germany transferred islands in the German Protectorate to the British Protectorate	2007 8.1 earthquake triggered tsunami

4000 Austronesians settled the Solomon Islands	1568 CE Spanish explorer Álvaro de Mendaña de Neira landed on the islands, naming them the Islas de Salomón	19TH CENTURY Blackbirding took place in the Solomon Islands to supply Fiji with labor	1893 Britain named the southern Solomon Islands the British Solomon Islands Protectorate	1978 Independence	2014 Cyclone Ita struck; 23 killed, 9000 became homeless, 50,000 persons affected, US$107.8 million in losses

Reef islands are the shapeshifters of the sea, but not like Māui, a trickster who exists in mythology throughout Oceania. In Maori legend Māui went fishing and pulled up a giant fish that shape-shifted into an island, Te-Ika-a-Māui (The Fish of Māui in Maori, also known as North Island of New Zealand). According to Hawaiian mythology, Māui used a magic fishhook and pulled up various islands from the ocean. The stories of Māui are traced as far as New Guinea, neighbor to the Solomon Islands.

Unlike in the Māui legend, reef islands do not emerge from the ocean. Reef islands are particularly vulnerable to erosion because they consist of sand and gravel on top of low-lying coral reefs. As a result, they shape-shift not up from below, like the islands Māui pulled up, but rather down from above and back into the sea. Since sea level erodes and inundates, it exacerbates this vulnerability.

In May 2016, dramatic headlines announced scientists had discovered that five uninhabited Solomon Islands had disappeared and six more islands, two of them inhabited, were severely eroded. The report tracked the shifting shapes of thirty-three reef islands between 1947 and 2014 in "two areas of the Solomon Islands with the highest density of exposed reef islands: Isabel and Roviana" (Albert et al. 3).

According to the scientists, in addition the fact that the islands are reef islands and sea level rise erodes, further factors, including higher winds and resulting higher waves as well as local tectonics, led to the islands' disappearance.

The islands' submergence might surprise, since the Solomon Islands, like other volcanic islands in the region, such as Vanuatu (23), Papua New Guinea (25), and Fiji (26), are typically considered less at risk for sea level rise, as these islands are mostly more mountainous and have lower population densities.

Yet to assume the Solomon Islands will be unaffected would be wrong. While the five reef islands off the northern coast of Santa Isabel eroded away, the report found a further six in this area have shrunk by over 20 percent between 1947 and 2014. These six islands are uninhabited but visited regularly for fishing. The eroded islands near Santa Isabel include Rapita, Kakatina, Zollies, and Rehana. On these islands wave action was higher and a factor leading to erosion. Wave energy fluctuates, so part of the study involved calculating the changes from one decade to another between 1980 and 2009.

In addition to the waves, winds were more intense near Isabel. According to the study, "the rapidly eroding islands identified in Choiseul and Isabel are all exposed to northerly swell and wind events" (Albert et al.). Winds, like waves, fluctuate, too. So the study tracked these fluctuations by decade. The variations are partially cyclical, a result of the Pacific Decadal Oscillation, and partially a result of global warming. Since the 1990s, trade winds in the region have experienced an uptick. The winds and *swell*, in turn, lead to higher wave energy. Thus, the report argues, in addition to sea level rise, studies need to consider wind and wave energy to accurately gauge future shorelines.

Then there is the impact of local tectonic shifts. Neighboring Roviana to the southwest has been impacted less by wave energy and wind events and even more by earthquakes. The authors wrote: "The Roviana site experienced an 8.1 megathrust earthquake in 2007[,] which led to the reef islands in Roviana subsiding by up to 60 cm [24 inches]." Thus, the authors argue, "island *subsidence* can compound sea level rise rates and makes these tectonically active islands particularly vulnerable under accelerated sea level rise scenarios" (Albert et al. 6). So when assessing shoreline erosion, sea level rise needs to be read together with other factors, such as wind and wave energy and local tectonics.

One community has already relocated, in part due to the shoreline erosion. To the northwest of Santa Isabel lies Choiseul Island. Off its eastern coast, the tiny island of Nuatambu has been severely inundated. "In Nuatambu village," the scientists wrote, "over 50% of houses have been washed into the ocean as a result of dramatic shoreline recession" (Albert et al.). Thus "many families have relocated to the adjacent high volcanic island of Choiseul." "In addition to these village relocations," the scientists wrote, "Taro, the capital of Choiseul Province[,] is set to become the first provincial capital globally to relocate residents and services due to the threat of sea-level rise." Yet problems abound. The study argues that unfortunately "the relocation . . . has not been conducted in a systematic way to ensure that this small insular community remains intact." And not all families have moved off-island: "Some economically disadvantaged families have re-built temporary housing in increasingly vulnerable areas of Nuatambu."

Then there are the Reef Islands: sixteen islands in the easternmost Solomon Islands archipelago. The majority of the Reef Islands are atolls and at risk of inundation. Collectively the islands' population totals around fifty-six hundred. The inhabitants are believed to be descended from Tuvalu (27) to the east and speak a Samoic language.

Pileni, one of the Reef Islands, measures merely 660 feet (201 m) in width by 1600 feet (487 m) in length, and its population numbers about two hundred inhabitants. Few elderly live on the island, as they typically move to islands with greater health-care services; few adolescents live on the island, as the high school is located on neighboring Nifiloli. Pileni was hit by cyclones in the 1950s, in 1983, and in 1993, and it also experienced a tsunami in 1990. Pileni is particularly at risk of sea level rise. Storm surges and high tides have been inundating the island, causing erosion and salinizing the water wells. Sea level rise combined with drought has challenged agricultural food production. While fruit trees used to yield three times a year, now they only yield once a year. Fish stocks have also declined.

According to the Solomon Islands Red Cross, Pileni is inundated at least three times per year. The Red Cross has conducted workshops in Pileni that center community participation and exchanges to ascertain the impacts of sea level rise and the community's needs and wishes, in order to address them.

Like other archipelagic island nations in the Pacific, the Solomon Islands archipelago is split between two nations, due to colonization: the majority forms the Solomon Islands, while the northernmost Bougainville Island forms part of Papua New Guinea and is also part of an Autonomous Region engaged in an independence struggle. The Solomon Islands consists of two island chains that run diagonally between Vanuatu in the southeast and Papua New Guinea to the west.

Jully Makini

ON THE ROCKS

Stormy, tumultuous, cyclones,
one hundred mile an hour winds
heavy pelting hailstones
battering my boat,
driving me ever towards
sharp jagged rocks.

Creaking, crashing, crunching,
mast breaking, bow cracking,
water flooding, children panicking!
Boiling surf, pulling, sucking me down
into a deep, dark whirlwind
of despair, hurt and agony.

Struggling against currents
of jealousy, anger, bitterness.
Floating with undertones
of religious beliefs,
long suffering,
and forgiveness,
weighing me down.
My clothes heavily waterlogged
with custom and culture,
ever pulling me down
nearer to the rocks of divorce.

Struggling, fighting, submerging,
cut and torn by sharp abrasive coral,
grabbing slippery, slimy seaweed of deceit
that dissolves at my touch,
clutching straws of
flotsam and jetsam
to keep afloat
and hold this shaky boat
together.

Buffeted by gale force winds,
knocked senseless by the tidal waves of regret,
giving up all hope of survival,
narrowly missing poisonous coral.
Battered, torn, bruised,
thrown from this seething cauldron
of mess and chaos
into a peaceful bay of tranquil waters,
safe at last
in the haven of your arms.

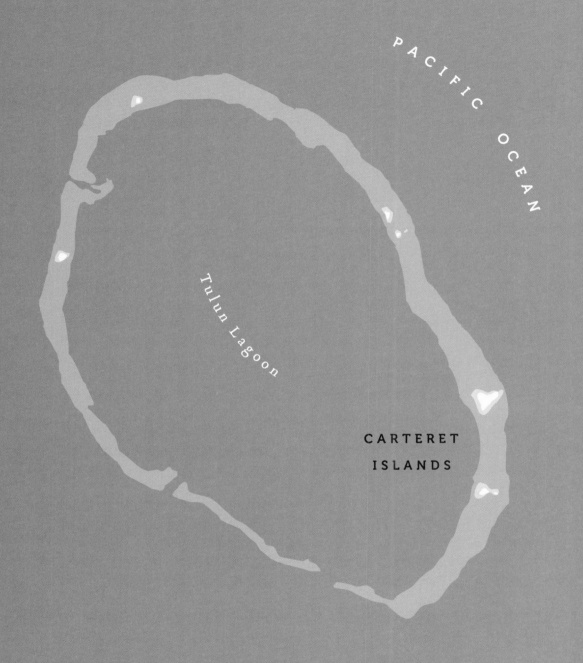

PACIFIC OCEAN

Tulun Lagoon

CARTERET
ISLANDS

0 5 mi
/- - - - /- - - - /- - - /- - - /- - - - /- - - - /

/- - - - /- - - - /- - - /- - - /- - - - /
0 5 km

■ Submerged coastline, 2020
■ Current coastline, 2020
□ Predicted coastline, 2100

Papua Niugini
Papua Niu Gini
Papua New Guinea

6.3150° S
143.9555° E

Archipelagic nation of eastern half of New Guinea, islands, and atolls

178,704 sq. mi. (462,840 km²) | Kilinailau Islands/Carteret Islands: 114 sq. mi. (295 km²)

Population: 9,593,498 (2022 est.) | Carteret Islands: 2600 (2006)

Melanesian, Negrito, Micronesian, Polynesian

Languages: 851 Languages: Tok Pisin, Hiri Motu, English | Carteret: Halia

Mean Elevation: 2188 ft. (667 m) | Carteret: 5 ft. (1.5 m)

1132 MI / 1821 KM
----/> SOLOMON ISLANDS (24)

2429 MI / 3909 KM
----/----/-> FIJI (26)

1052 MI / 1693 KM
----/> FEDERATED STATES OF MICRONESIA (19)

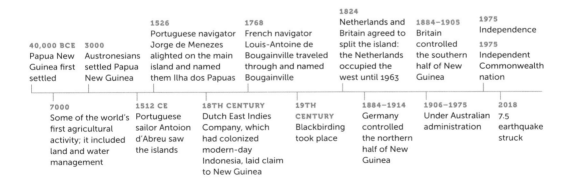

1824
Netherlands and Britain agreed to split the island: the Netherlands occupied the west until 1963

1884–1905
Britain controlled the southern half of New Guinea

1975
Independence

1975
Independent Commonwealth nation

1526
Portuguese navigator Jorge de Menezes alighted on the main island and named them Ilha dos Papuas

1768
French navigator Louis-Antoine de Bougainville traveled through and named Bougainville

40,000 BCE
Papua New Guinea first settled

3000
Austronesians settled Papua New Guinea

7000
Some of the world's first agricultural activity; it included land and water management

1512 CE
Portuguese sailor Antoion d'Abreu saw the islands

18TH CENTURY
Dutch East Indies Company, which had colonized modern-day Indonesia, laid claim to New Guinea

19TH CENTURY
Blackbirding took place

1884–1914
Germany controlled the northern half of New Guinea

1906–1975
Under Australian administration

2018
7.5 earthquake struck

The flightless cassowaries—related to emu and ostriches—live in the Independent State of Papua New Guinea, on other Indonesian islands as well as in northeastern Australia. Cassowaries can be up to 6 feet (1.8 m) tall, the third largest birds after ostriches and emus. Their feathers are like the fur of a black Pomeranian, but their body, by contrast, is perched atop very long legs. They have turquoise blue heads, crowned by a casque (is it a protective helmet, a ridge, a mohawk?). Reddish-pink wattles (flaps of skin) descend from their blue necks.

Biologists and ornithologists are of different opinions about the casque's purpose. Are they intended to attract mates as males' bright feathers often are? Are they supposed to protect their heads, for example, when they push their way through bushes in the dense rainforests they inhabit? Or do the fibers inside the casques amplify sounds, which are vital not only to their courting rituals but also to determining location? (Is it akin to echolocation?)

Like with the megapodes on Vanuatu (23), the males play the key role in parenting. They build the nest. They forgo food and water for fifty days, while they incubate the three to five green eggs. Then they feed, guard, and raise the young for twelve months until the young are able to forage and fend for themselves. Aside from this childrearing, cassowaries tend to be loners. So a dash of cassowary is a rarity.

Cassowaries are famous as one of the deadliest birds. They are pretty scary in appearance. They have powerfully strong long legs and kick when threatened. Their feet have three claws and the middle claw has a longer, dagger-like nail. According to ornithologist Ernest Thomas Guilliard, it has a "murderous nail[,] which can sever an arm or eviscerate an abdomen with ease." But they're flightless birds! Wouldn't you be a little feisty if you were a bird that couldn't fly?

When a scientist carried out an analysis of cassowaries' attacks in 2003, he found that of 221 instances, 150 involved humans and of these attacks 75 percent involved humans who had been feeding the cassowaries and 73 percent were cases where the bird snatched the food. So perhaps cassowaries are not murderers but rather self-protective birds because flightless and even more self-protective when hungry.

Cassowaries are an important part of the intricate ecosystem they inhabit. They are frugivores, meaning they have a mainly fruit-based diet. When they ingest the fruit, it passes through their system, leaving the seeds, which they distribute via their scat. Around the world different animals— from aardvarks to bats and from elephants to kangaroo rats—carry out this crucial function to disperse seeds.

Pesquet's parrot—also known as Dracula's parrot because the feathers on its head and back are black and bright red on its belly—continues this work. The parrots have a very long, hooked beak. According to one theory, the bird uses it to pick apart the cassowary droppings and find the seeds.

Cassowaries, like all birds, are descended from dinosaurs and among the world's oldest creatures. They survived the Cretaceous or fifth mass extinction. That said, cassowaries are believed to be closer to dinosaurs than other birds in two specific ways: namely due to their casque, which dinosaurs might have had, and to their enormous feet.

New Guinea is also home to one of the world's oldest species found nowhere else: the long-beaked echidna. These small-bodied mammals have coarse brown hair and white spines like a porcupine or a hedgehog but much shorter and less dense. They lay eggs like a platypus. But they incubate them in a pouch like a marsupial. Like the platypus and reptiles, they use the same orifice to urinate, defecate, and reproduce. They have strong legs with claws on the front paws. *And* they have a very long, thin boney beak with electro-receptors able to detect food in the ground, such as worms and insects. A few of these features are believed to date back to the time when some reptiles transitioned to mammals. Little is known about echidnas because they live in the high mountains of New Guinea and are rarely seen. Even more mysterious: they burrow underground for days at a time. No one knows why. There are only three known species of echidna. They are critically endangered. The two species that existed in Australia are now extinct. And as recently as 2015, only one biologist had conducted a systematic study. The echidna appear in Aboriginal rock art in northern Australia and in Indigenous Pawai'ia tales of New Guinea.

New Guinea actually boasts a richer biodiversity than Australia: while Australia dried out, Papua New Guinea is mostly humid, its interior became mountainous due to tectonic shifts, and the island is home to the third largest rainforests after the Amazon and the Congo. *Mangrove* forests line much of the southern coast of New Guinea. Further inland, near the border to Indonesia, are dry Trans-Fly savanna and grasslands similar to northern Australia and distinct from the rest of New Guinea, which is mainly rainforests. They give way to lowland jungles where the cassowary lives. Then, in the higher central zone, a mountainous region called the Highlands runs west to east. It reaches over 14,000 feet (4267 m) in height. The trees at this height are stunted, gnarled, and overgrown with moss. The low-beaked echidna lives here.

A range of reptiles and birds inhabit the island, including an estimated forty species of birds-of-paradise, thirty-six of them unique to New Guinea. Many have puzzled over the abundance of birds on the island. No real predators exist on New Guinea as they do on other islands. All the mammals are all fairly small. In fact, a bird, the cassowary, is the largest animal.

The island of New Guinea is the world's second largest island after Greenland (1). As a result of colonization, the island of New Guinea is split between Western New Guinea or West Papua, a province of Indonesia, and Papua New Guinea on the eastern half. Papua New Guinea is the

world's fourth largest island nation-state (after Greenland, Indonesia, and Madagascar), and one of the world's most diverse countries, culturally and linguistically. Over eight hundred languages are spoken in Papua New Guinea.

New Guinea was settled at least forty thousand years ago and was among the first locations globally to exhibit agricultural activity; it involved land and water management. It has a long history of voyaging. Indigenous Motu, the original and current inhabitants of the area where the capital city of Port Moresby is now located, designed *lakatoi*, multihulled sailing crafts with crab-claw sails that widen at the upper edge to catch the stronger wind. The Motu use the lakatois to carry out the traditional *hiri* voyages through the waters of the Gulf of Papua to secure supplies of the starchy sago.

New Guinea rests just south of the equator and to the north of Australia. For tens of millions of years, New Guinea and Australia were connected by a land bridge. Then sea levels rose twelve thousand years ago. Much of the shared flora and fauna reflects this former physical connection. For example, marsupials, such as the spotted cuscus and tree kangaroos, live both in northern Australia and on New Guinea. The spotted cuscuses are cat-sized creatures with big brown, yellow-rimmed eyes and an opossum-like tail. They have lemur-like brown eyes lined in yellow. The males have a brown fur coat with splotches of pale yellow fur like bleach-spotted jeans. The tree kangaroos, as the name suggests, inhabit trees, as all marsupials once did.

Papua New Guinea's rich biodiversity is at risk due both to mining and to sea level rise. About 560 miles (900 km) to the northeast of the island of New Guinea lies the Autonomous Region of Bougainville. Geologically, Bougainville forms part of the Solomon Islands (24). In fact, Bougainville lies a mere 30 miles (50 km) northwest of Choiseul Island in the Solomon Islands. Bougainville was split from the Solomon Islands in 1886 when Britain and Germany signed an agreement divvying up the Solomon Islands among themselves.

The mining giant Rio Tinto operated a copper and gold mine in Bougainville from 1972 to 1989. The area's inhabitants were frustrated by the environmental degradation twinned with a lack of revenue from the extraction returning to the local economy. The mine did boost the economy of Papua New Guinea, but little returned to the local community. Meanwhile, the degradation increased. These concerns combined with a secession movement led to uprisings and were among the factors that led to the Bougainville Conflict (1988–1998).

Due to the fierce opposition, the mining stopped. Yet it had already poisoned the rivers and the soil. Most of the area's inhabitants rely on the waters for bathing and washing and for potable water that supplements their rainwater catchment. In 2020, they filed a lawsuit against Rio Tinto for poisoning its water and soil.

Located about 53 miles (86 km) northeast of Bougainville are the Carteret Islands. Their population is related to that of Buka Island, the second largest in Bougainville. The Carteret Islands total 0.2 square miles (0.6 km²). What was once a low-lying *atoll* ring is now mostly submerged and consists of five to seven islands. An estimated 50 percent of the land has disappeared since 1994.

Here, sea level rise is not the only issue. Drought means water shortages are common. Most of the potable water comes from *rainwater harvested* in catchment tanks. As a result of soil *salinization*, it is difficult to grow food and it has become scarce. Due to the lacking nourishment, schools often close early because children cannot concentrate.

In 2005, one week before the annual UN climate negotiations, environmental journalist John Vidal reported in *The Guardian* that "yesterday a decision was made that will make their group of low-lying islands literally go down in history . . . the Carterets' people became the first to be officially evacuated because of climate change." Plans to address the issue have been made.

Here, like in Fiji (26), relocation is on the table. In 2007, the Council of Elders founded the nongovernmental organization Tulele Peisa (Sailing the Waves on Our Own) led by Ursula Rakova to address the need to relocate (Munoz). The following year, they released a plan for *resettlement* in Bougainville. Thus far, the financial costs associated with relocation have been prohibitive. Moreover, in December 2019, 98 percent of the population voted for independence, meaning that Bougainville could soon become the world's newest country, which could complicate the resettlement plan. While some islands, such as Kiribati (21), have bought land on another island nation to "Migrate with Dignity," intra-island resettlement due to sea level rise is also not uncommon.

Kamalau Tawali

PACIFIC TINGTING

Not the thoughts of Chairman Mao,
Not the genius animality of Stalin,
Not the evil calculation of Marx's dialectics,
Not the greed of capitalists' inhumanity,
Not the piousness of soft clergymen,
Not the rationalization by scientists and
 philosophers of immorality,
Not the nihilism of intellectuals,
Neither the brutality of fascism,
Nor the sentimentality of detente,
By the dynamism of quietneness [*sic*]
In the heart of our people.
Checking each fault,
Calming each fear.
Speaking softly as a land breeze at sunset . . .
Of shedding greed,
Of shedding hate.
New men, new women.
Our latent might,
Pacific free.

Note: Tingting is a New Guinea Pidgin word
meaning "the mind" or "thought."

Philomena Isitoto

THE FIVE SENSES

I like the smell of new-ripened oranges;
And newly picked yellow pumpkin;
The sweet smell of roasted pig;
The colourless smell of hot taro;
The passing salt breeze of the sea;
And the scent of flowering shrubs.

What sounds now come into my ears?
The stream, rushing down its rocky wall;
The bumping truck along the rough road;
The groaning of hungry pigs;
Drop, drop, of falling rain on a roof;
And tapping of a bird on a hollow trunk.

I love to see the beauty around me:
People in straight lines like marching ants;
The silver moon shining on green leaves,
Making them glassy and silvery;
The glorious sun rising in the early dawn;
And the calmness of the blue Pacific Ocean.

What's that I feel attacking me?
Only the blazing sun that strikes my body.
The bite of a black ant surprises me;
Sharpness of roughest rock hurts my feet;
The softness of bed sends me to sleep -
But the stinging mosquito wakes me.

It's my taste which I rely on:
The sweetness of taro satisfies me;
Starchy kaukau helps my growth and
The protein of fishes brings saliva to my mouth;
Greasy pig is horrible on my tongue;
But coconut liquid quenches my thirst.

Kamalau Tawali

WHO HOLDS THE STEER?

A canoe now sets for sailing,
Her sails hang like huge claws in the calm lagoon.
I hear the sounds of its conch shell,
And the voices of the men
Who will sail it through unknown waters.
May they travel back in hearts and minds,
Our ancient seafarers millenniums before Cook,
Their compasses, the stars, winds, tides and current,
But above all each other.

That canoe out there has not even lifted its anchor,
Yet its crew are at each other's throat.
Not in mutiny,
But as to who should hold the steer.
I, the old man who sees into the past
And into the future,
See storms out there to fight
And treacherous reefs
With their ceaseless mocking smiles to avoid.
They must decide.

The evening sky is blotted out.
The anchor has come aboard.
They will sail.
Careful, careful, O youth of adventures,
The sea has a voice
According to our ancient literature,
And it must be listened to.
"Togetherness, togetherness,"
Says the voice in the still sunset sky,
That is your secret."

Kamalau Tawali

SIGNS IN THE SKY

Facing the sunless western sky
what was in his mind?
What could he see in the sky?
Like a man with his mind adrift
he whispered to himself.

He looked north, he looked south
then he raised his left hand to his face
and counted the member.
And he raised his right hand up to his eyes
and he counted the fingers once more.

Ten—ten—yes, ten days!
Ten days since the wind started blowing.
Tonight shall see the end of the storm
and the beginning of the good sky -
according to our ancient calculation.

And his mind remembered the days:
when trees were falling
canoes were sent adrift
and houses blown down -

Tonight the skies are red
from the west to the eastern horizon.
The signs are in the sky. -
The wind has been appeased -
calm days return to us.

PACIFIC OCEAN

VANUA LEVU

Vunidogoloa Village

0 20 mi
/----/----/----/----/----/----/
/----/----/----/----/
0 20 km

Coastline, 2020
Predicted coastline, 2050
Predicted coastline, 2100

Matanitu Tugalala o Viti
Republic of Fiji

17.7134º S
178.0650º E

Archipelago of over 330 islands and 500 islets

7056 sq. mi. (18,274 km²) | Vanua Levu: 2157 sq. mi. (5587 km²)

Population: 943,737 (2022 est.) | Vanua Levu: 135,961 (2007 census)

56.8% i-Taukei (Fijian), 37.5% Indo-Fijian, 1.2% Rotuman

Languages: Fijian, English, Hindustani

Highest Elevation: 4344 ft. (1324 m)

752 MI / 1211 KM
---> VANUATU (23)

500 MI / 804 KM
--> TONGA (32)

733 MI / 1179 KM
---> TUVALU (27)

1500–1300 BCE Austronesians (Lapita) settled Fiji

1643 CE Dutch explorer Abel Janzsoon Tasman sighted the islands

19TH CENTURY Blackbirding took place to supply plantations with labor

1970 Independence

2012 Cyclone Evan hit Fiji

2016 Cyclone Winston hit Fiji

1100 Trade with Tonga and Samoa established

1774 British captain James Cook sighted the islands

1874 Britain colonized Fiji

1987 Two coups

2014 Return to parliamentary democracy

2018 Cyclone Gita struck Fiji

The Republic of Fiji has already adopted a plan that found 830 communities vulnerable to sea level rise and cyclones and in possible need of relocation. To date, more than eighty communities have been earmarked for future resettlement. At least four villages have already moved.

Sea level rise is disproportionately affecting this part of the Pacific Ocean. As Elisabeth Holland, director of the Pacific Centre for the Environment and Sustainable Development at the

University of the South Pacific, put it: "The worst case scenario is that we would be looking at one to three meters [3.28 to 9.84 feet] of sea level rise [in the next 100 years]."

Additionally, numerous *cyclones* have struck Fiji. In 2012, Cyclone Evan hit and caused US$108.8 million in damages (2012 USD). In 2016, Cyclone Winston struck, killing forty-four and causing more than US$1.4 billion of damage (2016 USD). In 2018, Cyclone Gita caused US$606,000 in damage and was then the worst storm in living memory (2018 USD). Tropical cyclones are forecast to increase in frequency and intensity due to climate change.

In response to both sea level rise and the risk of cyclones, the government of Fiji adopted the National Adaptation Plan Framework in 2017, which proposed resettlement—namely *managed retreat* from the coast. This plan made Fiji one of the first countries globally to begin managed retreat via state policy.

Understandably, the moves were difficult. Communities left villages they had lived in for generations. They left the coast, which provided easy access to fish, a vital food source. They left behind cemeteries. They also left behind the remains of houses flattened by cyclones.

In late 2017, a team of scholars visited Vunidogoloa and Denimanu, two of four already moved villages, to assess "the outcomes of the relocations on those directly affected." As the scholars elaborate in their article, "relocating communities involves much more than simply rebuilding houses in a safer location" (McNamara, Piggott-McKellar, and Nunn).

Fiji has already taken many factors into account. In 2018 Fiji released the "Planned Relocation Guidelines" to outline them. According to an article published in 2019 in *Policy Forum,* in Fiji "they emphasize the importance of community consent, the conservation of traditions and cultural identities, and community involvement and engagement in decision-making" (Michael, Powell, and Ramatu).

Even if a life lived in one location cannot be duplicated, a relocation, as the first team of scholars put it, "involves providing the right conditions for people to rebuild the lives they knew, such as equitable access to resources and services, social capital and community infrastructure" (McNamara, Piggott-McKellar, and Nunn).

In January 2014, all 153 residents of Vunidogoloa moved 0.62 miles (2 km) inland. It was the first Fijian village to relocate as a result of climate change.

Fiji sits north of New Zealand, east of Vanuatu (23), and west of Tonga (32). About one-third of its islands are inhabited.

Viti Levu, where the capital Suva is located, and Vanua Levu are the two main islands. They constitute about 85 percent of the nation's landmass, and about 95 percent of the population lives

on them: 75 percent on larger Viti Levu and 20 percent on Vanua Levu. Most of the larger islands are *volcanic islands*, so mountainous with very hilly interiors. As a result, about three-quarters of the population resides along the coastlines. The smaller islands are coral atolls.

Fiji has a rich biodiversity. According to the Convention on Biological Diversity, 50 percent of the flora on Fiji is endemic. About half of Fiji is forested. It was logged out intensely in the nineteenth century but a reforestation program has been actively replanting, especially the sandalwood, known locally as *yasi*.

The biodiversity is also present underwater. A fringing reef runs along the southern edge of Viti Levu and a long barrier reef, the Cakaulevu Reef, runs along the northern coast of Vanua Levu. It is among the world's longest barrier reefs, stretching for 124 miles (200 km). Kadavu Island, which lies just south of Viti Levu, is encircled by the Great Astrolabe Reef. These reefs teem with marine wildlife, including manta rays, sea turtles, and sharks.

Austronesians settled Fiji about thirty-five hundred years ago, initially establishing coastal settlements whose residents relied predominantly on fishing. They then moved further inland and established agricultural practices, growing cassava, kava, and taro. As early as 1100 BCE, Fiji traded with neighboring Samoa and Tonga.

Fijians designed some of the largest and swiftest sailing canoes. Among them is the *drua*, a double-hulled canoe, like the proa in Guåhan (17), one of the fastest boats. The drua's two hulls are of different sizes. The main hull is rounded and kept facing windward. Drua shunt, meaning they can reverse direction as the front and the aft part of the main hull are the same shape. Drua use the claw sail, which is wider at the top and can be moved from one side of the boat to the other when shunting. The Fijian canoes' design suggests influences from the Micronesia region. And it, in turn, influenced the *'Alia* boats in Samoa (29) and the *Kalia* boats in Tonga (32). The canoe is Fiji's national symbol.

Britain colonized Fiji in 1874. The British colonial government preserved some aspects of Fijian government—for example, land was not sold to foreigners. During British colonization, Indians were transported to Fiji between 1879 and 1916 as a source of labor for the cotton and sugar plantations. While the decision to preserve Fijian structures was beneficial for Indigenous Fijians, it was detrimental to the Indian laborers the British had brought in and created a two-tiered structure with lasting social, political, and economic consequences. Fiji's energy sources, in contrast to some Pacific Islands, are mixed: 34 percent is derived from fossil fuels; 38 percent from hydroelectric plants; and 27 percent from renewable energy.

At the 2018 UN climate negotiations, Fiji put forward the Talanoa Dialogue Platform: "Talanoa is a traditional word used in Fiji and across the Pacific to reflect a process of inclusive, participatory and transparent dialogue. The purpose of Talanoa is to share stories, build empathy and to make wise decisions for the collective good."

Tagi Qolouvaki

TELL ME A STORY (FOR UNCLE TALANOA)

He vows I am planted beneath the Frangipani
Promises I am seeded beneath the Bua.

He has his father's tongue,
Owns his mother's languages,
They sing honeyed songs together.
He has even tamed the palagi one—
It rides his tongue
And he is fertile with story.

Deftly, he weaves tales
Like the finest mats
Constructs memories
Tapa-tapestries
Stained in soil and
Colored with song.

We store them,
Cultural currency for the next birth
Death and wedding.
We carry them
To make us
Real.

He is a teller of tall tales, Talanoa

But what are stories if not lies
Though sweet as vakalolo
Cleaved to our fingers
Floating our souls
in the fat of coconut?

What are memories if not construction:
 They storyteller as tattooist
 Marking,
 And not marking,
 Brown skin.

And They say
If your pito-pito is unplanted
 You will wander
They say
If it is unplanted
 Home will elude you

Well mine is buried in story
Planted in a tall tale
And I wander
Yes,
And home is a story
Home is a story where the Frangipani flowers.

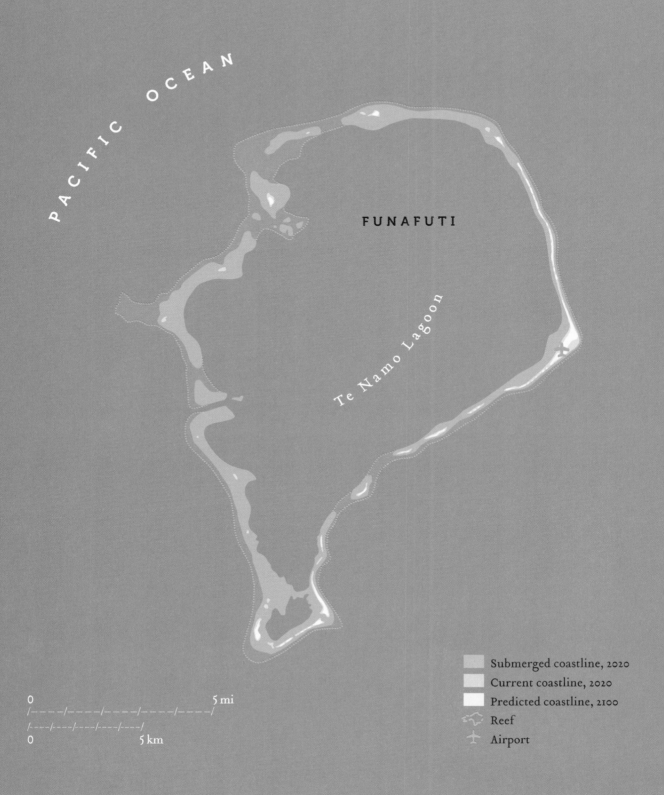

PACIFIC OCEAN

FUNAFUTI

Te Namo Lagoon

0 5 mi

0 5 km

Submerged coastline, 2020
Current coastline, 2020
Predicted coastline, 2100
Reef
Airport

Tuvalu

8.3100° S
179.1200° E

Archipelago of 9 islands, 8 of which are inhabited

10 sq. mi. (26 km²) | Funafuti: 0.9 sq. mi. (2.4 km²)

Population: 11,544 (2022 est.) | Funafuti: 6,025 (2012 census)

86.8% Tuvaluan, 5.6% I-Kiribati

Languages: Tuvaluan, English, Samoan, Kiribati (Nui)

Mean Elevation: 6.5 ft. (2 m) | Highest Elevation: 15.1 ft. (4.6 m)

```
      705 MI / 1134 KM
--> FIJI (26)

       962 MI / 1548 KM
---> VANUATU (23)

        1774 MI / 2885 KM
----/---> KIRIBATI (21)
```

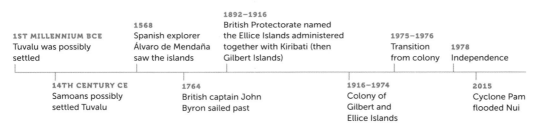

1ST MILLENNIUM BCE Tuvalu was possibly settled	1568 Spanish explorer Álvaro de Mendaña saw the islands	1892–1916 British Protectorate named the Ellice Islands administered together with Kiribati (then Gilbert Islands)	1975–1976 Transition from colony	1978 Independence
14TH CENTURY CE Samoans possibly settled Tuvalu	1764 British captain John Byron sailed past	1916–1974 Colony of Gilbert and Ellice Islands	2015 Cyclone Pam flooded Nui	

In 2014, a family from Tuvalu drew international attention when it emigrated to New Zealand and demanded to be granted refugee status as *climate refugees*. The United Nations 1951 Convention Relating to the Status of Refugees does not include climate change. But while Australia has rejected Tuvalu's attempts to negotiate resettlement, New Zealand has said it will accommodate Tuvaluans if necessary. Many Tuvaluans have already emigrated to Australia, Fiji, and New Zealand.

Collectively, Tuvalu's area totals just 10 square miles (26 km²), making it the fourth smallest nation. Its population numbers around 11,544. The archipelago consists of nine islands, featured on the state's flag as the nine golden stars against a background of blue. Tuvalu means "eight," referring to the eight inhabited islands. The islands consist of three *reef islands* and six *atolls*; that is, they are all low-lying and highly at risk of sea level rise.

The archipelagic nation lies just south of the equator about halfway between Australia and Hawai'i. The nation's islands run northwest to southeast in a chain measuring about 420 miles (676 km) in length. Tuvalu is encircled by other Pacific Island nations: to the north is Kiribati (21), to the east Tokelau (28), to the southeast Samoa (29) and Tonga (32), to the south Fiji (26), to the southwest Vanuatu (23), to the west the Solomon Islands (24), and to the northwest Nauru (22).

Tuvalu has been inhabited for at least a thousand and possibly up to three thousand years. In the fourteenth century, Samoans possibly settled Tuvalu. Subsequently, islanders from Tonga and the Cook Islands arrived. Like other Pacific Islands, Tuvaluans used canoes—specifically *paopao* (single outrigger canoes) and *lualua* and *foulua* (double-hulled outrigger canoes) for fishing or interisland travel (see Selina Tusitala Marsh's poem "A Samoan Star-chant for Matariki" following). The Tuvaluan language is closely related to Samoan, which is also spoken on the islands. Kiribati is spoken on the Tuvalu atoll Nui.

Together with Kiribati (then referred to as Gilbert Islands), Tuvalu (then referred to as Ellice Islands) was administered as a British Protectorate from 1892 to 1916 and then as the British colony of Gilbert and Ellice Islands until 1974. In 1975 the transition toward independence began. In 1978, Tuvalu became independent. Tuvalu remains one of sixteen British Commonwealth realms. Akin to other small island nations in the Pacific, such as Kiribati (21) and the Solomon Islands (24), and in the Caribbean, such as Dominica (40), Grenada (35), and Saint Lucia (38), Tuvalu has no military.

Most residents rely on subsistence agriculture and fishing. Rainwater catchment provides the freshwater. Bananas and breadfruit grow, as do coconut palms and pandanus, as well as taro, but most of the island's food is shipped in. Obesity rates are among the highest globally on Tuvalu, due in part to the quality of food shipped in. Obesity rates are high throughout the region. The ten nations globally ranked highest for obesity rates are in Pacific Islands. Fish and copra are key exports, and fishing licenses generate almost half of Tuvalu's GDP. Remittances also form an important part of the economy.

Tuvalu's mean elevation is 6.5 feet (2 m) above sea level. It is one of the four low-lying island nations globally—alongside the Maldives (12), the Marshall Islands (20), and Kiribati (21)—most at risk due to sea level rise. Scientists are concerned that Tuvalu could be completely submerged by 2050.

As a result, Tuvalu is taking various actions. To reduce CO_2 emissions and its reliance on diesel shipped in for electricity, which is both expensive and CO_2 intensive, Tuvalu plans to install rooftop solar panels and battery storage systems. Currently on Tuvalu, as on Trinidad and Tobago (34),

Grenada (35), Saint Lucia (38), Puerto Rico (42), and other islands, most electricity—a whopping 96 percent—is derived from fossil fuels that are shipped in.

Tuvalu is also pursuing plans to construct an *artificial island* in the lagoon at the southern tip of Funafuti, an atoll and Tuvalu's capital. Well over half of the nation's population lives on the atoll of Funafuti. Funafuti actually consists of twenty-nine to thirty-three islets because so much of its atoll is submerged already that it does not form one contiguous land mass. The sole airport is located on Funafuti.

The artificial island will cost up to US$280 million. Prime Minister Kausea Natano stated that the new area would measure about 6.17 square miles (16 km²). Like other Pacific islands, Tuvalu is at risk not only because it is low-lying but also because it is extremely narrow. *All* of the population of Tuvalu lives within 0.62 miles (1 km) of the shore.

Selina Tusitala Marsh

A SAMOAN STAR-CHANT FOR MATARIKI

fetu tasi

I call forth Mata Ariki, the Eyes of God
to watch over Papatuanuku and her people
I call forth wishes for the new June moon
spoken in shadow corners
steaming in palmy places

fetu lua

I call forth the pickled eel in brine
lolling like tongues of story
let loose under a feasting sky
I call forth the moki and korokoro
to fatten nets
that they might feel the weight
of wealth in giving

fetu tolu

I call forth matariki ahunga nui
the overturning of the earth
the bearing of new seedlings
I call forth the kumara and kalo
rooting in fanua for this divine moment
of cyclic beginnings
I call forth the planting of all things
fresh in the soil of the mind

feta fa

I call forth the pakau
the six-tailed kites
to tickle the heavens
make us laugh
I call forth kite bulging with treasures
woven histories pressed
and plated by kuia thumb

fetu lima

I call forth the smaller hand
unfurling in the bigger
whanau spiralling like
an unfathomable prime
I call forth the harvesting of whakapapa
the sowing of blood lines
the clearing of weeds from graves
the tihei in that first born breath

fetu ono

I call forth the knotting of star-charts
by sinnet and shell
I call forth the vaka and all manner of vehicle
navigating by our light
into the long safe journey home
into the uncharted night

fetu fitu

I call forth the rising of my six sisters
in Ranginui's pre-dawn cloak
I call in greeting
talofa mata ali'i
ia orana matarii'i
aloha makali'i
kia ora matariki
I call forth the music of bone flutes
the chant, the song, the karakia
guiding the traveller's feet
and heavenward eyes

Selina Tusitala Marsh

FAST TALKING PI

For Anne Waldman

I'm a fast talkin' PI
I'm a power walking' PI
I'm a demographic, hieroglyphic fact-sheetin' PI

I'm a theorising PI
I'm a strategising PI
I'm a published in a peer reviewed journal PI

I'm a slot machine PI
I'm a lotto queen PI
I'm tote-ticket church bingo TAB PI

I'm a vegan PI
a rainbow warrior PI
I'm a protest sign against the rising waters PI

I'm a criminal PI
behind the bar graphs PI
I'm a gun smokin' patching totin' king cobra PI

I'm a fale PI
I'm a marae PI
I'm a living breathing dwelling of my ancestors PI

I'm a lazy PI
I'm a p-crazy PI
I'm a hard drinkin' hard speakin' where my eggs? PI

I'm a land-based PI
I'm a fanua PI
I'm a village is the centre of my world PI

I'm a harvesting PI
a copra sacking PI
I'm a buy tinned beef 'cos no more fish in reef PI

I'm a diabetic PI
I'm a heart-diseased PI
I'm a gout-inflated, incubated, case study PI

I'm a siva Samoa PI
I'm an ava-pouring PI
I'm a tulafale tonguing genealogy PI

I'm an independent PI
I'm a flag-raisin' PI
I'm a fa'alavelave lovin' givin' livin' PI

I'm a still PI
I'm a broken PI
I'm a wheelchair bound from drunken westie driver PI

I'm a standing PI
I'm a beehive PI
I'm a labour MP gonna be PM one day PI

I'm a quiet PI
I'm a small PI
I'm a take no lunch to school today but . . . anyway PI

I'm an all-black PI
I'm an all-white PI
I'm a gold silver bronze blue street-signed PI

I'm an angry PI
I'm a dawn-raided PI
I'm a crouching poly panther in grey lynn PI

I'm a shark-toothed PI
I'm a tatau PI
I'm a malu and a pe'a, flying fox let loose PI

I know how to be in this world
I know how to feed in its waters
I know how to read the stars and sea-birds
I know how to live off poetry
I know how to give it away

I'm a propertied PI
a self-employed PI
I'm a mocha-drinkin', horn-rimmed glasses, real
 TV PI

I'm a movin' PI
I'm a groovin' PI
I'm a nesian mystikstratospheric whippin' it PI

I'm a krumpin' PI
A go-for-God PI
I'm a colour-free gangsta wannabe for the Lord PI

I'm a BA PI
I'm an MA PI
I'm a PhD, BCOM, LLB, MD PI

I'm a bi PI
I'm a gay PI
I'm a cross-gendered, soul-blended, mascara'd PI

I'm a coloured PI
I'm a canvassed PI
an acrylic, oil PVC, four by two PI

I'm a bit of both PI
a chameleon PI
a hybrid, mongrelised self-satisfied PI

I'm a shadowing PI
I'm a fathoming PI
I'm an ocean, I'm the wave, I'm the depths of it PI

I'm a territorial PI
I'm a pure blood PI
I'm a border language Stop Do Not Pass Go PI

I'm a freezing works PI
I'm an IT PI
I'm a sewing, stuffing, soaking, shaking, stirring PI

I'm a talanoa PI
I'm a ta/va PI
I'm the space, the time, the tune, the transcending PI

I'm a pair of jimmy choos
I'm a size 12 in fuchsia please
I'm a no shoe fits the foot of an earth mama

I'm a royal PI
I'm a commoner PI
I'm a coup-supported, you and you and you, deported PI

I'm a white Sunday PI
An LMS PI
I'm a born-again no mandatory tithing PI

I'm tihei, that first born breath
I'm that pulsating cord
I'm that breaking water
I'm that loose knot threatening to tighten

I'm that blood clot PI
that topknot PI
that loosener of sun and skin and brothers PI

I'm a lover PI
I'm a mama PI
I'm a breast-feed till they tell you *I'm done now!* PI

I'm a Nafanua PI
I'm a warrior PI
I'm the breast-kept secret in ancient samoan warfare PI

I'm a dub dub dub PI
I'm a bebo PI
I'm a good lookin', face bookin' hookin' up PI

I'm a melting pot PI
an homogenous PI
I'm a skim milk green top fat free heterogeneous PI

I'm a denny's PI
I'm a sawadee PI
I'm a finger lickin' KFC MDs BK PI

I'm a matariki PI
I'm a slammin' poetry PI
I'm a riding high and whippin' the hide of a Clydesdale PI

I'm a niu FM PI
I'm a curtained stage PI
I'm a naked and I'm laughing and cartooning PI

I'm a vaka PI
I'm a star-charting PI
I'm a navigating by nissan navara PI

I'm a long poem PI
I'm a long song PI
I'm a smooth crooner softly lullabying PI

I'm a red-lipsticked PI
I'm a big-haired PI
a multi-coloured, stilhouetted fafafine PI

I'm a crying PI
I'm a laugh too loud PI
I'm a my *jandal your mouf* derek-wannabe PI

I'm a lali
I'm where we once belonged
I'm a dream fish floating
I'm wild dogs under my skirt
I'm search for nei nim'anoa
I'm a native daughter
I'm poétes du pacifique en couleur
I'm light in the crevice never seen
I'm the girl in the moon circle
I'm niu voices
I'm songs of love
I'm mi mere
I'm houses
I'm a pinnacle
I'm a nuanua
I'm blackstone
I'm tapa talk
I'm kakala
and langakali
and hingano
I'm tai, heart of a tree
I'm colonised people
I'm praying parents
I'm a shark-skin drum
I'm solaua, a secret embryo
I'm whetu moana
I'm a young artist in contemplation
I'm the choice of your parents I'm an act of war
I'm na buka vivinei malivi pa zinama roviana
I'm threads of a tivaevae
I'm cyclone country

I'm a theorising slot machine
bloodless coup jimmy choos
lover blood clot melting pot
shark-toothed brothers let loose
white Sunday lipp BA

I'm a fast talkin' PI

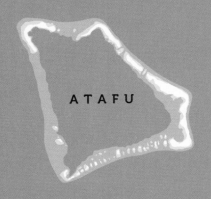

ATAFU

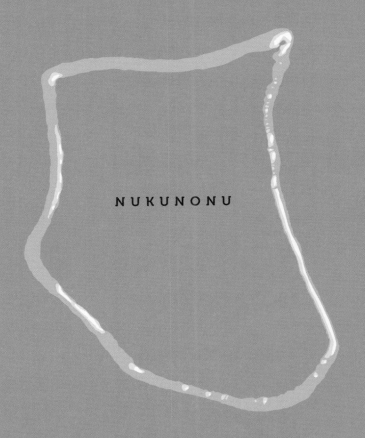

PACIFIC

NUKUNONU

0 — 1 mi
/—————/
/————/
0 1 km

0 — 1 mi
/—————/
/————/
0 1 km

Submerged coastline, 2020
Current coastline, 2020
Predicted coastline, 2100

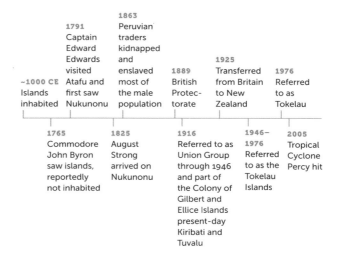

OCEAN

FAKAOFO

Tokelau NORTH WIND

9.2002° S
171.8484° W

Archipelago of 3 atolls

4.63 sq. mi. (12 km²) | 3 atolls: Atafu, Nukunonu,
 Fakaofo

Population: 1647 (2019 est.)

88.1% Tokelauan, 7.5% Tuvaluan, 5.8% Samoan

Languages: Tokelauan, English, Samoan, Tuvaluan

Highest Elevation: 16.4 ft. (5 m)

732 MI / 1178 KM
--> TUVALU (27)

1155 MI / 1859 KM
----/> COOK ISLANDS (31)

315 MI / 507 KM
-> SAMOA (29)

1863
Peruvian
traders
kidnapped
and

1791
Captain
Edward
Edwards
visited enslaved
Atafu and most of **1925**
first saw the male Transferred **1976**
Nukunonu population from Britain Referred
 1889 to New to as
~1000 CE British Zealand Tokelau
Islands Protec-
inhabited torate

1765 **1825** **1916** **1946–** **2005**
Commodore August Referred to as **1976** Tropical
John Byron Strong Union Group Referred Cyclone
saw islands, arrived on through 1946 to as the Percy hit
reportedly Nukunonu and part of Tokelau
not inhabited the Colony of Islands
 Gilbert and
 Ellice Islands
 present-day
 Kiribati and
 Tuvalu

0 1 mi
/————/

/----/
0 1 km

Tokelau counts among the smallest colonized archipelagic island nations globally. It consists of three *atolls*: Atafu, Nukunonu, and Fakaofo. The capital rotates among the islands. Tokelau rests about halfway between Hawai'i and New Zealand, sitting just south of the equator between Kiribati (21) to the north and Samoa (29) and American Samoa to the south, Tuvalu (27) to the west, and Pukapuka in the northern Cook Islands (31) to the east.

Geologically, the island chain also includes Olohega (Swain Islands), which the US claims and administers as part of American Samoa. Culturally, Tokelau is closely related to Tuvalu and Samoa. Linguistically, the Tokelauan language is related to Samoan. Tuvaluan is also a common language. (See Helen Tionisio's poem "My Father Speaks 4 Languages" following.)

Each atoll consists of concentric circles of a reef around the atoll around a lagoon. Tokelau's total land area equals a scant 4.63 square miles (12 km²). With around 1600 residents, it is the fourth smallest nation population-wise.

Most of the inhabitants rely on *subsistence* agriculture and fishing. About 60 percent of the land is used for agriculture. Bananas, breadfruit, coconuts, and taro are plentiful.

Freshwater shortages are a constant concern, and most of freshwater is caught via rainwater catchment.

Politically, Tokelau is currently a New Zealand Protectorate. Of a list of seventeen non-self-governing territories put together by the United Nations General Assembly that have yet to be decolonized, Tokelau is the only region occupied by New Zealand. With the exception of the Western Sahara, the territories are all islands. The list includes Guåhan (17) and Samoa (29). In 2006 and 2007, referenda were held to change the island's status to one of free association with New Zealand. They missed the two-thirds' threshold to pass. A new referendum has been put forward to be held by 2025, which marks one hundred years since Tokelau has been a New Zealand Protectorate.

Tokelau has the world's smallest economy. It relies on New Zealand for subsidies for about 80 percent of its national budget. Fishing licenses provide a key source of revenue. Additionally, remittances from family living abroad in the *diaspora*, especially in New Zealand, are vital. Four times more Tokelauans live abroad than at home, mainly in New Zealand and Samoa. All Tokelauans have New Zealand citizenship.

Tokelauans have emigrated for a variety of reasons. Among them are severe land shortages. These have been exacerbated by erosion. Gabion walls, which consist of shell- and stone-filled gabions or cages stacked on top of one another, have been erected along the shoreline in an effort to fortify the coastline and slow the erosion. The soil is also of poor quality. It is very alkaline and has high salinity, posing challenges to subsistence agriculture.

The nation's atolls are extremely vulnerable to sea level rise. Their highest elevation is 16.4 feet (5 m) above sea level. All of the population of Tokelau lives within 0.62 miles (1 km) of the shore.

Reaching Tokelau takes time. There are no airports. One can fly to the nearest island, Samoa, and travel over via boat, which takes about twenty-four hours. Travel between the islands also takes time. Nine hours between Atafu and Fakaofo, which are furthest apart. The boat that drops one off only stops by the islands once a week. For these reasons, unlike on many Pacific Islands, the tourism industry in Tokelau is minimal.

There are also no large shipping ports for large vessels, no buses, and apparently only three fossil fuel–powered cars. Most vehicles are electric. As a result of the lacking airport, shipping ports, and vehicles, Tokelau's emissions might be the world's lowest, contributing 2.86 kilotons or less than 0.000007 percent to global greenhouse gas emissions in 2017—and dropping. In 2012, Tokelau became the world's first nation to be 100 percent solar powered.

The US$829,000 Tokelau previously spent annually importing fossil fuels, it now plans to spend on essentials such as health care and education.

Helen Tionisio

A DAY IN THE VILLAGE

Tokelau
The seas the sky
The birds that fly
The roosters that crow
The memories I sowed,
Have grown

And I'm blown away
By the images that pave
A way in my mind
That leaves me pining
In my heart I'm reminding
Myself to always remember . . .

Falë
And its abundance
Of neighbours,
And work
And the windows
That opened up your homes
To the hustle and bustle
Of Village life
To the serenity
Of Sunday afternoons
And daily siestas
To neighbouring ears
Listening in on your
Overseas calls
On every conversation
As their mouths drip
Hungry for something to say
As they make their way
To their cousins house
Or the newsroom

Tokelau,
Where I learnt that
Sea toilets
Ain't just a place
To do business
But talk business
Start revolutions?
More like verbal exchanges
Symbolic of
What came out the other end.
At least
Out of a good gossip session,
You could say,
The fish were fed
And eventually,
We'd be fed

Eating Ota (with uto)
As we swim in the Lagoon
Maneas' radio blasting
Some of her favourite tunes
As boats go by
To feed their pigs
And we tried to figure out
Who it is
That passes by
As we float in our waters
In our cool, cool waters
On a late afternoon

Another day in the village
(And it's Lotu time soon!)

Helen Tionisio

MY FATHER SPEAKS 4 LANGUAGES

My Father speaks 4 languages
Broken english, Bit of Samoa, Fluent in Tokelau
 and Laughter
He knows how to tickle the butterflies in my stomach
Reminds me to never be afraid to laugh at yourself
And when the life get hard—you laugh

. . . you know i went to the real estate today,
 had a look at some houses . . .
went inside to ask some more questions about
 a couple of them
you know what the agent say to me?
"you can't afford those houses"
and you know what i do?
i just laugh and walk out

Laughter not only is medicating
it's death defying
death deterring
death repelling

My Father speaks 4 languages
Speaks Broken English, Bit of Samoa,
Fluent in Tokelau and Laughter
And he's going to live forever.

Helen Tionisio

ON THE EDGE

Stand
There
On the edge
Cliff tops
Bridges
Outskirts
Slums
Beaches
Housing projects
Reserves
Deserts
Atolls
Highlands
Highways
Urban
Rural
Inner Outer Edges
Though they
Push you
Pull you
Mar
Gin
All
Eyes
You
Ignore u
Rip u
Try 2
Waste u
Go ahead

Jump

Show them
Us
Coloureds
Know
How
2 Fly
We
Are
One
With
Water
With
Sky
There
Are
No
Mar
Gin
All
Eyes
No
Edges
In
Sky
Or
Water
Just an
Endless
Supply
Of
Colours

Samoa SACRED CENTER OR PEOPLE OF THE DEEP SEA

13.7590° S
172.1046° W

Archipelago of 2 large, 2 small, and several uninhabited islands

1097 sq. mi. (2842 km²)

Population: 206,179 (2022 est.)

92.6% Samoan, 7.0% Euronesian, 0.4% European

Languages: Samoan, English

Highest Elevation: 6096 ft. (966 m)

315 MI / 507 KM
-> TOKELAU (28)

395 MI / 635 KM
-> NIUE (30)

551 MI / 887 KM
--> TONGA (32)

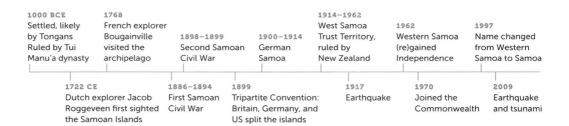

1000 BCE	1768			1914–1962		
Settled, likely	French explorer			West Samoa	1962	1997
by Tongans	Bougainville	1898–1899	1900–1914	Trust Territory,	Western Samoa	Name changed
Ruled by Tui	visited the	Second Samoan	German	ruled by	(re)gained	from Western
Manu'a dynasty	archipelago	Civil War	Samoa	New Zealand	Independence	Samoa to Samoa

	1722 CE	1886–1894	1899		1917	1970	2009
	Dutch explorer Jacob	First Samoan	Tripartite Convention:		Earthquake	Joined the	Earthquake
	Roggeveen first sighted	Civil War	Britain, Germany, and			Commonwealth	and tsunami
	the Samoan Islands		US split the islands				

According to Samoan mythology, Polynesia began in the Samoan islands, created by Tagaloa. He created the sky, the sea, the earth, the plants, and the people, as well as the islands of Manu'a in American Samoa; Savai'i, Tutuila, and Upolu in Samoa; and Tonga (32) and Viti (Fiji (26)). Historical relations existed among Samoans, Fijians, and Tongans.

Ancient Lapita pottery found in Malifanua Lagoon on Upolu confirm that the islands have been inhabited since at least 1000 BCE. And the Samoan language is believed to be among the oldest Polynesian languages and is related to Hawaiian, Maori, Tahitian, and Tongan.

Samoans have a long history of maritime voyaging. They used the *paopao* and *soatau,* both dugout outrigger canoes, as well as the *va'a alo,* a small outrigger with a sewn hull for fishing.

They also used the *amatasi,* a sailing outrigger. And they built *soatau,* longer and larger multiboom canoes. The *'iatolima* or *la'au lima,* for example, had five booms, which connected the canoe to the outrigger. *'Alia,* a double canoe, were also used.

The Samoan archipelago is stretched out west to east over a few hundred miles and encircled by Fiji (26) to the southwest, Tuvalu (27) to the northwest, Tokelau (28) to the north, Niue (30) and the Cook Islands (31) to the southeast, and Tonga (32) to the south.

Geologically, the Samoan archipelago includes the Independent State of Samoa and American Samoa. But like the Marianas (16, 17), the Caroline Archipelago (18, 19), and the Solomon Islands (24), the archipelago was split by colonization. Starting in the nineteenth century, Britain, Germany, and the US fought over Samoa, splitting the islands in 1899 in a Tripartite Convention, without Samoan participation. As a result, the eastern islands became a US territory, referred to since then as American Samoa, and the western islands were then known as German Samoa.

In the early twentieth century, the *Mau a Pule* (the Mau movement) organized to resist colonization. In 1909 the occupying German governor exiled Lauaki Namulau'ulu Mamoe and other leaders of the movement to Saipan in the Northern Mariana Islands (16), then also a German colony. In 1914, at the outset of World War I, New Zealand began governing the western islands that constituted German Samoa, renaming them the West Samoa Trust Territory.

During the global pandemic in 1918, a ship from New Zealand arrived and the ruling New Zealand administration allowed its passengers who had influenza to disembark. It led to an outbreak of influenza on the islands that killed about a quarter of the population. While it was not the first outbreak of diseases brought to the islands, it had the most severe effect.

The Mau uprising continued through various forms of resistance, such as not paying taxes or refusing to recognize the jurisdiction of courts. In 1929, in what became known as Black Saturday, the New Zealand police fired at a demonstration, killing eight and wounding many more. Former Mau leaders and affiliates were the nation's first heads of state when Western Samoa (re)gained independence in 1962.

In 1997 the archipelago changed its name from Western Samoa to Samoa. And in 2011, it jumped over the dateline: Samoa now sits just to the west of the dateline and American Samoa sits just to the east.

Samoa consists of two main islands and eight small islets, of which six are uninhabited. All of the islands are *volcanic.* The two large islands, Upolu and Savai'i, constitute 99 percent of Samoa's land area. While Savai'i is the largest Samoan island, the capital, Apia, is on Upolu, where 75 percent of the population lives.

The archipelago's islands are lush. Forests still cover over half of the islands. Along the coast, coconut trees grow. Samoan poet and author Albert Wendt writes: "Each island . . . has a high backbone of hills . . . between the strandline and the foothills lie undulating belts of fertile alluvium. These belts provided the main areas for agriculture and settlement" ("Guardians and Wards"). Taro is harvested. Rainforests are plentiful further inland along the hilly terrain. The climate is humid, and severe storms can occur during the wet season between December and April (see Sia Figiel's poem "Rain" following).

In the waters surrounding the islands, dolphins, geckos, pilot whales, porpoises, and turtles abound. Over fifty species of birds can be found across the archipelago, sixteen of them indigenous to Samoa, including the rare tooth-billed pigeon, Samoa's national bird.

The majority of Samoans live in villages along the coast. About 82 percent of the population is rural. Over 90 percent of the land in Samoa is communal and inhabited by a chiefly clan consisting of relatives. Stewardship of the land is vital to Samoans.

Agriculture is an important industry, accounting for two-fifths of Samoa's GDP and employing two-thirds of the labor force. The main crops are arrowroot, bananas, breadfruit, coconuts, and taro. Additionally, coconut products, such as copra and coconut oil, are exported. The service sector accounts for two-thirds of Samoa's GDP and employs 30 to 50 percent of the labor force. Tourism contributes 25 percent of GDP. Remittances are also an important source of revenue. In addition, food is imported.

Samoa relies on fossil fuels for 48 percent of its electricity, on renewable energy for 29 percent, and on hydroelectric courses for 23 percent of its electricity, unlike neighboring American Samoa, which derives 98 percent of its electricity from fossil fuels and an estimated 2 percent from renewable sources. American Samoa's figures are similar to those of other Pacific islands colonized by the US, such as Guåhan (17), Belau (18), Micronesia (19), Marshall Islands (20), and Hawai'i. This fossil fuel economy tethers American Samoa to the US, keeping it (energy) dependent.

Sea level rise is a concern on the Samoan archipelago, in particular how it intersects with earthquakes. In 2009, an 8.1 earthquake struck near Samoa causing extensive damage. The island chain rests on the *Ring of Fire*, so earthquakes and volcanic activity are common. The islands also sit at the northern end of the deep underwater Kermadec-Tonga Trench. The 2009 earthquake unleashed a *tsunami* with waves over 46 feet (14 m) high that caused over 170 fatalities in Samoa and Tonga. The earthquake led to an estimated US$147 million in damages and about two hundred deaths.

Earthquakes can lead to geological *subsidence*—that is, the sinking of rock or sediment. According to a 2019 study, Samoa has been sinking and thus has been impacted more by sea level rise (Han et al.). American Samoa has been more hard hit than Samoa (Han et al.). Prior to 2009, sea level rise in American Samoa was on par with the global average. Now it is approximately five times the global average. Sea levels on Samoa are predicted to rise an additional 12–16 inches (30–40 cm) by 2100.

Sea level rise, this research puts forward, is a lot more complicated than merely tracking elevation and mapping sea level rise onto it. Local conditions, which might include sink as a result of earthquakes or the extraction of groundwater or other fluids, can lower the level of the island, which will intensify the impact of higher sea levels. Subsidence affects not only Samoa but also neighboring Vanuatu (23), the Solomon Islands (24), and Isle de Jean Charles (48) in the Gulf of Mexico.

Sia Figiel

THE WIND

Blows through Malaefou. In the dead of the night. While leaves sing. To me. And I sing back. The song of the origin of the removal of Pili from the gathering place of the gods on earth—Le Lalolagi.

And the night breathes in and out. In and out. And the fragrance of flowers surrounds me. Embrace me. Manifesting differing realities. A dog. An owl. A cloud. A taupou. Dancing in the middle of the malae. And the aiuli throw themselves at her feet. Beat themselves too with oiled banana leaves. Fern. Leaves. Fern. Coral. Stones. Screaming to the moon they do. Screaming to the night they do. Eating grass. Stones. Grass. Lava. Until the sky falls in rain. And the blood flows and flows. Waking snails. Centipedes. Crickets. Who sleep and sleep and sleep. In the hollow of bamboo.

Sia Figiel

RAIN

Falls on the earth like a blessing. A blessing from the skies. Heeding the calls of cracks in the soil. Of thirsty kalo. Thirsty auke. Rivers. Auke. Rivers again.

That's when it rains hard. Real hard. Especially after a long time of sun only. No rain. Not a single drop. And everyone puts buckets out. Under their tin roofs. Or pans. Or bowls. And all of us kids run in the rain. Slide in the rain. Throw mud at each other. Smearing it on each other's faces. Igikia! We would yell out. And we play cowboys and indians.

And Ivoga who has asthma and can't breathe correctly. Who is not allowed to go outside when it rains sits in the house. Looking at all us kids play outside. And she yells out to the rain Go! Away! Come again another day. Us kids want to play! Rain-rain go away!

And we say shame back to her. And put our hands on our faces. And skip to my Lou my darling to the malae. And run some more and some more. Until our mothers call us in. Or until someone slips. And breaks something. And cries. And then we have to go in.

No matter how fun it is to be out in the rain.
No matter how fun it is to be.
No matter how fun it is.
No matter how fun.
No matter how.
No matter.
No.

Sia Figiel

TO A YOUNG ARTIST IN CONTEMPLATION (FOR ALLAN)

Y(our) anguish
is a flame
only the night
understands
a journey
with no beginning
no middle
no end

y(our) pain
a child of the salt
in the sea
that surrounds you
a journey
with no beginning
no middle
no end

listen to the stars for like the night
they too know of
your loneliness
and to the waves
in the distance
for they alone
hear your cry
in silence
the moon will
touch the part of you
—no one else sees
the one that cries
in the day

between your smiles
your laugh
birds will bring joy
from far away
you will hear it
on the tongues of leaves
—eternal joy of
the free spirit that you are
press it gently
to your heart
it is (y)our only possession
the one that will
carry you
carry you
carry you
throughout y(our) journey

and when no one else listens
and when no else understands you
go back to the sea
and scream
(in silence)
and the mana of salt
will heal
over and over
as you begin y(our) journey
again
and again
and again . . .

Niue

19.0544º S
169.8672º W

100 sq. mi. (260 km²)

Population: 2000 (2022 est.)

67% Niuean, 13% part-Niuean, 12% European and Asian, 8% other Pacific Islander

Languages: Niuean, English

Highest Elevation: 262 ft. (80 m)

395 MI / 635 KM
-> SAMOA (29)

671 MI / 1080 KM
--> COOK ISLANDS (31)

375 MI / 604 KM
-> TONGA (32)

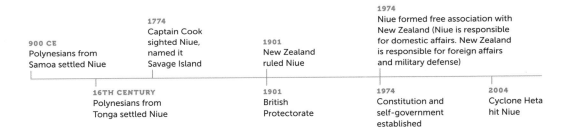

900 CE
Polynesians from
Samoa settled Niue

1774
Captain Cook
sighted Niue,
named it
Savage Island

1901
New Zealand
ruled Niue

1974
Niue formed free association with
New Zealand (Niue is responsible
for domestic affairs. New Zealand
is responsible for foreign affairs
and military defense)

16TH CENTURY
Polynesians from
Tonga settled Niue

1901
British
Protectorate

1974
Constitution and
self-government
established

2004
Cyclone Heta
hit Niue

Niue is the world's largest and highest coral island, nestled among Samoa (29) to the north, the Cook Islands to the east (30), and Tonga (32) to the southwest. The Niuean language is similar to neighboring Samoan and Tongan.

The island is often referred to as the "Rock of Polynesia" or "the Rock." In the island's center a plateau rises to about 200 feet (60 m). As a result, most people live around the coastline, parts of which are steep limestone cliffs. A reef encircles the island except for near Alofi, the capital.

About 70 percent of the island is forested. Banyan and coconut trees, palm trees and pandanus grow. And about 20 percent of the land is used for agriculture. Bananas, including the red fe'i bananas, coconuts, guava, lemons, limes, papaya, passion fruit, talo, and yams are harvested.

Humpback whales abound in the waters around Niue between July and October, migrating to these warm waters to nurse their young.

Like other Pacific Islands, such as Tokelau (28) and Vanuatu (23), Niue is at a high risk of *cyclones*, since it is located just to the south of the cyclone belt. Historically the island has experienced a cyclone every four years. Between 1969 and 2010 about ten cyclones per decade passed through the Niue Exclusive Economic Zone. Between 1982 and 2010 a quarter of the cyclones became severe—that is, Category 3 or higher. In 2004, Cyclone Heta hit Niue. It damaged the island extensively and killed two people.

Additionally, Niue's water supply is imperiled. Niue relies mostly on *rainwater harvesting* through catchment. Rising sea levels now threaten to salinize its aquifers.

As a result, many Niueans have emigrated to Aotearoa (New Zealand). Niue stands in free association with New Zealand and is a member of the Commonwealth. Niueans are also New Zealand citizens. An estimated fifteen times more Niueans live in the *diaspora* in New Zealand than on Niue. The remittances diasporic Niueans send home are vital to the Niue economy. Niue's population is the smallest for any independent insular nation-state.

Artist and author John Puhiatau Pule was born on Niue and emigrated with his family to Auckland, New Zealand, and later returned to Niue. He has written about the experience of growing up in New Zealand (see the excerpts that follow). After he returned to Niue, he was regarded as not quite local. Writing, as he put it, was key to "decolonizing his mind." His writings engage the experience of diasporic populations. Climate change and sea level rise threaten to increase the numbers of islanders who spend time outside of their homelands.

Niue produces the second lowest emissions from energy globally, second only to the Federated States of Micronesia (19).

John Puhiatau Pule

FROM **THE BOND OF TIME**

Dolphins, nectarines and turtles,
and all at once, they jump out from your
mouth. Tears miles long like the great River
of American, pour from the eyes of the albatross,
that flings its head from below your breast.

Fascinating parrots and doves too,
fly from the wheat of your palms
straight to heaven. A silent sea
pulls an island up by its roots and
you sleep there with horses from a dream.

John Puhiatau Pule

FROM **BURN MY HEAD IN HEAVEN**

One of the first sounds I heard was the sea down at Tautu. Men were down there casting the vaka on the
right wave to take them over the reef. My mum shifted me from her swollen belly to her breast and the
warm milk that oozed into my mouth knocked me out for the night. My Great-grandfather Pa threw
firewood outside our front door when he heard my cries. He told my Great-grandmother Salona that he
saw the kulukulu leave my mouth, which was an omen of song. Salona and Pa talked incessantly through
the first night of my cries, interpreting each movement of certain birds and sounds that coincided with
my sighs and pauses. Uncle said that Tagaloa the rainbow stretched from the sea to this house, which
meant we would be leaving for another country faraway. He knew which country the people were slowly
leaving to, and to mention the name would only bring bad luck. Salona hit Pa with a stick, warning him.
Stop that nonsense. She proceeded to translate the bit of moon in the sky as my guiding start, then glanced
over to the figure sitting outside under the mei tree as my true guide in life.

John Puhiatau Pule

FROM **DESIRE LIVES IN HIAPO**

Hiapo is a surface that cleverly accepts people into the fibre of Oceania, because it is by water that life is formed, where journeys begin and end.
[...]
So after reopening these folded treasures I sense that something new and unique must approach the nature of my inquiries. I am grateful for reading the languages that stipulate a galaxy, and the ocean that is my first name and the country of my birth that is my last name. The state house that offered sanctuary and poverty. I have walked through the gardens that were reproduced in hiapo. To that artist that made and painted the hiapo, I want to say: I have found a way in. We need the past to dwell in. Through roaming we generate the future to live.

Kūki 'Āirani
Cook Islands

21.2367° S
159.7777° W

Archipelago of 15 atolls and islands

92.7 sq. mi. (240 km²)

Population: 8128 (2022 est.)

81.3% Māori, 6.7% part-Māori, 12% other

Languages: Māori, English

Highest Elevation: 2139 ft. (652 m)

961 MI / 1547 KM
- - -> SAMOA (29)

671 MI / 1080 KM
- -> NIUE (30)

992 MI / 1597 KM
- - -> TONGA (32)

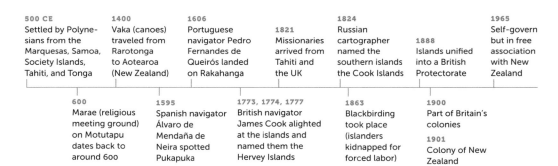

500 CE	1400	1606	1821	1824		1965
Settled by Polynesians from the Marquesas, Samoa, Society Islands, Tahiti, and Tonga	Vaka (canoes) traveled from Rarotonga to Aotearoa (New Zealand)	Portuguese navigator Pedro Fernandes de Queirós landed on Rakahanga	Missionaries arrived from Tahiti and the UK	Russian cartographer named the southern islands the Cook Islands	**1888** Islands unified into a British Protectorate	Self-govern but in free association with New Zealand

	600	1595	1773, 1774, 1777	1863	1900
	Marae (religious meeting ground) on Motutapu dates back to around 600	Spanish navigator Álvaro de Mendaña de Neira spotted Pukapuka	British navigator James Cook alighted at the islands and named them the Hervey Islands	Blackbirding took place (islanders kidnapped for forced labor)	Part of Britain's colonies **1901** Colony of New Zealand

The Cook Islands consist of fifteen islands spread over 849,425 square miles (2,200,000 km²) of ocean between Tonga (32) and Samoa (29) to the west, New Zealand to the southwest, and the Society Islands to the east. Niue (30) belongs to the island chain geologically but is administered separately. The Cook Islands consist of two ranges, the northern Cook Islands and the southern Cook Islands. The six northern islands are low-lying atolls, often not very wide. The nine islands in the southern range are a combination of low-lying atolls and mountainous volcanic islands.

Most of the population lives on the southern volcanic islands, mainly on Rarotonga, which is the largest island and along its coastline's white beaches. Reefs encircle the island with deep turquoise waters beyond. Inland, after fairly flat coastal lands and lush farmland and fields, the elevation climbs to a mountainous and forested interior.

Many Cook Islanders rely on subsistence agriculture and fishing. Plants harvested include bananas, breadfruit, coconut, pandanus, sweet potatoes, and taro. About 8 percent of the land is agricultural and about 65 percent, especially on the volcanic islands, is forested—a high percentage for Pacific Island nations. Rarotonga features one of few remaining pristine native forests in Polynesia. That said, deforestation is a major environmental concern. Overfishing is a problem as well. Commercial fishing is carried out by Japanese, South Korean, and Taiwanese fishing vessels. Fish include tuna, sharks, and rays. Shellfish are abundant. Sea turtles also nest on the islands. Humpback and other types of whales migrate through. Black pearls, a lead export, are harvested off the shores of the northern atolls.

As on other Pacific Islands, tourism is a major employer. Finance, too, is a major economic motor: the Cook Islands are, like the US Virgin Islands, a major offshore tax haven.

The Cook Islands stand in free association with New Zealand and is a member of the Commonwealth. Cook Islanders are also New Zealand citizens. The Cook Islands have the highest emigration rate of any island nation worldwide; it is followed by Micronesia (19) and Tonga (32). Twice as many Cook Islanders live in New Zealand than in the islands. Remittances from Cook Islanders living in New Zealand and aid from New Zealand are key to the Cook Islands economy measured by per capita income or GDP.

Like on other limestone islands and coral atolls, the main source of drinking water is a freshwater *lens*, which consists of rainwater that forms a layer over saltwater, being denser. *Rainwater harvesting* and wells are vital sources of freshwater. Drought induced by global warming runs the risk of depleting these water sources, especially on the northern islands.

Pukapuka is an atoll to the far north. Unlike the people on other Cook Islands, its people descended mainly from Samoans and Tongans. The current population is estimated to be about five hundred inhabitants. Its land area totals only 1.2 square miles (3 km²). Its language, Pukapukan, is distinct from Māori spoken on the other Cook Islands. Pukapuka rests a mere 7 feet (2 m) above sea level. With projections of 3 feet (0.9 m) of sea level rise by 2100 and 1 foot (0.3 m) by 2050, Pukapuka is already experiencing *saltwater intrusion*. According to the Intergovernmental Panel on Climate Change's Fifth Assessment Report: "Wave overtopping and wash-over can be expected to become more frequent with SLR [sea level rise], and this has been shown to impact freshwater lenses dramatically. On Pukapuka Atoll, Cook Islands, storm surge over-wash occurred in 2005.

This caused the freshwater lenses to become immediately brackish and [they] took 11 months to recover to conductivity levels appropriate for human use" (Terry and Falkland).

Additionally, *cyclones* pose a threat. According to a report produced for the United Nations Framework Convention on Climate Change (UNFCCC)'s conference in 2017, "the Cook Islands sit at the heart of the 'cyclone belt.' Between 1969 and 2010, the nation recorded 74 cyclones. . . . In 2005, five consecutive cyclones over a two-month period blazed through the nation" (COP 23).

Previously, most of the islands' energy was derived from oil shipped in. Nonetheless, in terms of CO_2 emissions, the Cook Islands are the eighth lowest country globally. Given the possible disruptions to the oil shipments by cyclones and the need to reduce CO_2 emissions, the Cook Islands have been shifting to renewable energy, in particular solar energy. According to the Secretariat of the Pacific Regional Environment Programme (SPREP), the Cook Islands have put forward a plan to be powered exclusively by renewable energy by 2020.

Recently, the islands have resumed discussions to change its name to something that, according to Deputy Prime Minister Mark Brown, "more reflects the true Polynesian nature of our island nation" (Pearlman).

Jean Mason

NOT THAT KIND OF MĀORI

At the Auckland Museum
An old Pākehā woman asks me
what the meaning of those patterns are
in the tukutuku panels on the walls of the whare
I'm sorry but I don't know
I'm not that kind of Māori
What kind of Māori are you, she asks
Cook Islands Māori
Never heard of them, she says.

Today, I have learned that there's story in the red,
black and white patterns
This one is the southern night sky: that's the Southern Cross
These are Takurua and Puanga.

Vaine-Iriano Rasmussen

LOST PEARL

My canoe is steered
By four winds,
Guided by eternal stars
That sink in your depths
The one almighty holds
My paddle
And steers my heart
Through the unknown night.

Hurricane bird high in
Your summit,
Give me your strength
In this doldrum of loss
Unleash my body
Let it soar in its climb
to seek that rest
In its search to find.

Pule'anga Fakatu'i 'o Tonga
Kingdom of Tonga

21.1790º S
175.1982º W

Archipelagic nation of ~170 islands

290 sq. mi. (750 km²) | Tongatapu: 100 sq. mi. (260 km²)

Population: 105,517 (2022 est.) | Tongatapu: 75,416 (2011)

97% Tongan

Languages: Tongan, English

Highest Elevation: 3432 ft. (1046 m) | Tongatapu: 213 ft. (65 m)

500 MI / 804 KM
--> FIJI (26)

551 MI / 887 KM
--> SAMOA (29)

376 MI / 605 KM
-> NIUE (30)

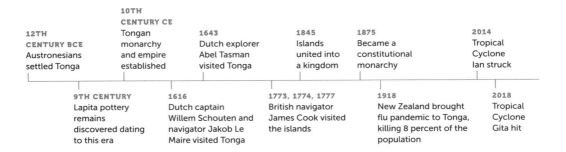

12TH CENTURY BCE
Austronesians settled Tonga

9TH CENTURY
Lapita pottery remains discovered dating to this era

10TH CENTURY CE
Tongan monarchy and empire established

1616
Dutch captain Willem Schouten and navigator Jakob Le Maire visited Tonga

1643
Dutch explorer Abel Tasman visited Tonga

1773, 1774, 1777
British navigator James Cook visited the islands

1845
Islands united into a kingdom

1875
Became a constitutional monarchy

1918
New Zealand brought flu pandemic to Tonga, killing 8 percent of the population

2014
Tropical Cyclone Ian struck

2018
Tropical Cyclone Gita hit

In some nations cows and elephants are sacred. In the Kingdom of Tonga flying bats, also referred to as flying foxes, are sacred and considered property of the monarchy. They thrive on the islands. On the main island Tongatapu, they live in Kolovai, a village on the western tip. There, a cauldron, cloud, or hanger of bats can be found dangling from trees.

Aside from the flying foxes, a bright green bird with a red throat and abdomen and blue crown known as the *henga* or the blue-crowned lorikeet lives on the islands, as do *malau* or incubator birds. They also live on Vanuatu (23). Also known as mound builders, these enterprising birds bury their eggs in warm soil to incubate them.

Rumor has it there are also fishing pigs on the eastern side of Tongatapu. They wander into the water at low tide seeking out seafood.

But back to the monarchy: the Kingdom of Tonga is the only Pacific island nation that has always been an independent nation with Indigenous self-governance. Since 1875, Tonga has been a constitutional monarchy. It is also among the Pacific islands that were inhabited the earliest—settled by the ninth century BCE.

Tonga consists of 171 islands in the southern Pacific Ocean. Tonga means "south," naming the archipelago's position relative to the central Polynesian islands. The majority of the population lives on Tongatapu ("sacred south"). The capital Nuku'alofa ("abode of love") is located on Tongatapu. Tongatapu is low-lying and consists of coral limestone and thus more at risk to sea level rise.

Near the *mangroves* that grow along some islands' edges and the lagoons, hangale, a short tree with red blossoms, grow. Langakali, trees with fragrant clusters of brown blossoms, once grew. Langakali flowers, the eponymous title of one of Konai Helu Thaman's volumes of poetry, were used to make lei (see Thaman's poems following).

Tonga's 290 square miles (750 km²) are spread out over 270,000 square miles (700,000 km²) of ocean. Engaging this range, Fiji-based Tongan anthropologist Epeli Hau'ofa wrote in "Our Sea of Islands": "There is a gulf of difference between viewing the Pacific as 'islands in a far sea' and as 'a sea of islands,'" continuing: "The first emphasizes dry surfaces in a vast ocean far from the center of power. When you focus this way you stress the smallness and remoteness of islands. The second," he argued, "is a more holistic perspective in which things are seen in the totality of their relationships" (see excerpt from Hau'ofa following).

The ocean, Hau'ofa underscores, connects the sea, islands, and all their life. Colonization, he argues, split apart the ocean people. By contrast, oceanic people, he writes, have traveled this vast sea for thousands of years, forging ties with other islands.

Tonga exports agricultural crops, mainly bananas, vanilla beans, coconut, copra, squash, and fish. That said, the island's economy is heavily reliant on remittances, from Tongans in Australia, New

Zealand, and the United States. About twice as many Tongans live in these countries as in Tonga. Remittances are closely followed by tourism. Tonga also relies on foreign aid.

One social scientist, Hau'ofa writes, referred to Pacific Islands as "MIRAB societies"—that is, "microstates condemned forever to depend on migration, remittances, aid and bureaucracy." Reframing this view, Hau'ofa writes: "The idea that the countries of Polynesia and Micronesia are too small, too poor and too isolated to develop any meaningful degree of autonomy is an economistic and geographic deterministic view of a very narrow kind that overlooks culture history and the contemporary process of what may be called world enlargement that is carried out by tens of thousands of ordinary Pacific Islanders right across the ocean . . . making nonsense of all national and economic boundaries, borders that have been defined only recently, crisscrossing an ocean that had been boundless for ages" ("Our Sea of Islands").

There's another type of modern-day network crisscrossing the ocean. In *The Undersea Network*, Nicole Starosielski discusses how islands often serve as the anchor points for fiber optic cables. She follows these cables from the US's West Coast to the South Pacific, pointing out that they are the material infrastructure underpinning the modern global information. The cables carry "99% of all transoceanic digital communications, including phone calls, text messages, email[s], websites, digital images and video[s], and even some television" (Surfacing.in). "It is cable systems, not satellites, that transport most of the Internet around the world," the site points out.

Starosielski writes that "recent moves to network previously uncabled locations [include] the Interchangeble cable to Tonga" (12). In 2013, an undersea fiber optic cable was installed to connect Tonga to Fiji and provide internet service. In January 2019 the cable was cut twice, leading to a two-week internet blackout. About 40 percent of Tonga's population uses the internet, ranking Tonga low globally for usage.

Artist Trevor Paglen made the location of underwater choke points of cables on the US's East and West Coasts and in Hawai'i visible via maritime charts and photographs (see Figures 4 and 5). In January 2022 an undersea volcanic eruption in Tonga led to a five-week internet disruption.

The islands rest at the northern end of the Tonga Trench, the world's second deepest trench, after the Mariana Trench (Federated States of Micronesia (19)). The 1242-mile-long (2000 km) Tonga Trench stretches from Tonga to New Zealand alongside the Tonga-Kermadec subduction system, one of the fastest-moving plate tectonic systems in the world. The Tonga Trench is also the southwestern tip of the Ring of Fire and one of the most active volcanic and earthquake zones, which can set off tsunamis.

Although Tonga already ranks among the ten lowest producers of CO_2 emissions globally, it has been working with the International Renewable Energy Agency to reduce emissions further by transitioning off fossil fuels. Tonga has ratcheted up renewable energy dramatically since 2011. In 2017, Tonga derived an estimated 26 percent of its electricity from renewable sources. It is among the world's top users of renewable energy, ranking behind Fiji (26) and Kiribati (21) and before Iceland and Finland. Of the twenty lowest emitters globally, all but two—Burundi and the Western Sahara—are island nations.

Konai Helu Thaman

THE SHELL

What does it matter
If the shell you've built
Around you is broken—
Think of the life
That is born . . .
New, eager to grow

The waves do not choose
Their beach
Nor the stars
The land
The trees will sway
With the wind
The gardenia must yield
At dawn

Once I tried
To shut you out
A feeble attempt perhaps
Now the thoughts are lost
And tangled
You refuse to fade away

It might have taken
Many a lifeline
For the polyps to build
An island
But it took only one dreamtime
To break the shell
And let life learn anew.

Konai Helu Thaman

STAY AWHILE

stay awhile
on the tree
my beautiful hingano
the salted winds
will bring you back
to me

if i could bend
the dateline
force the days back
to the comfort

of the night . . .
if I could run to Makuluva
sweat out all the dreams
of you
and others like you

I would go home
and rediscover
the soul of the universe
and decide that ours
is worth nourishing

Epeli Hau'ofa

FROM OUR SEA OF ISLANDS

Do people in most of Oceania live in tiny confined spaces? The answer is yes if one believes what certain social scientists are saying. But the idea of smallness is relative; it depends on what is included and excluded in any calculation of size. When those who hail from continents or from islands adjacent to continents—and the vast majority of human beings live in these regions—when they see a Polynesian or Micronesian island they naturally pronounce it small or tiny. Their calculation is based entirely on the extent of the land surfaces they see.

But if we look at the myths, legends and oral traditions, indeed the cosmologies of the peoples of Oceania, it becomes evident that they did not conceive of their world in such microscopic proportions. Their universe comprised not only land surfaces but the surrounding ocean as far as they could traverse . . . it, the underworld with its fire-controlling and earth-shaking denizens, the heavens above with their hierarchies of powerful gods and named stars and constellations that people could count on to guide their ways across the sea. Their world was anything but tiny.

"Oceania" denotes a sea of islands with their inhabitants. The world of our ancestors was a large sea full of places to explore to make their homes in, to breed generations of seafarers like themselves. People raised in this environment were at home with the sea. They played in it as soon as they could walk steadily, they worked in it, they fought on it. They developed great skills for navigating their waters—as well as the spirit to traverse even the few large gaps that separated their island groups.

Theirs was a large world in which peoples and cultures moved and mingled, unhindered by boundaries of the kind erected much later by imperial powers. From one island to another they sailed to trade and to marry, thereby expanding social networks for greater flows of wealth. They travelled to visit relatives in a wide variety of natural and cultural surroundings. . . .

Melanesia is supposedly the most fragmented world of all: tiny communities isolated by terrain and at least one thousand languages. The truth is that large regions of Melanesia were integrated by trading and cultural exchange systems. . . .

Evidence of the conglomeration of islands with their economies and cultures is readily available in the oral traditions of the islands and, too, in blood ties that are retained today. The highest chiefs of Fiji, Samoa, and Tonga, for example, still maintain kin connections, forged centuries before Europeans entered the Pacific, in the days when boundaries were not imaginary lines in the ocean but points of entry that were constantly negotiated and even contested. The sea was open to anyone who could navigate a way through.

This was the kind of world that bred men and women with skills and courage that took them into the unknown, to discover and populate all the habitable islands east of the 130th meridian. The great fame that they have earned posthumously may be been romanticised, but it is solidly based on real feats that could have been performed only by those born and raised with an open sea as their home.

Islanders in their homelands are not the parasites on their relatives abroad that misinterpreters of "remittances" would have us believe. Economists do not take account of the social centrality of the ancient practice of reciprocity—the core of all oceanic cultures. They overlook the fact that for everything homeland relatives receive, they reciprocate with goods they themselves produced, by maintaining ancestral roots and lands for everyone, homes with warmed hearths for travellers to return to permanently or to strengthen their bonds, their souls, and their identities before they move on again. This is not dependence but interdependence—purportedly the essence of the global system. To say that it is something else and less is not only erroneous but denies people their dignity.
[. . .]
Oceania is vast, Oceania is expanding, Oceania is hospitable and generous, Oceania is humanity rising from the depths of brine and regions of fire deeper still, Oceania is us. We are the sea, we are the ocean, we must wake up to this ancient truth and together use it to overturn all hegemonic views that aim ultimately to confine us again, physically and psychologically, in the tiny spaces that we have resisted accepting as our sole appointed places and from which we have recently liberated ourselves. We must not allow anyone to belittle us again, and take away our freedom.

FIGURE 4. Trevor Paglen, "NSA-Tapped Fiber Optic Cable Landing Site, Morro Bay, California, United States," 2015. C-print, mixed media on navigational chart, 48 in. × 60 in.

FIGURE 5. Trevor Paglen, "NSA-Tapped Fiber Optic Cable Landing Site, Keawaula, Hawai'i, United States," 2016. C-print, mixed media on navigational chart, 48 in. × 65 in.

Isle de Jean Charles

Gulf of Mexico

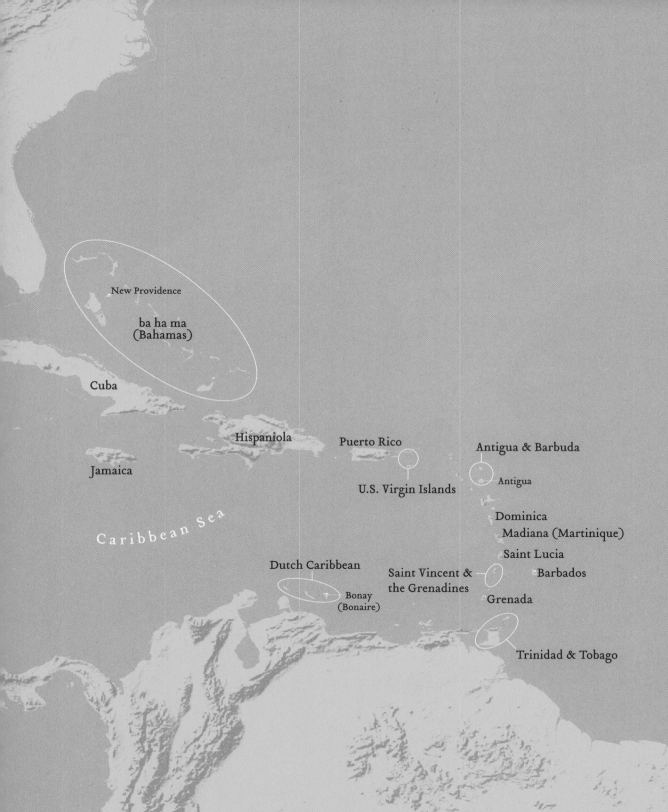

New Providence

ba ha ma
(Bahamas)

Cuba

Hispaniola

Puerto Rico

Antigua & Barbuda

Jamaica

U.S. Virgin Islands

Antigua

Dominica

Madiana (Martinique)

Caribbean Sea

Saint Lucia

Dutch Caribbean

Saint Vincent &
the Grenadines

Barbados

Bonay
(Bonaire)

Grenada

Trinidad & Tobago

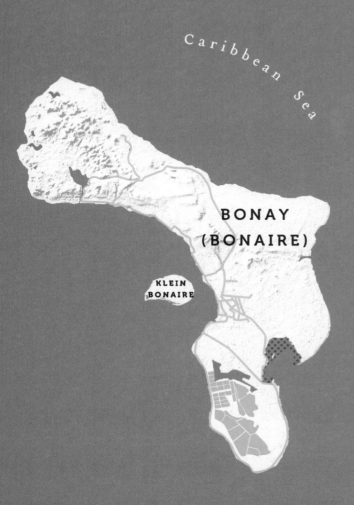

Caribbean Sea

BONAY
(BONAIRE)

KLEIN BONAIRE

 Major road

Salt ponds

Mangrove forest

0 5 mi
/----/----/----/----/----/
/---/---/---/---/---/
0 5 km

Bonay
Bonaire

12.2019° N
68.2624° W

114 sq. mi. (294 km²)

Population: 20,104 (2019)

Languages: Papiamento, Dutch, Spanish, English

Highest Elevation: 790 ft. (240 m)

540 MI / 869 KM
--> ANTIGUA AND BARBUDA (41)

1068 MI / 1719 KM
----/> THE BAHAMAS (47)

3034 MI / 4882 KM
----/----/----/> CABO VERDE (5)

1000 CE
Indigenous Caquetio (Arawak) from Venezuela settled Bonay

1499
Spanish navigator Alonso de Ojeda landed on neighboring Curaçao, accompanied by Italian explorer and cartographer Amerigo Vespucci and Spanish cartographer Juan de la Cosa

1515
Spanish colonizers enslaved Indigenous Arawak, shipping them to Hispaniola to work on plantations; slave trade continued through use of Africans for labor on plantations on neighboring Curaçao

1621
Dutch West India Company founded

1636
Netherlands colonized Bonaire

1807–1816
Britain colonized Bonaire

1833
British Slavery Abolishment Act passed

1834
British Slavery Abolishment Act took effect

1838
Slavery banned in British colonies

1862
Enslaved people freed

1954–2010
Was part of Netherland Antilles

2004
Hurricane Ivan struck

2010
Part of the Caribbean Netherlands

Flamingos. Pink. Those long, spindly legs. That slow, sauntering gate. They are like the flamboyant runway models of the salt ponds. After too long a night out, they balance delicately on one leg—and fall asleep that way! In lieu of donning big fat sunglasses or sleep masks, flamingos wind their long necks around and tuck their heads into their feathery bodies.

Elegant, flamingos are. Disproportionately leg. The high knee bending backwards. The gentle curve and movement of their graceful neck, as they stand bent forward like a flexible dancer doing a toe touch, as they wade in the waters and seek food with their large solid black beaks gently stirring up the shallow waters below in search of food. (Wonder if their feet and toes are turned out?) Why are they pink? Because of the pigments in the algae and shrimp they eat, which contain carotenoid pigments, which also give carrots and tomatoes their bright colors.

Highly social, even gregarious, flamingos tend to congregate in groups. Their mating dances look like the highly orchestrated movements of a ballet troupe. They cluster and move in a tight group, like a group of ballerinas on pointe shoes, heads held aloft, beaks tilted up, heads turning this way and that—akin to the Dance of the Little Swans in Swan Lake. Alternately, some have hypothesized that the word flamenco derives from the birds' name due to similarities of the dance style to the bird's movements.

Flamingos are Bonaire's national bird.

Pink. White. Turquoise. The colors of Bonaire. The pink flamingos. Pink salt flats. White salt. Turquoise blue ocean.

At the southern end of Bonaire sit the *salt ponds*, where the flamingos are abundant. This part of Bonaire is level and rests at about sea level. Bonaire is mostly arid and flat. Donkeys and goats abound on the island. The island's name is derived not from the French, meaning good air, as is sometimes mistakenly believed, but rather from the Indigenous Caquetio word bonay, which means low country. Bonaire mostly consists of coral limestone pushed up to the surface.

Indigenous Caquetio, a branch of the Arawak, arrived from nearby Venezuela just 50 miles (80 km) to the south, and settled the islands by 1000 CE. Archaeological remains, such as pottery, track their history on Bonaire.

Bonaire rests at the southern end of the Lesser Antilles archipelago, an arc of islands that stretches along the eastern edge of the Caribbean Sea from off the coast of South America to the Greater Antilles in the northwest.

Fringing reefs ring Bonaire and provide a crucial habitat for myriad fish species. Sea turtles and spotted eagle ray thrive in the vivid blue waters. Tourism—especially for diving and snorkeling on the tiny, neighboring and uninhabited island Klein Bonaire—is vital to Bonaire's economy.

Unfortunately, beach *erosion* and coral bleaching have negatively impacted the tourism industry not only on Bonaire but also on Barbados (37) and Martinique (39).

The northern part of Bonaire has a few hills and its highest elevation, Brandaris. Cacti and shrubby trees grow here. In the southeast, near Lac Bay, *mangrove* forests line and protect the shore.

In 1499 Spanish navigator Alonso de Ojeda alighted on neighboring Curaçao, accompanied by Italian explorer and cartographer Amerigo Vespucci and Juan de la Cosa, who famously included Bonaire in his 1500 Mappa Mundi, credited with being the first cartographic representation of the Caribbean and America.

Spanish colonizers enslaved Indigenous Arawak and shipped them to work in mines and on plantations on other Caribbean islands. Within twenty years of Spanish colonization, no Arawak remained on Bonaire.

Subsequently, the Dutch West India Company established plantations on Bonaire and used enslaved labor on them and in the salt ponds. The enslaved people lived in short white huts that still stand on the island.

Like in Cabo Verde (5), colonizers harvested salt to preserve fish and meat. The salt ponds were shut down until after World War II.

Now, the US-based company Cargill manages the salt ponds. According to Forbes, Cargill is the largest private company in the US measured by revenue. (It also manages the enormous San Francisco Bay salt ponds, among others.)

Aside from the southern region of Bonaire, sea level rise will most impact uninhabited neighboring Klein Bonaire, a low-lying small uninhabited coral island about 0.5 miles (800 m) from Bonaire. Klein (meaning small in Dutch) Bonaire measures less than 6.5 feet (2 m) above sea level and will be mostly submerged as early as 2050.

Lëre LAND OF THE HUMMINGBIRDS
Trinidad
Ulinga BIG SNAIL
Aloubaéra GIANT SNAKE
Tobago

Republic of Trinidad and Tobago — 10.6918° N 61.2225° W —

2 main islands and several smaller islands
1980 sq. mi. (5128 km²)
Population: 1,405,646 (2022 est.)
35.4% East Indian, 34.2% African descent, 30.4% mixed
Languages: English, Trinidadian Creole English, Tobagonian Creole English, Caribbean Hindustani,
 Trinidadian Creole French, Spanish, Chinese
Mean Elevation: 272 ft. (83 m) │ Highest Elevation: 3084 ft. (940 m)

 103 MI / 166 KM
-> GRENADA (35)

 273 MI / 439 KM
-> MARTINIQUE (39)

 631 MI / 1016 KM
--> PUERTO RICO (42)

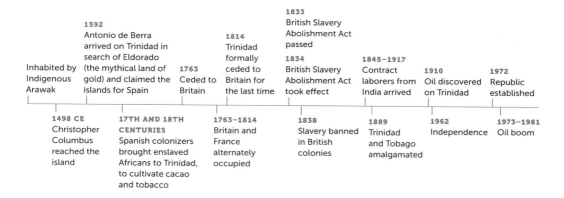

1592
Antonio de Berra
arrived on Trinidad in
search of Eldorado
(the mythical land of
gold) and claimed the
islands for Spain

Inhabited by
Indigenous
Arawak

1763
Ceded to
Britain

1814
Trinidad
formally
ceded to
Britain for
the last time

1833
British Slavery
Abolishment Act
passed

1834
British Slavery
Abolishment Act
took effect

1845–1917
Contract
laborers from
India arrived

1910
Oil discovered
on Trinidad

1972
Republic
established

1498 CE
Christopher
Columbus
reached the
island

17TH AND 18TH
CENTURIES
Spanish colonizers
brought enslaved
Africans to Trinidad,
to cultivate cacao
and tobacco

1763–1814
Britain and
France
alternately
occupied

1838
Slavery banned
in British
colonies

1889
Trinidad
and Tobago
amalgamated

1962
Independence

1973–1981
Oil boom

"Water is the first thing in my imagination," Trinidad-born author Dionne Brand (*A Map to the Door of No Return: Notes to Belonging*) writes. "Over the reaches of the eyes at Guaya when I was a little girl, I knew that there was still more water. All beginning in water, all ending in water. Turquoise, aquamarine, deep green, deep blue, ink blue, navy, blue-black cerulean water." Water. Water. Water.

"Water is the first thing in my memory," Brand continues. "The sea sounded like a thousand secrets, all whispered at the same time. In the daytime it was indistinguishable to me from air."

"Our entrance to the past," writes Tobago-born poet M. NourbeSe Philip, "is through memory—either oral or written. And water. In this case salt water. Sea water. And, as the ocean appears to be the same yet is constantly in motion, affected by tidal movements, so too this memory appears stationary yet is shifting always."

Zong! #1

So opens Philip's *Zong!*, which tells of the 1781 massacre of 150 enslaved Africans aboard a ship en route from São Tomé (7) to Jamaica (45), murdered so that the ship's owners could collect insurance. (J. M. W. Turner's *The Slave Ship* [1840] is based on these events.) Philip, a lawyer, poet, and writer, wrote the poetic fragment *Zong!* solely using words from the *Gregson v. Gilbert* trial, which challenged that insurance claim. "The line of dissent from the *Zong* case to the successful

campaign for abolition of slavery," historian James Walvin writes in *Black Ivory*, "was direct and unbroken, however protracted and uneven."

"What is the word for bringing bodies back from water? From a 'liquid grave'? Exaqua," Philip asks. "What marks the spot of subaquatic death?"

Lëre, land of the hummingbirds, is what, according to some historical linguists, Indigenous Arawak called Trinidad. "The rufous hummingbird travels five thousand miles from summer home to winter home and back," Brand writes in *A Map to the Door of No Return*. "This humming-bird," she continues, "can fit into the palm of a hand. Its body defies the known physics of energy and flight. It knew its way before all known mapmakers. It is a bird whose origins and paths are the blood of its small body. It is a bird whose desire to find its way depends on drops of nectar from flowers." Writing about hummingbirds, but not only.

Hummingbirds are the only birds that can hover midair and fly in any direction, including backward and upside down! Their remarkable vibrant array of colors inspired colonizers to name them after gems, such as blue-chinned sapphire, emerald-chinned, and ruby-throated or ruby topaz. Depending on whom you ask, the Republic of Trinidad and Tobago has seventeen, eighteen, or nineteen species of hummingbirds.

Given how abundant they are on the islands, hummingbirds, one would think, would be the national bird of Trinidad and Tobago. But for Trinidad that honor goes to the vividly colored scarlet ibis, which has a bright red head and body with wings tipped in black. For Tobago it goes to the corico, a game bird also referred to as the Tobago pheasant that welcomes the morning dawn with a raucous call. Corico are related to Oceania's megapodes (see Vanuatu (23)). Yes, Trinidad and Tobago have two national birds, one for each island. But each island could have more, given the abundance of birds. Many can be seen in the Caroni Bird Sanctuary just south of the capital.

Again, writing about hummingbirds, Brand was, but possibly not only. The passage above appears after the opening one: "My grandfather said he knew what people we came from. I reeled off all the names I knew. Yoruba? Ibo? Ashanti? Mandingo?"

"The rufous hummingbird travels five thousand miles from summer home to winter home and back," Brand continues. It is about five thousand miles from Trinidad to the African continent, depending on which part. Coincidence?

The Caroni Bird Sanctuary is low-lying. It will be most impacted by sea level rise, which combined with coastal *erosion* is already impacting the islands' beaches and shorelines. Land area is decreasing and the marine area increasing.

The twin islands are *continental islands*, which typically sit closer to and often were once part of continents. They rest just 7 miles (11 km) off of the northeastern coast of South America, of Venezuela specifically. Trinidad is the larger of the two islands, measuring 1850 square miles (4800 km²); Tobago measures 115 square miles (300 km²) and sits 20 miles (32 km) to the northeast of Trinidad.

Continental islands often also have higher landmasses. Trinidad's name comes from the three mountain peaks that Columbus spotted upon first alighting on the island (or, others say, because he spotted Trinidad on his third voyage). Trinidad features three mountain ranges, one along the northern edge. These higher elevations tend to be more wooded, even if only about 20 to 30 percent of the island's original forests remain. Red howler monkeys and white-fronted capuchin monkeys inhabit the rainforests. Across the middle of the island runs a second range. Its southern side and foothills descend to a plain. A third range of hills skirt the island's southern edge.

Mangroves line Trinidad's west and east coasts. On the west coast, between the northern and central mountain ranges, the Caroni Bird Sanctuary stretches just south of the capital of Port of Spain. Here, white egrets and pink flamingos, herons and spoonbills abound. On the east coast is the Nariva Swamp. Macaws, parrots, and snakes, such as the anaconda and boa constrictors, live here. In the shallow waters the West Indian manatee graze on sea grasses and leaves.

Tobago, too, features a mountain range, although of a lower height. Tobago Main Ridge Forest Reserve, toward the northeast, is home to many different kinds of hummingbirds. At the southwest tip sits a coral plain. This plain parallels a *coral reef*, which features a rich marine life. Eels and sardines are abundant. Along the shores of both islands, different species of turtles can frequently be seen. They include green-back turtles, loggerhead, hawksbill, Olive Ridley, and leatherback turtles. Two species of tortoises live on Trinidad: the red-footed and the yellow-footed tortoise.

Trinidad and Tobago's politics and culture have been influenced not only by its people but also by their interisland affiliations. "An oral ruttier," Brand writes, "is a long poem containing navigational instructions which sailors learned by heart and recited from memory. The poem contained the routes and tides, the stars and maybe the taste and flavour of the waters, the coolness, the saltiness; all for finding one's way at sea. Perhaps, too, the reflection and texture of the sea bed, also the sight of birds, the direction of their flight. This and an instrument called a Kamal which measured the altitude of stars from the horizon."

Its inhabitants have included or include the Indigenous Arawak, the colonizing Spanish, the enslaved Africans, more colonizers from France and Britain, contract laborers from India brought in after Britain abolished slavery, and of course diasporic populations from other Caribbean islands and elsewhere. Historian C. L. R. James, best known as the author of *The Black Jacobins* (1938), a

history of the Haitian revolution, provides a vivid portrait of early twentieth-century Trinidad in his novel *Minty Alley*. Nobel Prize–winner V. S. Naipaul, born in Trinidad and later making Britain his home, engaged Trinidad in many of his early books, such as *The Mystic Masseur* (1957), *Miguel Street* (1959), and *A House for Mr. Biswas* (1961), and his later *A Way in the World* (1994). Naipaul's grandfather was a Brahmin from northern India, who moved to Trinidad to cut cane. Fellow Nobel laureate Derek Walcott moved from Saint Lucia (38) to Trinidad to establish his Trinidad Theatre Workshop. Kwame Ture (Stokely Carmichael) was born in Trinidad and moved to Harlem when he was eleven to join his parents, who had emigrated there when he was two.

Both calypso and soca, with their faster beats, originated in Trinidad, as did the steel pan drum, developed from the 55-gallon drums the US Navy brought with it when in 1941 it started leasing Chaguaramas, land in the northwest of Trinidad, to establish a naval base. The base existed until Trinidad and Tobago's independence in 1962.

Rich in natural gas and oil deposits, Trinidad and Tobago are not as reliant on tourism as other Caribbean islands. The country is the largest exporter of liquefied natural gas (LNG) to the US. Due to its natural resources, Trinidad and Tobago has a high per capita income among Caribbean island nations at about US$31,300, and unemployment is low at about 4 percent, according to 2017 estimates. The country relies on fossil fuels for 100 percent of its electricity, which makes it tied for first place along with The Bahamas (47) and Bahrain (8). As a result, it ranks high among island nations for CO_2 emissions.

M. NourbeSe Philip

FROM DISCOURSE ON THE LOGIC OF LANGUAGE

. . . and English is
my mother tongue
is
my father tongue
is a foreign lan lan lang
language
l/anguish
anguish . . .

Marsha Prescod

EXILES

Forty years in the factory,
Thirty years on the bus,
Twenty years with machinery,
They don't make them any more like us.

Happy to know which place to go,
Canada, US and Britain,
Whether is canal to build,
War to fight,
Land to till,
We eager to make we heaven.

Small fish in an ocean
Of greed, and gold,
All we dreaming is how to get rank.
So, is families wasted,
An health all gone,

Whilst we putting we lives in the bank.

An when you hear the shout—
We can't get out,
Our pride and spirit get break.
At home prices too high,
An no jobs left to try,
Here,
We is crippled by the Welfare State.

Is a little beer here,
Little dominoes there,
And a lot of funeral to follow,
Having ketch as ketch arese,
Just a pensioner's pass,
An a old folks home come tomorrow.

Forty years in the factory
Thirty years on the bus,
Twenty years with machinery,
Yes . . .
They don't make them anymore like us.

Grenada
12.1165° N
61.6790° W

Main island and 6 smaller islands

135 sq. mi. (349 km²) | Carriacou: 12 sq. mi. (31 km²)

Population: 113,949 (2022 est.) | Carriacou: 10,000

82.4% African descent, 13.3% mixed, 2.2% East Indian, 2.1% other

Languages: English, French patois

Highest Elevation: 2757 ft. (840 m)

103 MI / 166 KM
-> **TRINIDAD AND TOBAGO (34)**

85 MI / 137 KM
-> **SAINT VINCENT AND THE GRENADINES (36)**

8115 MI / 13,060 KM
----/----/----/----/----/----/----/----/> **SEYCHELLES (11)**

2ND MILLENNIUM BCE Indigenous tribes, including the Arawak, inhabited Grenada	**1649** France colonized Grenada, established sugar plantations and brought enslaved Africans to the island	**1779** France recolonized **1783** Britain recolonized	**1791** The Grenadines partitioned between Grenada and Saint Vincent	**1833** British Slavery Abolishment Act passed; **1834** took effect	**1955** Hurricane struck	**1979, 1980** Hurricanes struck **1983** US invaded Grenada
1498 CE Italian navigator Christopher Columbus on a Spanish expedition sighted Grenada and named it Concepción						
1400 Caribs inhabited Grenada	**1609** Caribs thwarted British attempt to colonize Grenada	**1762** France's occupation ended; France ceded to Britain in Treaty of Paris (1763)	**1766** Earthquake **1767** Enslaved Africans revolted	**1795–1796** Uprisings attempted to gain independence	**1838** Slavery banned in British colonies	**1974** Independence
						2004 Hurricane Ivan struck **2005** Hurricane Emily struck

Grenada, sometimes called the "spice island," produces most of the world's nutmeg. A nutmeg pod graces its flag. Nutmeg was introduced to the island in the nineteenth century. The plant actually yields two spices: the nutmeg from the seeds and mace from the aril or vivid red membrane that spans the nut. Cocoa beans and chocolate are Grenada's main crops. Many of both are harvested by cooperatives. Other spices grown on Grenada include bay leaves, cinnamon, cloves, and ginger.

Agriculture and tourism are the main industries. Yet unemployment hovers around 24 percent. Only three islands have higher rates: Kiribati (21) at 30.6 percent, the Marshall Islands (20) at 36 percent, and Haiti (44) at 40.6 percent. During the era of the People's Revolutionary Government (1979–1983), unemployment had dipped from 40 percent to 14 percent.

Grenada consists of one main island and six smaller islands as well as the southern Grenadines. Grenada administers the southern Grenadines; Saint Vincent (36) administers the northern Grenadines. Grenada measures about 21 miles (34 km) in length and 12 miles (19 km) in width and totals 135 square miles (349 km²). Grenada rests 100 miles (160 km) northeast of Venezuela and 103 miles (166 km) to the north of Trinidad and Tobago (34).

A *volcanic island*, or high island, the mountains in the interior run north to south with steep declines on the west and more gradual ones on the east. Its highest elevation is Mount Saint Katherine, peaking at 2757 feet (840 m). About half of the island, especially the interior, is forested.

Originally, Indigenous Arawak and then Caribs inhabited Grenada. The Caribs thwarted the British attempt to colonize in 1609. Subsequently, in 1649, the French colonized the island. On the northern tip of the island, the Caribs that lived in the region plunged off 130-foot-high cliffs to their death, instead of surrendering to the French. So the French named the town Sauteurs ("jumpers").

Although Grenada rests at the southern edge of the *hurricane belt* and is thus typically spared, it has been struck. In 2004, Grenada was struck by Hurricane Ivan, which led to thirty-nine deaths, destroyed 85 percent of the buildings, and caused US$815 million in damages. In 2005, Hurricane Emily followed, causing an estimated US$110 million in damages and leading to widespread flooding, including of two hospitals.

Sea level rise is also impacting Grenada. Like on other volcanic islands in the Caribbean and elsewhere, such as the Seychelles (11) in the Indian Ocean, *population density* is highest along the shoreline. An estimated 85 percent of Grenada's population lives in the narrow strip along the coastline and less than 16 feet (5 m) above sea level rise, one-third in Saint George, the capital, on the west coast. On the east coast the rising ocean floods houses in Marquis and Soubise.

More at risk is the island of Carriacou, which forms part of Grenada and lies about 24 miles (38 km) to the northeast of the main island. Carriacou is the Grenadine's largest island. But "largest" means 12 square miles (31 km²) or about 7 miles (11 km) in length by 2 miles (3 km) in width. The island's name is derived from the Carib *Kayryouacou,* meaning "land surrounded by reefs." Reefs abound here and barracudas, eagle rays, stingrays, and sea turtles thrive amid them. Carriacou is comprised of limestone in the east, which will be impacted. The west coast, especially near Hillsborough, will also be intensely affected by sea level rise.

The mother of self-proclaimed "Black, lesbian, mother warrior, poet" Audre Lorde was from Carriacou; Lorde's father was from Barbados (37). "*Carriacou,* a magic name like cinnamon,

nutmeg, mace," writes Lorde in *Zami*, "the delectable little squares of guava jelly each lovingly wrapped in tiny bits of crazy-quilt wax-paper cut precisely from bread wrappers, the long sticks of dried vanilla and the sweet-smelling tonka bean, chalky brown nuggets of pressed chocolate for cocoa-tea, all set on a bed of wild bay laurel leaves, arriving every Christmas time in a well-wrapped tea-tin."

Lorde continues: "*Carriacou* which was not listed in the index of the *Goode's School Atlas* nor in the *Junior Americana World Gazette* nor appeared on any map that I could find, and so when I hunted for the magic place during geography lessons or in free library time, I never found it, and came to believe my mother's geography was a fantasy of crazy. . . . But underneath it all as I was growing up, *home* was still a sweet place somewhere else which they had not managed to capture yet on paper, nor to throttle and bind up between the pages of a schoolbook. It was our own, my truly private paradise of blugoe and breadfruit hanging from the trees, of nutmeg and lime and sapadilla, of tonka beans and red and yellow Paradise Plums."

Lorde's parents emigrated to Harlem, where Lorde grew up. Her work consistently engaged and addressed ableism, classism, heterosexism, homophobia, misogyny, racism, and sexism. She was involved with the Combahee River Collective, which put forward the concept of "simultaneity" to name the confluence of factors such as class, disability, gender, race, and sexual orientation both in oppression and resistance to it.

In Lorde's essay "Grenada Revisited: An Interim Report," she writes about the 1983 US invasion of Grenada and asks "Whose country was Grenada?" Her essay considers not only the US's history of invading and still occupying independent islands (Puerto Rico) and their use for military exercises (Vieques) but also the US fear of the then burgeoning self-liberation and self-determination movements in the Caribbean, Southeast Asia, and Africa.

"Revolutions," as Dionne Brand puts it in "Nothing of Egypt," written after the US invasion of Grenada, "do not happen outside of you, they happen in the vein, they change you and you change yourself, you wake up in the morning changing. You say this is the human being I want to be. You are making yourself for the future, and you do not even know the extent of it when you begin but you have a hint, a taste in your throat of the warm elixir of the possible."

Present-day Grenada relies heavily on imported fossil fuels for 96 percent of its energy, a rate paralleled by the Comoros (9), the Maldives (12), the Federates States of Micronesia (19), and Tuvalu (27). Yet Grenada's CO_2 emissions are low relative to other nations. Moreover, steps are afoot to reduce them further. According to Dessima Williams, former ambassador from Grenada to the United Nations (see foreword), Grenada has pledged to reduce emissions by 30 percent by 2025 (based on 2010 levels), and solar panels and wind turbines have been installed.

Audre Lorde

GRENADA REVISITED: AN INTERIM REPORT*

The first time I came to Grenada I came seeking "home," for this was my mother's birthplace and she had always defined it so for me. Vivid images remained of what I saw there and of what I knew it could become.

- Grand Anse Beach was a busy thoroughfare in the early, direct morning. Children in proper school uniforms carrying shoes, trying to decide between the lure of a coco palm adventure to one side and the delicious morning sea on the other, while they are bound straightforward to well-worn chalky desks.
- The mended hem of the print dress the skinny old woman wore, swinging along down the beach, cutlass in hand. Oversized, high rubber boots never once interfering with her determined step. Her soft shapeless hat. Underneath, sharp, unhurried eyes snapped out from chocolate skin dusted grey with age.
- Another woman, younger, switch held between elbow and waist, driving seven sheep that look like goats except goats carry their tails up and sheep down.
- The Fat-Woman-Who-Fries-Fish-In-The-Market actually did, and it was delicious, served on the counterboards with her fragrant chocolate-tea in mugs fashioned from Campbell's Pork 'n Beans cans with metal handles attached.
- The full moon turning the night beach flash green.

I came to Grenada for the first time eleven months before the March 13, 1979, bloodless coup of the New Jewel Movement which ushered in the People's Revolutionary Government (PRG) of Grenada under Prime Minister Maurice Bishop. This brought an end to twenty-nine years of Sir Eric Gairy's regime—wasteful, corrupt, and United States sanctioned.

[. . .]

The second time I came to Grenada I came in mourning and fear that this land which I was learning had been savaged, invaded, its people maneuvered into saying thank you to their invaders. I knew the lies and distortions of secrecy surrounding the invasion of Grenada by the United States on October 25, 1983; the rationalizations which collapse under the weight of facts; the facts that are readily available, even now, from the back pages of the New York Times.

[. . .]

As even Arthur Schlesinger, Jr., observed, "Now we launch a sneak attack on a pathetic island of 110,000 people with no army, no navy or air force, and claim a glorious victory."

* I spent a week in Grenada in late December 1983, barely two months after the U.S. invasion of the Black Caribbean island my parents left some sixty years earlier. It was my second visit in five years. This is an interim essay, a report written as the rest of *Sister Outsider* was already being typeset.

Hairoun
Saint Vincent and the Grenadines

12.9843° N
61.2872° W

1 main island, Saint Vincent, and 32 smaller islands

150 sq. mi. (389 km²)

Population: 100,969 (2022 est.)

71.2% African descent, 23% mixed, 3% Indigenous, 1.1% East Indian, 1.5% European descent, 0.2% other

Languages: English, Vincentian Creole English, French patois

Highest Elevation: 4049 ft. (1234 m)

85 MI / 137 KM
-> GRENADA (35)

177 MI / 284 KM
-> TRINIDAD AND TOBAGO (34)

20 MI / 32 KM
-> SAINT LUCIA (38)

5000 BCE Inhabited by the Indigenous Ciboney

1400 CE Inhabited by Indigenous Caribs

18TH CENTURY French settled the island's west coast

1772–1773 Caribs waged war to resist Britain's colonization

1783 Britain regained Saint Vincent through Treaty of Versailles

19TH CENTURY Laborers from India and Madeira arrived

1833 British Slavery Abolishment Act passed; **1834** took effect

1838 Slavery banned in British colonies

1979 Independence

1980 Hurricane Allen struck

100 Inhabited by Arawak, who originated in Venezuela

17TH CENTURY Africans arrived on the islands, either escaped enslaved Africans from Barbados or shipwrecked Africans in the Grenadines

1763 Saint Vincent granted to Britain through the Treaty of Paris

1779 France seized Saint Vincent

1791 Grenadines partitioned between Grenada and Saint Vincent

1795–1796 Caribs waged war to resist Britain's colonization

1796 Caribs lost war, charged with treason and deported by the British

1805 Britain "pardoned" the Caribs

1960–1962 Part of the Federation of the West Indies

Hairoun, as the island's Indigenous Caribs called Saint Vincent, is one of the world's major exporters of arrowroot. Arrowroot cultivation dates back to the island's Caribs. Currently it is grown on the eastern side of the highlands, particularly around Owia in the northeast, which has a high

population of people of Carib descent. Arrowroot starch can be used as a substitute for cornstarch by those who are allergic to corn, and arrowroot flour can be used by those who with celiac disease and allergic to wheat flour's gluten.

Indigenous Ciboney inhabited Saint Vincent about seven thousand years ago. Then, around two thousand years ago, Indigenous Arawak from Venezuela inhabited the island. Subsequently, starting around 1400, Indigenous Caribs inhabited it.

Africans began arriving in the seventeenth century. Some were escaped enslaved people from Barbados. Others survived shipwrecks in the Grenadines. Garifuna are descendants of Caribs and Africans.

Caribs resisted colonization by British, Dutch, and French. During the eighteenth century, Britain and France fought for control of the island. In 1783 the Treaty of Versailles granted Saint Vincent to Britain. Caribs led two wars (1772–1773 and 1795–1796) against Britain. Britain, according to their logic, won the war, charged the Caribs with treason, and exiled them to islands off the coast of Central America, especially Honduras. Many of these Caribs later migrated to Belize.

Saint Vincent and the Grenadines consists of one main island, Saint Vincent, and thirty-two smaller islands. The Grenadines were split by colonization: Saint Vincent administers the northern Grenadines; neighboring Grenada (35) administers the southern Grenadines.

Saint Vincent measures 18 miles (30 km) in length and 11 miles (18 km) in width. A *volcanic island*, it is fairly mountainous. La Soufrière, its highest peak, towers at 4049 feet (1234 m). A younger volcanic island, it has an active volcano, which remains a constant risk. About 70 percent of the island's central mountains are densely forested.

Due to the island's hilly terrain, the majority of its population and infrastructure is nestled along the coast. A single road almost encircles the island, except for in the too mountainous region of the northwest. Along the eastern edge or windward side, the road runs very close to the shore. Sea level rise will inundate and flood it and homes along the east coast. Kingstown, the capital, which lies in the southwest, will also be intensely impacted by sea level rise.

Even more at risk are the *cays*, low-elevation, sandy islands on the surface of a coral reef. Tobago Cays, five islands and coral reefs in the Southern Grenadines, sit above a large lagoon protected by a reef. Most of the region constitutes the Tobago Cays Marine Park. Sea grass is abundant in the area and an important feeding ground for green, hawksbill, and leatherback turtles, as well as conchs and starfish. Because the cays are low-lying and consist of limestone, among other geological matter, they are particularly at risk of the impacts of sea level rise.

Ichirouganaim
Barbados

13.1939° N
59.5432° W

166 sq. mi. (430 km²)

Population: 302,674 (2022 est.)

92.4% Black, 3.1% mixed race, 2.7% white, 1.3% (East) Indian

Languages: Bajan Creole, English

Highest Elevation: 1102 ft. (336 m)

162 MI / 261 KM
-> GRENADA (35)

118 MI / 190 KM
-> SAINT VINCENT AND THE GRENADINES (36)

206 MI / 333 KM
-> TRINIDAD AND TOBAGO (34)

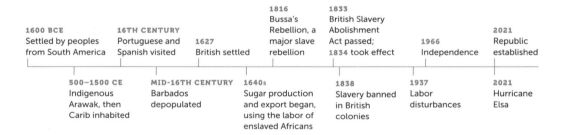

1600 BCE Settled by peoples from South America

500–1500 CE Indigenous Arawak, then Carib inhabited

16TH CENTURY Portuguese and Spanish visited

MID-16TH CENTURY Barbados depopulated

1627 British settled

1640s Sugar production and export began, using the labor of enslaved Africans

1816 Bussa's Rebellion, a major slave rebellion

1833 British Slavery Abolition Act passed; **1834** took effect

1838 Slavery banned in British colonies

1966 Independence

1937 Labor disturbances

2021 Republic established

2021 Hurricane Elsa

Like an upside-down cake. Unlike in most geologic formations, where the oldest layer rests at the bottom, in Barbados it rests at the top.

This layer was first pushed up about seven hundred thousand years ago. Since then, sedimentary rock has accreted and pushed above sea level. As it ascends, like a trailing bride's train, it pulls with it the coral reefs that encircle the island. The reef, exposed, dies. A new one forms. It, too, is eventually pulled up. Layer upon layer. Like a staircase. Consisting of reefs.

The layers are pushed up because the island sits on the Barbados Ridge, a subduction or collision zone between two tectonic plates: the Caribbean Plate and the South American Plate.

Most subduction zones are submerged. The one on Barbados is not.

This combination of upside-down, age, and aboveground makes Barbados of keen interest to geologists. They have been studying its geology since the 1840s. Now there's a climate change angle to the interest: the layers or terraces provide a chronology of previous fluctuations in temperatures and how they pair up with sea level rise.

"Red land with white teeth" is what the Indigenous Arawak name, *Ichirouganaim,* for the island is thought to have meant. Portuguese named the island Barbados, which, like Barbuda (41), is believed to refer to the giant bearded fig trees that grow on the islands. Barbados is a small island measuring 20 miles (32 km) by 15 miles (25 km) that lies to the east of Saint Vincent and the Grenadines (36).

Sugar plantations were important to Barbados's economy starting in the 1640s. In the nineteenth century there were major slave rebellions, most notably Bussa's Rebellion in 1816. In 1834 slavery was abolished. Over the course of the twentieth century, particularly starting in the 1950s, the economy shifted to tourism and more recently to finance services. *Remittances* are also a key source of revenue.

Barbados is the tenth most densely populated island globally and the most densely populated island regionally. One-third of the population lives in urban areas. *Population density* is highest in the capital, Bridgetown, to the southwest.

Although it is usually clustered with the Lesser Antilles, Barbados is distinct geologically and lies about 118 miles (190 km) miles to the east of the Lesser Antilles, specifically of Saint Vincent. The Lesser Antilles is a volcanic arc.

The coral layer that constitutes this *limestone island* is in parts about 300 feet (90 m) thick. Rainfall moves through the limestone to underground *aquifers* and water systems. These underground springs provide the island's *freshwater*. Sea level rise threatens to salinize these water supplies, making them no longer potable for humans, animals, and soil. A *desalination plant* supplements the underground water supplies.

Coral reefs encircle the island, providing a barrier and a rich habitat for fish. The reefs also buffer the waves. Four species of sea turtles nest along the beaches: green, hawksbill, leatherback, and loggerhead turtles. Aside from saltwater inundation, *erosion* is a risk in Barbados. Both have been intensified by climate change–induced sea level rise.

Edward Kamau Brathwaite

ISLANDS

So looking through a map
of the islands, you see
rocks, history's hot
lies, rot-
ting hulls, cannon
wheels, the sun's
slums: if you hate
us. Jewels,
if there is delight
in your eyes.
The light shimmers on water,
the cunning
coral keeps it
blue.

Looking through a map
of the Antilles, you see how time
has trapped
its humble servants here. De-
scendants of the slave do not
lie in the lap
of the more fortunate
gods. The rat
in the warehouse is as much king
as the sugar he plunders.
But if your eyes
are kinder, you will observe
butterflies
how they fly higher
and higher before their hope dries
with endeavour
and they fall among flies.

Looking through a map of the islands, you see
that history teaches
that when hope
splinters, when the pieces
of broken glass lie
in the sunlight,
when only lust rules
the night, when the dust
is not swept out
of the houses,
when men make noises
louder than the sea's
voice; then the rope
will never unravel
its knots, the branding
iron's travelling flame that teaches
us pain, will never be
extinguished. The islands' jewels:
Saba, Barbuda, dry flat-
tened Antigua, will remain rocks,
dots, in the sky-blue frame
of the map.

Hewanorra
Saint Lucia

18.2208° N
66.5901° W

238 sq. mi. (616 km²)

Population: 167,122 (2022 est.)

85.3% African descent, 10.9% mixed, 2.2% East Indian, 1.6% other

Languages: English, French patois

Highest Elevation: 3110 ft. (948 m)

48 MI / 77 KM
-> **SAINT VINCENT AND THE GRENADINES (36)**

50 MI / 81 KM
-> **MARTINIQUE (39)**

108 MI / 174 KM
-> **BARBADOS (37)**

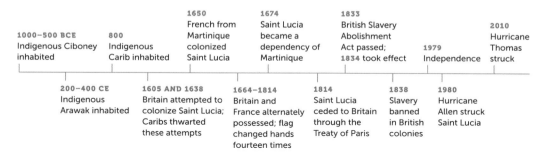

1000–500 BCE
Indigenous Ciboney inhabited

800
Indigenous Carib inhabited

1650
French from Martinique colonized Saint Lucia

1674
Saint Lucia became a dependency of Martinique

1833
British Slavery Abolishment Act passed; **1834** took effect

1979
Independence

2010
Hurricane Thomas struck

200–400 CE
Indigenous Arawak inhabited

1605 AND 1638
Britain attempted to colonize Saint Lucia; Caribs thwarted these attempts

1664–1814
Britain and France alternately possessed; flag changed hands fourteen times

1814
Saint Lucia ceded to Britain through the Treaty of Paris

1838
Slavery banned in British colonies

1980
Hurricane Allen struck Saint Lucia

Saint Lucia—originally named *Loaunaloa* by the Indigenous Arawak and then *Hewanorra* by the Indigenous Carib, both meaning "land where the iguana is found"—is the only country named after a woman (see Christian Campbell's poem "Iguana" in The Bahamas (47)). (An actual woman, that is; Ireland is named after Eire, the goddess of land.) Saint Lucia forms part of the Lesser Antilles. It sits 21 miles (34 km) to the south of Saint Vincent and the Grenadines (36) and 24 miles (39 km) to the north of Martinique (39). Like most Caribbean islands, it is a *volcanic island* and thus fairly mountainous. A ridge runs down the island from north to south. It peaks at Mount Gimie at 3145 feet (959 m). Two other peaks, the Gros Piton and the Petit Piton, are dramatically tapering mountains in the southwest. An estimated three-quarters of the hillier terrain is forested.

The island's national bird, the Saint Lucia parrot, is at home in these rainforests. A green bird with a blue head and red-orange-yellow colorations around its neck and belly, the Saint Lucia parrot can only be found on this island. Other endemic species include the jet black Saint Lucia black finch, the black and orange Saint Lucia oriole, the Saint Lucia peewee, and the blue and gray Saint Lucia warbler.

As a result of the terrain, most of the population lives around the island's periphery. Fishing villages, beaches, and reefs, a popular diving site, line the shores. _Erosion_ and sea level rise pose serious threats to Saint Lucia's _infrastructure_, given that it is clustered along the coast. The runways of the two airports, located at the island's southern tip and to the northwest, are both at severe risk of flooding from a mere 5 feet (1.5 m) of sea level rise. Given that 1 to 3 feet (0.3–0.91 m) are projected by the century's end, inundation hampering their use could well take place earlier.

Derek Walcott

FROM MAP OF THE NEW WORLD

I Archipelagoes

At the end of this sentence, rain will begin.
At the rain's edge, a sail.

Slowly the sail will lose sight of islands;
into a mist will go the belief in harbours
of an entire race.

The ten-years war is finished.
Helen's hair, a grey cloud.
Troy, a white ashpit
by the drizzling sea.

The drizzle tightens like the strings of a harp.
A man with clouded eyes picks up the rain
and plucks the first line of the Odyssey.

Derek Walcott

FROM THE SCHOONER *FLIGHT*

11 After the Storm

There's a fresh light that follows a storm
while the whole sea still havoc; in its bright wake
I saw the veiled face of Maria Concepcion
marrying the ocean, then drifting away
in the widening lace of her bridal train
with white gulls her bridesmaids, till she was gone.
I wanted nothing after that day.
Across my own face, like the face of the sun,
a light rain was falling, with the sea calm.

Fall gently, rain, on the sea's upturned face
like a girl showering; make these islands fresh
as Shabine once knew them! Let every trace,
every hot road, smell like clothes she just press
and sprinkle with drizzle. I finish dream;
whatever the rain wash and the sun iron:
the white clouds, the sea and sky with one seam,
is clothes enough for my nakedness.
Though my *Flight* never pass the incoming tide
of this inland sea beyond the loud reefs
of the final Bahamas, I am satisfied
if my hand gave voice to one people's grief.
Open the map. More islands there, man,
than peas on a tin plate, all different size,
one thousand in the Bahamas alone,
from mountains to low scrub with coral keys,
and from this bowsprit, I bless every town,
the blue smell of smoke in hills behind them,
and the one small road winding down them like twine
to the roofs below; I have only one theme:

The bowsprit, the arrow, the longing, the lunging heart—
the flight to a target whose aim we'll never know,
vain search for one island that heals with its harbor
and a guiltless horizon, where the almond's shadow
doesn't injure the sand. There are so many islands!
As many islands as the stars at night
on that branched tree from which meteors are shaken
like falling fruit around the schooner *Flight*.
But things must fall, and so it always was,
on one hand Venus, on the other Mars;
fall, and are one, just as this earth is one
island in archipelagoes of stars.
My first friend was the sea. Now, is my last.
I stop talking now. I work, then I read,
cotching under a lantern hooked to the mast.
I try to forget what happiness was,
and when that don't work, I study the stars.
Sometimes is just me, and the soft-scissored foam
as the deck turn white and the moon open
a cloud like a door, and the light over me
is a road in white moonlight taking me home.
Shabine sang to you from the depths of the sea.

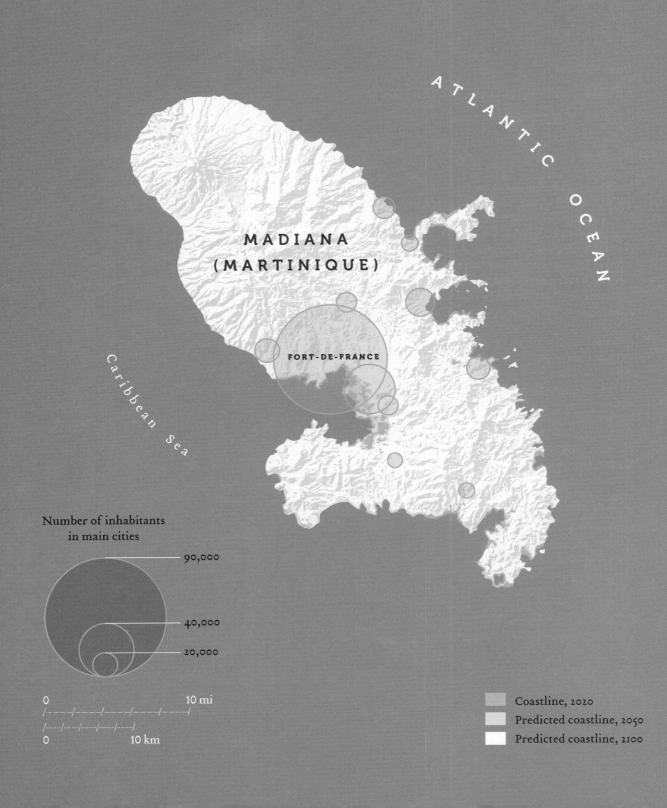

ATLANTIC OCEAN

MADIANA
(MARTINIQUE)

FORT-DE-FRANCE

Caribbean Sea

Number of inhabitants
in main cities

90,000

40,000

20,000

0 10 mi

0 10 km

Coastline, 2020
Predicted coastline, 2050
Predicted coastline, 2100

Madiana ISLAND OF FLOWERS
Martinique

14.6415º N
61.0242º W

436 sq. mi. (1128 km²)

Population: 376,480 (2016)

Languages: French, Antillean Creole

Highest Elevation: 4853 ft. (1397 m)

141 MI / 227 KM
-> **BARBADOS (37)**

16 MI / 26 KM
-> **SAINT LUCIA (38)**

22 MI / 35 KM
-> **DOMINICA (40)**

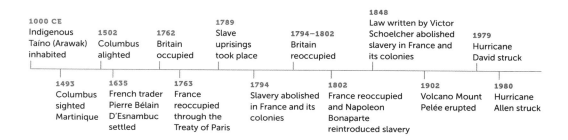

1000 CE
Indigenous Taíno (Arawak) inhabited

1502
Columbus alighted

1762
Britain occupied

1789
Slave uprisings took place

1794–1802
Britain reoccupied

1848
Law written by Victor Schoelcher abolished slavery in France and its colonies

1979
Hurricane David struck

1493
Columbus sighted Martinique

1635
French trader Pierre Bélain D'Esnambuc settled

1763
France reoccupied through the Treaty of Paris

1794
Slavery abolished in France and its colonies

1802
France reoccupied and Napoleon Bonaparte reintroduced slavery

1902
Volcano Mount Pelée erupted

1980
Hurricane Allen struck

Madiana ("island of flowers"), or *Madinina* ("fertile island with luxuriant vegetation"), is what the Indigenous Taíno called Martinique.

A *volcanic island*, the northern region is mountainous, densely forested, and contains its highest point, Mount Pelée, towering 4853 feet (1397 m) above sea level. Mount Pelée erupted in 1792, 1851, and 1902. The 1902 eruption lasted until 1905, killed twenty-eight thousand people, and destroyed Saint-Pierre, once the capital and often referred to as the Paris of the Caribbean. The volcano has been dormant since 1932.

When France began to settle Martinique in 1635, it forced the Indigenous Carib into its eastern half. Sugar plantations were established, and beginning in 1664, enslaved Africans were brought to the island to work on them. Subsequently, cotton and cacao were introduced.

In 1794 slavery was abolished in French colonies. But in 1802 Napoleon—whose first wife, Joséphine, grew up on Martinique on a slave-owning sugar plantation—reintroduced slavery. Slave uprisings took place in 1814 and 1815. Not until 1848 through legislation written by French abolitionist Victor Schoelcher was slavery abolished in Martinique. Both the main library as well as the school, which Aimé Césaire, Frantz Fanon, and Édouard Glissant attended, are named after Schoelcher.

Martinique is one of France's five overseas regions, alongside French Guiana in South America and the islands Mayotte and Réunion in the Indian Ocean and Guadeloupe in the Caribbean. Thus the euro is used and Martinique has a higher standard of living than other Caribbean islands. Its wage scale is higher, as it is based on the amount in effect for urban France.

Population density impacts Martinique. Nine-tenths of the population lives in urban areas and one-fourth lives in the region around the capital, Fort-de-France.

Additionally, most of the population lives along the coast. The Intergovernmental Panel on Climate Change has called this density along Martinique's coast combined with sea level rise the "coastal squeeze." "Martinique in the Caribbean exemplifies the point," the IPCC states. A number of factors converge. Due to the mountains, people are crammed into the coastal zone. But competing interests vie for this limited spatial area: the island's residents and the tourism industry with its development, including hotels, restaurants, and shopping. Now, sea level rise further shrinks the coastline, impacting most of the region south of the capital.

Martinique has played an enormous role in postcolonial studies. Césaire, Fanon, and Glissant as well as Paulette and Jane Nardal hailed from Martinique. Although playwright, poet, and politician Césaire—together with Senegalese poet and politician Léopold Sédar Senghor and French Guianan poet and politician Léon Damas, who went to school in Martinique, where he met Césaire—is credited with coining the term *Négritude*, the movement began among Francophone writers and thinkers living in Paris in the 1930s, often gathering at a weekly salon hosted by the Nardal sisters: Paulette, Jane, and Andrée. Members of the Harlem Renaissance, such as Langston Hughes and Claude McKay, also attended these gatherings.

Paulette and Jane Nardal studied French literature at the Sorbonne in the 1920s. Paulette was the first Black person and the sisters were the first women from Martinique to study at the Sorbonne. Jane Nardal, in an early essay titled "Internationalisme Noir" (1928), presented many arguments that later became hallmarks of *Négritude*—for example, suggesting "turning back

toward Africa . . . in remembering a common origin." *Négritude* not only focused on Africa but also planted the seeds for a pan-African movement.

Césaire returned to Martinique in 1939 and taught at the Lycée Schoelcher, where Fanon was his pupil. Fanon later pursued medical studies in France, specializing in psychiatry and then moving to Algeria, during the Algerian War of Independence from France. Fanon's *Black Skin, White Masks* (1952) and *The Wretched of the Earth* (1961) were among the most influential texts of the 1950s and 1960s anticolonial self-liberation and self-determination movements in Asia and Africa.

Poet and writer Glissant, who studied at the Lycée Schoelcher, too, critiqued *Négritude* for its focus on Africa and proposed instead the concept of *Antillanité*. He saw the value in the concept of *Négritude*, writing in *Caribbean Discourse*: "Arawaks and Caribs ploughed through this sea before the arrival of Columbus. . . . Colonization has divided into English, French, Dutch, Spanish territories a region where the majority of the population is African: making strangers out of people who are not. The thrust of negritude among Caribbean intellectuals was a response perhaps to the need, by relating to a common origin, to rediscover unity (equilibrium) beyond dispersion."

Rather than focusing solely on the shared African heritage among Black Caribbeans and recognizing that Caribbean islanders were not only of African descent, *Antillanité* sought to forge alliances among Caribbean islanders of diverse heritages, including Indigenous Arawaks, Caribs, and Taínó as well as Chinese and Indian immigrants, among others. "*Antillanité*," Glissant writes "is grounded concretely in affirmation of a place, the Antilles, and would link cultures across language barriers" (*Poetics of Relation*).

Antillanité was also the island geography and how it informed islanders. Glissant's translator Betsy Wing referred to his writings as textual geography, as writings, essayistic or poetic, that perform the very geography of the islands.

The concept of "relationality," put forward in *Poetics of Relation*, complements *Antillanité*. Glissant elaborates the concept, comparing islands in the Caribbean and the Pacific: "The Caribbean is . . . a sea that explodes the scattered lands into an arc. A sea that diffracts. Without necessarily inferring any advantage whatsoever to their situation, the reality of archipelagos in the Caribbean or the Pacific provides a natural illustration of the thought of Relation." "Relation" means not only that the islands refer to one another (rather than a colonial center), and do so respecting differences and particularities, but also that they are interdependent in a horizontal form of relation.

"What is the Caribbean in fact?" Glissant writes in *Caribbean Discourse*. "A multiple series of relationships. We all feel it, we express it in all kinds of hidden or twisted ways, or we fiercely deny it. But we sense that this sea exists within us with its weight of now revealed islands."

Given this focus on relationships, Glissant continues, "insularity takes on another meaning. Ordinarily, insularity is treated as a form of isolation, a neurotic reaction to place. However, in the Caribbean each island embodies openness. The dialectic between inside and outside is reflected in the relationship of land and sea. It is only those who are tied to the European continent who see insularity as confining. A Caribbean imagination liberates us from being smothered."

Aimé Césaire

FROM NOTEBOOK OF A RETURN TO THE NATIVE LAND

But before reaching the shores of future orchards
grant that I deserve those on their belt of sea
grant me my heart while awaiting the earth
grant me on the ocean sterile
but somewhere caressed by the promise of the clew-line
grant me on this diverse ocean
the obstinacy of the proud pirogue
and its marine vigor.

Édouard Glissant

FROM POETICS OF RELATION

The poetics of Relation remains forever conjectural and presupposes no ideological stability. It is against the comfortable assurances linked to the supposed excellence of a language. A poetics that is latent, open, multilingual in intention, directly in contact with everything possible.
[. . .]
The politics of ecology has implications for populations that are decimated or threatened with disappearance as a people. For, far from consenting to sacred intolerance, it is a driving force for the relational interdependence of all lands, of the whole Earth. It is this very interdependence that forms the basis for entitlement. Other factors become null and void.

Wai'tu kubuli HER BODY IS TALL
Commonwealth of Dominica
15.4150° N
61.3710° W

290 sq. mi. (751 km²)

Population: 74,629 (2022 est.)

85–86% Black, 9% mixed, 3% Indigenous Caribs, 1.4% other

Languages: English, French patois

Highest Elevation: 4747 ft. (1447 m)

107 MI / 173 KM
-> SAINT LUCIA (38)

58 MI / 94 KM
-> MARTINIQUE (39)

118 MI / 190 KM
-> ANTIGUA AND BARBUDA (41)

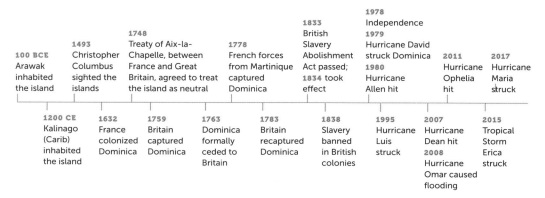

| 100 BCE Arawak inhabited the island | 1493 Christopher Columbus sighted the islands | 1748 Treaty of Aix-la-Chapelle, between France and Great Britain, agreed to treat the island as neutral | 1778 French forces from Martinique captured Dominica | 1833 British Slavery Abolishment Act passed; 1834 took effect | 1978 Independence 1979 Hurricane David struck Dominica 1980 Hurricane Allen hit | 2011 Hurricane Ophelia hit | 2017 Hurricane Maria struck |

| 1200 CE Kalinago (Carib) inhabited the island | 1632 France colonized Dominica | 1759 Britain captured Dominica | 1763 Dominica formally ceded to Britain | 1783 Britain recaptured Dominica | 1838 Slavery banned in British colonies | 1995 Hurricane Luis struck | 2007 Hurricane Dean hit 2008 Hurricane Omar caused flooding | 2015 Tropical Storm Erica struck |

Wai'tu kubuli, the island's Indigenous Kalinago name, means "her body is tall." This island is tall. The muscle of mountains runs along the spine. Veins of rivers. Christopher Columbus spotted the island on a Sunday and named it Dominica. Now, formally, the Commonwealth of Dominica. The island's capital is Roseau, named later by the French after the abundant reeds (*roseaux*).

Dominica was the last Caribbean island to be colonized. It is also the only eastern Caribbean island still inhabited by Kalinago, which Columbus named Caribs. About twenty-two hundred Kalinagos live in eastern Dominica. They create dugout canoes, which they use to fish. They weave baskets, hats, and mats. And they also process cassava.

Dominica's demographics break down as follows: about 3 percent are Indigenous, 85–86 percent are of African descent, and 9 percent are of mixed-race heritage. Here, too, race relations have been fraught. Martinique writer Aimé Césaire in *Une Tempête* (1969) rewrote the ending of Shakespeare's *The Tempest* to confront colonialism's legacy. Dominican Jean Rhys confronted it as well three years earlier in her 1966 novel *Wide Sargasso Sea*. (It is named after the Sargasso Sea, the region of the Atlantic Ocean with no real boundaries but four ocean currents, which create a gyre and a garbage patch. The sea, in turn, is named for the Sargassum seaweed that can be found in this region of the Atlantic.) *Wide Sargasso Sea* serves as a prequel to Charlotte Brontë's *Jane Eyre,* telling the backstory of Bertha Mason, the madwoman in the attic, renaming her Antoinette Cosway. She was a Creole heiress from the Caribbean whom Mr. Rochester married and took with him to Britain (see excerpt from Rhys following).

A boiling lake. Volcanic water bubbling up from beneath the sea floor like champagne in a flute. Sulfur hot springs with medicinal properties. Tall waterfalls. Twin waterfalls. With a swimming hole below. In one swimming hole cool water from waterfalls above mixes with hot water bubbling up from springs below. Another swimming hole can be reached by swimming away from a waterfall and through a narrow gorge. High lakes. And 365 rivers. The boiling lake is a flooded fumarole, a volcanic vent or crack that allows hot gases from the lava below to heat the water. This boiling lake is second in size only to the one in New Zealand. A water lover's dream.

But there's not only benevolent water. Dominica rests in the hurricane belt and has been hit by *hurricanes* . . . often. Most recently, in 2017, Hurricane Maria struck, devastating more than 85 percent of the island's houses and destroying 25 percent of the houses completely. Two-thirds of the island's residents were displaced. There was no access to food. The water system was demolished.

Dominica is a *volcanic island*. In fact, the Caribbean's youngest island, formed 26 million years ago, Dominica has a few volcanoes that are still active, although they rarely erupt. To wit, it has five of the sixteen in the Lesser Antilles, the most of any island in the Caribbean. They are the source of the fumaroles and the hot springs.

Since it is a volcanic island, Dominica is very mountainous. As a result, over 70 percent of the island's population is crowded on a narrow strip along the coast. It is also where the infrastructure is located. Here's where the topography and the flooding intersect in problematic ways. When the hurricanes and tropical storms strike, the attendant storm surge often floods and inundates coastal cities and homes.

Phyllis Shand Allfrey

LOVE FOR AN ISLAND

Love for an island is the sternest passion;
pulsing beyond the blood through roots and loam
it overflows the boundary of bedrooms
and courses past the fragile walls of home.

Those nourished on the sap and the milk of beauty
(born in its landsight) tremble like a tree
at the first footfall of the dread usurper—
a carpet-bagging mediocrity.

Theirs is no mild attachment, but rapacious
craving for a possession rude and whole;
lovers of islands drive their stake, prospecting
to run the flag of ego up the pole,

sink on the tented ground, hot under azure,
plunge in the heat of earth, and smell the stars
of the incredible vales. At night, triumphant,
they lift their eyes to Venus and to Mars.

Their passion drives them to perpetuation:
they dig, they plant, they build and they aspire
to the eternal landmark; when they die
the forest covers up their set desire,

Salesmen and termites occupy their dwellings,
their legendary politics decay.
yet they achieve an ultimate memorial:
they blend their flesh with the beloved clay.

Jean Rhys

FROM WIDE SARGASSO SEA

The scent that came from the dress was very faint at first, then it grew stronger. The smell of vetivert and frangipanni, of cinnamon and dust and lime trees when they are flowering. The smell of sun and the smell of the rain.

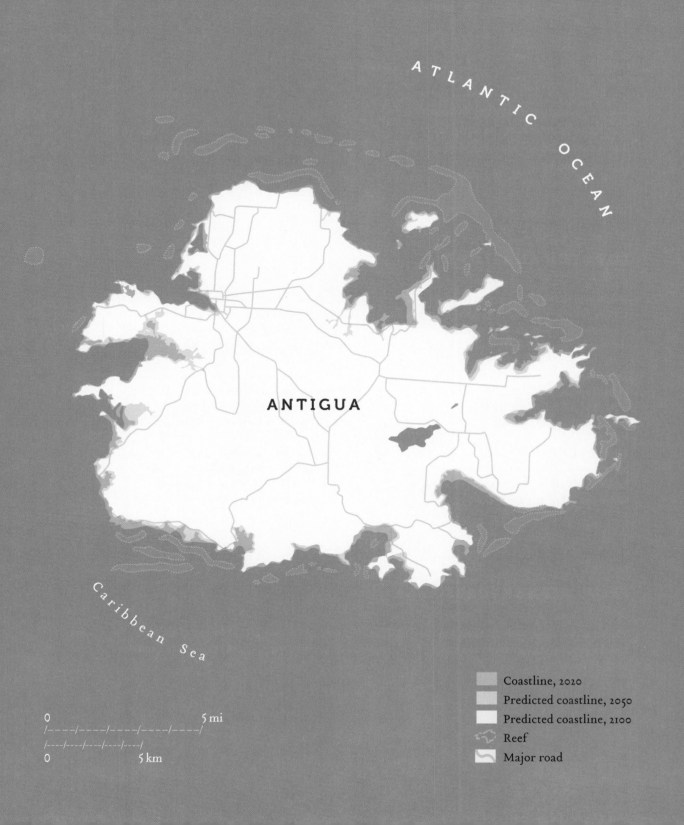

ATLANTIC OCEAN

ANTIGUA

Caribbean Sea

Coastline, 2020
Predicted coastline, 2050
Predicted coastline, 2100
Reef
Major road

0 5 mi

0 5 km

Waladli or Wadadli and Dulcina
Antigua and Barbuda

17.0608° N
61.7964° W

2 main islands and more than 45 smaller islands

171 sq. mi. (443 km²) | Antigua: 109 sq. mi. (281 km²)

Population: 100,335 (2022 est.) | Antigua: 80,161 (2011 census)

87% African descent, 5% multiracial, 2% European descent

Languages: English, Antiguan and Barbudan Creole, Spanish

Highest Elevation: 1319 ft. (402 m) | Barbuda, Mean Elevation: 125 ft. (38 m)

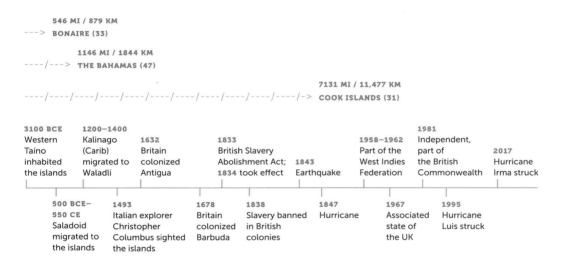

546 MI / 879 KM
---> BONAIRE (33)

1146 MI / 1844 KM
----/---> THE BAHAMAS (47)

7131 MI / 11,477 KM
----/----/----/----/----/----/----/----/----/----/-> COOK ISLANDS (31)

3100 BCE	1200–1400					1958–1962	1981	
Western	Kalinago	1632	1833			Part of the	Independent,	
Taíno	(Carib)	Britain	British Slavery			West Indies	part of	2017
inhabited	migrated to	colonized	Abolishment Act;	1843		Federation	the British	Hurricane
the islands	Waladli	Antigua	1834 took effect	Earthquake			Commonwealth	Irma struck

500 BCE–							
550 CE	1493		1678	1838	1847	1967	1995
Saladoid	Italian explorer		Britain	Slavery banned	Hurricane	Associated	Hurricane
migrated to	Christopher		colonized	in British		state of	Luis struck
the islands	Columbus sighted		Barbuda	colonies		the UK	
	the islands						

Mating rituals, let's admit it, can be weird. Male magnificent frigate birds inflate their bright red throat pouches, which can expand to the size of a person's head, to attract their mates. They tuck what looks like an inflated red birthday balloon under their long hooked beak. As if that were not enough, they beat their beaks on the drumlike pouch. Not sure why that holds appeal. But two thousand to three thousand of the black-feathered red-throated birds can be seen involved in the ritual, perched in the mangrove trees at the northern end of the large Cordington Lagoon on Barbuda. It's one of the world's largest frigate bird colonies.

Antigua and Barbuda consists of the two main islands and over forty-five smaller islands. It rests at the northern end of the Lesser Antilles, a volcanic arc running between the Greater Antilles to the north and the continent of South America to the south. Antigua is a *volcanic island*. Boggy Peak towers at 1319 feet (402 m). Giant bearded fig trees, after which the island, like Barbados (37), is thought to have been named, grow across the islands.

Antiguan-American essayist, novelist, and avid gardener Jamaica Kincaid has written starkly about Antigua: about her experiences growing up there, about racism, and about the legacies of slavery and colonialism. She has penned essays on gardens for *The New Yorker* and also authored *My Favorite Plant: Writers and Gardeners on the Plants They Love* (1998) and *My Garden Book* (1999). Kincaid pinpoints a moment where the literary and the botanical intersect. "I do not like daffodils," she writes, "but that's a legacy of the English approach: I was forced to memorize the poem by William Wordsworth when I was a child," referring to the Wordsworth poem "I Wandered Lonely as a Cloud." "The reason I do not like daffodils," she states in "Alien Soil," "is not at all aesthetic but much more serious than that: having been forced to memorize a poem about daffodils, when none were to be found in the place I grew up." The colonizers exported a literary canon—without regard for the local. Flip the structure. Learn from the ground up. What then might emerge?

In *A Small Place* (1988), Kincaid revisited Antigua. The book received mixed reviews, undoubtedly because of the searing critiques found in the opening and closing sections. In opening the book, Kincaid wrote from the vantage point of "a tourist, a North American or European—to be frank, white—and not an Antiguan black returning to Antigua from Europe or North America." In the short closing section she wrote of then contemporary Antigua. In the second section she wrote about the Antigua she knew as a child. Kincaid's *A Small Place* tackles a vexing issue for islands: tourism is a main economic motor for many islands. On Antigua and Barbuda tourism accounts for nearly 60 percent of the GDP. Yet the industry sits in an uneasy relationship to pandemics and climate change.

While over 97 percent of the population lives on Antigua, the larger of the two islands, Barbuda, by contrast is sparsely populated. Barbuda lies to the north of Antigua. It is a coral limestone island and thus much flatter. It has a mean elevation of 125 feet (38 m) and the highest point is at 145 feet (44 m). Most residents are *subsistence* farmers and fishers and live in Codrington, its one sleepy village that lies next to a lagoon. Like islands in the Pacific, Barbuda suffers from extremely limited *freshwater*. It has no rivers or lakes. Most water is gathered through rainwater catchments.

Antigua and Barbuda sit in the hurricane belt and thus the threat of *hurricanes* is real: one strikes the island about every year. The most intense hurricane on record struck the islands in 1847.

In 1989, Hurricane Hugo tore through. Audre Lorde writes of the devastating impacts in "Of Generators and Survival—Hugo Letter": "No one who experienced it will ever forget that night when the hurricane winds rode us down to a stand and the trees gave up their leaves and the land almost gave up her name."

In the aftermath, she continues, "We venture forth, wet, trembling, exhausted, and relieved to be alive. The sky over our wrecked and roofless rooms is sodden and wet. . . . Couches are blown end-up against the wall, chandeliers fallen, kitchen cabinets down, their doors stoven in and their contents strewn everywhere. The refrigerator has been wrenched away from the wall. . . . Our cisterns have water which is fairly clean, since . . . we had covered the overflow pipes to prevent groundwater fouling. . . . Ninety percent of the island's dwellings are gone or damaged. We step outside to look around. . . . Nothing green is visible, except for the battered, wind-chewed collard greens at the back of our once-garden. Later I wonder at the hardiness. There are no leaves left on the trees, no flowers, no bushes. Everywhere, burned, blasted landscapes of sparse and tortured broken trees."

After Hugo, the hurricanes continued. In September 1995, Hurricane Luis, a Category 4 storm, hit Barbuda, killing 3, injuring 165, and destroying most homes and infrastructure.

In September 2017, Hurricane Irma, a Category 5 storm, struck Barbuda directly, destroying 95 percent of the island's buildings and downing electricity and communications. It was the most powerful hurricane ever recorded in the Atlantic and caused US$222 million worth of damages. Barbuda's fifteen hundred residents were evacuated to Antigua. Philmore Mullin, director of the National Office of Disaster Services, said in an interview, "In my 25 years in disaster management, I have never seen something like this."

Since Irma struck, Barbudans have returned to their island. Yet even four years later, the rebuilding process remains challenging. The one elementary school reopened in 2020. But electricity is not reliable. Housing has not been fully rebuilt. A hospital is being built and, meanwhile, a mobile medical clinic tries to tend to basic needs.

While attention could have focused on rebuilding housing and the hospital and ensuring reliable electricity, and then attending to how best to prepare for future hurricanes, some took a different route, aiming to profit from the crisis. On Barbuda, like on Samoa (29) in the Pacific, land has traditionally been held communally. That is, only Barbudans have the right to land for housing, agriculture, or commercial purposes. But any Barbudan, be they a doctor or a housecleaner, can own beachfront property. After Hurricane Irma the current prime minister, Gaston Bowne, proposed an amendment to privatize land rights. It has faced legal challenges. The privatization of land is part of an attempt to build the Barbuda Ocean Beach Club, a resort for the very wealthy.

Arriving visitors would also need an airport, which presently does not exist on the island. Its construction, too, has been contentious with the Office of the High Commissioner for Human Rights weighing in in July 2021. Here's why: after Barbudans were evacuated in advance of Hurricane Irma, and before they were allowed to return, land was cleared in preparation for construction of an airport. The airport would run right alongside the Codrington Lagoon. At the lagoon's northern end is the Frigate Bird Sanctuary. Mangroves and sea grass alongside the lagoon provide a crucial habitat for the birds and a buffer against hurricanes and storm surge.

Construction began but the requisite Environmental Impact Assessments (EIA) did not consult with the population and were not made publicly available, as required. According to coverage, "A subsequent EIA, which was made public, found that the runway had been built on cavernous limestone" (Boyle). It means that the runway could collapse under the weight and pressure of arriving airplanes. An injunction halted construction in August 2018. So while the effects of climate change intensifies hurricanes and sea level rise might devastate islands, they also open the door for disaster capitalism.

Jamaica Kincaid

FROM **A SMALL PLACE**

Antigua is beautiful. Antigua is too beautiful. Sometimes the beauty of it seems unreal. Sometimes the beauty of it seems as if it were stage sets for a play, for no real sunset could look like that; no real seawater could strike that many shades of blue at once: no real sky could be that shade of blue—another shade of blue, completely different from the shades of blue seen in the sea—and no real cloud could be that white and float just that way in that blue sky; no real day could be that sort of sunny and bright, making everything seem transparent and shallow; and no real night could be that sort of black, making everything seem thick and deep and bottomless. No real day and no real night be that evenly divided— twelve hours of one and twelve hours of the other; no real day would begin that dramatically or end that dramatically. . . . No real sand on any real shore is that fine or that white (in some places) or that pink (in other places); no real flowers could be these shades of red, purple, yellow, orange, blue, white; no real lily would bloom only at night and perfume the air with a sweetness so thick it makes you slightly sick; no real earth is that colour brown; no real grass is that particular shade of dilapidated, rundown green (not enough rain); . . . no real rain would fall with that much force, so that it tears up the parched earth.

ATLANTIC OCEAN

PUERTO RICO

SAN JUAN

Caribbean Sea

0 20 mi
/ — — — / — — — /

/ — — — / — — — /
0 20 km

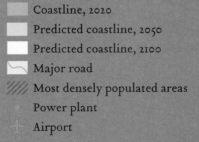

Coastline, 2020
Predicted coastline, 2050
Predicted coastline, 2100
Major road
Most densely populated areas
Power plant
Airport

Borikén
Commonwealth of Puerto Rico

18.2208° N
66.5901° W

Main island and several smaller islands

3515 sq. mi. (9104 km²)

Population: 3,098,423 (2022 est.)

75.8% white, 12.4% Black

Languages: Spanish, English

Mean Elevation: 856 ft. (261 m) | Highest Elevation: 4390 ft. (1338 m)

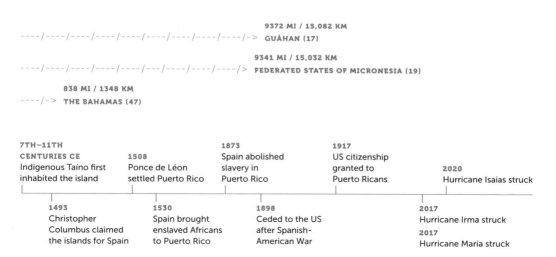

9372 MI / 15,082 KM
----/----/----/----/----/----/----/----/----/-> GUÅHAN (17)

9341 MI / 15,032 KM
----/----/----/----/----/---/----/----/----/> FEDERATED STATES OF MICRONESIA (19)

838 MI / 1348 KM
----/-> THE BAHAMAS (47)

7TH–11TH CENTURIES CE
Indigenous Taíno first inhabited the island

1508
Ponce de Léon settled Puerto Rico

1873
Spain abolished slavery in Puerto Rico

1917
US citizenship granted to Puerto Ricans

2020
Hurricane Isaias struck

1493
Christopher Columbus claimed the islands for Spain

1530
Spain brought enslaved Africans to Puerto Rico

1898
Ceded to the US after Spanish–American War

2017
Hurricane Irma struck

2017
Hurricane Maria struck

In 2017, Hurricane Maria struck the Commonwealth of Puerto Rico as an almost Category 5 hurricane. Power was knocked out across the island for all of its more than 3 million residents. It took months and in some cases a year to restore. A full 95 percent of the cell phone networks and 85 percent of landline phones were down. Residents were also without water. Mudslides blocked roads. The storm caused an estimated US$90 billion in damages and caused almost three thousand fatalities. It was the most devastating storm in Puerto Rico's history.

Maria followed on the heels of Hurricane Irma, another Category 5 hurricane, which had passed just north of Puerto Rico a few weeks earlier. Irma caused widespread power outages and disruptions in phone service. It led to US$1 billion in damages and caused three fatalities.

And these hurricanes, in turn, came along after an economic downturn brought on by a change in Section 936 of the Internal Revenue Code, passed in 1976, which had allowed US companies to operate tax-free on the island, combined with the North America Free Trade Agreement (NAFTA), which took effect in 1994 and shifted manufacturing to Mexico. As a result of these two factors, Puerto Rico began to experience a recession.

In the 1990s the Puerto Rican government privatized a number of services that were previously state-run, such as hospitals and health services in 1994; transportation, such as ports, in 1995; and telecommunications in 1998, which led to massive strikes. The economic downturn was severe starting in 2006. It was compounded by the 2007–2008 financial crisis.

In 2015, Puerto Rico's governor stated that the island's "debt is not payable." Since Puerto Rico, like states, although not one, cannot declare bankruptcy, in 2016 the Financial Oversight and Management Board, a federal board, appointed by the US president, restructured Puerto Rico's debt. It did so by pushing for the privatization of electricity and schools. And it made massive cuts in public education and pensions. Puerto Rico had closed schools and abandoned maintenance of infrastructure. Then, in 2017, the hurricanes followed and exacerbated these already existing economic challenges and woes.

To make matters worse, rather than tend to the task at hand, rebuilding and with an eye to safeguarding against future climate change–related impacts, there were those who sought to profit from the crises. In Puerto Rico the latter have been called Puertopians (see Denice Frohman's poem "Puertopia" following). The outmigration of populations after a climate change disaster, such as a hurricane, can also create a vacuum for those seeking to swoop in and redraw the lines of the map, as occurred in New Orleans after Hurricane Katrina. An estimated two hundred thousand people left Puerto Rico after Hurricane Maria. In other words, disaster capitalism, mentioned with regard to Barbuda (41), has manifested full force in Puerto Rico.

Climate crises, however, like all disasters, highlight competing models in response. One can read Naomi Klein's *Shock Doctrine: The Rise of Disaster Capitalism* (2007) for one side of the narrative; and Rebecca Solnit's *A Paradise Built in Hell: The Extraordinary Communities That Arise in Disaster* (2009) for its flipside. That is, does one swoop in to profit? Or does one work to build community? This question is not only a retrospectively focused one with regard to Hurricane Maria in Puerto Rico. It is also a forward-focused question about how to build a resilient environment now, one that can withstand future climate upheavals. They are sure to come. (And it's not, to be sure, necessarily either/or.)

One can consider two different models for energy and food security. Like other island nations tethered to continental economies, Puerto Rico derives 94 percent of its electricity from fossil fuels. In this regard it ranks just behind Guåhan (17) and The Bahamas (47), which rank highest globally.

Instead, one could establish an energy system reliant on renewable energy, such as solar and wind, which are abundant on Puerto Rico and many other islands in the Caribbean and the Pacific. Microgrids could be locally and publicly owned and decentralized, which would strengthen them in an emergency, as a downed line in one location would not equal a downed system throughout, since energy systems would function in smaller discreet units or pods. Currently, 4 percent of Puerto Rico's electricity is derived from renewable sources. Klein opens *The Battle for Paradise: Puerto Rico Takes on the Disaster Capitalists* writing about how Casa Pueblo in the mountain munici-pality of Adjuntas was the only beacon of light with sustained power after Hurricane Maria. The reason? It was powered by solar panels. It charged up electronics and phones, powered oxygen machines of the elderly, and continued to broadcast radio.

Like with energy, a high percentage of Puerto Rico's food, about 85 percent, is shipped in. Again, many other islands have a similar percentage. Only one island nation in the Caribbean dis-cussed in this atlas is self-sufficient in fruits and vegetables: Dominica (40). The food shipped to Puerto Rico is typically canned, pre-packaged, and heavily processed, leading to the high rates of diabetes and obesity on islands. Colonizers often clear-cut forests in order to establish plantations and grow sugar (and also coffee and tobacco on Puerto Rico). Later, other monoculture crops, such as banana, corn, and papaya, replaced sugar. The plantations destroyed the small, decentral-ized farm systems worked by *jíbaro* (small farmers) on Puerto Rico.

Groups such as the Organización Boricuá de Agricultura Ecológica de Puerto Rico have been training farmers in agroecology and working toward food security. Founded in 1989, Organización Boricuá uses traditional methods, such as diversifying crops, sharing seeds, and using compost, which reduces waste (important on an island!) and returns moisture and nutrients to the soil. These strategies also build soil and conserve water.

A branch of group Organización Boricuá applies these approaches on Vieques. An island often associated by tourists with its remarkable bioluminescence, Vieques—like Bloodsworth Island near Deal Island (4) in the Chesapeake Bay and the Hawaiian Island Kahoʻolawe—was used by the US Navy, which "owns" two-thirds of the island, as a bombing range between 1945 and 2003. Agent Orange, depleted uranium, and napalm were all tested on Vieques. Toxins such as lead and mer-cury remain in the soil and in the water. Both activists and political representatives have opposed the US Navy's exercises on Vieques since the 1960s, given the environmental and health impacts. In the 1970s activists occupied Vieques. (Much like activists in Hawaiʻi occupied Kahoʻolawe.) The

US Navy's use of Vieques has been linked to the high cancer rates. They bring to mind the nuclear tests carried out in the Pacific not only by the US but also the UK and France; and Japanese artist Isao Hashimoto's time-lapse map of the 2053 nuclear explosions between 1945 and 1998; and Kathy Jetñil-Kijiner's poem "History Project" about the US Navy's nuclear bomb testing in the Marshall Islands (20) in the Pacific and its cancerous legacies.

Organización Boricuá has been working for decades to ensure that healthy, sustainably grown produce is grown and shared on Puerto Rico. It turns the tide from reliance on food shipments to self-reliance and from dependence to sovereignty. It also creates safeguards to protect against disruptions of shipments given the increased risk of hurricanes.

Puerto Rico is volcanic and thus mostly mountainous. About 60 percent is forested. Just 70 miles (114 km) north of Puerto Rico is the deepest part of the Atlantic Ocean, the Puerto Rico Trench. Its deepest point, in turn, is the Milwaukee Deep, which is an estimated 27,600 feet (8400 m) deep.

The majority of the population lives along the coast and about 94 percent of it is urban. Residents are clustered near the cities of San Juan (the capital), Bayamón and Carolina, which are located in close proximity to one another on the north coast, and Ponce located on the south coast. These areas and their *population density* will be most impacted by *sea level rise*.

The 2017 Fourth National Climate Assessment Report found that sea level rise of 1.6 feet (0.5 m) would affect over eight thousand structures—a combination of private, commercial, and residential property—in Puerto Rico's low-lying areas. A sea level rise of 6.5 feet (2 m) would impact more than fifty thousand structures along the coast and cause an estimated US$11.8 billion in losses (2017 USD). Puerto Rico would lose 3.6 percent of its coastal land. The higher water level would flood coastal *infrastructure*, such as water pumping stations and pipelines, a wastewater treatment plant, and six power plants. It would also inundate the airport in San Juan.

Puerto Rico rests in the *hurricane* alley and has recently been intensely hit twice in short succession. According to the 2017 climate assessment report, Puerto Rico has experienced events necessitating disaster declarations every year since 2001.

Denice Frohman

PUERTOPIA

Puerto: port, from Latin "porta," meaning "gate, door";

Utopia: Modern Latin meaning "nowhere"

the coquís don't sing anymore / they click / mosquitoes turned drones / metropolis of crypto-bro / tax-deductible greed / a door opens / an island drowns / a playground emerges / a boy / his toy // depending on the faith / the most dangerous part of a wealthy man is his index finger / what he points to / who he lands on / a civilization disposable income / pirate in cargo shorts / New World / Old Order // meanwhile we diaspora / separated by sea / peel platanos & cut them on the same angle our mothers taught us to clap / when the plane lands on either shore / now / the beaches are gated & no one knows the names of the dead / now / investors clean their beaks in the river & this is how a man becomes a flood // landlord of nothing / king of no good sky / watch paradise / misbehave / watch the night pearl / into a necklace of fists / watch this / El Yunque / a real god machine / unhinge her jaw / & swallow the flock / where are the Puerto Ricans? / cuchifrito ghost town / battery-operated citizenship / an island is not a tarmac / a disaster is not a destination—

Kiskeya (Hispaniola)
Dominican Republic

18.7357° N
70.1627° W

18,657 sq. mi. (48,320 km²)

Population: 10,694,700 (2022 est.)

70.4% mixed (58% mestizo/indio, 12.4% mulatto), 15.8% African descent, 13.5% European descent

Language: Spanish

Mean Elevation: 1391 ft. (424 m) | Highest Elevation: 10,164 ft. (3098 m)

562 MI / 904 KM
----> **ANTIGUA AND BARBUDA (41)**

237 MI / 382 KM
-> **PUERTO RICO (42)**

731 MI / 1176 KM
----/> **CUBA (46)**

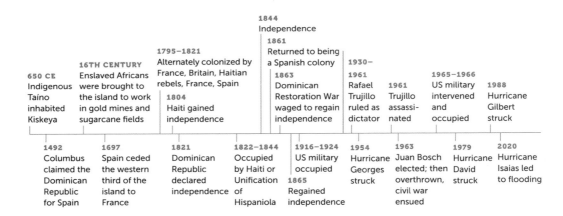

650 CE
Indigenous Taíno inhabited Kiskeya

16TH CENTURY
Enslaved Africans were brought to the island to work in gold mines and sugarcane fields

1795–1821
Alternately colonized by France, Britain, Haitian rebels, France, Spain

1804
Haiti gained independence

1844
Independence

1861
Returned to being a Spanish colony

1863
Dominican Restoration War waged to regain independence

1930–1961
Rafael Trujillo ruled as dictator

1961
Trujillo assassinated

1965–1966
US military intervened and occupied

1988
Hurricane Gilbert struck

1492
Columbus claimed the Dominican Republic for Spain

1697
Spain ceded the western third of the island to France

1821
Dominican Republic declared independence

1822–1844
Occupied by Haiti or Unification of Hispaniola

1916–1924
US military occupied

1865
Regained independence

1954
Hurricane Georges struck

1963
Juan Bosch elected; then overthrown, civil war ensued

1979
Hurricane David struck

2020
Hurricane Isaias led to flooding

Ciguapas is a female trickster from Dominican folklore. Long hair covers her body, and her feet are backward-facing. If someone is lured by her, they are never seen again. So the story goes. But it is unclear if she is ugly or beautiful. Artist Firelei Báez, who was born in the Dominican Republic and is of Dominican and Haitian descent, paints the figure onto colonial-era maps and *portolas* of the Caribbean. The dark hair glistens. Flora and fauna surround the *ciguapas*. A Lilith wild woman of the forest, Báez has called them. One ciguapas Báez painted puts into question the classificatory

systems (Linnaean taxonomy) Europeans brought with them to islands. Another squats on a colonial map. Playful. Whimsical. Layers. Báez looks for the silences. The overlooked. The mythical. And reframes.

The Dominican Republic takes up the eastern two-thirds of the island of Hispaniola; Haiti (44) forms the western third. Hispaniola is nestled between Cuba (46) and Jamaica (45) to the west and Puerto Rico (42) to the east.

Starting in the seventh century, Indigenous Taíno inhabited the island they called Kiskeya (or Quisqueya), meaning "the cradle of life." Spanish colonizers decimated the Taíno population through enslavement and disease. But the Taíno legacy continues today in Taíno words, such as *barbacoa* (barbeque, grilling meat), *cacique* (chief), *hamaca* (hammock), and *tabaco* (tobacco), which were adopted into the Spanish language after colonization.

The Dominican Republic was the first island to be colonized, and Santo Domingo, the capital, was the first city established in the Americas.

Geographically diverse, the Dominican Republic has some of the Caribbean's highest and lowest elevations: tropical rainforests in the mountains, savannahs in the valleys, and deserts in the southwest. Four parallel mountain ranges cross the island. Some feature *sky islands*, mountain peaks surrounded by radically different lowland environments. Between the mountain ranges are valleys. Cibao Valley in the north is densely populated. It's also very fertile: two of the island's main rivers flow into it and it receives much more rainfall than valleys to the south.

About 50 percent of the land, a high percentage, is used for agriculture. As a result, the Dominican Republic produces most of its own fruits and vegetables. In this regard, it, like Dominica (40), stands out in the Caribbean. Historically, cocoa, coffee, and sugarcane were the main crops. Now, crops include bananas, corn, potatoes, and rice. Despite the agricultural bounty, farming does not pay well and farmers have to supplement their income.

The economy has shifted to a combination of agriculture, mining, services, and tourism. Minerals play an important economic role. The Pueblo Viejo gold mine is one of the world's oldest and largest and the biggest in the Americas. The island's natural resources include bauxite, nickel, and silver as well. Amber and blue larimar can also be found in the Dominican Republic. Remittances are vital, too, especially from the US, where a large diasporic Dominican population lives. Economic inequality remains an issue, reflected in how much of the population lacks access to drinking water (15 percent) or sanitation facilities (16 percent).

The Dominican Republic has a lower cost of electricity, especially when compared to neighboring Puerto Rico (42). While 77 percent of the electricity is derived from fossil fuels, 16 percent

is derived from hydroelectric plants and 7 percent from other renewable sources. Additionally, the Dominican Republic plans to reduce greenhouse gas emissions by 25 percent by 2030 and to be carbon neutral by 2050. President Medina plans to reforest "over 119,000 acres and [install] over 604 MW of solar and wind energy, [which constitutes] one quarter of the country's energy matrix" (Herrera). These two factors—food independence and a shift to renewable energy—provide crucial safeguards against disruptions to shipments to the Dominican Republic. These safeguards are also vital, given that the Dominican Republic lies in the middle of the *hurricane belt* and has experienced numerous storm strikes.

The Dominican Republic is deeply impacted by climate change–induced sea level rise. The World Bank predicts that in Latin America, Santo Domingo will be the city second most affected by it. Four-fifths of the island's population lives in urban environments. *Population density* is highest in Santo Domingo, on the southern coast, and in the Cibao Valley. In Santo Domingo's La Barquita neighborhood, many residents live along the shore of the Ozama River. During cyclones and storm surge, homes flood. Nonetheless, residents return to live in simple tin wall and roof houses.

In 2016 the government began *resettlement* of residents of La Barquita into La Nueva Barquita, a neighborhood constructed further inland. It includes a water treatment facility and a daycare center. Housing is on the building's top floors and spaces for businesses are on the ground floor. In old La Barquita, housing will be demolished to discourage others from living there. The region will be turned into a coastal nature preserve to help provide a buffer against sea level rise. These housing improvements are vital since those living in informal settlements are most vulnerable to extreme weather events related to global warming. While some islands, such as the Maldives (12) and Kiribati (21), are looking to resettle their entire population, other islands, such as Papua New Guinea (25), Fiji (26), and the Dominican Republic are resettling their most vulnerable populations internally.

Julia Alvarez

NAMING THE ANIMALS

Let's name the animals no longer with us,
except in language: start with the dodo,
the Haitian long-tongued bat, the dwarf emu,
the laughing owl, the eastern buffalo.
And then animals like the nukupuu,
the lorikeet, the broad-faced potoroo,
[. . .]
But now, we . . . find ourselves
uttering names no one comes up to claim:
no iridescent, billed, web-footed
quacks back when we say *Leguat's Gelinote*—
in fact, unless we say the name out loud
or write it down, the gelinot is gone.
And so, our language, which singles us out
from dwarf emus, nukupuus, potoroos,
becomes an elegy, as with each loss
our humanness begins to vanish, too.

Kiskeya (Hispaniola)
Ayiti (Haiti)

18.9712º N
72.2852º W

Eastern two-thirds of Hispaniola and Navassa Island (under territory dispute with the US)

10,714 sq. mi. (27,750 km²)

Population: 11,334,637 (2022 est.)

Languages: French, Creole

Mean Elevation: 1542 ft. (470 m) | Highest Elevation: 8793 ft. (2680 m)

397 MI / 979 KM
----/> CUBA (46)

120 MI / 190 KM
---> JAMAICA (45)

802 MI / 1290 KM
----/--> MARTINIQUE (39)

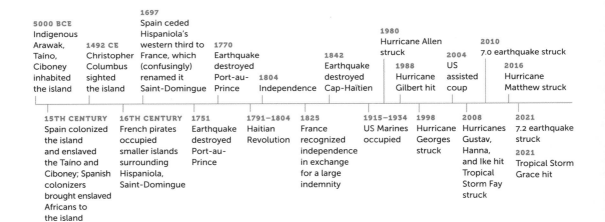

5000 BCE
Indigenous Arawak, Taíno, Ciboney inhabited the island

1492 CE
Christopher Columbus sighted the island

1697
Spain ceded Hispaniola's western third to France, which (confusingly) renamed it Saint-Domingue

1770
Earthquake destroyed Port-au-Prince

1804
Independence

1842
Earthquake destroyed Cap-Haïtien

1980
Hurricane Allen struck

1988
Hurricane Gilbert hit

2004
US assisted coup

2010
7.0 earthquake struck

2016
Hurricane Matthew struck

15TH CENTURY
Spain colonized the island and enslaved the Taíno and Ciboney; Spanish colonizers brought enslaved Africans to the island

16TH CENTURY
French pirates occupied smaller islands surrounding Hispaniola, Saint-Domingue

1751
Earthquake destroyed Port-au-Prince

1791–1804
Haitian Revolution

1825
France recognized independence in exchange for a large indemnity

1915–1934
US Marines occupied

1998
Hurricane Georges struck

2008
Hurricanes Gustav, Hanna, and Ike hit Tropical Storm Fay struck

2021
7.2 earthquake struck

2021
Tropical Storm Grace hit

A rodent that is estimated to be derived from a species that dates back 75 million years to the era of the dinosaurs, the solenodon has a ball and socket joint in its long snout to facilitate foraging for insects in the dirt. Solenodons can be found only on two islands: Hispaniola and neighboring Cuba (46). On Haiti the remarkably rare solenodons inhabit the 3–4 percent of forests that remain.

These rodents have very long claws and a venomous bite, a special power very few mammals have. As if the snout and the venom were not enough to make this animal unusual, the female's teats are located in the armpit of their hind legs, meaning they often drag their suckling young along behind them. Deforestation on Haiti has threatened these rare creatures.

Haiti's name is derived from the Indigenous Arawak *Ayiti,* meaning "mountainous land." Haiti forms the western third of Hispaniola—the most mountainous Caribbean island—the Dominican Republic (43) its eastern two-thirds. Four mountain ranges cross the island. The terrain is mostly rugged. The coastline is varied, rough in parts and sandy soft beaches elsewhere. Rhinoceros iguanas, a large lizard indigenous to Hispaniola, inhabit the coasts.

A few plains exist between the ranges. Most of the agriculture is cultivated here and in the adjacent valleys, as the alluvial soil is rich. About 66 percent of Haiti is agricultural land, and about 40 percent to 60 percent of Haitians rely on agricultural jobs. Agriculture is the largest economic sector. Nonetheless, the food produced is not enough to feed the population. So food is also imported.

Historically, forests were cleared to make way for plantations. Nowadays, their wood is burned for energy. The intense deforestation has led to severe erosion and loss of topsoil.

Vetiver, grown on the islands, helps control erosion somewhat, since it has long roots. Haiti, alongside India and Indonesia, is the leading global producer of vetiver. Originally from India but common in tropical zones, vetiver yields an oil popular for use in perfumes and aromatherapy. It also has medicinal properties.

Established in 1804, Haiti is the only nation founded by a revolution of enslaved Africans. It was also the first independent nation in the Caribbean and in Latin America. And it fought off Napoleon's attempts to reinstate slavery. The US, fearing slave revolts, refused to recognize the new nation. France eventually recognized Haiti in 1825 but for a steep fee, arguing that Haiti owed *it* money for financial losses incurred from losing the colony. To pay France, Haiti borrowed; the loans typically had high interest rates. They were not paid off until 1947 and severely hampered Haiti's economy. This history is vital for any discussions of present-day Haiti.

Haiti is the poorest economy in the Western Hemisphere. An estimated three-fifths of the population is unemployed or underemployed. The majority of the population lives in poverty. Most residents survive on less than two dollars per day. As a result, many Haitians have emigrated to seek out work elsewhere. While some Haitians live in neighboring Cuba (46) or the Dominican Republic (43), working in agriculture, many Haitians also live in Canada and the United States. *Remittances* sent home constitute a large part of Haiti's economy.

Environmental devastation compounds Haiti's dire economic straits. Haiti sits in the *hurricane belt* and rests on two fault lines. Thus it is at high risk for both hurricanes and earthquakes. In 2008, Haiti was devastated by a succession of storms and hurricanes, including Tropical Storm Fay and Hurricanes Gustav, Hanna, and Ike. These hurricanes killed almost eight hundred people and led to widespread flooding as well as mudslides, which destroyed housing, infrastructure, and crops.

Then, in 2010, disaster struck again as a 7.0 earthquake with an epicenter just 15 miles (25 km) southwest of the capital Port-au-Prince killed over three hundred thousand and destroyed most buildings, leaving more than one million homeless. In 2012, Hurricane Sandy wreaked havoc on Haiti's attempts to rebuild. Extensive flooding damaged crops and buildings, infrastructure, and agriculture. Then, in 2016, Hurricane Matthew, a Category 4 storm, reached Haiti, damaging crops, homes, and infrastructure and affecting 2.1 million people.

"I think Haiti," Edwidge Danticat told Robert Birnbaum in an interview in 2004, "is a place that suffers so much from neglect that people only want to hear about it when it's at its extreme. And that's what they end up knowing about it."

Haiti not only has the weakest economy in the Caribbean and has been devastated by the 2010 earthquake and hurricanes, it also is severely impacted by sea level rise. Of islands in the Caribbean, Hispaniola—Haiti and the Dominican Republic—has the largest population on low-lying land. In Haiti an estimated tenth of the population lives on land below 1.6 feet (0.5 m). By 2050, predictions for sea level rise in Haiti range from 0.82 to 1.05 feet (0.25–0.32 m). By 2100, predictions of sea level rise in Haiti range from 1.7 to 5.18 feet (0.52–1.58 m). So Haiti will be severely impacted by sea level rise.

Michel-Rolph Trouillot

FROM "THE ODD AND THE ORDINARY"

When we are being told over and over again that Haiti is unique, bizarre, unnatural, queer, freakish, or grotesque, we are also being told, in varying degrees, that it is unnatural, erratic, and therefore unexplainable. We are being told that Haiti is so special that modes of investigation applicable to other societies are not relevant here.

Xaymaca

Jamaica

18.1096° N
77.2975° W

4235 sq. mi. (10,991 km²)

Population: 2,818,596 (2022 est.)

Languages: English, Jamaican Creole

Mean Elevation: 59 ft. (18 m) | Highest Elevation: 7401.57 ft. (2256 m)

334 MI / 537 KM
--> HAITI (44)

237 MI / 381 KM
--> CUBA (46)

478 MI / 770 KM
---> THE BAHAMAS (47)

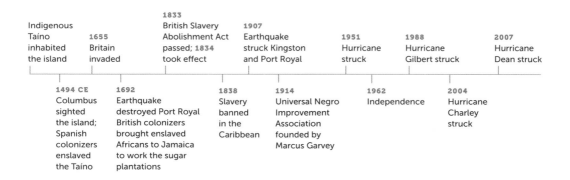

Indigenous Taíno inhabited the island

1655 Britain invaded

1833 British Slavery Abolishment Act passed; 1834 took effect

1907 Earthquake struck Kingston and Port Royal

1951 Hurricane struck

1988 Hurricane Gilbert struck

2007 Hurricane Dean struck

1494 CE Columbus sighted the island; Spanish colonizers enslaved the Taíno

1692 Earthquake destroyed Port Royal British colonizers brought enslaved Africans to Jamaica to work the sugar plantations

1838 Slavery banned in the Caribbean

1914 Universal Negro Improvement Association founded by Marcus Garvey

1962 Independence

2004 Hurricane Charley struck

Jamaica's name from the Indigenous Taíno "xaymaca" is believed to mean "Land of Water." Over one hundred rivers cross the island, disappearing for a stretch into *karst* geology, irregular *limestone* that features caves, sinkholes, and underground streams. The island's geography is fairly mountainous, particularly in its central region, and toward the east where the Blue Mountains peak at 7402 feet (2256 m). Flatter coastal plains ring the island. Mangroves line much of the coastline, and *coral reefs* run along the northern shore. The area between the reef and the shore provides a rich marine habit for myriad species of fish.

Although the biodiversity of Jamaica is less rich than that of Cuba or Hispaniola, Jamaica's past and present biodiversity is richly documented in the caves and sinkholes, which contain many microfossils, for example, of a sea cow and a rhinoceros-like hyrachyus. The island has over two hundred bird species, including the red-billed streamer-tail, also known as the scissor-tail hummingbird. Indigenous to Jamaica and the national bird, it has emerald green feathers, a red bill, a jet-black crown, and two long and curved tail feathers.

Like neighboring Hispaniola, much of the island was once forested. Successive waves of colonizers—Spanish, followed by British—cut down the trees to use them for building and for fuel and to clear space for plantations. Coffee and sugarcane—the latter turned not only into sugar but also molasses and rum—were planted. About 31 percent of the island is now forested, and about 41 percent of the land is agricultural. Coconuts and cacao, allspice, and ginger are grown. Agriculture contributes about 5 percent to the national economy and employs about 17 percent of the labor force. Additionally, fishing is a big industry.

Many Jamaicans have emigrated to work due to the economic situation. Early on, Jamaicans emigrated to Panama. In the 1850s, Jamaicans helped to build a railway across Panama's isthmus. Jamaicans also worked on the two attempts to build a canal across Panama: the failed nineteenth-century French attempt and the successful 1904–1914 US attempt. Subsequently, after the Immigration Act of 1948 was passed in the UK to recruit workers from the Caribbean, Jamaicans emigrated to the UK as part of the Windrush Generation. Many Jamaicans have also emigrated to Canada and to the US. This trend has continued, especially in the 1980s and 1990s, when the Jamaican economy weakened. _Remittances_ constitute 14 percent of the island's economy. Tourism is currently a key motor of the economy, accounting for 20 percent of GDP.

In the Caribbean, aside from The Bahamas (47), Jamaica is among the islands most at risk of sea level rise. The Palisadoes is a narrow stretch of sand—also known as an ayre, a spit, or a tombolo—that runs parallel to and serves as a protection for Kingston on Jamaica's southern coast. At the end of the Palisadoes rests the village of Port Royal. Port Royal is a _tied island_, connected or tied by an ayre or a tombolo to the mainland. For the village of Port Royal, an increase of 1 foot (0.3 m) is predicted by 2050 and of 2.65 feet (0.81 m) by 2100.

What's more, a large part of the village is already underwater. After Spanish colonization, Port Royal was the largest city on Jamaica. It continued to expand during British colonization. To make room for the expansion, infill was used. In 1692, an earthquake struck, followed by a tsunami. Since most of the buildings had been built on sand with infill, liquefaction led the city to sink underwater. Donny Hamilton, a retired professor of anthropology and nautical archaeology,

writing about the location, called it a "catastrophic site"—that is, a site "created by some disaster that has preserved both the cultural features and material and all-important archaeological context." It is a place, he wrote, where "time has frozen, and life in the past is revealed as it was lived." Hamilton likens it to Pompeii or Herculaneum in Italy or the Ozette Native American Village Archaeological Site in Washington State.

While Port Royal serves as site of past life, it also serves as a harbinger of future life in the region. That is, it yields lessons about building on sand (and with sand, often mixed into concrete), on infill, in liquefaction zones, and along coastlines.

Kei Miller

WHAT THE MAPMAKER OUGHT TO KNOW

On this island things fidget.
Even history.
The landscape does not sit
willingly
as if behind an easel
holding pose
waiting on
someone
to pencil
its lines, compose
its best features
or unruly contours.

Landmarks shift,
become unfixed
by earthquake
by landslide
by utter spite.
Whole places will slip
out from your grip.

Coabana
Republic of Cuba

21.5218º N
77.7812º W

Archipelago that consists of 1 large island and 1600 islands, islets, and cays

42,426 sq. mi. (109,884 km²)

Population: 11,008,112 (2022 est.)

64.1% white, 26.6% mixed European and African heritage, 9.3% Black

Language: Spanish

Mean Elevation: 354 ft. (108 m) | Highest Elevation: 6476 ft. (1974 m)

48 MI / 77 KM
-> HAITI (44)

87 MI / 140 KM
-> JAMAICA (45)

9095 MI / 14,637 KM
----/----/----/----/----/-----/----/----/----/----/----/----/----/----/--> SEYCHELLES (11)

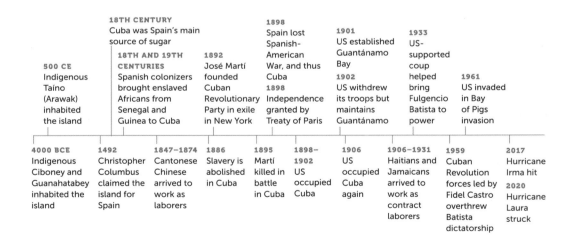

18TH CENTURY
Cuba was Spain's main source of sugar

1898
Spain lost Spanish-American War, and thus Cuba

1901
US established Guantánamo Bay

1933
US-supported coup helped bring Fulgencio Batista to power

500 CE
Indigenous Taíno (Arawak) inhabited the island

18TH AND 19TH CENTURIES
Spanish colonizers brought enslaved Africans from Senegal and Guinea to Cuba

1892
José Martí founded Cuban Revolutionary Party in exile in New York

1898
Independence granted by Treaty of Paris

1902
US withdrew its troops but maintains Guantánamo

1961
US invaded in Bay of Pigs invasion

4000 BCE
Indigenous Ciboney and Guanahatabey inhabited the island

1492
Christopher Columbus claimed the island for Spain

1847–1874
Cantonese Chinese arrived to work as laborers

1886
Slavery is abolished in Cuba

1895
Martí killed in battle in Cuba

1898–1902
US occupied Cuba

1906
US occupied Cuba again

1906–1931
Haitians and Jamaicans arrived to work as contract laborers

1959
Cuban Revolution forces led by Fidel Castro overthrew Batista dictatorship

2017
Hurricane Irma hit

2020
Hurricane Laura struck

Cuba derives its name from the Indigenous Taíno's name for the island, *Coabana*, meaning "great place." Cuba has the richest biodiversity among Caribbean islands. The Cuban trogon or tocororo, named thusly because that is what its call sounds like, is endemic to the island, found nowhere else, and the national bird. The brightly colored Cuban tody exists only on Cuba as well. Its head is yellowish-green, its lore is yellow, and its beak and throat are bright red. Cuban emeralds, a Cuban hummingbird, and Cuban parrots live in the trees. Flamingoes are abundant, too. Frogs, iguanas, lizards, and toads are plentiful. The flora includes ceiba trees, used medicinally, rare cork palms, and towering royal palms. Cuban holly (*Begonia cubensis*), a low shrub with bright flowers, grow.

The Republic of Cuba is an archipelagic nation that consists of one large island and 1600 islands, islets, and *cays*. The archipelago forms part of the Greater Antilles chain and rests where the Atlantic Ocean, the Caribbean Sea, and the Gulf of Mexico meet. Cuba is the largest and most populated island in the Caribbean. Haiti (44) lies just to the east, Jamaica (45) to the south, and The Bahamas (47) to the north.

The main island is 778 miles (1250 km) long and spans from 19 miles (31 km) to 119 miles (191 km) across. Cuba's geology is complicated and varied. Its terrain ranges from flat to rolling plains to hilly and mountainous chains. Its soils span from fertile to sandy. Extensive deforestation took place during colonization to make way for the cane and tobacco plantations, once the main crops on the flatter plains. Reforestation has restored some of the forests, which now account for 27 percent of the land use.

The island's main crops include bananas, manioc (cassava), citrus, corn, and rice, which is a staple of the diet. Other fruits such as *anón* (or sweetsop) and *guanábana* (or soursop), avocados, and papaya grow. An estimated 60 percent of the land is agricultural.

Cuba's shoreline is diverse, featuring bays, beaches, cliffs, *coral reefs*, *mangrove* forests, and swamps. Hake, needlefish, shark, and tuna are abundant. Cuban crocodile can be found in the freshwaters and slinking through the marshes, rivers, and swamps.

Cuba's location at the entrance to the Gulf of Mexico makes it prone to hurricanes. In 2017, Hurricane Irma hit the island, and 32-foot- (10 m) high waves inundated Havana. Hurricane Irma caused US$13.185 billion in damage and killed ten people. It was the costliest hurricane in Cuban history.

The low-lying coasts of Cuba will be very impacted by sea level rise. It is estimated that 20 percent of the island could be submerged by 2100. Particularly at risk are the coasts in the central region of both the northern and southern coasts as well as the peninsula to the west of Cienfuegos. Impacts are already palpable: for example, seawater has salinized agricultural lands and *aquifers*.

In 2017, Cuba put forward a plan, Tarea Vida (Project Life), which, among other things, bans building homes along the shoreline and stipulates *managed retreat* of people from coastal zones prone to flooding. Already in 2017, Cuba relocated residents of Palmarito, a fishing village, further inland. Additionally, agricultural lands are retreating inland away from saltwater intrusion.

Like the Seychelles (11), Cuba has a high *population density* along the shoreline. Cuba is working to protect its coral reefs and to restore mangrove forests to buffer the coastlines against the impacts of sea level rise. According to *Science Magazine*, the Seychelles has also offered to collaborate with Cuba on coastal protection (Stone).

Nancy Morejón

BLACK WOMAN

I can still smell the spray of the sea they made me cross.
The night, I can't remember.
Not even the ocean itself could remember.
But I can't forget the first alcatraz I saw.
High up, the clouds, like innocent witnessing presences.
By chance, I have forgotten neither my lost coast, nor my ancestral tongue.
They brought me here and here I have lived.
And because I worked like a beast
here I was born again.
How many a mandinga legend have I resorted to.

 I rebelled.

His Honour bought me in a public square.
I made His Honor's shirt and a son.
His son was without a name.
And His Honour died by the hand of an impeccable
 English Lord.

 I wandered.

This is the land where I suffered the whip and degradation.
I trod the length of all her rivers.

Under her sun I planted and gathered harvests I did not eat.
My home was a barracoon.
I myself carried the stones to build it,
yet I sang to the natural rhythms of native birds.

I rose up.

In this same land I touched the damp blood
and the rotting bones of many others,
some brought to this place like me, others not.
And I never again thought of the road to Guinea.
Was it to Guinea? Or Benin? Was it to Madagascar? Or Cape Verde?

I work harder.

I enhanced my hope and age-old song.
Here I built my world.

I went to the hills.

My real independence brought me to the fort
and I rode with Maceo's troops.

Only a century later
with my descendants
of the blue mountain

would I come down from the Sierra

to put an end to capital and moneylenders,
to generals and bourgeoisie
Now I am: only today do we have and create.
Nothing is taken from us.
Ours is the land.
Ours the sea and the sky.
Ours the magic and vision.
My peers, here I see you dance
around the tree we plant for communism.
Her prodigious wood already resounds.

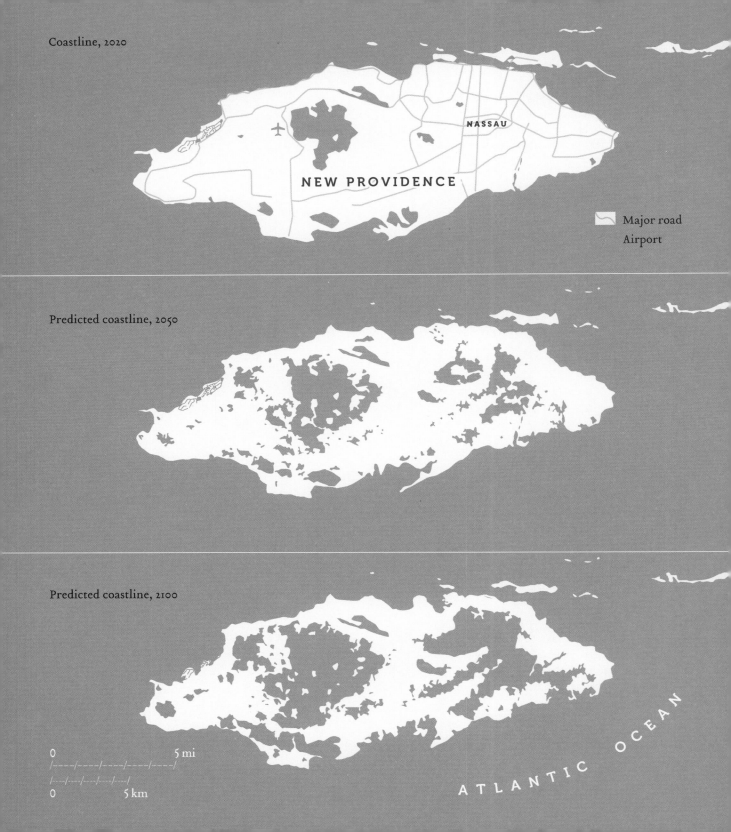

Coastline, 2020

NEW PROVIDENCE

NASSAU

Major road
Airport

Predicted coastline, 2050

Predicted coastline, 2100

0 5 mi

0 5 km

ATLANTIC OCEAN

ba ha ma BIG UPPER MIDDLE LAND

Commonwealth of The Bahamas

25.0343° N
77.3963° W

Archipelago of 700 islands and cays of which ~30 are inhabited

5359 sq. mi. (13,880 km²)

Population: 355,608 (2022 est.)

92.7% African descent, 4.7% European descent, 2.1% mixed race, 1.9% American

Languages: English, Bahamian Creole

Highest Elevation: 210 ft. (64 m)

```
                                                     7481 MI / 12,039 KM
----/----/----/----/----/----/----/----/----/----/----/----/----/>  BAHRAIN (8)

                                                     8540 MI / 13,744 KM
----/----/----/----/----/----/----/----/----/----/----/----/---->  GUÅHAN (17)

          838 MI / 1348 KM
----/->  PUERTO RICO (42)
```

9TH CENTURY CE
Indigenous Lucayan inhabited the island

16TH CENTURY
Spanish enslaved Lucayans and used them on neighboring islands

17TH AND 18TH CENTURIES
Piracy thrived

1838
Slavery banned in the Caribbean

2017
Hurricane Matthew struck

2020
Hurricane Isaias struck

1492
Christopher Columbus on a Spanish expedition alighted on Guanahani late 15th century and early 16th century

1648
Britain began settling The Bahamas

1718
Britain established colony

1833
British Slavery Abolishment Act passed

1973
Independence within the British Commonwealth

2019
Hurricane Dorian struck

Pink. Like the color of . . . flamingoes. Pink. Like the color of . . . the pink sand beaches of Harbour Island.

The Commonwealth of The Bahamas is an archipelago of over seven hundred islands, of which thirty are inhabited, and more than two thousand are small islets or *cays*. The islands form part of the Lucayan Archipelago, named after the region's Indigenous Lucayan people, a branch of the Taíno people who lived on most Caribbean islands. The islands' name derives either from the

Taíno ba ha ma ("big upper middle land") or from the later Spanish baha mar ("shallow sea"), describing the shallow waters around the islands.

In the Caribbean The Bahamas are the islands most at risk due to sea level rise for three reasons. First, the islands have a low elevation. Mount Alvernia is the highest point in the islands, measuring 210 feet (64 m). Most of the islands rest just a few feet above sea level.

Second, they consist of *limestone*, the Swiss cheese of geology. It is the most permeable and porous geologic matter. It allows saltwater to intrude. Some even say it soaks up saltwater—like a sponge. As a result, when sea levels rise, the islands will be inundated not only at the shoreline from sea level rise but also from underground as water can percolate up through the porous material. The southern tip of neighboring Florida, only 50–60 miles (80–100 km) away, also consists of limestone, which has led to inundation for the Everglades and Miami.

And third, The Bahamas have a high *population density* along the coastline. The majority (83 percent) of the population lives in urban environments; 75 percent lives on Providence Island, the main island, where Nassau lies and 71 percent lives.

According to a report on "Sea-Level Rise Threats in the Caribbean" published by Climate Central, "The Bahamas confront by far the greatest proportional threat: 32% of land [and] 25% of population . . . are below .5 meters [1.64 feet]." Furthermore, the report continued, "The Bahamas, Guyana and Suriname have the largest fractions of their populations occupying land below 0.5 m [1.64 feet] or 1 m [3.28 feet] . . . by wide margins." For The Bahamas, 1.04 feet (0.32 m) of sea level rise is predicted by 2050, and 2.68 feet (0.82 m) by 2100. These forecasts are dramatic.

The Bahamas are also at a high risk of *hurricanes* and tropical storms because the archipelago sits at the northern end of the Atlantic Hurricane Alley. According to the Intergovernmental Panel on Climate Change (IPCC)'s Fifth Assessment Report, the impacts of sea level rise measured in terms of national GDP found that alongside islands in the Pacific—specifically Belau (18), the Federated States of Micronesia (19), the Marshall Islands (20), and Nauru (22)—the island group in the Caribbean that would be most impacted is The Bahamas. On January 16, 2020, Moody's rating agency stated that The Bahamas is among the top four nations forecast to be hit hardest financially by sea level rise, with an estimated 11 percent of its residents and 15 percent of its GDP at risk and 12 percent of its total land mass at risk of submersion with 3 feet (1 m) of sea level rise forecast by the IPCC by 2100. If global temperatures increase by 5.4°F (3°C), 67 percent of The Bahamas' population would be impacted.

In September 2019, this prediction played out when Hurricane Dorian, a Category 5 hurricane, struck Abaco and devastated it and other islands. It caused US$3.4 billion in losses and damages. Speaking after the storms, The Bahamas prime minister Hubert Minnis stated: "We are in the midst of one of the greatest national crises in our country's history" (AP "Hurricane Dorian").

Christian Campbell

IGUANA

My friend from Guyana
was asked in Philadelphia
if she was from "Iguana."

Iguana, which crawls and then
stills, which flicks its tongue at the sun.

In History we learned that Lucayans
ate iguana, that Caribs
(my grandmother's people)
ate Lucayans (the people of Guanahani).
Guiana (the colonial way,
with an *i*, southernmost
of the Caribbean) is iguana; Inagua
(southernmost of The Bahamas,
northernmost of the Caribbean)
is iguana—Inagua, crossroads with Haiti,
Inagua of the salt and flamingos.
The Spanish called it *Heneagua,*
"water is to be found there,"
water, water everywhere.

Guyana (in the language of Arawaks,
Wai Ana, "Land of Many Waters")
is iguana, veins running through land,
grooves between green scales.
My grandmother from Moruga
(southernmost in Trinidad)
knew the names of things.
She rubbed iguana with bird pepper,
she cooked its sweet meat.

The earth is on the back
of an ageless iguana.

We are all from the Land of Iguana,
Hewanorra, Carib name for St. Lucia.

And all the iguanas scurry away from me.
And all the iguanas are dying.

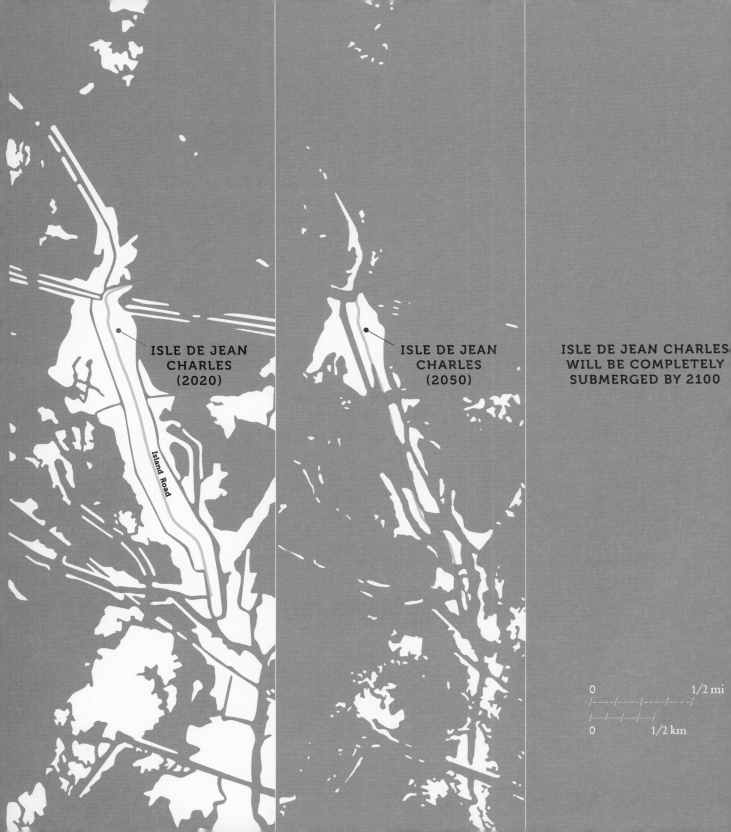

ISLE DE JEAN
CHARLES
(2020)

Island Road

ISLE DE JEAN
CHARLES
(2050)

ISLE DE JEAN CHARLES
WILL BE COMPLETELY
SUBMERGED BY 2100

0 1/2 mi
/----/----/----/----/
/----/----/----/----/
0 1/2 km

Isle de Jean Charles

0.6875 sq. mi. (1.78 km²)

Population: 85

Biloxi, Chitimacha, Choctaw

Languages: Coushatta, French, English

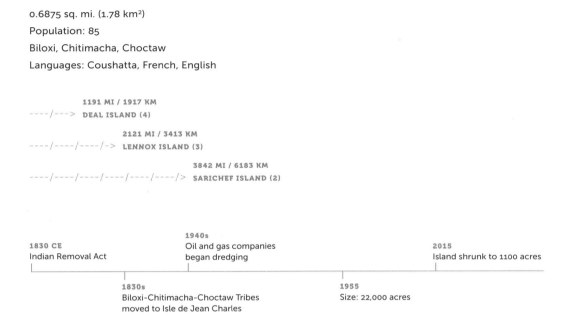

1191 MI / 1917 KM
----/---> DEAL ISLAND (4)

2121 MI / 3413 KM
----/----/----/-> LENNOX ISLAND (3)

3842 MI / 6183 KM
----/----/----/----/----/----/> SARICHEF ISLAND (2)

1830 CE
Indian Removal Act

1940s
Oil and gas companies
began dredging

2015
Island shrunk to 1100 acres

1830s
Biloxi-Chitimacha-Choctaw Tribes
moved to Isle de Jean Charles

1955
Size: 22,000 acres

Isle de Jean Charles has lost 98 percent of its landmass to rising sea levels and eroding shorelines since 1955. Then, it consisted of 34 square miles (89 km²). Now, it measures only 0.69 square miles (1.78 km²) or about 2 miles in length and 0.25 mile in width. Its population has decreased, too. Once four hundred people lived on the island. Now, only eighty-five persons remain.

Located about 80 miles southwest of New Orleans, the island faces the *bayou* (derived from the Choctaw word *bayuk,* meaning "slow-moving stream") and the Gulf of Mexico. Hurricanes have torn through its waters almost annually for the past twenty years. When they flood the land, the island's residents rebuild, removing the mud, often a few feet deep, from inside their homes. Local residents have traditionally been subsistence farmers and fishers, catching crawfish and also dredging for oysters, using *pirogues,* the flat-bottomed shallow boats common to the area. But with the frequency of the storms, such as Hurricane Katrina in 2005 and Hurricane Gustav in 2008, and Hurricanes Cristobal, Delta, Laura, and Zeta in 2020, and the resulting diminished remaining land, many islanders have relocated.

Most of the islanders descend from Biloxi, Chitimacha, and Choctaw Tribes that moved to the region in order to escape the forced relocation to west of the Mississippi mandated by the 1830 Indian Removal Act. They work as fishers and oyster harvesters. The island is named after Jean Charles Naquin, a Frenchman whose son, Jean Marie Naquin, settled on the island and married Pauline Verdine, who was Native American. Intermarriage between the Tribes and the area's French Cajun inhabitants was not uncommon.

Now the island's future is at risk. Its land loss is not only due to sea level rise and coastal erosion. Both the canals dredged by the oil and gas industry since the 1950s and the levees built to protect other areas have interfered with the natural process of sedimentation that counters coastal erosion. But the oil and gas industries were also the main employers in the region.

Not only are sea levels rising but Isle de Jean Charles is also subsiding or sinking, like islands in the Pacific, such as the Solomon Islands (24), Samoa (29), or Tegua in Vanuatu (23). In fact, scientists believe the _subsidence_ or sink plays a bigger role here than erosion. Thus inundation here results from both island height decrease and sea level increase.

Isle de Jean Charles, like Lennox Island (3) and Deal Island (4), is connected to the mainland by one road, Island Road, which often floods. Like on other islands, the salinization of the soil due to the flooding makes agriculture untenable. The water and area available for livestock have disappeared. When the water that soaks the buildings in storms lingers in this humid environment, mold and mildew soon follow. Since most of the buildings are of wood, they rot and then have to be rebuilt.

In January 2016, the US Department of Housing and Urban Development awarded US$48 million to resettle the island's population. A _New York Times_ article referred to them as the nation's first climate refugees (Davenport and Robertson). In March 2018, the Louisiana Office of Community Development announced it would buy 515 acres of land near Schriever, Louisiana, which is 40 miles to the north. Unlike Sarichef Island (2), which has voted three times to relocate, Isle de Jean Charles residents have twice voted against _resettlement_, bespeaking the traumatic legacy of the 1830 Indian Removal Act and its forced relocation of Native Americans as well as how strongly history, culture, and worldview are tied to a specific place and what its loss means. As Pat Forbes, executive director of the Louisiana Office of Community Development put it: "They do not want to leave the island; it is leaving them" (AP "Louisiana").

Solastalgia is a term coined by Glenn Albrecht in 2007 to describe the distress caused by environmental change and environmental degradation. Guamanian (17) poet Craig Santos Perez writes about how the term combines solace, desolation, and nostalgia. Solastalgia, Santos Perez writes, "speaks to the pain and distress caused when your homeland is destroyed but you are not necessarily displaced. In other words, you yearn for what your home was before it was desecrated

by mining, logging, fracking, military testing or oil spill; 'it is the homesickness you have when you are still at home.' Sadly, solastalgia is becoming more and more common, especially for peoples of color and those in developing countries" ("Pacific Eco-Poetics"). Due to and through environmental destruction the place one has known leaves, which in turn leads to solastalgia.

On January 9, 2019, Louisiana announced that the purchase of the land, a former sugar cane plantation, near Schriever had been completed. Albert Naquin—Chief of the Isle de Jean Charles Biloxi-Chitimacha-Choctaw (IDJC) Tribe and a descendant of the island's founder Charles Naquin—turned down the offer to move (Dermansky "Louisiana Breaks Ground").

According to *DeSmog*, "IDJC Chief Albert Naquin played a large role in helping the state's Office of Community Development (OCD) win a grant from the U.S. Department of Housing and Urban Development (HUD) in the $1 billion National Disaster Resilience Competition. That grant was intended to build the island resettlement project. But while the winning proposal was based on Naquin's vision of a tribal-led community, shortly after securing the grant, Louisiana's OCD radically changed the original plan, resulting in Naquin withdrawing the tribe's support of the project" (Dermansky "Louisiana Breaks Ground").

The Tribe says that the state did not take into consideration its plans, which centered its tribe and gave it control over the new territory and who moves there. The OCD, by contrast, planned to offer homes in three waves: first, to current island residents; second, to people who left in 2012 after Hurricane Isaac; and third, to anyone who could afford the homes, regardless of whether or not they have a connection to Isle de Jean Charles or the Tribe. Subsequent meetings between the OCD and the IDJC Tribe have not resolved the differences.

In July 2019, when Hurricane Barry passed over the island, it flooded the homes of residents who were airlifted out by the US Coast Guard. One resident said: "I have never seen the water come in so fast. There was over four feet within 30 minutes. I have nothing left" (Dermansky "Latest Gulf Storm").

COVID-19, *DeSmog* reports, compounded the financial precarity of many tribal members and highlighted the proposals' differences. Many of the island's residents hope to move to safer ground but also want to be able to maintain their island homes. Chief Naquin is concerned that under the guidelines, island residents are not allowed to do so. There are also financial considerations. The new homes have increased costs, while COVID-19 led to many lost jobs. Naquin's plan had included a community center that would have provided a safety net to generate revenue for tribal members who are unemployed or short on funds. Having the voices of tribal members not only included but also leading the process is vital to ensure that past traumas of *settler colonialism*—of the genocide, forced migration and cultural assimilation, and thus loss—are not repeated.

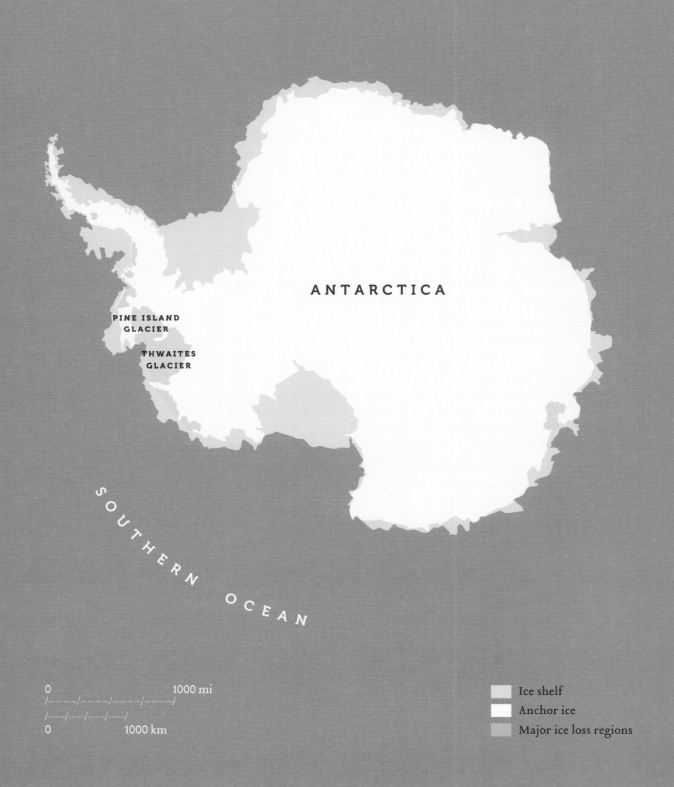

ANTARCTICA

PINE ISLAND
GLACIER

THWAITES
GLACIER

SOUTHERN OCEAN

0 1000 mi
/—/—/—/—/
/—/—/—/—/
0 1000 km

Ice shelf
Anchor ice
Major ice loss regions

Pine Island Glacier, Antarctica

75.1667° S
100.0000° W

68,000 sq. mi. (175,000 km²)

Uninhabited

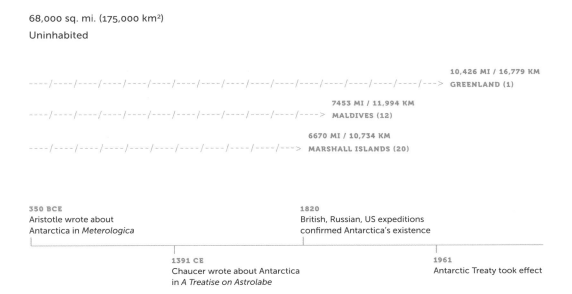

----/----/----/----/----/----/----/----/----/----/----/----/----/----/----/----/----> **10,426 MI / 16,779 KM**
GREENLAND (1)

----/----/----/----/----/----/----/----/----/----/----/----/----> **7453 MI / 11,994 KM**
MALDIVES (12)

----/----/----/----/----/----/----/----/----/----/----/----> **6670 MI / 10,734 KM**
MARSHALL ISLANDS (20)

350 BCE
Aristotle wrote about
Antarctica in *Meterologica*

1820
British, Russian, US expeditions
confirmed Antarctica's existence

1391 CE
Chaucer wrote about Antarctica
in *A Treatise on Astrolabe*

1961
Antarctic Treaty took effect

Pine Island Glacier is located in the Amundsen Sea, one of many seas that constitute the Antarctic Ocean, also known as the Southern Ocean. Although Antarctica was not visited until the nineteenth century, it was written about as early as 350 BCE in Aristotle's *Meterologica* and in 1391 by Geoffrey Chaucer, better known as an author and poet but also an astronomer, who wrote *A Treatise on the Astrolabe* in which he mentioned Antarctica.

British, Russian, and US expeditions of the region in 1820 confirmed the existence of Antarctica. The island is uninhabited and uninhabitable. Claims to the region have been made by various nations; however, no claim is recognized. In fact, the Antarctic Treaty, which took effect in 1961, explicitly neither denies nor gives recognition to any territorial claims.

An estimated 98 percent of Antarctica consists of a thick *ice sheet*; the other 2 percent consists of barren rock. The ice sheet constitutes 62 percent of the world's *freshwater*. According to the

CIA's *World Factbook*, "if all this ice were converted to liquid water, . . . it would be sufficient to raise the height of the world's oceans by 58 m (190 ft)."

Pine Island Glacier and neighboring Thwaites Glacier form the two major streams feeding into Amundsen Sea from the West Antarctica Ice Sheet. To wit, Pine Island Glacier is Antarctica's fastest melting *glacier*. Due to its melt, it is referred to as an *ice stream*. On October 29, 2018, a 115-square-mile (298 km²) section of Pine Island Glacier calved off. The chunk is five times the size of Manhattan. According to a 2019 NASA article, "Collectively, the region contains enough vulnerable ice to raise global sea level by 1.2 meters (4 feet)" (Hansen).

On July 8, 2019, a study published in the *Proceedings of the National Academy of Sciences* stated that the Thwaites Glacier is heading toward instability and could melt within 150 years. Its melt alone would lead to 1.64 feet (0.5 m) in *sea level rise* (Robel et al).

Unfortunately the glaciers are melting not only from above but also from below, known as bottom melting or *ablation*. This melt is taking place both in the Arctic and Antarctic and Greenland and evidences the increased water temperatures.

Sea level rise is not the only impact of the ice melt. Emperor penguins, which live in Antarctica, are also increasingly imperiled. They rely on the thick ice as a site on which to breed and raise their young. A study published on August 3, 2021, found that the population of emperor penguins could be cut in half by 2050 if greenhouse gas emissions are not reduced (Jenouvrier et al). And they could be almost extinct by 2100.

Previously, snowfall balanced out the *icebergs* calving into the ocean. But now glacier melt outpaces the snowfall. A study published in May 2019 in the journal *Geophysical Research Letters* found that one-quarter of West Antarctica's ice is unstable and at risk of melting (Shepard). According to the study, the areas are losing ice five times faster now than in the 1990s. If all the ice in Antarctica were to melt, sea levels would rise 16.4 feet (5 m).

Glossary

ablation—combined processes that remove snow or ice from the surface of a glacier or from below. (The opposite of accumulation.) Examples: sublimation, fusion, melting, evaporation.

albedo (physics)—the amount of light or energy that is reflected back.

Alliance of Small Island States (AOSIS)—an alliance of forty-four low-lying small island nations. AOSIS was established in 1990 to bring together Small Island Developing States (SIDS) impacted by global warming.

aquifer (hydrology)—a rock layer that contains water and releases it. Wells can be drilled into aquifers. They are a key source of freshwater. *See also* freshwater, lens.

archipelago—an island group.

artificial island—an artificial island has been constructed by humans rather than by natural means. Early artificial islands include Nan Madol off the eastern coast of Pohnpei in Micronesia. For examples in this atlas, see South China Sea Islands (15), Federated States of Micronesia (19), Marshall Islands (20), and Tuvalu (27). *See also* land reclamation, polder.

atoll (geology)—from the Maldivian word *atolu*. Atolls are also referred to as low-lying islands. Atolls consist of a very small land area relative to continental islands. They tend to be no more than 9.84 feet (3 m) in height and transient in nature. Atolls are often a ring-shaped coral reef or coral reef sedimentation that encircles a lagoon partially or completely. They typically rest atop the rim of an extinct and submerged volcano or seamount. Atolls are low-lying and contrast in height with islands of volcanic origin (also referred to as high islands). Most atolls are located in the warmer waters of the Indian and Pacific Ocean. They tend to have no surface freshwater and thus to be highly reliant on rainfall for potable water. *See also* volcanic island.

barrier island (geology)—typically elongated islands that are separate from and parallel to the shore. Barrier islands consist mostly of sand and often move either landward (transgressive) or seaward (regressive).

barrier reefs—border a shoreline. Separated from land by water. *See also* coral reefs, fringing reefs.

bathyscaphe—a free-diving deep-sea submersible.

bayou—derived from the Choctaw *bayuk*, meaning "slow-moving stream."

benthic zone—meaning "deep of the sea," the lowest ocean region, the ocean floor.

blackbirding—a practice carried out in the Pacific Ocean in the nineteenth and early twentieth century of coercing or kidnapping people to use as labor.

carbon dioxide (CO_2)—one of the three main greenhouse gas emissions, aside from methane and nitrous oxide (N_2O), responsible for climate change.

catchment—the collection of freshwater especially through rainfall—for example, in a cistern.

cay—a low-elevation, sandy island on the surface of a coral reef.

ciguatera—a toxin found in microalgae. As a result of coral bleaching, coral expel microalgae. This microalgae is, in turn, ingested by reef fish. The reef fish are, in turn, consumed by humans. The toxins can lead to fevers, diarrhea, and vomiting.

climate refugee—a term used to describe people who are forced to leave their homeland or region due to climate change–related impacts. These can be short-term and sudden changes or long-term changes. The term is not agreed upon. Climate refugees do have rights and recognition, although climate change does not constitute one of the grounds covered by the 1951 United Nations Convention Relating to the Status of Refugees.

commonwealth—a political unit having local autonomy but united with another state. The term is used officially with regard to the Northern Mariana Islands (16) and Puerto Rico (42) to express their relationship to the US. It is also used for states associated with the British Crown, such as Papua New Guinea (25), Samoa (29), Antigua and Barbuda (41), and The Bahamas (47).

continental island—refers to islands that are continents, such as Australia or Greenland (1). It also refers to islands that emerge from the continental shelf and thus are located close to large continental landmasses, such as the Seychelles (20). Typically they have higher elevations. They contrast with oceanic islands or coralline islands. *See also* coralline island, oceanic islands.

coralline island (geology)—islands of coral, typically low-lying and flat, often atolls around a central lagoon. They contrast with granitic islands. *See also* atolls, granitic islands.

coral reefs (geology)—forming a crucial barrier around islands against sea level rise, coral reefs break waves as they reach the island and thus reduce waves' impact. They also form a pivotal habitat for fish and other marine life. The ocean's absorption of CO_2 emissions and ocean temperature increase leads to the bleaching of coral reefs. While they can, if given the opportunity, recover, consistent and increasing CO_2 emissions lead the reefs to die off. Often referred to as the lungs of the ocean, coral reefs are to the oceans what rainforests are to the land: the region with the most biodiversity.

cryosphere—the parts of the earth that are frozen water, including land ice, ice sheets, and more, predominantly but not exclusively in the Arctic and Antarctic Oceans. *See also* ice sheet.

cyclone (meteorology)—a large system of winds circulating around a strong center of low atmospheric pressure. Cyclones occur in the Indian or South Pacific. *See also* hurricanes, typhoons.

deforestation—the process of clearing trees. Deforestation has a number of impacts. Forests are carbon sinks, so deforestation decreases the opportunity to capture carbon naturally. Deforestation, especially of mangroves along coastlines, increases erosion. *See also* erosion.

desalination plants—technological plants that remove salt from saltwater to render it drinkable for humans, animals, and plants.

dhow—a boat with one or two masts and lateen rigging (slanting, triangular sails). They have been common in the Indian Ocean, the Persian Gulf, and the Red Sea for millennia.

diaspora—a group of people dispersed from their original homeland.

dory—a small and shallow boat used in Nova Scotia and New England to fish and to harvest lobster and crabs in the Atlantic Ocean. It has a flat bottom, sharp bows, and high sides.

drua—a double-hulled canoe that originated in Fiji (26). Druas do not tack. They shunt: the bow can become the stern and the stern the bow.

epipelagic zone—the upper open ocean, where sunlight allows photosynthesis.

erosion (geology)—removal of soil and rock by natural agencies, such as water and wind. About 70 percent of world's beaches are said to be eroding. Islands are at particular risk of erosion because of their setting and because they have a limited sediment supply.

Exclusive Economic Zone (EEZ)—established by the 1982 United Nations Convention on the Law of the Sea, the EEZ establishes that a sovereign nation has the right to the marine area and its resources, including those below the surface of the sea, stretching 200 nautical miles from the coast of the state.

freshwater—naturally occurring water that is not saltwater. It includes water in ice caps, ice sheets, icebergs, glaciers, lakes, ponds, river, and streams. It also includes all forms of precipitation: hail, mist, rain, and snow. *See also* aquifer, glacier, ice cap, ice sheet, lens.

fringing reefs (geology)—these reefs grow directly from the shore. *See also* barrier reefs, coral reefs.

ghost forest—trees that have died, often due to the salinization of soil. Ghost forests are often a sign of inland retreat. As saltwater reaches further inland, the trees attempt to retreat from the shoreline. Also a sign of conversion (or return) to wetlands, ghost forests can include many different species of trees, from pine trees in cooler climates to palm trees in warmer ones.

glacier (geology)—a mass of ice that covers more than 19,000 square miles (50,000 km²). Also referred to as an ice sheet. *See also* ice cap, ice sheet.

granitic island (geology)—extensions or fragments of continents, also known as continental islands. Typically found closer to continents, they rest above sea level and rarely show signs of subsidence. The Falkland Islands and the Seychelles (11) are two examples. They contrast with and are much older and more diverse in composition than oceanic or coralline islands. *See also* continental islands, coralline islands, oceanic islands.

gross domestic product (GDP)—a measurement used to gauge a country's economic output, tracking the monetary value of goods and services. GDP has been criticized as a measurement for various reasons. For example, it does not take into account the value of household and other unpaid work. Environmentalists argue that GDP does not take into account harm to the environment. GDP does not take into account the benefits of a higher standard of living as a result of health care and education. A range of alternatives, such

as the Human Development Index, have been proposed that take into account other factors. *See also* Human Development Index.

hadal zone—the deepest region of the ocean, lying in oceanic trenches.

high island (geology)—an island of volcanic origin that stands in contrast to low-lying islands or atolls. High islands are small (relative to continental islands) and often are surrounded by coral barrier reefs. Their slopes tend to be steep. They tend to be younger than atolls. *See also* low-lying islands.

homing birds—birds that return home, in this case to an island. Spotting homing birds was a technique used by Micronesian navigators to determine proximity to an island (see Federated States of Micronesia (19)).

Human Development Index—a metric that combines a country's average life expectancy, education, and per capita income, to rank countries. It is produced by the United Nations Development Programme. It was designed and launched in 1990 as an alternative to the gross domestic product. *See also* gross domestic product.

hurricane (meteorology)— a large system of winds circulating around a strong center of low atmospheric pressure. Hurricanes occur in the Atlantic and Pacific Ocean. *See also* cyclones, typhoons.

hurricane belt—also known as hurricane alley. An area of warm water in the Atlantic Ocean with heightened hurricane activity. It rests between the west coast of Africa and the east coast of Central America, between Florida to the north to South America to the south.

iceberg (ice formation)—a large piece of ice that has broken off of a glacier or an ice shelf.

ice cap (geology)—a mass of ice that covers less than 19,000 square miles (50,000 km²). *See also* ice sheet.

ice sheet (geology)—a mass of ice that covers more than 19,000 square miles (50,000 km²). Also referred to as a glacier. *See also* ice cap.

ice stream—a type of glacier or region of an ice sheet that moves significantly faster than the surrounding ice. They exist in Greenland (1) and in Antarctica. The biggest ice streams are

the Lambert Glacier in East Antarctica and Pine Island (49) and the Thwaites Glacier in West Antarctica. *See also* ice sheet.

infrastructure—the basic system or organizational structures and facilities required for an activity. They can include water and sewage treatment plants, power plants, roads, airports, etc. They are often public works operated by a country, state, or city. Much infrastructure is at risk due to sea level rise.

Intergovernmental Panel on Climate Change (IPCC)—a United Nations body established in 1988 and tasked with providing, according to its website, "policymakers with regular scientific assessments on climate change, its implications and potential future risks, as well as to put forward adaptation and mitigation options."

kamal—a navigational device that determines latitude by the elevation of the Pole Star. The kamal consists of a rectangular wooden card about 2 by 1 inch (5.1 by 2.5 cm). A string with several evenly spaced knots is strung through a hole in the card's middle. The end of the string is held between the teeth and the card at the other end of the string is held away from the body with its lower edge parallel to the ground and even with the horizon. The upper edge tries to parallel a key star, such as Polaris. The number of knots from the card to the teeth determines the angle.

karst—an irregular limestone region with caves, sinkholes, and underground streams.

king tide—the highest astronomical tides of the year. The scientific term is a perigean spring tide. They occur at the full moon and new moon, specifically when at perigee (when the moon is closest to the earth in its orbit). Since king tides are the highest tides of the year, they can predict some of the impacts of sea level rise, such as coastal flooding and inundation.

lakatoi—multihulled sailing crafts developed by Motuans in Papua New Guinea (25) using crab-claw sails, which are wider at the upper edge to catch stronger wind.

land clouds—clouds that form near islands, which were a technique used by I-Kiribati navigators to locate islands (see Kiribati (21)).

land ice—glaciers, ice caps, and ice sheets that cover most of Greenland (1) and Antarctica (see Pine Island (49)). The melt of land ice is one of the two main reasons for sea level rise. The other is increased ocean temperatures. When water heats up, it expands. So warmer oceans take up more space.

land reclamation—also referred to as infill. The process of expanding the physical footprint of an area of land by filling in the surrounding area. It is somewhat of a misnomer since the land is not being reclaimed but created. Often waters reclaim the land.

lens—a freshwater lens consists of rainwater that forms a layer over saltwater, which is denser and thus hangs a bit lower. Drought induced by global warming runs the risk of depleting these water sources as they are tapped but not replenished. Sea level rise can flood the freshwater lens with saltwater. When the freshwater is salinized, it is no longer potable for humans, animals, and plants. Freshwater lenses are common on limestone or coral atolls and often the main source of drinking water. *See also* aquifer, freshwater.

limestone islands—islands that tend to have a concave inner basin and steep outer slopes. Like atolls, they have no surface water and thus are highly reliant on rainwater, which nourish their aquifers.

low-lying islands—also referred to as atolls. Atolls consist of a very small land area relative to continental islands. Atolls tend to be a ring-shaped coral reef or coral reef sedimentation that encircles a lagoon partially or completely. They often rest atop the rim of an extinct and submerged volcano. Atolls contrast in height with islands of volcanic origin, also referred to as high islands. Most atolls are located in the Indian and Pacific Ocean. They tend to have no surface freshwater and thus to be highly reliant on rainfall for potable water. *See also* atolls.

managed retreat—a strategy for addressing sea level rise by moving infrastructure and humans inland from areas threatened by or already experiencing inundation.

mangrove (plant)—trees that grow in dense thickets along tidal estuaries, salt marshes, and on muddy

coasts, mangroves are extremely important to the coastal ecosystems they inhabit. Physically, they serve as a buffer between the land and the ocean, protecting shorelines from damaging winds, waves, and floods. Mangrove forests filter pollutants and trap sediments from the land, improving water quality. They also reduce coastal erosion. Ecologically, they provide a habitat for a diverse array of terrestrial organisms and many species of coastal and offshore fish and shellfish, which rely on mangroves as their breeding, spawning, and hatching grounds. Because of their high salt tolerance, mangroves are often among the first species to colonize mud and sandbanks flooded by seawater. An increase in coastal development and saltwater intrusion has led to a decline in global mangrove populations. *See also* saltwater intrusion.

mudflat—coastal wetlands, often in regions such as estuaries, where rivers meet the sea and have deposited silt and sediments. These tidal zones are an important habitat for marine species and migratory birds. They also provide a buffer zone against sea level rise.

oceanic island—arise from deep waters (2.5 miles or 4 km or more) and volcanic activity. They are not located close to a continental landmass and contrast with continental islands. Every oceanic island began as a volcano. The main types are volcanic or high islands; high limestone islands; and atolls or low-lying islands. *See also* atolls, continental islands, volcanic islands.

overwash—when water floods over coastal dunes or crests during storms. Overwash inundates with saltwater, which contaminates freshwater and can kill vegetation. Overwash is a particular concern on low-lying atolls and barrier islands.

oyster reefs—oyster reefs are to the temperate zone what coral reefs are to the tropical regions: they protect shorelines. They promote sedimentation and they buffer waves. This dual action allows sea grass to grow, preventing erosion. Oyster reefs also filter water. Globally, since the late nineteenth century, 85 percent of oyster reefs have been lost.

permafrost (geology)—ground frozen continuously for two or more years.

phosphate—a mineral derived from bird droppings and used as a fertilizer. It can also be derived from the shells of marine invertebrates and the bones of vertebrates. Typically, formed underwater. Bird guano has a higher fertilizer value than bat guano.

pirogue—a flat-bottomed shallow boat common to Bijagós (6) and the Louisiana Delta (see Isle de Jean Charles (48)), used for dredging oysters, among other regions around the world.

plantation—according to Merriam-Webster, plantations are "2. a settlement in a new country or region" and "3. a place that is planted or under cultivation." Plantations, often on islands, are a place colonized and settled, trees clear-cut, and agriculture planted for profit, often using the labor of enslaved people.

polder—a tract of lowland reclaimed from the sea by the construction of dikes or of artificial islands. A practice developed in the Netherlands, it is now being applied in other places, such as the Bay of Bengal. *See also* artificial island.

population density—the number of people living in a unit of measurement, such as a square mile or square kilometer. On islands, population density is often high along the coastline, since it provides access to fishing and on volcanic islands is flatter terrain. This density interfaces with sea level rise, not only on islands but also in urban coastal cities, creating highly vulnerable populations.

proa—a sailboat that typically has two hulls of differing lengths. One hull is kept windward (upwind or the direction from which the wind is blowing) and the other leeward (downwind). The main hull (waka) is curved on the windward side and straight on the leeward side. One of the boat's distinguishing features is that stern can become bow and vice versa. Proa are noted for their remarkable speed.

rainwater harvesting—the practice of collecting rainwater in barrels, cisterns, or tanks. On islands with limited freshwater, harvesting it is a common practice.

reef islands—accumulations of sand and gravel derived largely from underwater environments.

remittance—a sum of money sent by a worker in the diaspora to members of their family or community in their home country. *See also* diaspora.

resettlement—moving people to a new place to live. With regard to islands and sea level rise, resettling sometimes involves the proposal of finding land for an island nation's entire population. Resettlement can happen domestically or internationally.

revetment—a wall built parallel to a shore to catch or break the impact of waves and protect the shoreline from erosion. *See also* erosion.

Ring of Fire—an upside-down horseshoe shape in the Pacific Ocean's basin, consisting of trenches, plate movements, and volcanic arcs, that leads to earthquakes, volcanic eruptions, and tsunamis.

sakman—single outrigger boats designed and sailed by Chamorros in the Northern Mariana Islands (16) and by CHamorus in Guåhan (17).

salinization—contamination, for example, of freshwater wells or soil, by saltwater.

salt ponds—artificial salt flats designed to extract salts from oceans and seas. Also called salt evaporation ponds, or salt works. They contrast with salt flats or salt pans, which occur naturally, typically in deserts.

saltwater—unlike freshwater, saltwater is undrinkable for humans, animals, and plants.

saltwater intrusion (or saltwater incursion)—this process can occur due to sea level rise. When saltwater intrudes, it salinizes freshwater aquifers, lenses, wells, or soil. It makes the water undrinkable for humans and animals and unusable for crop irrigation. Most plants cannot process salinized water, challenging agriculture and leading to ghost forests. *See also* ghost forests.

sastrugi—wavelike grooves, ridges, and furrows created in snow, typically by wind. Used by Inuit to navigate snowy terrain.

sea level rise—the increase of sea levels due either to the melt of land ice or to the increased temperature of oceans. Sea levels rise disproportionately globally.

seawalls—a strategy for addressing sea level rise by building an armor to defend against the water's incursion. Seawalls cannot stem sea level rise, which can go over or around them. Studies have shown that when the saltwater goes around the walls, it intensifies erosion.

settler colonialism—according to the *Oxford English Dictionary,* "Settler colonialism is an ongoing system of power that perpetuates the genocide and repression of indigenous peoples and cultures. Essentially hegemonic in scope, settler colonialism normalizes the continuous settler occupation, exploiting lands and resources to which indigenous peoples have genealogical relationships. Settler colonialism includes interlocking forms of oppression, including racism, white supremacy, heteropatriarchy, and capitalism. This is because settler colonizers are Eurocentric and assume that European values with respect to ethnic, and therefore moral, superiority are inevitable and natural. However, these intersecting dimensions of settler colonialism coalesce around the dispossession of indigenous peoples' lands, resources, and cultures."

shoal—geologic ridge or bank that is partly submerged or partly exposed, consisting of sand and other natural material. Shoals move as a result of storms, wave action, and sand shifts.

sidereal compass—a compass developed by Micronesian navigators that divided the horizon's circle into thirty-two points by marked so-called compass stars and noting when they rose and set, this constituting the points, distributed irregularly around the horizon and the compass.

skipjack—a boat designed in Chesapeake Bay for the purpose of oyster dredging (see Deal Island (4)). The boat has an extremely long boom and a sloop. The jib is mounted on a bowsprit. The wooden hull is V-shaped, has a hard chine, and a square stern. The centerboard is retractable, allowing it to move through shallow waters.

sky island—isolated mountains surrounded by radically different lowland environments.

Small Island Developing States (SIDS)—an intergovernmental organization of thirty-eight developing countries at the United Nations first recognized in 1992.

solastalgia—a term coined by Glenn Albrecht in 2007 to describe the distress caused by environmental change and environmental degradation.

storm surge (oceanography)—often the deadliest part of a tropical cyclone, storm surge can measure up to 20 feet (6 m) and push water onto the shore at this height. An already elevated base water level, for example, due to sea level rise, means that storm surge will reach further inland or reach higher elevations. *See also* sea level rise.

subsidence—the sinking of the earth's surface. The reasons for subsidence can be natural or human. Natural causes include tectonic shifts, earthquakes, or the dissolution of limestone. Human causes include the extraction of fluids, such as water or petroleum.

subsistence—farming, fishing, and hunting means one survives off of what one farms, fishes, and hunts, leaving little if any for trade or sale, or inversely, little need to buy.

surface sea temperatures (SSTs)—the water temperature closest to the ocean's surface. Due to global warming, SSTs are increasing and disproportionately near the equator and in the western Pacific Ocean. This increase fuels more intense storms and precipitation and has negative effects on the health of marine life.

swell—swells are generated by strong winds; they travel beyond the wind systems that generate them and remain after the wind has died away. Swells from distant origins tend to have a longer and slower undulation than swells and wind waves from nearby sources, which are shorter and steeper. Swells can be used to navigate.

terripelago—CHamoru poet and literary scholar Craig Santos Perez has proposed "a new term, terripelago (which combines *territorium* and *pélago*, signifying sea), to foreground territoriality as it conjoins land and sea, islands and continents" ("Transterritorial Currents"). "Indeed, mapping the American imperial terripelago," he writes, "draws our attention to the shifting histories of territorial regimes, including incorporated territories (states), unincorporated territories, trust territories, commonwealth territories, freely associated states, tribal territories, and federal territories."

territory—from the Latin *territorium* (from terra, "land," and -orium, "place"). According to Merriam-Webster, "a geographic area of land belong[ing] to or under the jurisdiction of a government authority." Also "a part of the U.S. not included within any state but organized with a separate legislature" and "a geographic space (such as a colonial possession) dependent on an external government but having some degree of autonomy." *See also* terripelago.

tetrapod (animal)—a four-limbed vertebrate (amphibians, birds, mammals, reptiles).

tetrapod (engineering)—four-legged marine engineering intended to buffer waves and prevent erosion. They are often used together with breakwater and seawalls (see Maldives (12)).

threat multipliers—how climate change intersects with economic, political, and social factors to create and heighten risk. For example, a severe hurricane that hits an under-resourced community. Climate change–induced events can exacerbate these factors and they can inversely exacerbate climate change impacts.

tied island—an island that rests at the end of a narrow strip of land known as an ayre, a spit, or a tombolo, connecting it to another island or the mainland.

tsunami—a series of enormous typically catastrophic waves caused by submarine earthquakes, coastal or underwater landslides, or volcanic eruptions.

typhoons—a large system of winds circulating around a strong center of low atmospheric pressure. Typhoons occur in the northwest Pacific Ocean. *See also* cyclones, hurricanes.

umiak—a boat used by the Inuit and in Greenland (1), northern Canada, Alaska, and Siberia. Like kayak (from the Inuit *qajaq*), the umiak consists of sealskin or other animal skin stretched over a whalebone or wood frame.

volcanic island (geology)—an island of volcanic origin also often referred to as a high island that stands in contrast to low-lying islands or atolls. They are small (relative to continental islands) and often are surrounded by barrier reefs. The slopes tend to be steep. *See also* atoll.

wa—single outrigger used in Federated States of Micronesia (19).

walap—single outrigger used in the Marshall Islands (20).

water sky—ice-free zones in the Arctic reflected as dark regions in the underbelly of clouds.

wetland—an important zone between ocean and land. Wetlands serve as a buffer to storm surge and to erosion. Wetlands are a crucial habitat for birds, fish, and microbes. They also filter water as it passes through. Wetlands are usually classified according to soil and plant life as bogs, marshes, swamps, and other environments.

Acknowledgments

It takes a village. This book is the product of many communities, contexts, and conversations. My deep gratitude to those who have supported me on the journey.

Climate change poses a strange challenge. We are all in this together. As the poem "Rise" by Kathy Jetñil-Kijiner and Aka Niviâna published following Greenland (1) underscores, the emissions unleashed by one population in one part of the globe impact another population in another part of it. The climate refugees from one island will migrate to another region. Climate change knows no boundaries.

In December 2009 I attended the Copenhagen climate conference, known formally as the United Nations Framework Convention on Climate Change (UNFCCC), and in March 2010 I attended the People's World Conference on Climate Change, convened near Cochabamba, Bolivia, by Evo Morales. As I covered the annual climate negotiations, I quickly realized a stark difference existed between the perception of them generated by the headlines of international press, in terms of which developed and BRIC nation (Brazil, Russia, India, China) would be the one to go first and lower emissions. On the ground, at the UNFCCC, by contrast, individual nation-states and various entities that represented clusters of nations (e.g., the Africa Group, the Alliance of Small Island States, the so-called Least Developed Countries, etc.) stood up one by one and shared stories of the harrowing impacts of climate change already unfolding in their home countries. The UNFCCC takes place annually in November and/or December, which is the end of the hurricane and typhoon season. Given that there are currently 194 nations, when they stand up individually and as clusters, the impacts disproportionately already affecting the majority of the globe starkly hits home.

As an environmental journalist, I had been grappling with questions of how to translate science to a lay audience and how to engage readers.

The idea for *Sea Change: An Atlas of Islands in a Rising Ocean* came to me shortly after: a multimedia and polyvocal approach. This book shares the impacts through maps and environmental science as well as the histories and stories of islands through islanders' writings, stories, and poems.

My deep gratitude to the UNFCCC negotiators and NGOs, especially of the Global South, for their work and for sharing their stories.

In 2011 I joined the faculty at the University of Hawai'i at Mānoa. The majority of the world's islands are located in the Pacific Ocean, and my time on Oahu has deeply enhanced my understanding of islands. While Oahu is not the island whose name translates to "the gathering place" (that honor goes to Kauai), Oahu is very much a gathering place for Pacific Islanders. UH Mānoa hosts centers and faculty devoted to Pacific Island studies and oceanography and has faculty and students from all parts of Moana Nui, the great Pacific Ocean. Living on Oahu and working at UH Mānoa was thus a foundation for the project. Thank you to my colleagues for illuminating exchanges throughout, and to my Dean for allowing me a generous stint of leave to complete this book. Gratitude to the ocean and the land and all they hold.

I am truly grateful for the generous support of this project. The Mesa Refuge Center provided a two-week residency in December 2020 that allowed me to transition from my duties at UH to devoting my undivided attention to the atlas in one of the world's most beautiful locations. It was so wonderful to be in residence. Thank you Peter Barnes for your commitment for fostering social and economic equity with a focus on the environment. The Currie C. and Thomas A. Barron Visiting Professorship in the Environment and the Humanities at the High Meadows Environmental Institute at Princeton University provided invaluable time and support to conduct final research and have edifying exchanges with colleagues and students between January 2021 and May 2022. My immense gratitude to Currie and Tom Barron for creating the Endowed Chair that made this work possible and for encouraging me to foster a sense of wonder about the environment in students. A Short-Term Fellowship at the Newberry Library in June 2022 allowed me to conduct archival research in the Ayer Collection. The Rachel Carson Center at the Ludwig Maximilian University in Munich, Germany, provided the time to finish revisions and see the book through to completion in Fall 2022.

Enormous gratitude to the San Francisco Bay, especially its waters. As ever, the unwavering and stalwart support of my bedrock community in the Bay Area allows me to experience a balanced and fulfilling life, to work and to play.

Thank you to Rebecca Solnit and to Niels Hooper for their enthusiasm about the project from the very first mention. My gratitude to the external reviewers for their constructive comments on the book proposal and manuscript: Antonia Juhasz, Darrin Jensen, Bill McKibben, Julie Sze, and the two anonymous reviewers.

My gratitude to the entire team at the University of California Press for their support and for the excellent teamwork. To Niels Hooper for his unwavering enthusiasm, to Lia Tjandra for her excellent design work, to Naja Pulliam Collins for pulling things together in the final rounds, to Amy Smith Bell for the very careful copyediting, to Julie Van Pelt for production, meaning for magically pulling everything together and catching last edits big and small, and to Alex Dahne, Teresa Iofolla, and Jolene Torr for the marketing and publicity.

Thank you, Alyne Spencer Gonçalves, for being such an excellent research assistant and contributing invaluable knowledge from your background and training in environmental studies and geography as well as from being an islander from one of the islands included in this atlas.

Enormous gratitude to cartographer Molly Roy for being such a joy to work with, starting with projects that predated this atlas. Our exchanges were invaluable to shaping this book. Thank you to Zina Deretsky, fellow Bay swimmer, for the illustrations. Gratitude to Trevor Paglen, for permission to print the art.

The atlas was received very enthusiastically by the burgeoning environmental humanities programs across the US. Gratitude to the venues and hosts named below who invited me to give guest lectures related to the book. The exchanges with my hosts and attendees were immensely illuminating. Material related to the atlas was presented as guest lectures and at conferences in numerous contexts, including the following: Princeton University, High Meadows Environmental Institute; the Exploratorium's San Francisco Fisher Bay Observatory; the University of Arizona, Institute of Sustainability; Arizona State University, Institute of the Environment; the University of Pennsylvania, Penn Program in Environmental Humanities; the University of Minnesota, Institute for Advanced Studies, Institute on the Environment and Department of German; the University of Toronto, Centre for Comparative Literature; the University of California at Davis, Environments and Societies Colloquium; Emory University; the University of California at Los Angeles, Laboratory for Environmental Narrative Strategies; the University of California at Santa Barbara, Literature and Environment Initiative; Linköping University, The Seedbox, An Environmental Humanities Initiative; Pacific University; Shaping San Francisco; the University of Oregon; Stanford University's Environmental Humanities Program; and the University of California at Berkeley, Institute of European Studies.

I thank the following people for the opportunities to present my work through guest lectures in these contexts: Jules Boykoff, Allison Carruth, Jeroen DeWulf, LisaRuth Elliott, Daniel Gilfillian, Vicky Googosian, Joela Jacobs, Lauren LaFauci, Stephanie LeMenager, Charlotte Melin, Simon Richter, Susan Schwartzenberg, Teresa Shewry, Kirk Wetters, and Michael Ziser.

Archival research was carried out at the following locations: the Ayer Collection at the Newberry Library in Chicago; the David Rumsey Map Collection at Stanford University; historical maps and nautical charts of the US Coast Survey/US Coast and Geodetic Survey at the National Oceanic and Atmospheric Administration; and the Library of Congress.

Thank you to senior librarian Stu Dawrs for his time and assistance in the Hawaiian and Pacific Collections at the University of Hawai'i at Mānoa.

For their support and edifying exchanges during various stages of my research, I would like to thank the following colleagues. In environmental journalism, deep gratitude, in particular to Bill McKibben and Naomi Klein, for coming to the University of Hawai'i in 2014 and 2015, respectively. For invitations to share my work as an environmental journalist to Rose Aguilar, Esther Amrah, Cat Brooks, Emily Douglas, Laura Flanders, Doug Henwood, Antonia Juhasz, Lisa Hymas, Bill Lueders, Sasha Lilley, Tara Lohan, Margaret Prescod, Betsy Reed, Matthew Rothschild, Kate Sheppard, Heather Smith, and Jennifer White.

In academia, deep gratitude to the following for their work in environmental humanities, geography, island studies, Black Caribbean Studies and/or Indigenous Studies and for our exchanges: Joni Adamson, Rachel Brahinsky, Allison Carruth, Ashley Dawson, Elizabeth DeLoughrey, Vicente Diaz, Chip Fletcher, John Foran, Anne-Lise François, Jaimey Hamilton Faris, Ken Hiltner, Joshua Jelly-Shapiro, Melody Jue, Stephanie LeMenager, Laurel Mei-Singh, Brandy Nālani-McDougall, Rob Nixon, Patrick Nunn, Robbie Richardson, Craig Santos Perez, and Teresa Shewry.

For exchanges about and feedback on specific chapters, gratitude to the following people: Emmanuel Bruno Jean-François, Derrick Higginbotham, Laura Lent, Craig Santos Perez, Robbie Richardson, Yasmine Romero, Earl Smith, and Sarah Marie Wiebe. Jules Boykoff was a wonderful writing partner and provided invaluable feedback on the entire manuscript.

Thank you, Luqman Abu El Foul, for providing valuable assistance with Arab cartography and navigation.

Thank you, Dolly Gerhardt, for your stellar copyediting.

For their solidarity and support, and fruitful exchanges, I thank Jules Boykoff, Rachel Brahinsky, Garance Burke, Sarolta Jane Cump, Roxanne Dunbar-Ortiz, Paul LaFarge, Patrick Marks, Melissa Nery, Rebecca Solnit, A. C. Thompson, and Michelle Vuckovich.

Lastly, sincere gratitude to the stalwart support of my family throughout this journey: my great-aunt, my father and stepmother, my aunt, my sister and her sons, my cousin, his wife, and their daughters.

Map Citations

1. GREENLAND

Allen, Jesse. "Melt at the Base of the Greenland Ice Sheet." NASA Earth Observatory based on data provided by Joe MacGregor (NASA/GSFC), August 4, 2016. earthobservatory.nasa.gov.

Gaba, Eric. "Thickness of the Greenland Ice Sheet." Wikimedia Commons. upload.wikimedia.org/wikipedia/commons/b/b5/Greenland_ice_sheet_AMSL_thickness_ map-en.svg.

Natural Earth Large-scale Coastline Data, 2019. Version 4.1.0. www.naturalearthdata.com.

2. SARICHEF ISLAND

Predicted and Historical Shorelines. Alaska District Corps of Engineers Civil Works Branch, 2009. www.poa.usace.army.mil/Portals/34/docs/civilworks/BEA/Shishmaref_Final%20Report. pdf.

SRTM 1-Arc Second Global Digital Elevation Model. United States Geological Survey, September 23, 2014. earthexplorer.usgs.gov.

3. LENNOX ISLAND

Fenech, A., N. Hedley, A. Chen, and A. Doiron. "Coastal Impact Visualization Map of Lennox Island, Prince Edward Island." University of Prince Edward Island's Climate Lab and Simon Fraser University's Spatial Interface Research Lab, 2014. projects.upei.ca/climate/clive/.

Surging Seas Risk Zone Map (SRTM Data), Lennox Island, Canada. Climate Central, 2014. https://ss2.climatecentral.org.

4. DEAL ISLAND

Greenhawk, Kelly. "Maryland's Historic Oyster Bottom." Maryland Department of Natural Resources, 2016. dnr.maryland.gov/fisheries/Pages/oysters/bars.aspx.

Satellite Map of Deal Island, Maryland, United States. Google Maps, 2019. maps.google.com.

Surging Seas Risk Zone Map (LiDAR Data), Deal Island, United States. Climate Central, 2014. https://ss2.climatecentral.org.

11. REPUBLIC OF SEYCHELLES

Martin, M., and Emilie Martin. *Seychelles: Water and How to Use It Sustainably.* Sustainability for Seychelles and Ministry of Education of Seychelles, September 2012. www.s4seychelles.com/uploads/6/1/6/7/6167574/teachers_guide_seychelles_final.pdf.

Satellite Map of Mahé, Seychelles. Google Maps, 2019. maps.google.com.

Surging Seas Risk Zone Map (SRTM Data), Seychelles. Climate Central, 2014. https://ss2.climatecentral.org.

13. BHASAN CHAR AND SANDWIP

Satellite Map of Sandwip, Bangladesh. Google Maps, 2019. maps.google.com.

Surging Seas Risk Zone Map (SRTM Data), Sandwip, Bangladesh. Climate Central, 2014. https://ss2.climatecentral.org.

Upazila Sandwip Map. Local Government Engineering Department of Sandwip, 2010. photos.wikimapia.org/p/00/02/73/71/57_full.jpg.

PACIFIC OCEAN LOCATOR MAP

Natural Earth Small-scale Coastline Data, 2019. Version 4.1.0. www.naturalearthdata.com.

16. COMMONWEALTH OF NORTHERN MARIANA ISLANDS

Map of Saipan Island, Mariana Islands. The Literature Production Center Trust Territory of the Pacific Islands, 1964. i.pinimg.com/736x/16/2d/e9/162de9770eac31f39492baeec6b88dfe.jpg.

Mushynsky, Julie. "Island of Saipan Archaeological Sites." In *Sea Fluidity: Recording Indigenous Seascapes and Maritime Cultural Landscapes in Saipan, Commonwealth of the Northern Mariana Islands,* 2011. www.researchgate.net/figure/Map-of-archaeological-sites-from-2011-and-some-known-site-locations_fig80_307214709.

Sea Level Rise Viewer, Northern Mariana Islands. Version 3.0.0. National Oceanic and Atmospheric Administration, 2017. https://coast.noaa.gov/slr/.

Topographic Map of the Island of Saipan, Commonwealth of the Northern Mariana Islands. US Department of the Interior, US Geological Survey, 1999. legacy.lib.utexas.edu/maps/topo/pacific_islands/txu-oclc-0607971266-saipan.jpg.

17. GUÅHAN

Herman, Rdk. "Inscribing Empire: Guam and the War in the Pacific National Historic Park." *Political Geography* (August 2008). www.researchgate.net/figure/Map-of-Guam-showing-the-seven-units-of-the-Park-and-lands-held-by-the-US-military_fig3_257421667.

Sea Level Rise Viewer, Guam. Version 3.0.0. National Oceanic and Atmospheric Administration, 2017. https://coast.noaa.gov/slr/.

Vann D. T., V. M. Bendixson, D. F. Roff, C. A. Simard, R. M. Schumann, N. C. Habana, and J. W. Jenson. "Map of the Northern Guam Lens Aquifer." Water and Environmental Research Institute of the Western Pacific, University of Guam, October 2016. www.guamhydrologicsurvey.com/index.php/sustainable-management/annual-report/.

18. BELAU

Palau Mangrove Map. Office of the Palau Automated Land and Resource Information System, Palau Ministry of Finance, 2017.

Satellite Map of Babeldaob, Palau. Google Maps, 2019. maps.google.com.

Surging Seas Risk Zone Map (SRTM Data), Babeldaob, Palau. Climate Central, 2014. https://ss2.climatecentral.org.

19. FEDERATED STATES OF MICRONESIA

Nunn, Patrick D., A. Kohler, and R. Kumar. *Identifying and Assessing Evidence for Recent Shoreline Change Attributable to Uncommonly Rapid Sea-Level Rise in Pohnpei, Federated States of Micronesia, Northwest Pacific Ocean.* Springer Science+Business Media B.V., 2017.

Satellite Map of Pohnpei, Federated States of Micronesia. Google Maps, 2019. maps.google.com.

Surging Seas Risk Zone Map (SRTM Data), Pohnpei, Federated States of Micronesia. Climate Central, 2014. https://ss2.climatecentral.org.

20. REPUBLIC OF MARSHALL ISLANDS

Satellite Map of Majuro, Marshall Islands. Google Maps, 2019. maps.google.com.

SRTM 1-Arc Second Global Digital Elevation Model. United States Geological Survey, September 23, 2014. earthexplorer.usgs.gov.

Tilley, Caitlin. Majuro Tide and Sea Level Rise Maps (University of Hawai'i) in "Graphics of Marshall Islands Sea Level Rise 'Brought EU Ministers to Tears.'" *Climate Home News,* June 2018. www.climatechangenews.com.

21. REPUBLIC OF KIRIBATI ISLANDS

Satellite Map of Tarawa, Kiribati. Google Maps, 2019. maps.google.com.

Surging Seas Risk Zone Map (SRTM Data), Tarawa, Kiribati. Climate Central, 2014. https://ss2.climatecentral.org.

22. REPUBLIC OF NAURU

Map of Nauru, 1988. legacy.lib.utexas.edu/maps/islands_oceans_poles/nauru.jpg.

Satellite Map of Nauru. Google Maps, 2019. maps.google.com.

SRTM 1-Arc Second Global Digital Elevation Model. United States Geological Survey, September 23, 2014. earthexplorer.usgs.gov.

Surging Seas Risk Zone Map (SRTM Data), Nauru. Climate Central, 2014. https://ss2.climatecentral.org.

23. REPUBLIC OF VANUATU

Coastal Risk Vanuatu Map. Vanuatu Coastal Adaptation Project, Vanuatu Meteorology and Geohazards Department, 2019. www.coastalrisk.com.vu/#.

SRTM 1-Arc Second Global Digital Elevation Model. United States Geological Survey, September 23, 2014. earthexplorer.usgs.gov.

Surging Seas Risk Zone Map (SRTM Data), Tegua, Vanuatu. Climate Central, 2014. https://ss2.climatecentral.org.

Satellite Map of Tegua, Vanuatu. Google Maps, 2019. maps.google.com.

24. SOLOMON ISLANDS

Albert, Simon, J. X. Leon, A. R. Grinham, J. A. Church, B. R. Gibbes, and C. D. Woodroffe. "Interactions between Sea-Level Rise and Wave Exposure on Reef Island Dynamics in the Solomon Islands." *Environmental Research Letters,* 11. 054011 (2016). https://iopscience.iop.org/article/10.1088/1748-9326/11/5/054011

Satellite Map of Santa Isabel, Solomon Islands. Google Maps, 2019. maps.google.com.

25. PAPUA NEW GUINEA

Satellite Map of Carteret Islands, Papua New Guinea. Google Maps, 2019. maps.google.com.

Surging Seas Risk Zone Map (SRTM Data), Carteret Islands, Papua New Guinea. Climate Central, 2014. https://ss2.climatecentral.org.

26. REPUBLIC OF FIJI

Satellite Map of Vanua Levu, Fiji. Google Maps, 2019. maps.google.com.

SRTM 1-Arc Second Global Digital Elevation Model. United States Geological Survey, September 23, 2014. earthexplorer.usgs.gov.

Surging Seas Risk Zone Map (SRTM Data), Vanua Levu, Fiji. Climate Central, 2014. https://ss2.climatecentral.org.

27. TUVALU

Satellite Map of Funafuti, Tuvalu. Google Maps, 2019. maps.google.com.

Surging Seas Risk Zone Map (SRTM Data), Funafuti, Tuvalu. Climate Central, 2014. https://ss2.climatecentral.org.

28. TOKELAU

Satellite Map of Tokelau. Google Maps, 2019. maps.google.com.

SRTM 1-Arc Second Global Digital Elevation Model. United States Geological Survey, September 23, 2014. earthexplorer.usgs.gov.

Surging Seas Risk Zone Map (SRTM Data), Tokelau. Climate Central, 2014. https://ss2.climatecentral.org.

33. BONAIRE

Mangrove Map of Bonaire. Dutch Caribbean Biodiversity Database, 1996. www.dcbd.nl/tags/mangroves.

Satellite Map of Bonaire, Caribbean Netherlands. Google Maps, 2019. maps.google.com.

SRTM 1-Arc Second Global Digital Elevation Model. United States Geological Survey, September 23, 2014. earthexplorer.usgs.gov.

Surging Seas Risk Zone Map (SRTM Data), Bonaire, Caribbean Netherlands. Climate Central, 2014. https://ss2.climatecentral.org.

Welcome to Bonaire. Skyviews Caribbean Maps, 2017. www.skyviews.com/bonaire-map/BON_MapSide_2017.jpg.

39. MARTINIQUE

Marques, B., and R. Cruse. *The Organisation of the Martinican Space.* 2013. www.caribbean-atlas.com. http://www.caribbean-atlas.com/en/themes/what-is-the-caribbean/the-caribbean-as-a-cultural-space.html.

Satellite Map of Martinique. Google Maps, 2019. maps.google.com.

SRTM 1-Arc Second Global Digital Elevation Model. United States Geological Survey, September 23, 2014. earthexplorer.usgs.gov.

Surging Seas Risk Zone Map (SRTM Data), Martinique. Climate Central, 2014. https://ss2.climatecentral.org.

41. ANTIGUA AND BARBUDA

Satellite Map of Antigua, Antigua and Barbuda. Google Maps, 2019. maps.google.com.

Surging Seas Risk Zone Map (SRTM Data), Antigua. Climate Central, 2014. https://ss2.climatecentral.org.

42. COMMONWEALTH OF PUERTO RICO

"Electric Power Plants and Transmission Lines in Puerto Rico." US Energy Information Administration, July 2018. www.eia.gov/todayinenergy/detail.php?id=36613.

Galarza, Javier Rodriguez. *Population Density of Puerto Rico.* US Census, 2008.

Sea Level Rise Viewer, Puerto Rico. Version 3.0.0. National Oceanic and Atmospheric Administration, 2017. https://coast.noaa.gov/slr/.

US Census, US Energy Information Administration.

47. COMMONWEALTH OF THE BAHAMAS

Satellite Map of New Providence, Bahamas. Google Maps, 2019. maps.google.com.

Surging Seas Risk Zone Map (SRTM Data), New Providence, Bahamas. Climate Central, 2014. https://ss2 .climatecentral.org.

48. ISLE DE JEAN CHARLES

Satellite Map of Isle de Jean Charles, Louisiana, United States. Google Maps, 2019. maps.google.com.

SRTM 1-Arc Second Global Digital Elevation Model. United States Geological Survey, September 23, 2014. earthexplorer.usgs.gov.

Surging Seas Risk Zone Map (SRTM Data), Isle de Jean Charles, Louisiana, United States. Climate Central, 2014. https://ss2.climatecentral.org.

49. PINE ISLAND

Shepherd Andrew, Lin Gilbert, Alan S. Muir, Hannes Konrad, Malcolm McMillan, Thomas Slater, Kate H. Briggs, Aud V. Sundal, Anna E. Hogg, and Marcus E. Hogg. "Trends in Antarctic Ice Sheet Elevation and Mass." *Geophysical Research Letters*, 2019. https://agupubs.onlinelibrary.wiley.com/doi/ full/10.1029/2019GL082182.

Works Cited

ARCHIVES

Newberry Library, Ayer Collection, Chicago, IL.

Stanford University Libraries, Rumsey Map Collection, Stanford, CA.

PRIMARY SOURCES

Climate Central. "Surging Seas. Risk Zone Map." https://ss2.climatecentral.org/.

Gillespie, Rosemary, and David A. Clague. *Encyclopedia of Islands*. University of California Press, 2009.

Intergovernmental Panel on Climate Change (IPCC). Sixth Assessment Report (AR6). United Nations, 2021.

The World Factbook. Central Intelligence Agency. www.cia.gov/the-world-factbook/.

SECONDARY SOURCES

Abel, Antonine. "Your Country." *Invitation to a Voyage*. Edited by Stephen Gray. Protea Book House, 2008.

Adams, Brian, and Julie Decker. *I Am Inuit*. Benteli, 2017.

Agius, Dionisius A. *Classic Ships of Islam: From Mesopotamia to the Indian Ocean*. Brill, 2007.

———. *In the Wake of the Dhow: The Arabian Gulf and Oman*. Ithaca Press, 2002.

Aguon, Julian. *The Properties of Perpetual Light*. University of Guam Press, 2021.

Akerman, James R., editor. *Cartographies of Travel and Navigation*. University of Chicago Press, 2006.

Albert, Simon, et al. "Interactions between Sea-level Rise and Wave Exposure on Reef Island Dynamics in the Solomon Islands." *Environmental Research Letters* 11.5 (2016): 1–9.

Albrecht, Glenn, et al. "Solastalgia: The Distress Caused by Environmental Change." *Australasian Psychiatry: Bulletin of Royal Australian and New Zealand College of Psychiatrists* 15.1 (2007): 95–98.

Alexander, M. Jacqui. *Pedagogies of Crossing: Meditations on Feminism, Sexual Politics, Memory and the Sacred*. Duke University Press, 2006.

Allen, Leslie. "Will Tuvalu Disappear beneath the Sea? Global Warming Threatens to Swamp a Small Island Nation." *Smithsonian Magazine*. August 2004.

Allfrey, Phyllis Shand. "Love for an Island." *Love for an Island: The Collected Poems of Phyllis Shand Allfrey*. Papillote Press, 2014.

Al-Najdi, Ahmad ibn Majid. "On the Origins and the Power of the Sea." *Arab Navigation in the Indian Ocean before the Arrival of the Portuguese*. Translation of *Kitab al-Fawa'id fi usul al-bahr wa'l-qawa'id* [Book of Lessons on the Foundation

of the Sea and Navigation]. Translated by G. R. Tibbetts. London: The Royal Asiatic Society of Great Britain and Ireland, 1971.

Alvarado Sierra, Melissa. "Warrior Foods: Food, Farming and Healing after the U.S. Navy Bombings." *The World We Need: Stories and Lessons from America's Unsung Environmental Movement.* Edited by Audrea Lim. New Press, 2021.

Alvarez, Julia. "Naming the Animals." *The Woman I Kept to Myself.* Algonquin Books, 2004.

Andrew, Neil L., et al. "Coastal Proximity of Populations in 22 Pacific Island Countries and Territories." *PLoS One* 14.9 (2019).

Anthes, Emily. "The Smart, Agile and Completely Underrated Dodo." *The Atlantic.* June 8, 2016.

Arnold, Stephanie, and Adam Fenech. "Prince Edward Island Climate Change Adaptation Recommendations Report." University of Prince Edward Island Climate Research Lab. Charlottetown, Canada. Report submitted to the Department of Communities, Land and Environment, Government of Prince Edward Island, 2017.

Associated Press. "Hurricane Dorian Slams the Bahamas, Heads along East Coast." September 4, 2019.

———. "Louisiana Paying $11.7M to Move Sinking Town." March 22, 2018.

Bagrow, Leo, and R. A. Skelton. *History of Cartography.* Harvard University Press, 1964.

"Bahrain's Second National Communication." United Nations Framework Convention on Climate Change. February 2012. Online.

Ballu, Valérie, et al. "Comparing the Role of Absolute Sea-Level Rise and Vertical Tectonic Motions in Coastal Flooding, Torres Islands (Vanuatu)." *Proceedings of the National Academy of Sciences of the United States of America* 108.32 (2011): 13019–13022.

Barlow, Maude. *Blue Covenant: The Global Water Crisis and the Coming Battle for the Right to Water.* New Press, 2007.

Barnett, Jon, and John Campbell. *Climate Change and Small Island States: Power, Knowledge and the South Pacific.* Routledge, 2015.

Benítez-Rojo, Antonio. *The Repeating Island: The Caribbean and the Postmodern Perspective.* Duke University Press, 1997.

Bloch, Michael. "Tuvalu Scores USD $6 Million Grant for Solar Power and Storage." *Solar Quotes.* November 8, 2019.

Bonilla, Yarimar. *Non-Sovereign Futures: French Caribbean Politics in the Wake of Disenchantment.* University of Chicago Press, 2015.

———. "Ordinary Sovereignty." *Small Axe* 42 (November 2013): 152–165.

Bonilla, Yarimar, and Max Hantel, dirs. *Visualizing Sovereignty: Animated Video of Caribbean Political History.* Film. 2016.

Bonilla, Yarimar, and Max Hantel. "Visualizing Sovereignty: Cartographic Queries for the Digital Age." *Small Axe* 1 (May 2016): 1–19.

Bonilla, Yarimar, and Marisol Le Brón. *Aftershocks of Disaster: Puerto Rico before and after the Storm.* Haymarket Press, 2019.

Boyle, Louise. "Residents of Hurricane-ravaged Barbuda Hopeful as UN Body Signals 'Deep Concern' over Resort for Uber-Rich." *The Independent.* July 17, 2021.

Brand, Dionne. *Bread Out of Stone: Recollections, Sex, Recognitions, Race, Dreaming, Politics.* Penguin, 1998.

———. *A Map to the Door of No Return: Notes to Belonging.* Grove Press, 1999.

———. *No Language Is Neutral.* McClelland and Stewart, 1998.

Brathwaite, Edward Kamau. "Islands." *The Arrivants: A New World Trilogy; Rights of Passage, Islands, Masks.* Oxford University Press, 1973.

Brown, Sally. Personal correspondence. April 29, 2019. University of South Hampton, UK.

Bruce, David. Personal correspondence. April 9, 2019. National Oceanic and Atmosphere Administration.

Burch, Ernest S. *The Iñupiaq Eskimo Nations of Northwest Alaska.* University of Alaska Press, 1998.

———. *Iñupiaq Ethnohistory: Selected Essays.* Edited by Erica Hill. University of Alaska Press, 2013.

———. *Social Life in Northwest Alaska: The Structure of Iñupiaq Eskimo Nations*. University of Alaska Press, 2006.

Burkett, Victoria, and Margaret Davidson, editors. *Coastal Climate Adaptation and Vulnerabilities: A Technical Input to the 2013 Climate Assessment*. Island Press / NCA Regional Input Reports, 2013.

Cabral, Amílcar. "Two Poems." *Unity and Struggle: Speeches and Writings*. Translated by Michael Wolfers. New York: Monthly Review Press, 1979.

Campbell, Christian. "Iguana." *Running the Dusk*. Peepal Tree, 2010.

Campbell, John, and Patricia Warwick. "Climate Change and Migration Issues in the Pacific." United Nations, 2014.

Carby, Hazel. *Imperial Intimacies: A Tale of Two Islands*. Verso, 2019.

Carson, Rachel. *The Edge of the Sea*. Houghton Mifflin, 1955.

———. *The Sea around Us*. Oxford University Press, 1951.

———. *Under the Sea Wind*. Simon and Schuster, 1941.

Castagnoli, Ferdinando. "L'orientamento nella cartografia greca e romana." *Rendiconti della Pontificia Accademia Romana di Archeologia* 48 (1975–76): 59–69.

Celia, Mike, Teresia Powell, and Sailosi Ramatu. "Rising Seas and Relocation in Fiji." *Policy Forum* (Asia and the Pacific). June 27, 2019.

Césaire, Aimé. *The Collected Poetry*. University of California Press, 1983.

———. *Discourse on Colonialism*. Translated by Joan Pinkham. Monthly Review Press, 2000.

———. *Notebook of a Return to the Native Land*. Translated by A. James Arnold and Clayton Eshleman. Wesleyan University Press, 2013.

Chakrabarty, Dipesh. "The Climate of History: Four Theses." *Critical Inquiry* 35 (2009): 197–222.

Chapelle, Howard I. *American Small Sailing Craft*. W. W. Norton, 1951.

"Chapter 13. Solomon Islands." *Climate Change in the Pacific: Scientific Assessment and New Research*. Vol. 2. Country Reports. Pacific Climate Change Science, 2013.

Chaturvedi, Sanjay, and Vijay Sakhuja. *Climate Change and the Bay of Bengal: Evolving Geographies of Fear and Hope*. ISEAS Publishing, 2015.

Choyce, Lesley, and Rita Joe. *The Mi'kmaq Anthology*. Pottersfield Press, 1997.

Choyce, Lesley, and Theresa Meuse-Dallien. *The Mi'kmaq Anthology: In Celebration of the Life of Rita Joe*. Vol. 2. Pottersfield Press, 2011.

Clark, Andrew. Personal correspondence. April 2, 2019. University of Calgary.

Clark, Campbell. "Residential School Survivors Grieve Loss of a Pioneer." *The Globe and Mail*. December 29, 2007.

"Comoros." United Nations Development Programme. n.d. www.adaptation-undp.org/explore/eastern-africa/comoros.

Cooper, J. A. G., and Orrin Pilkey. *Pitfalls of Shoreline Stabilization: Selected Case Studies*. Springer, 2012.

Cornwall, Warren. "As Sea Levels Rise, Bangladeshi Islanders Must Decide between Keeping Water Out or Letting It In." *Science Magazine*. March 1, 2018.

Crocker, Michael. Former Adviser to the Alliance of Small Island States. Personal correspondence. May 22, 2019.

Cronin, William B. *The Disappearing Islands of the Chesapeake*. Johns Hopkins University Press, 2005.

Couzens, Dominic. *Tales of Remarkable Birds*. Bloomsbury, 2015.

Crutzen, Paul J., and Eugene F. Stoermer. "The 'Anthropocene.'" *IGBP Newsletter* 41 (May 2000): 17–18.

Danticat, Edwidge. Interview with Robert Birnbaum, 2004. *Conversations with Edwidge Danticat*. Edited by Maxine Lavon Montgomery, 7–20. University of Mississippi, 2017.

D'Arcy, Paul. *The People of the Sea: Environment, Identity and History in Oceania*. University of Hawai'i Press, 2006.

Davenport, Coral, and Campbell Robertson. "Resettling the First American 'Climate Refugees.'" *New York Times*. May 5, 2016.

Davis, Heather, and Zoe Todd. "On the Importance of a Date, or Decolonizing the Anthropocene."

ACME: An International Journal for Critical Geographies 16.4 (2017): 761–780.

Dawson, Ashley. *Extinction: A Radical History*. OR Books, 2016.

Decker, Drew. National Map Liaison. US Geological Survey. Personal correspondence. June 5, 2019.

DeLoughrey, Elizabeth. *Roots and Routes: Navigating Caribbean and Pacific Island Literatures*. University of Hawai'i Press, 2007.

Denzin, Norman K., Yvonne S. Lincoln, and Linda Tuhiwai Smith. *Handbooks of Critical and Indigenous Methodologies*. 2nd ed. Zed Books, 2003.

Dermansky, Julie. "Critics Say State 'Hijacked' Isle de Jean Charles Tribe's Resettlement Plan." *Truthout*. April 24, 2019.

——. "Gulf Storm Brings Tough Choices for Residents of Disappearing Isle de Jean Charles." *DeSmog*. July 17, 2019.

——. "Louisiana Breaks Ground on Isle de Jean Charles Resettlement Project amid Pandemic." *DeSmog*. May 22, 2020.

DeYoung, Karen. "Tiny Mauritius Learns the Limits of Biden's Invocation of the International 'Rules-based Order.'" *Washington Post*. August 8, 2021.

Diaz, Vicente. "No Island Is an Island." *Native Studies Keywords*. Edited by Stephanie Nohelani Teves, Andrea Smith, and Michelle H. Raheja, 90–108. University of Arizona Press, 2015.

——. "Voyaging for Anti-colonial Recovery: Austronesian Seafaring, Archipelagic Rethinking and Remapping of Indigeneity." *Pacific Asia Inquiry* 2.1 (Fall 2011): 21–32.

Diouf, Henry Rene. Regional Technical Advisor on the Comoros Islands. Representative to the United Nations Development Programme. Personal correspondence. April 9, 2019.

Duvat, Virginie K. E., and Alexandre K. Magnan. "Rapid Human-Driven Undermining of Atoll Island Capacity to Adjust to Ocean Climate-Related Pressures." *Nature Science Reports* 9, article no. 15129 (2019).

Earle, Sylvia A. *Sea Change: A Message of the Oceans*. Putnam's, 1995.

Edwards, Tamsin. "Revisiting Ice Loss Due to Marine Ice-Cliff Instability." *Nature* 566 (February 6, 2019): 58–64.

Engelhard, Michael. "Arctic Wayfinders: Inuit Mental and Physical Maps." *Terrain*. March 15, 2019.

——. "Sky Above, Sea Below, Inuit Wayfinding." *Above & Beyond—Canada's Arctic Journal* (2018): 28–32.

Epps, Lewis Nathan. Chief, Hydraulics Hydrology Section. Alaska District. US Army Corps of Engineers. Personal correspondence. March 18, 2019.

Espírito Santo, Alda Graça or Alda do. "The Same Side of the Canoe." Translated by Allan Francovich and Kathleen Weaver. *The Penguin Book of Women Poets*. Edited by Carol Cosman, Joan Keefe, and Kathleen Weaver, 303–305. Viking, 1978.

Fanon, Frantz. *Black Skin, White Masks*. Translated by Charles Lam Markmann. Grove Press, 1967.

——. *The Wretched of the Earth*. Translated by Constance Farrington. Grove Press, 1963.

Figiel, Sia. "Rain" and "The Wind." *The Girl in the Moon Circle*. Mana Press, 1996.

——. "To a Young Artist in Contemplation (for Allan)." *To a Young Artist in Contemplation: Poetry and Prose*. University of South Pacific, 1998.

Figueroa-Vásquez, Yomaira C. *Decolonizing Diasporas: Radical Mappings of Afro-Atlantic Literature*. Northwestern University Press, 2020.

Filibert, Canisius. "Time." *Indigenous Literatures from Micronesia*. Edited by Evelyn Flores and Emelihter Kihleng, 18. University of Hawai'i Press, 2019.

Finney, Ben. "Nautical Cartography and Traditional Navigation in Oceania." *The History of Cartography*. Edited by David Woodward and Malcolm G. Lewis, 443–492. *Cartography in the Traditional African, American, Arctic Australian and Pacific Societies*. Vol 2.3. University of Chicago Press, 1998.

Flannery, Tim. *Mammals of New Guinea*. Reed/Australian Museum, 1995.

Flores, Evelyn, Emelihter Kihleng, and Craig Santos Perez, editors. *Indigenous Literatures*

from Micronesia. University of Hawai'i Press, 2019.

Foulman, Rajendra. Divisional Environment Officer for the Information and Environment Division. Mauritius. Personal correspondence. May 22, 2019.

Friedlingstein, Pierre, et al. "Global Carbon Budget 2019." *Earth System Science Data* 11 (2019): 1783–1838.

Frohman, Denice. "Puertopia." *Kweli Journal* (2018).

Fuller, Errol. *Dodo: A Brief History.* Universe, 2002.

———. *Lost Animals: Extinction and the Photographic Record.* Princeton University Press, 2013.

Gelardi, Chris, and Sophia Perez. "'This Isn't Your Island': Why Northern Mariana Islanders Are Facing Down the US Military." *The Nation.* June 12, 2019.

Ghosh, Amitav. *The Great Derangement: Climate Change and the Unthinkable.* University of Chicago Press, 2016.

Gibbons-Decherong, Lolita. Palau Conservation Society. Personal correspondence. May 29, 2019.

Gilroy, Paul. *The Black Atlantic: Modernity and Double Consciousness.* Harvard University Press, 1993.

Gingerich, Stephen B., et al. "Water Resources on Guam: Potential Impacts of and Adaptive Response to Climate Change." *USGS Scientific Investigations Report* 2019-5095. September 13, 2019.

Girard, Peter. Climate Central. Personal correspondence. June 21, 2019.

Glissant, Édouard. *The Collected Poems of Édouard Glissant.* Translated by by Jeff Humphries with Melissa Manolas. University of Minnesota Press, 2005.

———. "For Opacity." *Poetics of Relation.* Translated by Betsy Wing. University of Michigan Press, 1997.

———. *Poetics of Relation.* Translated by Betsy King. University of Michigan Press, 1997.

Goffe, Tao Leigh. "Sugarwork: The Gastropoetics of Afro-Asia after the Plantation." *Asian Diasporic Visual Cultures and the Americas* 5 (2019): 31–56.

Goodell, Jeff. *The Water Will Come: Rising Seas, Sinking Cities, and the Remaking of the Civilized World.* Little, Brown and Company, 2017.

Goodman, Steven M., and Jonathan P. Benstead. *The Natural History of the Madagascar.* University of Chicago Press, 2003.

Gould, Abegweit First Nation Chief Junior, and Lennox Island First Nation Chief Darlene Bernard. "Statement by Abegweit First Nation Chief Gould and Lennox Island First Nation Chief Darlene Bernard in Response to Member of Parliament Wayne Easter's Comments on a Moderate Livelihood Fishery." Press release. November 9, 2020.

Greenhawk, Kelly. Maryland Department of Natural Resources. Personal correspondence. April 9, 2019.

Gumbs, Alexis Pauline. *Dub: Finding Ceremony.* Duke University Press, 2020.

———. *M. Archive: After the End of the World.* Duke University Press, 2018.

———. *Spill: Scenes of Black Feminist Fugitivity.* Duke University Press, 2017.

———. *Undrowned: Black Feminist Lessons from Marine Mammals.* AK Press, 2020.

Haddon, A. C., and J. Hornell. *Canoes of Oceania. The Canoes of Polynesia, Fiji and Micronesia.* Vol. 1. Bishop Museum Press, 1936.

Hall, Stuart. *The Fateful Triangle: Race, Ethnicity, Nation.* Harvard University Press, 2021.

Hamilton, Donny L., and Robyn Woodward. "A Sunken 17th-Century City: Port Royal, Jamaica." *Archaeology* 37.1 (1984): 38–45.

Hamilton, Jon. "Maldives Builds Barriers to Global Warming." NPR. Morning Edition. January 28, 2008.

Han, Shin-Chan, et al. "Sea Level Rise in the Samoan Islands Escalated by the Viscoelastic Relaxation after the 2009 Samoa-Tonga Earthquake." *JGR Solid Earth.* March 28, 2019.

Hanlon, David. *Remaking Micronesia: Discourses over Development in a Pacific Territory, 1944–1982.* University of Hawai'i Press, 1986.

———. *Upon a Stone Altar: A History of the Island of Pohnpei to 1890.* University of Hawai'i Press, 1988.

Hansen, Kathryn. "The Wide View of a Shrinking Glacier: Retreat at Pine Island." NASA. April 9, 2019.

Haraway, Donna. *Staying with the Trouble: Making Kin in the Chthulucene*. Duke University Press, 2016.

Harjo, Joy. *When the Light at the End of the World Was Subdued, Our Songs Came Through: A Norton Anthology of Native Nations Poetry*. W. W. Norton, 2020.

Harjo, Joy, and Gloria Bird. *Reinventing the Enemy's Language: Contemporary Native Women's Writing of North America*. W. W. Norton, 1997.

Harley, J. B., and David Woodward, editors. *The History of Cartography*. 6 vols. University of Chicago Press, 1987.

Harmsen, Hans. Email correspondence with the author. June 18, 2020.

———. "Wooden Maps for Storytelling Not Navigation." *Atlas Obscura*. May 2, 2018.

Hartman, Saidiya. *Lose Your Mother: A Journey along the Atlantic Slave Route*. Farrar, Straus and Giroux, 2007.

———. "Venus in Two Acts." *Small Axe* 12.2 (2008): 1–14.

Hau'ofa, Epeli. "The Ocean in Us." *The Contemporary Pacific* 10.2 (1998): 392–410.

———. "Our Sea of Islands." *We Are the Ocean: Selected Works*. University of Hawai'i Press, 2008.

Hedge Coke, Allison Adelle, Brandy Nālani McDougall, and Craig Santos Perez, editors. *Effigies III*. Salt Publishing, 2019.

Heine, Hilda. "Climate Risks Are Rising—and They Are Not Limited to the Islands." *Thomson Reuters Foundation*. September 7, 2018.

———. @President_Heine, Hilda. "Our parliament has officially declared a national climate crisis." *Twitter*. October 10, 2019. 4:56 a.m. twitter.com/President_Heine/status/1182263738885427200/.

Heise, Ursula. *Imagining Extinction: The Cultural Meanings of Endangered Species*. University of Chicago Press, 2016.

Herrera, Carolina. "Latin American Reaffirms Climate Action Commitment at COP 25." Natural Resources Defense Council. December 6, 2019.

Hickel, Walter J. *Who Owns America?* Prentice-Hall, 1971.

Hinkel, Jochen. "The Abilities of Societies to Adapt to Twenty-First Century Sea Level Rise." *Nature Climate Change* 8 (2018): 570–578.

Holland, Paul R., et al. "West Antarctic Ice Loss Influenced by Internal Climate Variability and Anthropogenic Forcing." *Nature Geoscience* 12 (2019): 718–724.

Horton, Tom. "Tale of Skipjack Captain and Caper Still Worthy of Praise." *Bay Journal*. December 16, 2020.

Hourani, George Fadlo. *Arab Seafaring in the Indian Ocean in Ancient and Early Medieval Times*. Princeton University Press, 1995.

Human Development Data (1980–2015). United Nations Development Programme, 2015.

Human Development Index. www.hdr.undp.org/data-center/human-development-index#/indicies/HDI.

Human Development Report, 2015. United Nations Development Programme, 2015.

Isitoto, Philomena. "The Five Senses." *Modern Poetry from Papua New Guinea*. Edited by Nigel Krauth and Elton Brash, 10. Papua Pocket Poets, 1972.

James, C. L. R. *Black Jacobins: Toussaint L'Ouverture and the San Domingo Revolution*. 1938; Random House, 1989.

James, Selma. "Jean Rhys (1983). Excerpts." *Sex, Race and Class: The Perspective of Winning, A Selection of Writings, 1952–2011*, 260–285. PM Press, 2012.

Jenouvrier, Stephanie, et al. "The Call of the Emperor Penguin: Legal Responses to Species Threatened by Climate Change." *Global Change Biology* (August 3, 2021): 1–22.

Jetñil-Kijiner, Kathy. "Dear Matafele Peinam." UN Climate Summit. New York City. September 24, 2014.

———. "Dear Matafele Peinam" and "Tell Them." *Iep Jāltok: Poems from a Marshallese Daughter*. University of Arizona Press, 2017.

———. Personal interview. April 25, 2017.

Jetñil-Kijiner, Kathy, and Aka Niviâna. "Rise." 350.org. September 12, 2018. https://350.org/rise-from-one-island-to-another/#poem.

Joe, Rita. "I Lost My Talk" and "Waters." *Song of Eskasoni: More Poems of Rita Joe*. Women's Press, 1989.

——. "The Language the Empire of My Nation." *We Are the Dreamers: Recent and Early Poetry*. Breton Books, 1999.

Johnstone, Caitlyn. "Portrait of an Island Part I: What Used to Be Home." *Chesapeake Bay Program*. June 20, 2018.

——. "Portrait of an Island Part II: What Binds Us Together." *Chesapeake Bay Program*. June 28, 2018.

——. "Portrait of an Island Part III: What the Water Brings." *Chesapeake Bay Program*. July 23, 2018.

Joshua, Tanya Harris. Deputy Policy Director. Department of Insular Affairs. US Department of the Interior. Personal correspondence. June 5, 2019.

Jue, Melody. *Wild Blue Media: Thinking through Seawater*. Duke University Press, 2020.

Keener, Victoria, John J. Marra, et al. *Climate Change and Pacific Islands: Indicators and Impacts. Report for the 2012 Pacific Islands Regional Climate Assessment*. Island Press / NCA Regional Input Reports, 2013.

Kimmerer, Robin Wall. *Braiding Sweetgrass: Indigenous Wisdom, Scientific Knowledge and the Wisdom of Plants*. Milkweed Editions, 2015.

Kincaid, Jamaica. "Alien Soil." *The New Yorker*. June 21, 1993.

——. "Antigua Crossings: A Deep and Blue Passage on the Caribbean Sea." *Rolling Stone*. June 29, 1978, 48–50.

——. *A Small Place*. Farrar, Straus and Giroux, 1988.

King, Michaela D., et al. "Dynamic Ice Loss from the Greenland Ice Sheet Driven by Sustained Glacier Retreat." *Communications Earth & Environment* 1.1 (2020).

King, Tiffany Lethabo. *The Black Shoals: Offshore Formations of Black and Native Studies*. Duke University Press, 2019.

——. "The Labor of (Re)reading Plantation Landscapes Fungible(ly)." *Antipode* 48.4 (2016): 1022–1039.

Kirwan, Matthew, and Keryn B. Gedan. "Sea-level Driven Land Conversion and the Formation of Ghost Forests." *Nature Climate Change* 9 (2019): 450–457.

Klein, Alice. "Eight Low-lying Pacific Islands Swallowed by Rising Seas." *New Scientist*. September 7, 2017.

Klein, Naomi. *The Battle for Paradise: Puerto Rico Takes on the Disaster Capitalists*. Haymarket, 2018.

——. "Let Them Drown." *London Review of Books* 38.11 (June 2, 2016): 11–14.

——. *Shock Doctrine: The Rise of Disaster Capitalism*. Picador, 2007.

——. *This Changes Everything: Capitalism vs. The Climate*. Simon and Schuster, 2014.

Kolbert, Elizabeth. "The Climate of Man-1: Disappearing Islands, Thawing Permafrost, Melting Polar Ice. How the Earth Is Changing." *The New Yorker*. April 25, 2005.

——. *Field Notes from a Catastrophe*. Bloomsbury, 2006.

——. *The Sixth Extinction: An Unnatural History*. Picador, 2015.

Koslov, Liz. "The Case for Retreat." *Public Culture* 28.2 (2016): 373–401.

Krauss, Benjamin, and Scott Kulp. "Sea-Level Rise Threats in the Caribbean: Data, Tools and Analysis for a More Resilient Future." *Climate Central*. February 2018.

Lewis, David. *We, the Navigators: The Ancient Art of Landfinding in the Pacific*. University of Hawai'i Press, 1994.

Lewis, Simon L., and Mark A. Maslin. "Defining the Anthropocene." *Nature* 519 (2015): 171–180.

Liboiron, Max. *Pollution Is Colonialism*. Duke University Press, 2021.

Lim, Charles. *SEA STATE*. Nine-part video installation. 56th Venice Biennale. 2015.

Lipuma, Lauren. "Sounds of Melting Glaciers Could Reveal How Fast They Shrink." *Geospace*. (AGU blog). May 10, 2018.

Lockwood, Keith. Maryland Department of Natural Resources. Personal correspondence. April 9, 2019.

Lopez, Barry. *Arctic Dreams: Imagination and Desire in a Northern Landscape.* Scribner, 1986.

Lorde, Audre. "Grenada Revisited: An Interim Report." *The Struggle for Grenada,* special issue of *The Black Scholar* 15.1 (January–February 1984): 21–29.

———. "Of Generators and Survival—Hugo Letter." *Callaloo* 14.1 (Winter 1991): 72–82.

———. *Zami: A New Spelling of My Name.* Crossing Press, 1982.

Makini, Jully. "On the Rocks." *Flotsam and Jetsam.* University of the South Pacific, 2007.

Marchaj, C. A. *Sail Performance: Design and Techniques to Maximize Sail Power.* 1996.

———. *Sailing Theory and Practice.* Dodd, Mead and Company, 1964.

Marsh, Selina Tusitala. "'Ancient Banyans, Flying Foxes and White Ginger': Five Pacific Women Writers." Dissertation. University of Auckland, 2004.

———. "A Samoan Star-chant for Matariki" and "Fast Talking PI." *Fast Talking PI.* Auckland University Press, 2012.

Maryland Historical Trust. "Deal Island Historic District." National Park Service. US Department of the Interior. 2013.

Mason, Jean. "Not that kind of Māori." *Mauri Ola: Contemporary Polynesian Poems in English.* Edited by Albert Wendt, Reina Whaitiri, and Robert Sullivan, 126. Whetu Moana II. Auckland University Press, 2010.

Maunick, Edouard J. *Les manèges de la mer* [Taming the Sea]. Présence Africaine, 1964.

Mauritius, Republic of. "Third National Communication Report to the United Nations Framework Convention on Climate Change." October 2016.

McAdam, Jane. "The High Price of Resettlement: The Proposed Environmental Relocation of Nauru to Australia." *Australian Geographer* 48.1 (2017): 7–16.

McCoy, Michael. "A Renaissance in Carolinian-Marianas Voyaging." *Journal of the Polynesian Society* 82.4 (1973): 355–365.

McGrail, Séan. *Boats of the World: From the Stone Age to Medieval Times.* Oxford University Press, 2004.

McKibben, Bill. *The End of Nature.* Penguin Random House, 1989.

McKittrick, Katherine. *Dear Science.* Duke University Press, 2021.

———. *Demonic Grounds: Black Women and the Cartographies of Struggle.* University of Minnesota Press, 2006.

McKittrick, Katherine, and Clyde Adrian Woods. "No One Knows the Mysteries at the Bottom of the Ocean." *Black Geographies and the Politics of Place.* South End Press, 2007.

McNamara, Karen, Annah Piggott-McKellar, and Patrick D. Nunn. "Climate Change Forced These Fijian Communities to Move—and with 80 Months at Risk, Here's What They Learned." *The Conversation.* April 30, 2019.

McPhee, John. *Annals of the Former World.* Farrar, Straus and Giroux, 1998.

Menezes Neves, Ernestina. Directora Executiva do Instituto de Género. Personal correspondence. April 5, 2019.

Miller, Kei. "What the Mapmaker Ought to Know." *The Cartographer Tries to Map a Way to Zion.* Carcanet, 2014.

Mintz, Sidney. *Sweetness and Power: The Place of Sugar in Modernity.* Viking, 1985.

Molisa, Grace Mera. *Blackstone: Poems.* Mana Publications, 1983.

———. "Integration of Women." *Colonised People: Poems.* Black Stone Publications, 1987.

Mooney, Chris, and Brady Dennis. "The Military Paid for a Study on Sea Level Rise. The Results Were Scary." *Washington Post.* April 25, 2018.

Moore, Jason. "Introduction." *Anthropocene or Capitalocene? Nature, History and the Crisis of Capitalism,* 1–11. PM Press, 2016.

Morejón, Nancy. "Black Woman." *Where the Island Sleeps like a Wing.* Translated by Kathleen Weaver. Black Scholar Press, 1985.

Mortreux, Colette, and Jon Barnett. "Climate Change, Migration and Adaptation in Funafuti, Tuvalu." *Global Environmental Change* 19 (2009): 105–112.

Munoz, Sarah M. "Understanding the Human Side of Climate Change Relocation." *The Conversation.* June 10, 2019.

Nanticoke Indian Museum. Millsboro, Delaware. www.nanticokeindians.org/page/museum.

Nasheed, Mohammed. Personal interview. UN COP 15, Cancún, 2010.

Naura, Jimmy. Senior Logistics Officer. National Disaster Management Office. Government of Vanuatu. Personal correspondence. June 17, 2019.

"Nauru 2017/2018." Amnesty International. 2018. Online.

Neall, Vincent E., and Steven A. Trewick. "The Age and Origin of the Pacific Islands: A Geological Overview." *Philosophical Transactions Royal Society London* 363.1508 (October 27, 2008): 3293–3308.

Nicholls, Robert. University of South Hampton. UK. Personal correspondence. April 29, 2019.

Nixon, Rob. *Slow Violence and the Environmentalism of the Poor.* Harvard University Press, 2011.

NOAA. "Territory of Guam." Pacific Regional Integrated Sciences and Assessments (RISA). 2012.

Nunn, Patrick D. *Oceanic Islands.* Blackwell, 1994.

———. "Sea Level Rise Is Washing Away Micronesia's History." *Newsweek.* November 9, 2017.

———. Personal correspondence. June 3–4, 2019.

Nunn, Patrick D., Augustine Kohler, and Roselyn Kumar. "Identifying and Assessing Evidence for Recent Shoreline Change Attributable to Uncommonly Rapid Sea Level Rise in Pohnpei, Federated States of Micronesia, Northwest Pacific Ocean." *Journal of Coastal Conservation* 21.6 (December 2017): 719–730.

Oakes, Robert, Andrea Milan, and Jillian Campbell. "Climate Change and Migration: Relationships between Household Vulnerability, Human Mobility and Climate Change." United Nations University, Institute for Environment and Human Security. November 2016.

Pacific Climate Change Science. Palau. 2013. www .pacificclimatechangescience.org/wp-content /uploads/2013/06/2_PACCSAP-Palau-11pp_WEB .pdf.

Palaseanu-Lovejoy, Monica, et al. "One-meter Topobathymetric Digital Elevation Model for Majuro Atoll, Republic of the Marshall Islands, 1944 to 2016." *US Geological Survey Scientific Investigations Report* 2018-5047. March 30, 2018.

Patel, Raj, and Jason W. Moore. *A History of the World in Seven Cheap Things: A Guide to Capitalism, Nature and the Future of the Planet.* University of California Press, 2017.

Pattyn, Frank, et al. "The Greenland and Antarctic Ice Sheets under 1.5°C Global Warming." *Nature Climate Change* 8 (2018): 1053–1061.

Pearlman, Jonathan. "Cook Islands to Change Name to Remove Any Association with James Cook." *Daily Telegraph UK.* March 6, 2019.

Perez, Craig Santos. *From Unincorporated Territory [hacha].* 2008; Omnidawn, 2017.

———. *From Unincorporated Territory [SAINA].* Omnidawn, 2010.

———. *From Unincorporated Territory [guma'].* Omnidawn, 2014.

———. *From Unincorporated Territory [lukao].* Omnidawn, 2017.

———. "Guam and Archipelagic American Studies." *Archipelagic American Studies.* Edited by Brian Russell Roberts and Michelle Ann Stephens, 97–112. Duke University Press, 2017.

———. *Habitat Threshold.* Omnidawn, 2020.

———. "Interwoven." *Native Voices: Indigenous American Poetry, Craft and Conversations.* Edited by CMarie Fuhrman and Dean Rader, 440–442. Tupelo Press, 2019.

———. *Navigating CHamoru Poetry from Guåhan.* University of Arizona Press, 2022.

———. "Pacific Eco-Poetics—Week 2: Solastalgia." *The Hawaii Independent.* September 7, 2015.

———. "Transterritorial Currents and the Imperial Terripelago." *American Quarterly* 63.7 (2015): 619–624.

Perez, Craig Santos, and Brandy Nālani McDougall, editors. *Home(is)Lands: New Art and Writing from Guåhan and Hawai'i.* Ala Press, 2017.

Peters, Mercedes. "The Future Is Mi'kmaq: Exploring the Merits of Nation-Based Histories as the Future of Indigenous History in Canada." *Acadiensis: Journal of the History of the Atlantic Region* 48.2 (Autumn 2019): 206–216.

Pettit, Christine, et al. "Unusually Loud Ambient Noise in Tidewater Glacier Fjords: Signal of Ice Melt." *Geophysical Research Letters* (March 4, 2015).

Philip, M. NourbeSe. "Discourse on the Logic of Language." *She Tries Her Tongue, Her Silence Softly Breaks.* Ragweed Press 1989; Poui Publications 2005, 2012; Wesleyan University Press, 2014.

———. *Zong!* Wesleyan University Press, 2011.

Phillips, Lori. Cartographer. US Geological Survey. National Geospatial Technical Operations Center. Applied Research & Technology Branch. Personal correspondence. June 5, 2019.

Pictou, Sherry Mae. "Decolonizing Mi'kmaw Memory of Treaty: L'sitkuk's Learning with Allies in Struggle for Food and Lifeways." PhD dissertation. Dalhousie University, 2017.

———. "Small 't' Treaty Relationships without Borders: Bear River First Nation Clam Harvesters, the Bay of Fundy Marine Resource Centre and the World Forum of Fisher Peoples." *Anthropologica* 57.2 (2015): 457–467.

Pilkey, Orrin H. *A Celebration of the Barrier Islands.* Columbia University Press, 2003.

———. *The World's Beaches: A Global Guide to the Shoreline.* University of California Press, 2011.

Pilkey, Orrin H., Linda Pilkey-Jarvis, and Keith C. Pilkey. *Retreat from a Rising Sea: Hard Decisions in an Age of Climate Crisis.* Columbia University Press, 2016.

Prescod, Marsha. "Exiles." Translated by Kathleen Weaver. *Daughters of Africa: An International Anthology of Words and Writings by Women of African Descent from the Ancient Egyptian to the Present.* Edited by Margaret Busby, 847–848. Ballantine, 1992.

Pule, John. *The Bond of Time: An Epic Love Poem.* Canterbury University Press, 2014.

———. *Burn My Head in Heaven (Tugi e Ulu Haaku He Langî).* Penguin, 1998.

———. "Desire Lives in Hiapo." John Pule and Nicholas Thomas, *Hiapo: Past and Present in Niuean Barkcloth.* University of Otago Press, 2005.

Puniwai, Noelani, Kiana Frank, Oceana Puananilei Francis, Rosanna 'Anolani Alegado, and Kealoha Fox. "Kāne and Kanaloa Are Coming: How Will We Receive Them? A Kanaka Talk (Take) on Climate Change." Keynote Panel. "Ko Hawai'i Pae 'Āina: Mai ka Lā Hiki a ka Lā Kau." Third Annual Lāhui Hawai'i Research Center Conference, March 30, 2019.

Pyper, Julia. "Storm Surges, Rising Seas Could Doom Pacific Islands This Century." *Scientific American.* April 12, 2013.

Qolouvaki, Tagi. "Tell Me a Story (For uncle Talanoa)." *Effigies III.* Edited by Allison Adelle Hedge Coke, Brandy Nālani McDougall, and Craig Santos Perez, 87–88. Salt Publishing, 2019.

Quammen, David. *The Song of the Dodo: Island Biogeography in an Age of Extinction.* Scribner, 1997.

Ragoonaden, Sachooda, et al. "Recent Acceleration of Sea Level Rise in Mauritius and Rodrigues." *Western Indian Ocean Journal of Marine Science* (July 2017): 51–65.

Rankin, William. *After the Map: Cartography, Navigation and the Transformation of Territory in the Twentieth Century.* University of Chicago Press, 2016.

Raphael, T. J. "For the First Time in 300 Years, There's Not a Single Living Person on the Island of Barbuda." *PRI.org.* September 24, 2017.

Rasmussen, Vaine-Iriano. "Lost Pearl." *Maiata. A Collection of Poetry.* Suva, Fiji, Commonwealth Youth Program, South Pacific Regional Centre, 1991.

Rhys, Jean. *Wide Sargasso Sea.* W. W. Norton, 1982.

Richmond, Noah, and Benjamin K. Sovacool. "Bolstering Resilience in the Coconut Kingdom: Improving Adaptive Capacity to Climate Change in Vanuatu." *Energy Policy* 50 (2012): 843–848.

Rifkin, Mark. *Beyond Settler Time: Temporal Sovereignty and Indigenous Self-Determinism.* Duke University Press, 2017.

Rizza, Dan. Climate Central. Personal correspondence. June 21, 2019.

Robel, Alexander A., et al. "Marine Ice Sheet Instability Amplifies and Skews Uncertainty in Projections of Future Sea-Level Rise." *PNAS* 116.30 (July 8, 2019): 14887-14892.

Roberts, Brian Russell, and Michelle Ann Stephens, editors. *Archipelagic American Studies.* Duke University Press, 2017.

Roberts, Paul. Former Adviser on Media and International Communications. Maldives. Personal correspondence. June 26, 2019.

Rogers, Robert F. *Destiny's Landfall: A History of Guam.* University of Hawai'i Press, 2011.

Rosenberg, Daniel, and Anthony Grafton. *Cartographies of Time: A History of the Timeline.* Princeton Architectural Press, 2012.

Rountree, Helen C., and Thomas E. Davidson. *Eastern Shore Indians of Virginia and Maryland.* University of Virginia Press, 1997.

Rowling, Megan. "Township in Solomon Islands 1st in Pacific to Relocate due to Climate Change." *Scientific American.* August 15, 2014.

Rozwadowski, Helen M. *Fathoming the Ocean: The Discovery and Exploration of the Deep Sea.* Harvard University Press, 2005.

———. *Vast Expanses: A History of the Oceans.* University of Chicago Press, 2018.

Rundstrom, Robert A. "A Cultural Interpretation of Inuit Map Accuracy." *Geographical Review* 80 (1990): 155–168.

Rush, Elizabeth. *Rising: Dispatches from the New American Shore.* Milkweed Editions, 2018.

———. "Rising Seas: 'Florida Is about to Be Wiped Off the Map.'" *The Guardian.* June 26, 2018.

Russell, Scott. *Tiempon I Manmofofo'na: Ancient Chamorro Culture and History of the Northern Mariana Islands.* Division of Historic Preservation, 1998.

Rytz, Matthieu, dir. *Anote's Ark.* Eye Steel Film, 2018.

Sanchez, Pedro. *Guahan Guam: The History of Our Island.* Sanchez Publishing House, 1987.

Sardoo, Didier Maxwell. Ministry of Environment and Sustainable Development. Mauritius. Personal correspondence. May 22, 2019.

Schwartz, Stuart B. *Sea of Storms: A History of Hurricanes in the Greater Caribbean from Columbus to Katrina.* Princeton University Press, 2015.

Seetah, Krish. "'Our Struggle'—Mauritius: An Exploration of Colonial Legacies on an 'Island Paradise.'" *Shima: The International Journal of Research into Island Cultures* 4.1 (2010): 99–112.

Sharpe, Christina. *In the Wake: On Blackness and Being.* Duke University Press, 2016.

Shaw, John, et al. "Tsunami Impacts in the Republic of Seychelles following the Great Sumatra Earthquake of 26 December 2004." Canadian Coastal Conference. January 2005.

Shepard, Krech, III. *Spirits of the Air: Birds and American Indians in the South.* University of Georgia Press, 2009.

Shewry, Teresa. *Hope at Sea: Possible Ecologies in Oceanic Literature.* University of Minnesota Press, 2015.

Simpson, Leanne Betasamosake. *As We Have Always Done: Indigenous Freedom through Radical Resistance.* University of Minnesota Press, 2021.

Sinnok, Esau. Interview with Aletta Brady. *Our Climate Voices.* November 11, 2016.

———. Testimony to the US House Natural Resources Committee. May 2016.

Slater, Thomas. "Earth's Ice Imbalance." *The Cryosphere* 15 (January 25, 2021): 233–246.

Smith, Linda Tuhiwai. *Decolonizing Methodologies: Research and Indigenous Peoples.* Zed Books, 1999.

Solnit, Rebecca. *Infinite City: A San Francisco Atlas.* University of California Press, 2010.

———. *Nonstop Metropolis: A New York City Atlas.* University of California Press, 2016.

———. *A Paradise Built in Hell: Extraordinary Communities That Arise in Disaster.* Viking, 2010.

———. *Unfathomable City: A New Orleans Atlas.* University of California Press, 2013.

Sovacool, Benjamin, et al. "Expert Views of Climate Change Adaptation in Least Developed Asia." *Journal of Environmental Management* 97.1 (April 2012): 78–88.

Spahan, Rose M. *Smash: International Indigenous Weaving: Salish, Mi'kmaq, Alaskan, Southwest, Hawaiian.* Art Gallery of Greater Victoria, 2010.

Speck, Frank G. "Frolic among the Nanticoke of Indian River Hundred, Delaware." *Archaeological Society of Delaware Bulletin* 4.1 (1943): 2–4.

Spillers, Hortense J. "Mama's Baby, Papa's Maybe: An American Grammar Book." *Diacritics* 17.2 (Summer 1987): 65–81.

Starosielski, Nicole. *The Undersea Network.* Duke University Press, 2015.

Stephen, Marcus. "On Nauru, a Sinking Feeling." *New York Times.* Op-Ed. July 18, 2011.

Stern, Nicholas. *The Stern Review on the Economics of Climate Change.* Government of the United Kingdom, 2006.

Stern, Pamela. *Historical Dictionary of the Inuit.* 2nd ed. Scarecrow Press, 2013.

Stern, Pamela, and Lisa Stevenson. *Critical Inuit Studies: An Anthology of Contemporary Arctic Ethnography.* University of Nebraska Press, 2006.

Stiglitz, Joseph. "The Mauritius Miracle." *Project Syndicate.* March 7, 2011.

Stilgoe, John. *Shallow Water Dictionary: A Grounding in Estuary English.* Princeton Architectural Press, 1990.

Stockholm Resilience Centre. *The Nine Planetary Boundaries.* Stockholm, 2009.

Stoler, Ann Laura. *Along the Archival Grain: Epistemic Anxieties and Colonial Common Sense.* Princeton University Press, 2009.

———, editor. *Imperial Debris: On Ruin and Ruination.* Duke University Press, 2013.

Stone, Richard. "Cuba Embarks on a 100-Year Plan to Protect Itself from Climate Change." *Science.* January 10, 2018.

Storlazzi Curt. Department of Interior. US Geological Survey. Personal correspondence. May 26, 2019.

Storlazzi, Curt D., et al. "Most Atolls Will Be Uninhabitable by the Mid-21st Century Because of Sea Level Rise Exacerbating Wave Driven Flooding." *Science Advances* 4.4 (April 25, 2018).

Stuhle, Andrew. *Unfreezing the Arctic: Science, Colonialism and the Transformation of Inuit Lands.* University of Chicago Press, 2016.

Sullivan, Kristin M., Erve Chambers, and Dennis Barbery. "Indigenous Cultural Landscape Study for the John Smith Chesapeake National Historic Trail: Nanticoke River Watershed." The University of Maryland and the National Park Service, Chesapeake Bay, Annapolis, December 2013.

Swift, Earl. *Chesapeake Requiem: A Year with the Watermen of Vanishing Tangier Island.* Harper Collins, 2018.

———. Personal interviews. August 22, 2020, and December 30, 2020.

Takawo Darlynne. Office of the Palau Automated Land and Resource Information System (PALARIS), Ministry of Resources and Development. Republic of Palau. Personal correspondence. June 4, 2019.

Talanoa Dialogue Platform. United Nations Framework Convention on Climate Change (UNFCCC). 2018.

Taub, Ben. "Thirty-Six Thousand Feet under the Sea." *The New Yorker.* May 18, 2020.

Tawali, Kumalau. "Pacific Tingting" and "Signs in the Sky." *Signs in the Sky: Poems.* University of Papua New Guinea Press, 2006.

———. "Who Holds the Steer." *Tribesman's Heartbeats.* Kristen Press, 1978.

Teaiwa, Teresia. "Bikinis and other s/pacific n/oceans." *The Contemporary Pacific* 6.1 (Spring 1994): 87–109.

———. *Consuming Ocean Island: Stories of People and Phosphate from Banaba.* Indiana University Press, 2014.

———. "I Will Drink the Rain (For Toma)." *Indigenous Literatures from Micronesia.* Edited by Evelyn Flores and Emelihter Kihleng, 334. University of Hawai'i Press, 2019.

———. "L(o)osing the Edge." *Native Pacific Cultural Studies on the Edge.* Special issue of *The Contemporary Pacific* 13.2 (Fall 2001): 343–357.

———. "Militarism, Tourism and the Native: Articulations in Oceania." PhD dissertation. University of California at Santa Cruz, 2001.

———. "Native Thoughts: A Pacific Studies Take on Cultural Studies and Diaspora." *Indigenous Diasporas and Dislocations.* Edited by Graham Harvey and Charles D. Thompson, 15–35. Ashgate, 2005.

———. "On Analogues: Rethinking the Pacific in a Global Context." *The Contemporary Pacific* 18.1 (2006): 71–87.

———. *Sweat and Salt: Selected Works.* University of Hawai'i Press, 2021.

Terry, James P., and Anthony C. Falkland. "Responses of Atoll Freshwater Lenses to Storm-Surge Overwash in the Northern Cook Islands." *Hydrogeology Journal* 18 (2010): 749–759.

Thaman, Konai Helu. "The Shell" and "Stay Awhile." *Hingano: Selected Poems, 1966–1986.* Mana Publications, 1987.

Thornton, John. *Africa and Africans in the Making of the Atlantic World, 1400–1800.* Cambridge University Press, 1998.

Tibbetts, Gerald R. *Arab Navigation in the Indian Ocean before the Coming of the Portuguese.* Royal Asiatic Society of Great Britain and Ireland, 1971.

Tigona, Robson S. Senior Scientific Advisor. Climate Division. Government of Vanuatu. Personal correspondence. June 17, 2019.

Tionisio, Helen. "A Day in the Village." *Blackmail Press* 18 (2007). http://www.blackmailpress. com/HT18.html.

———. "My Father speaks 4 languages" and "On the Edge." *Blackmail Press* 31 (November 2011). http://www.blackmailpress.com/HT31.html.

Titus, James G., and Charlie Richman. "Maps of Lands Vulnerable to Sea-Level Rise: Modeled Elevations along the U.S. Atlantic and Gulf Coasts." *Climate Research* 18.3 (November 2001): 205–228.

Tjörnqvist, Torbjörn, et al. "Tipping Points of Mississippi Delta Marshes due to Accelerated Sea-Level Rise." *Science Advances* 6.21 (May 22, 2020).

Tolentino, Dominica. "Ancient CHamoru Cave Art." *Guampedia.org.*

Torabully, Khal. "Like Spume, Each Body." Translated by Naomi Nancy Carlson. *World Literature Today* (Winter 2019).

Trouillot, Michel-Rolph. "The Odd and the Ordinary: Haiti, the Caribbean and the World." *Cimarrón: New Perspectives on the Caribbean* 2.3 (1990): 3–12.

———. *Silencing the Past: Power and the Production of History.* Beacon Press, 1995.

Trusel, Luke D., et al. "Nonlinear Rise in Greenland Runoff in Response to Post-industrial Arctic Warming." *Nature* 564 (2018): 104–108.

Tulele Peisa Inc. (Sailing the Waves on Our Own). "Carterets Integrated Relocation Project. Project Proposal." Bougainville, 2008.

Turner, Phillip J., et al. "Memorializing the Middle Passage on the Atlantic Seabed in Areas beyond the National Jurisdiction." *Marine Policy* 122 (December 2020).

Tuten-Puckett, Katharyn. *"We Drank Our Tears": Memories of the Battles for Saipan and Tinian as Told by Our Elders.* Pacific START Center for Young Writers, 2004.

Union of the Comoros. Ministry of Rural Development, Fisheries, Handicraft and Environment. *National Action Programme of Adaptation to Climate Change (NAPA).* March 2006. UNFCCC. https://unfccc.int/resource/docs/napa/com01.pdf.

United Nations Economic Commission for Africa. "Addressing Climate Change Comoros and Sao Tome and Principe. n.d. https://archive.uneca.org/stories/addressing-climate-change-comoros-and-sao-tome-and-principe.

Urick, R. J. "The Noise of Melting Iceberg." *Journal of the Acoustical Society of America* 50, Issue 1B (1971): 337.

US Army Corps of Engineers. "Alaska Baseline Erosion Assessment." AVETA Report Summary. Shishmaref. n.d.

———. "Incorporating Sea Level Change in Civil Works Programs." Regulation No. 1100-2-8162. December 13, 2013.

———. "Procedures to Evaluate Sea Level Change: Impacts, Responses, Adaptation." Technical Letter No. 1100-2-1. June 30, 2014.

———. "Shishmaref Final Report." 2009.

"USGS Study: Guam Freshwater Seen to Ebb by 2080." *Saipan Tribune*. October 25, 2019.

Uyarra, M. C., et al. "Island-specific Preferences of Tourists for Environmental Features: Implications of Climate Change for Tourism-dependent States." *Environmental Conservation* 32.1 (2005): 11–19.

Vanuatu National Statistics Office. n.d. https://vnso.gov.vu/index.php/document-library?view=download&fileId=4438.

Vidal, John. "Pacific Atlantis: First Climate Change Refugees." *The Guardian*. November 25, 2005.

Virginia Institute of Marine Science. "Oyster Diseases of the Chesapeake Bay: Dermo and MSX Fact Sheet." William and Mary, School of Marine Science. n.d.

Voosen, Paul. "Greenland's Dying Ice." *Science Magazine*. October 10, 2019.

Vorrath, Sophie. "Tuvalu Heads for 35% Renewables with $6m Solar and Storage Grant." *Renew Economy Clean Energy News and Analysis*. November 8, 2019.

Waiki, John Dademo. *A Short History of Papua New Guinea*. Oxford University Press, 2014.

Walcott, Derek. "A Map of the World" and "The Schooner *Flight*." *The Poetry of Derek Walcott, 1948–2013*. Farrar, Straus and Giroux, 2014.

Walker, Ben. "An Island Nation Turns Away from Climate Migration, Despite Rising Seas." *Inside Climate News*. November 20, 2017.

Walters, Laura. "Pacific Climate Migration a Political Tug of War." *Newsroom*. April 23, 2019.

Walvin, James. *Black Ivory: Slavery in the British Empire*. Wiley, 1992.

Wanless, Harold. Personal interview. June 28, 2021.

Watt-Cloutier, Sheila. *The Right to Be Cold: One Woman's Fight to Protect the Arctic and Save the Planet from Climate Change*. University of Minnesota Press, 2018.

Watts, Jonathan. "The Sound of Icebergs Melting." *The Guardian*. April 9, 2020.

Webb, Arthur. "Technical Report—Analysis of Coastal Change and Erosion—Tebunginako Village, Abaiang, Kiribati." South Pacific Applied Geoscience Commission, 2006.

Weheliye, Alexander. *Habeas Viscus: Racializing Assemblages, Biopolitics and Black Theories of the Human*. Duke University Press, 2014.

Wei-Haas, Maya. "Big Earthquakes Might Make Sea Level Rise Worse. Here's How." *National Geographic*. June 17, 2019.

Wendt, Albert. "Guardians and Wards: A Study of the Origins and the First Two Years of the Mau in Western Samoa." MA thesis. Victoria University, Wellington, 1965.

———. *Nuanua: Pacific Writing in English since 1980*. University of Hawai'i Press, 1995.

Wendt, Albert, Reina Whaitiri, and Robert Sullivan. *Mauri Ola: Contemporary Polynesian Poems in English*. Auckland University Press, 2013.

———. *Whetu Moana: Contemporary Polynesian Poems in English*. Auckland University Press, 2003.

"What Climate Change Means for Guam." US Environmental Protection Agency. August 2016. https://19january2017snapshot.epa.gov/sites/production/files/2016-09/documents/climate-change-gu.pdf.

Whitney, Scott. "The Bifocal World of John Pule: This Niuean Writer and Painter Is Still Searching for a Place to Call Home." *Pacific Magazine*. October 6, 2008.

Whyte, Kyle Powys. "Indigenous Climate Change Studies: Indigenizing Futures, Decolonizing the Anthropocene." *English Language Notes* 55.1–2 (Fall 2017): 153–162.

Willey, Karl. Chesapeake Bay Foundation. Personal correspondence. April 9, 2019.

Williams, Dessima. "As Waves Crash Ever Closer to Our Doors in Grenada, Will Paris Talks Stem the Tide?" *The Guardian*. November 24, 2015.

Witschge, Loes. "In Fiji, Villages Need to Move Due to Climate Change." *Al Jazeera*. February 24, 2018.

Woodward, David, editor. *Art and Cartography.* University of Chicago Press, 1987.

———. *Five Centuries of Map Printing.* University of Chicago Press, 1975.

Woodward, David, and G. Malcolm Lewis. *The History of Cartography: Cartography in the Traditional African, American and Pacific Societies.* University of Chicago Press, 1998.

Worland, Justin. "The Leaders of These Sinking Countries Are Fighting to Stop Climate Change. Here's What the Rest of the World Can Learn." *Time.* June 13, 2019.

World Bank. "Can You Imagine a Caribbean Minus Its Beaches? It's Not Science Fiction, It's Climate Change." November 6, 2013.

———. "The Impact of Climate Change on Low Islands, The Tarawa Atoll, Kiribati." http://siteresources.worldbank.org/INTPACIFICISLANDS/Resources/4-Chapter+4.pdf.

Wynter, Sylvia. "1492: A New World View." *Race, Discourse, and the Origin of the Americas: A New World View.* Edited by Vera Lawrence Hyatt and Rex Nettleford, 5–57. Smithsonian Institution Press, 1996.

———. "On How We Mistook the Map for the Territory, and Reimprisoned Ourselves in Our Unbearable Wrongness of Being, of Desêtre: Black Studies toward the Human Project." *Not Only the Master's Tools: African American Studies in Theory and Practice.* Edited by Lewis Gorden, 107–169. Paradigm, 2006.

———. "Unparalleled Catastrophe for Our Species? Or, To Give Humanness a Different Future: Conversations." *Sylvia Wynter: On Being Human as Praxis.* Edited by Katherine McKittrick, 9–89. Duke University Press, 2015.

Yamada, Seijii, Maxine Burkett, and Gregory G. Maskarinec. "Sea Level Rise and the Marshallese Diaspora." *Environmental Justice* 10.4 (August 2017): 93–97.

Yerta, Lopagna. Information Management Officer. National Disaster Management Office. Government of Vanuatu. Personal correspondence. June 17, 2019.

Young, Rob, and Orrin Pilkey. *The Rising Sea.* Island Press, 2009.

Yusoff, Kathryn. *A Billion Black Anthropocenes or None.* University of Minnesota Press, 2018.

Zanolli, Lauren. "Louisiana's Vanishing Island: The Climate Refugees Resettling for $52m." *The Guardian.* March 15, 2016.

Credits

Grateful acknowledgment is made for permission to reprint the following:

Wooden map, ca. 1885. Courtesy Museumsinspektør, Greenland National Museum and Archives | Trevor Paglen. "NSA-Tapped Fiber Optic Cable Landing Site, New York City, New York, United States," 2015; "NSA-Tapped Fiber Optic Cable Landing Site, Morro Bay, California, United States," 2015; "NSA-Tapped Fiber Optic Cable Landing Site, Keawaula, Hawai'i, United States," 2016 | Stick Chart, Republic of the Marshall Islands. Collection of the Denver Museum of Nature and Science | Antonine Abel. "Your Country." *Invitation to a Voyage*, edited by Stephen Gray. Protea Book House, 2008 | Ahmad ibn Majid Al-Najdi. From "On the Origins and the Power of the Sea." *Arab Navigation in the Indian Ocean before the Arrival of the Portuguese*. Translation of *Kitab al-Fawa'id fi usul al-bahr wa'l-qawa'id* [Book of Lessons on the Foundation of the Sea and Navigation]. Trans. G. R. Tibbetts. Royal Asiatic Society of Great Britain and Ireland, 1971. Courtesy of the the Royal Asiatic Society of Great Britain and Ireland | Phyllis Shand Allfrey. "Love for an Island." *Love for an Island: The Collected Poems of Phyllis Shand Allfrey*. Papillote Press, 2014 | Julia Alvarez. From *The Woman I Kept to Myself*. Copyright © 2004 by Julia Alvarez. Published by Algonquin Books of Chapel Hill in 2004. By permission of Susan Bergholz Literary Services, New York, NY and Lamy, NM. All rights reserved | Edward Kamau Brathwaite. "Islands." *The Arrivants: A New World Trilogy: Rights of Passage, Islands, Masks*. Oxford Publishing Limited (Academic), © 1973. Reproduced with permission of the Licensor through PLSclear | Amilcar Cabral. "Two Poems." *Unity and Struggle: Speeches and Writings*. Trans. Michael Wolfers. Monthly Review Press, 1979 | Christian Campbell. "Iguana" from *Running the Dusk*. Peepal Tree Press, 2010. © Christian Campbell, reproduced by permission of Peepal Tree Press | Aimé Césaire. From *Notebook of a Return to the Native Land*. © 2013 by Aimé Césaire. Published by Wesleyan University Press. Used by permission | Sia Figiel. "Rain" and "The Wind." *The Girl in the Moon Circle*. Mana Press, 1996; "To a Young Artist in Contemplation (for Allan)." *To a Young Artist in Contemplation: Poetry and Prose*. University of South Pacific, 1998 | Canisius Filibert. "Time." *Indigenous Literatures from Micronesia*. Ed. Evelyn Flores and Emelihter Kihleng. University of Hawai'i Press, 2019 | Denice Frohman. "Puertopia." This poem originally appeared in *Kweli Journal* (2018) | Édouard Glissant. From *Poetics of Relation*. Trans. Betsy King. University of Michigan Press, 1997 | Epeli

Hau'ofa. From "Our Sea of Islands." *We Are the Ocean: Selected Works*. University of Hawai'i Press. © 2008 by University of Hawai'i Press. Reprinted with permission | Philomena Isitoto. "The Five Senses." *Modern Poetry from Papua New Guinea*. Ed. Nigel Krauth and Elton Brash. Papua Pocket Poets, 1972 | Kathy Jetñil-Kijiner. "Dear Matafele Peinam" and "Tell Them" from *Iep Jāltok: Poems from a Marshallese Daughter*. © 2017 Kathy Jetñil-Kijiner. Reprinted by permission of the University of Arizona Press | Kathy Jetñil-Kijiner and Aka Niviâna. "Rise." 350.org. September 12, 2018. https://350.org/rise-from-one-island-to-another/#poem | Rita Joe. "I Lost My Talk" and "Waters." *Song of Eskasoni: More Poems of Rita Joe*. Women's Press, 1989; "The Language the Empire of My Nation." *We Are the Dreamers: Recent and Early Poetry*. Breton Books, 1999 | Jamaica Kincaid. From *A Small Place*. © 1988 by Jamaica Kincaid. Reprinted by permission of Farrar, Straus and Giroux. All Rights Reserved | Audre Lorde. From "Grenada Revisited: An Interim Report." *The Black Scholar* 15:1 (1984) | Jully Makini. "On the Rocks." *Flotsam and Jetsam*. University of the South Pacific, 2007 | Selina Tusitala Marsh. "Fast Talking PI" and "A Samoan Star-chant for Matariki." *Fast Talking PI*. Auckland University Press, 2012. © Selina Tusitala Marsh, used with the permission of the publisher | Jean Mason. "Not that kind of Māori." *Mauri Ola: Contemporary Polynesian Poems in English*. Whetu Moana II. Auckland University Press, 2010 | Edouard J. Maunick. From *Les Manèges de la mer*. © Présence Africaine Editions, 1964 | Kei Miller. From *The Cartographer Tries to Map a Way to Zion*. © Kei Miller, 2014, published by Carcanet, reproduced by kind permission by David Higham Associates | Grace Mera Molisa. "Integration of Women." *Colonised People: Poems*. Black Stone Publications, 1987. Courtesy of Ms. Viran Molisa Trief on behalf of grantors Sela Molisa and children Viran Molisa Trief, Pala Molisa, and Vatumaraga Molisa | Nancy Morejón. "Black Woman." *Where the Island Sleeps like a Wing*. Trans. Kathleen Weaver. Black Scholar Press, 1985 | Craig Santos Perez. "Interwoven." *Native Voices: Indigenous American Poetry, Craft and Conversation*. Ed. CMarie Fuhrman and Dean Rader. Tupelo Press, 2019 | © M. NourbeSe Philip. From "Discourse on the Logic of Language." *She Tries Her Tongue, Her Silence Softly Breaks*. Ragweed Press 1989; Poui Publications 2005, 2012; Wesleyan University Press, 2014 | Marsha Prescod. "Exiles." Trans. Kathleen Weaver. *Daughters of Africa*. Ed. Margaret Busby. Ballantine, 1992 | John Pule. From *The Bond of Time: An Epic Love Poem*. Canterbury University Press, 2014; From *Burn My Head in Heaven*. Penguin, 1998; From "Desire Lives in Hiapo," in John Pule and Nicholas Thomas, *Hiapo: Past and Present in Niuean Barkcloth*. University of Otago Press, 2005 | Tagi Qolouvaki. "Tell Me a Story (For uncle Talanoa)." *Effigies III*. Ed. Allison Adelle Hedge Coke, Brandy Nālani McDougall, and Craig Santos Perez. Salt Publishing, 2019 | Vaine-Iriano Rasmussen. "Lost Pearl." *Maiata. A Collection of Poetry*. Suva, Fiji, Commonwealth Youth Program, South Pacific Regional Centre, 1991 | Jean Rhys. From *Wide Saragasso Sea*. W. W. Norton, 1982 | Marcus Stephen. From "On Nauru, a Sinking Feeling." *New York Times*, Op-Ed, July 18, 2011 | Teresia Teaiwa. "I Will Drink the Rain (For Toma)." *Indigenous Literatures from Micronesia*. Ed. Evelyn Flores and Emelihter Kihleng. University of Hawai'i Press, 2019 | Konai Helu Thaman. "The Shell" and "Stay Awhile." *Hingano: Selected Poems, 1966–1986*. Mana Publications, 1987 | Helen Tionisio. "A Day in the Village." *Blackmail Press* 18 (2007). http://www.blackmailpress.com/HT18.html; "My Father speaks 4 languages" and "On the Edge." *Blackmail Press* 31 (November 2011). http://www.blackmail-press.com/HT31.html | Michel-Rolph Trouillot. "The Odd and the Ordinary: Haiti, the Caribbean and the World." *Cimarron* 2.3 (1990) | Derek Walcott. Excerpts from "A Map of the World" and "The Schooner *Flight*." *The Poetry of Derek Walcott, 1948–2013*. Farrar, Straus and Giroux, 2014.